PICTURE PERFECT POSING

Practicing the Art of Posing for Photographers and Models

ROBERTO VALENZUELA

New Riders

VOICES THAT MATTER™

Picture Perfect Posing: Practicing the Art of Posing for Photographers and Models
Roberto Valenzuela

New Riders

Find us on the Web at www.newriders.com
To report errors, please send a note to errata@peachpit.com
New Riders is an imprint of Peachpit, a division of Pearson Education

Editors: Christina Leung and Ted Waitt
Senior Production Editor: Lisa Brazieal
Cover and Interior Design: Mimi Heft
Developmental Editor: Nolan Hester
Copyeditor: Liz Welch
Compositor: WolfsonDesign
Indexer: James Minkin

About the Cover Photo

Model: Kristen Dalton (Miss USA 2009)
Photo Shoot Location: Mogul Los Angeles
Make Up, Hair, and Nails: Fiore Beauty
Dress: Alexander McQueen
Stylist: Laura Hine
Camera: Hasselblad H5D
Photo Editor: Rocco Ancora
Photographer: Roberto Valenzuela

ISBN-13 978-0-321-96646-9
ISBN-10 0-321-96646-5

9 8 7 6 5 4 3

Printed and bound in the United States of America

I want to dedicate this book to my mom. *To me you are the most amazing and inspiring woman in my life. I thank God every day for giving me a mother like you.*

To my wife Kim—my life partner and my best friend. *I am who I am thanks to your unconditional love. You make me want to be a better person. I know I am not easy, but you love me and accept me just the way I am. Regardless of where we are in the world, it always feels like home when we are together. I love you!*

To our dog Chochos. *You have been around my life before I was even a photographer. You have blessed our family with your company and love when we needed it the most. You have enriched our lives, Chochos. We love you and will always carry you in our hearts.*

ACKNOWLEDGMENTS

This book was a colossal amount of work. But I couldn't have done it alone. The team at Peachpit is second to none! I thank you for making my book possible and for making it look beautiful. Honestly, I could not ask for a better acquisitions editor than Ted Waitt. It is Ted who initially believed in me and gave me a chance to write my first book, *Picture Perfect Practice*. For this, I will always be grateful to him. If you don't know Ted, you should. He is a good man. Many thanks also go to Peachpit's Mimi Heft, Lisa Brazieal, and Nolan Hester for their great work on the book.

I also want to thank my family for their support throughout this project. A special shout-out goes to my mother-in-law Christina. She was the first editor for this book, as well as for my first book. The amount of work it takes to fix all my grammar mishaps is monumental. Trust me, the reason this book reads so beautifully is because of her skill, the countless hours she spent fixing my errors and, most importantly, her love for the English language. Christina, I love you very much and this book would not be the same without you. I also want to thank my whole family. My amazing wife Kim, for loving me, caring for me, and supporting me every day through the good and bad throughout our nearly 10 years of marriage. To my beautiful Mutti, for being the greatest gift God blessed me with. To my brother Tono, my sisters Blanca and Susy, my brother-in-law Kent, my father-in-law Peter, my sisters-in-law Amy and Sarah, my cutie-pie niece Alexandra, my new brother-in-law Neal, my awesome nephews Ethan and Caleb, and my super flexible and talented niece Elliana. A special thanks to my cousin Wendy for always believing in me.

To my amazing best friends Jerry and Melissa Ghionis, for always pushing me to go further and think harder. I thank you for helping me reach my potential and for being unconditional friends to Kim and me. The memories of those crazy nights we spend talking, laughing, and singing over red wine will live in my heart forever. I love you both very much!

I also want to send a huge thanks to Arlene Evans, who believed in me from the very start and launched my career when I was completely unknown. Thank you, Arlene, for your friendship and the trust you endowed me with in this industry.

To my adopted father David Edmonson, thank you for being a father figure to me. I have so much love and respect for you and your whole family. I could not have asked for a more meaningful person to write the foreword to this book. I consider my relationship with you a blessing and a gift from God.

A special thanks to my friends Laura Hine and Robiat Balogun, for styling, organizing, and making beautiful the models for this book with amazing hair and make-up. You ladies were a big part of this book project and I am forever grateful for you volunteering your time and skills to make this a better-looking book. I want to send a special thanks to Rocco Ancora for applying his seriously world-class editing skills to the photo on the cover of this book. Rocco, I am honored to have a piece of your enormous talent in the most visible part of the book. Thank you, my friend.

I also want to thank industry organizations and my friends who help run them, such as Wedding and Portrait Photographers International (WPPI), the Professional Photographers of America (PPA), Photo Plus, Junebug Weddings, creativeLIVE, and Hasselblad for continuing to provide photographers worldwide with an opportunity to learn and push the artistic envelope with the art of photography.

Lastly, I want to send a sincere thank-you to all my readers worldwide. Thank you so much for your support. I hope your photography careers forever prosper! Remember that learning never ends and skill is nothing but the result of deliberate practice.

ABOUT THE AUTHOR

Roberto Valenzuela is a photographer based in Beverly Hills, CA. He developed his unique teaching style by following the same practice regimen he developed as a professional concert classical guitarist and educator. Roberto believes that it is not talent but deliberate practice that is at the core of skill and achievement. He has traveled to every corner of the world, motivating photographers to practice and break down the various elements of photography in order to master them through goal setting, self-training, and constant dedication.

Roberto serves as a judge for photographic print competitions in Europe, Mexico, South America, and the most prestigious international photography competitions held in the United States through Wedding and Portrait Photographers International (WPPI) in Las Vegas, NV.

Roberto teaches private workshops, seminars, and platform classes at the largest photography conventions in the world. He has been an international first-place winner three times and has been nominated by his peers as one of the ten most influential photographers and educators in the world. His first book, *Picture Perfect Practice,* became a bestselling photography training book, and it is sold worldwide.

Aside from the world of photography, Roberto is a high-performance remote-control helicopter pilot, a (not so good anymore) classical guitarist, and a table tennis fanatic. He is also a major foodie and is still searching for the most amazing red wine and the most pungent cheeses. His search for the perfect steak is over; he found it in the Japanese Wagyu.

CONTENTS

PART 2

POSING COUPLES WITH THE PICTURE PERFECT POSING SYSTEM 237

16: POSING COUPLES WITH THE PICTURE PERFECT POSING SYSTEM 239

CONCLUSION 301

INDEX 304

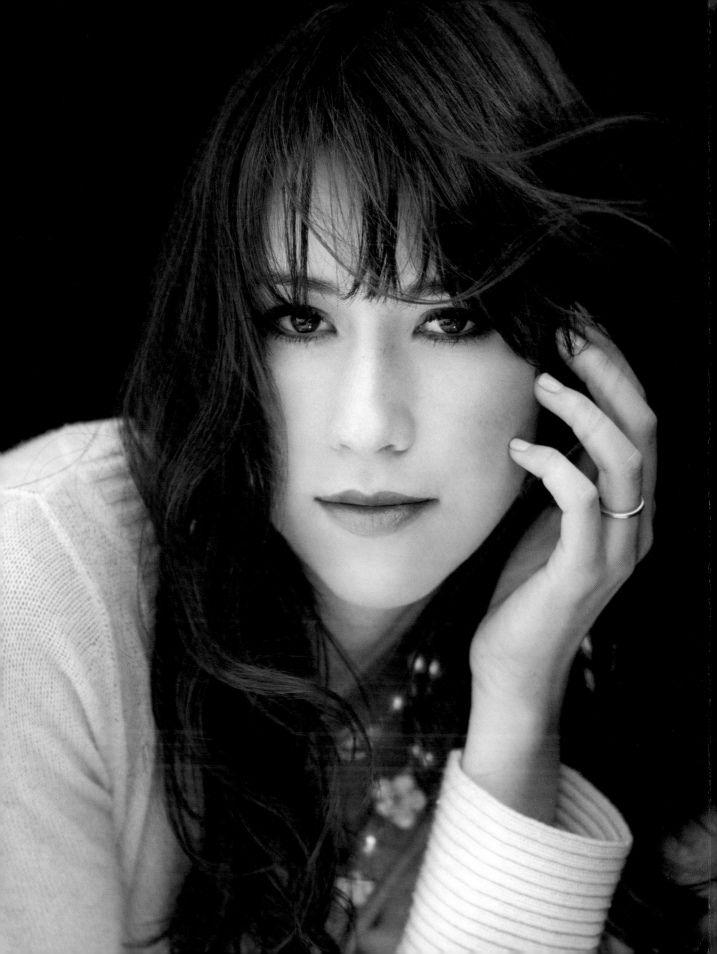

FOREWORD

BY DAVID EDMONSON

I absolutely love Roberto Valenzuela like an adopted son, and I am so proud of him! He has challenged me and my way of thinking about photography. He has loved me and my family in times of need. Getting to know Roberto on a personal level has shown me that practice has been his life story. I wasn't sure myself of what I valued more as an artist—practice or talent. Growing up, my talent alone had taken me to great heights and provided well for my family. It wasn't until I had a stroke and had to relearn some of my skills that I realized the two most important things to me now are passion and practice.

If you want to be truly great at something you have to practice your craft. Life is full of many failures, mistakes, and plateaus that you have grown through in order to reach great heights. It takes discipline, a compass for knowing where you want to go, and wisdom to know what to do once you get there. We all know photographers who break out their camera only for paying gigs, and they will go only as far as their talent takes them. When you look at great artists, athletes, and musicians who have achieved a high level of success, one thing is a common thread: They have spent and continue to spend countless hours perfecting their craft. They learn and have applied the discipline of practice.

Just think of Vincent van Gogh, one of the most influential artists of the nineteenth century. He spent a year drawing and redrawing *The Sower* just to get the feeling that was in his head expressed correctly to match his vision. As soon as he finished, he then decided to take something as simple as a sunflower to study how to best visually communicate it in its simplicity. In his future paintings, he would incorporate whole parts and portions of the lessons he had learned. Near the end of his life, his passion and discipline led him to produce 60 paintings in 60 days. A painting a day! By comparison, Paul Gauguin would take up to five years to finish his works, and he happened to be van Gogh's mentor!

Roberto lives a disciplined and passionate life that extends far beyond his love for photography. He learned how to play classical guitar well enough to not only teach but also perform concerts. He pursued his wife with persistence, asking her out over 500 times before she ever agreed to their first date! He saw a need among photographers looking for the "quick fix" and sat down and wrote his first book, *Picture Perfect Practice*. Can you start to see the pattern here?

Photography was originally known as a scientific art that didn't have the flexibility of other media, where one can, for example, rework paint and clay to refine subtle details like posing until the artist is completely content. Once it filled that void, it allowed painters and sculptors to evolve beyond the formal styles of the day, leading to more freedom and expression first seen in impressionism. Suddenly, you had to pose your subject as a photographer with all the refinement done in camera. With this book, Roberto has taken his systematic approach to studying the various aesthetic ways you can refine your posing, applying it to body parts such as heads and hands in order to visually problem solve any shooting situation. It's not posing that's bad—it's bad posing that's bad.

Here's where your practice and the lessons in this book will pay huge dividends. When someone is in front of your lens, you have all of their personal and external issues going on inside of them. Knowing what to do in any given posing scenario will give you the confidence to quickly rework a scene through posing and use the power of your voice to connect, disarm, and direct your clients. If your insecurity comes out because you haven't learned the art of posing, and you are relying only on your talent as I did, you will not always serve your clients or yourself well.

What I love about Roberto's work is how he handles some of the toughest challenges in posing while leaving room for serendipity. In the end, whatever the pose is, it only serves to reinforce and not distract from the emotion and believability of the impact of your image.

I encourage you to devour this book and apply what you learn by putting it into practice. That's the only way you will grow beyond your talent and elevate your work to a new and higher level. Credit goes to my friends Roberto Valenzuela and Jerry Ghionis, who reminded me that if you want to be a better photographer, it starts with being a better person. Passion and discipline are the fruits of a person moving in the right direction!

PICTURE PERFECT POSING SYSTEM (P3S) DECISION POINTS

SPINE	WEIGHT DISTRIBUTION	90-DEGREE ANGLES
THREE-POINT CHECK	GAPS	ARMS/HANDS HCS
STYLING HANDS & FINGERS	ORIGIN OF HANDS & FINGERS	MIRRORING
INTERACTION & PLACEMENT OF SUBJECTS	POINT OF CONTACT CHECK	BALANCING THE SUBJECT RATIO
NOSE X-FACTOR	SUBJECT EMPHASIS	POSING WITH MOVEMENT, FEELING, & EXPRESSION

THE PICTURE PERFECT POSING SYSTEM (P3S)

POSING IS ENERGY. There's more to a pose than how it looks. Posing is a form of body language, and therefore, it emits a certain energy to the viewer. Just as words can be inviting or defensive, so can the energy produced by any pose.

I designed the P3S method to clear out the guessing and the madness that has dominated many photographers' approaches to posing. Photographers, including myself, have posed our subjects by shouting out numerous directions to them, without really knowing the *why* behind our posing commands. We have tried to remedy the situation by browsing through fashion magazine ads and dispatching as many poses into our brain as possible, in the hope that we can recall them perfectly during a photo session. We also often expect the people we are photographing to move and pose as experienced models. It's like shooting darts in the dark, hoping that one in a hundred will score a success. This is no way to manage a career or a business. Even if you are a hobbyist, you will find it very frustrating that you must rely on luck to achieve a good pose. This book proposes a different approach, an approach with which you can make conscious decisions and be in complete control of every aspect of the posing process. Here's how the P3S method works.

Each square in the illustration on page xiv represents a decision point you must make when posing people. The chart includes a total of 15 points, representing each of the chapters in this book. Three of the squares are pink, because they denote decision points that only relate to posing couples or groups. In other words, when posing individuals, you have only 12 points to consider. When posing couples or groups, you have to consider all 15 points. Implementing the P3S method, you start your decision-making process with the spine, mainly ensuring that the spine is not hunched. The spine is the foundation of all poses, so making sure that your subjects have great posture is paramount. At the end of the decision process is posing with movement, feeling, and expression. I recommend saving this decision for last—hence their positions on the P3S diagram. Other than the first and last posing points, the 13 points in the middle can be decided in any order you wish. In the illustration, the decision squares are placed in the order that the chapters appear in the book, but you can shift them around as you see fit while posing individuals or groups. As you read and understand the photographic issues, oversights, and styling options in each of the chapters, you will learn the look and energy of the poses, and you will become well equipped to go through each of these points and make decisions based on your own vision for a particular photograph.

Depending on the style of shoot, you will make different decisions at each point. For example, if you were shooting a boudoir session, you might make a choice at each of the decision points that would result in a glamorous, elegant, and perhaps a seductive, feminine look. However, if you were shooting a fashion spread, the P3S decisions would change to provide you with higher energy angles and a more overall dynamic look. During a wedding, you could make decisions that yield a romantic pose that also says something about the couple. Each of these points not only helps you with your styling choices but also serves as a guide for spotting potential issues that will definitely come up during the posing process and could potentially ruin your photo. For example, imagine that you are working with a couple, and as you pose them, you notice the man's fingers are awkwardly peeking out from behind the female's waist. That topic is covered in Chapter 8, which is the eighth decision point in the illustration. Another example would be if you are on a shoot, and you see that your subject's hands and arms are creating a distraction rather than having a purpose. This is covered in Chapter 6, regarding the *Hand/Arm Context System (HCS)* decision point on the chart. To review, the P3S posing method serves two main purposes:

1. To create the style you envision through purposeful posing
2. To spot and fix posing oversights that are distracting and damaging to the pose

Think of the P3S method as 15 individual parts where choices must be made and which make up a single pose. *All decision points must be considered for every pose.*

This means that you make the call. It is up to you how and what you decide to do at every point, as long as you consider all of them.

Although it may seem complicated to think of 12 or 15 points during the posing process, you will be surprised how easy they are to remember. Eventually, the decision points will present themselves to you over and over during every pose you create. You can't help but memorize them. My recommendation is to read and follow along with the book the way it was intended. Try to re-create the posing lessons as you read them. Go back through your old work and analyze the photos using the P3S system. Combining different learning methods

in addition to just reading through the chapter will be the key to how much you get out of this book.

I am well aware that if people see a high school senior photo or a wedding photo in a book, they automatically jump to conclusions that this book is not for them, since they don't photograph seniors or weddings. Rest assured that this book is about posing human beings, regardless of the event or the style of their clothes. Although I am primarily a wedding photographer, I have spent years photographing for magazines, fashion editorials, commercial photography, high school seniors, and celebrities. My training is very diverse, but I do have an unexplainable passion for wedding photography, due to the unique location, posing, and psychological challenges that weddings present. Therefore, I purposely limited the number of wedding photos used as examples in this book and replaced them with photographs from a variety of genres. However, for Part 2 of the book (*Posing Couples with the Picture Perfect Posing System*), I did include, for the most part, photos of couples during their weddings or engagement sessions. As I said, couples are couples, regardless of what they are wearing, so focus on the posing lessons being taught.

WHY ARE SOME PHOTOS USED REPETITIVELY?

Throughout the book, you will notice some photos are shown over and over. The reason is simple: If I felt that a particular photo would help clarify a point, I used it. This book is divided into 15 sections that discuss various aspects of posing. Some of the photo examples contain teaching material from several points of view that correspond to more than one chapter. For example, in one chapter, I might be referring to a photo that focuses on the subject's expression, but in a different chapter, I could use that same photo to explain how the subject's arms are posed. I spent countless hours looking for the right photos to use for each point I was making.

WHY THE AMATEUR PHOTOS?

The purpose of this book is to give you the very best written educational experience on the topic of posing—not to use up valuable pages trying to impress you with my beautiful photos. To demonstrate many of the points in the P3S, I used several photos from the first couple of years of my career that do not represent my proudest moments as a photographer. But depending on the lesson, I also show more recent work that I love. Both types of photos are featured throughout the book. But, for the sake of education, I put my ego aside to help you and to make the material in this book more memorable. After all, if I only showed you my very best work, how are you supposed to learn what *not* to do? People learn so much more from studying their mistakes than their successes. Therefore, if it helps you, I want you to see my mistakes, learn from them, and grow as a photographer. If you are interested in seeing more of my recent work, flip to Chapter 15, where the majority of the photos are all recent work, or visit my website at www.robertovalenzuela.com.

A NOTE TO MODELS, BRIDES, AND ANYONE ELSE INTERESTED IN POSING

I wrote this book not only for photographers but also for models, brides, and anyone else who wishes to know how to pose themselves and others in a flattering manner. Understanding the principles of photography and their outcomes is both fascinating and not that difficult. For the sake of language clarity, I address photographers directly, but I wrote this book with all of you in mind. If you do not wish to read the entire book, I recommend skimming through the chapters and focusing on the Flash Cards that appear throughout the chapters. These Flash Cards give you a quick way to learn the essential principles and techniques from each chapter.

FOR BRIDES

If you are a bride-to-be, this book will give you a head start for knowing how to pose yourself well and what to avoid doing. Naturally, you have probably hired a photographer and expect that person to be responsible for posing you well. But, trust me, judging from experience, you do not want to rely completely on your photographer. During weddings, photographers have to wear different hats and manage multiple challenges simultaneously; therefore, the posing aspect of a photographer's job could suffer. This is the reason it would be worthwhile to know the principles of how to pose yourself for the most flattering results. Even for what would seem a rudimentary task, such as putting on your wedding dress or walking, you should be aware of good posture, hand/arm placement, and the overall dynamics that yield the most beautiful photograph. A couple of years ago, I was asked by a prominent dress designer to teach a few classes on posing for future brides. The classes were packed, which indicated to me that there is a great need and desire for brides to learn the principles of posing so that they look their best and do not always have to depend on the photographer.

FOR MODELS

If you are a model, the concepts taught in this book will make you aware of the importance of how you move, what angles you choose, how to create a strong versus a passive pose, and much more. Not only will you be able to move with a purpose, you will also know the reasoning behind the way you pose for the camera. A knowledgeable model is aware of his or her movements and, thus, the energy he or she emits through posing. Learning and applying the skills taught in this book will result in an overall more positive shooting experience for the client, the photographer, and yourself, not to mention giving you an edge over your competition.

It is my hope that after reading this book, you will pose with the great confidence that can come only from knowledge, not guesswork.

INTRODUCTION

HANDS DOWN, posing people is one of the most daunting skills that photographers struggle with. At every convention or workshop around the world where I have taught, I always ask my students to share what the most difficult aspect of photography is for them. Nearly 80 percent of the time, the answer is posing! All aspects of posing have been pinpointed as the source of their headaches and/or panic attacks—how to pose women, men, groups, couples, and so forth. During my early career, I experienced similar difficulties with posing. After years of frustration and despite my best efforts, I was accomplishing merely a few good poses in an entire photo shoot. I decided to change my approach. A paradigm shift in the study of posing was necessary and long overdue.

Why is it that both novice and veteran photographers become stumped by posing? I believe the reason is the method we use to study this topic. We have relied mainly on two types of techniques to tackle this posing issue. The first is that we turn to our comfort zone poses. These are poses we always rely on when our brain betrays us, and we don't want to enter panic mode. Most photographers have five or so of these types of poses, and regardless of whom we are photographing, we just force our clients to fit into those five poses, so we don't lose face.

The second technique is simply to force ourselves to memorize poses. I would like to share with you an analogy from my classical guitar days. If a guitar instructor is trying to teach students how to play chords on a guitar, the instructor could download a chart of popular guitar chords that work well in most situations and ask the students to simply memorize the chart and practice their finger placement on the strings. Or, the instructor could teach the students the theory and structure behind chords, so that the students can build any chord their heart desires. Now, the students can jam right alongside any popular song by building the correct chords, instead of being limited to only the three or four chords they memorized. We must stop relying on memorization of poses. Instead, I suggest we begin to understand the structure of how a successful pose is built from scratch!

The purpose of this book is, therefore, to teach you how to correctly create a pose, instead of memorizing poses. I strongly believe you will feel a great relief when you no longer have to use a memory flash card system. Instead, we will build poses using the 15-point system called the Picture Perfect Posing System (P3S) that I have created to simplify the posing process.

WHAT THIS 15-POINT PICTURE PERFECT POSING SYSTEM (P3S) IS AND IS NOT

I would like to quickly highlight just a couple of points about this book and the P3S.

WHAT IT IS

Like all art, photography is subjective. It is part science and part art. Every photographer is entitled to his or her opinion. The challenge when writing a book on posing is that the topic of posing is one of the most subjective aspects of photography. The human body can be shaped, bent, and contoured in countless ways that can yield some pretty interesting visual results. Fine-art photographers such as Sylvie Blum have focused much of their work on contouring the human body in ways I never thought possible. Yet the end result is pretty amazing to see. So, if posing is so subjective, how is it possible to be able to wrap it up in a neat little package that I call a "system"? The reason is that there are some universal techniques that make the human body look more relaxed and pleasant. This book is not for the photographer trying to bend the human body in bizarre ways for the sake of art. This book is for the photographer posing normal people—men, women, family members, children, couples, high school seniors, and so on.

The 15-point P3S method came about after years of research, keen observation, and much frustration along the way. I wanted to know how it was possible to create poses that look effortless, pleasing to the eye, and comfortable for the client, whether that client is sitting, standing, or lying down. I wanted to know what to do with a person's arms to focus attention on his or her face and not the arms, and what to do with a person's legs so that the body looks more relaxed. These are just a couple of examples of what I was seeking. After much observation and trial and error, I slowly began to see patterns that seemed to work.

I began to study these patterns and to apply them to my clients. The results were pretty amazing! I was building a pose from scratch instead of just memorizing poses and copying them piecemeal.

One pattern after another began to emerge, and little by little the P3S approach was organically created. I use this system as a guide to remember when I pose my clients. The system has also helped me understand why a pose does not work or why it looks awkward. Most importantly, it has helped me understand how to keep visual emphasis on my subject's face, regardless of the pose. This is important because one of the main challenges we have as people photographers is to avoid letting the arms, waist, legs, knees, or shoulders take attention away from the subject's face. Even though these parts of the body can potentially draw attention away from the face, they can also be used to frame the face or create an inviting portrait instead of a defensive one. Careful positioning of the arms can also be a great help in slimming a subject's body.

WHAT IT IS NOT

By no means do I claim that that the P3S method is the be-all and end-all of posing techniques. It is very important to set expectations from the beginning. There is no right or wrong way in photography or posing. Both you and your clients have to like the photographs, and if you have achieved that much, then you have met your primary goal. This system is not meant to be a set of "must-follow" rules or the commandments of posing. Each point of the P3S approach can be broken, and you can still achieve a great image. One thing is for certain: This posing system has helped me tremendously throughout my career. Because I constantly practice the P3S method, I know all 15 points by heart; therefore, I know when it is best to break them, and how to get the most out of each point based on my vision. It all comes from situational experience and trial and error. For example, in certain high-fashion or fine-art photography, the poses can be avant garde; therefore, there are no rules or logic to any of it. But for the most part, in portrait and wedding photography, knowing the 15 points of the P3S method will definitely serve you well.

My goal for this book is to help dispel your fear of posing in a way that is practical and easy to implement, without hampering your creativity or personal style. I believe that a person's fear of posing is rooted in self-doubt. You doubt your posing skills, you doubt yourself, and you compare yourself to other photographers. Let's remove these doubts once and for all! Read on…

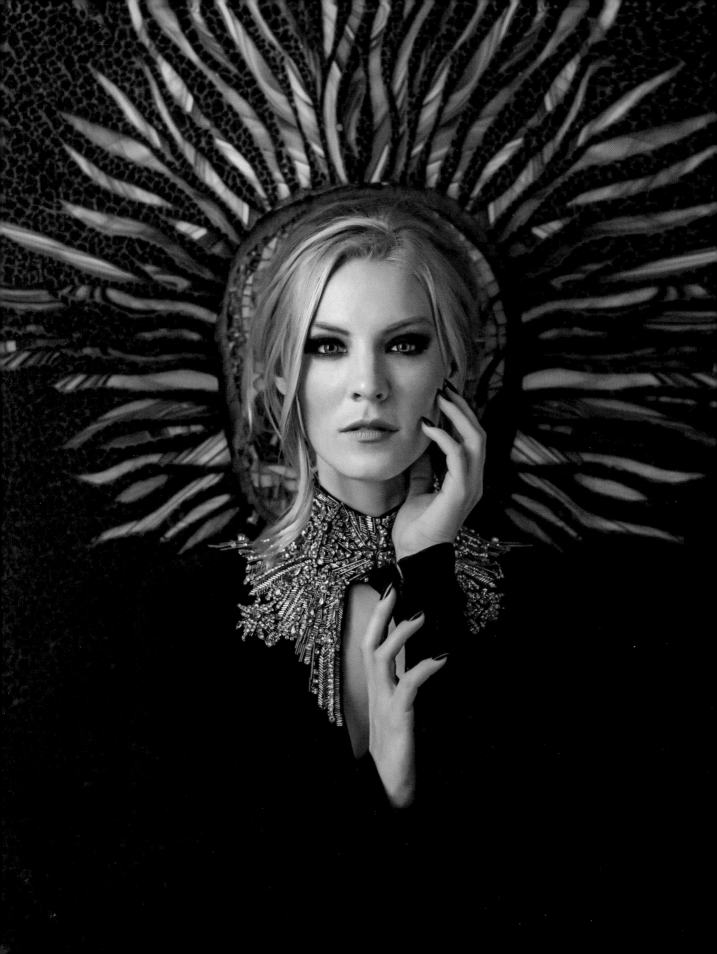

THE PICTURE PERFECT POSING SYSTEM (P3S)

1

UNDERSTANDING AND POSING THE SPINE

THE COMBINATIONS THAT a photographer can choose from when posing a subject are endless. Literally. But the one thing that is constant is that your subject's spine *must* be straight. The spine is the cornerstone of any pose. Ignore the spine and the whole pose will fly out the window. So, if I can help you with one thing in this book, let it be this statement: *The spine must always be straight and as tall as possible*. Now, there are times when we must push the spine into positions that it is not used to.

For example, to make a person look more confident, we must stretch the spine to make it as long as possible. However, as we take the spine to its limits, we must also keep in mind what I call the "posing threshold." Every moving part of the body has its threshold. If we exceed that threshold by manipulating a part of the spine or body too far, it looks extremely uncomfortable. This can happen with any part of the body, but it happens more often with the placement of a subject's head.

Spine tip: Study what good and comfortable postures look like for both men and women. For live interactions with other people, this is good enough. But in photography, we must take that acceptable posture a step further into a slightly uncomfortable state. It is much easier to look good to others when there is movement. The angles others see you from are always changing.

So if someone happens to catch a glimpse of you from a bad angle, it will be just a glimpse. That's it! But in a photograph, that glimpse of time becomes permanent—which is why it takes effort to make sure we look our best in a photograph.

PARTS OF THE SPINE YOU MUST KNOW, AND HOW THEY AFFECT POSING

Although the anatomy of a person's spine is obviously incredibly complicated (**Figure 1.1**), a photographer who wants to master posing should take the time to understand the basics. There are three main sections of the spine of interest to photographers:

- The cervical spine
- The thoracic spine
- The lumbar spine

THE CERVICAL SPINE

The cervical spine begins at the base of the skull. This may sound simple enough, but careful analysis of this part of the spine is critical for solving many posing problems and challenges. For instance, when one person is much taller than the other and you are trying to pose them so that they appear to be closer in height, it is the cervical spine that comes to the rescue.

The key is to use the bottom of the cervical spine as the pivot point to tilt the head down. This will point the head to where you want to focus your viewer's attention. Here's the general guideline I follow when dealing with the cervical spine: When photographing one person, I use the cervical spine to lift the back of the subject's head as high as possible above the collarbone. When photographing two people together, such as a couple, the cervical spine can be pivoted toward the other person to create a feeling of romance and interest.

Remember that the cervical spine should only be pivoted from the bottom of the neck (Figure 1.1). Imagine having a ball bearing at the base of the neck from which the head can pivot. The rest of the cervical spine should always be as long as possible. If you position it up or down correctly, only the chin—and nothing else—should move.

THE THORACIC SPINE

The thoracic spine runs from just below the neck to above your waist. It is usually the culprit for most of the problems with a pose, because it is the part of the spine responsible for hunching and slouching. If you ever wonder why your subject's pose appears awkward but can't put your finger on it, look at the thoracic spine.

If you see someone hunching, check the thoracic spine. If your parents ever yelled at you to stand up straight, it was your thoracic spine getting you into trouble. Thanks to the

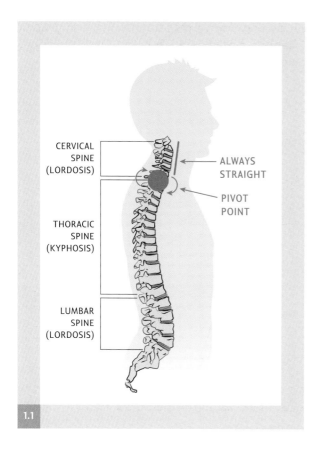

CERVICAL SPINE (LORDOSIS)
ALWAYS STRAIGHT
PIVOT POINT
THORACIC SPINE (KYPHOSIS)
LUMBAR SPINE (LORDOSIS)

1.1

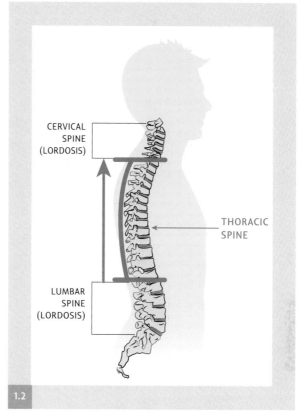

CERVICAL SPINE (LORDOSIS)
THORACIC SPINE
LUMBAR SPINE (LORDOSIS)

1.2

hours we spend sitting improperly in front of our computers, we have developed a terrible habit of slouching when we sit and hunching when we stand. As photographers, we must realize that people do this habitually. It's our job to be aware of it and correct it.

Before any photo session, I assume that my subject has bad posture. The assumption has served me well, because I know that no matter what, I can improve my subject's posture by paying attention to the thoracic section of the spine. While it seems as though I am giving the thoracic spine a bad reputation, just realize that while many things can look wrong with this part of the spine, it can also be corrected and result in very flattering and polished poses (**Figure 1.2**).

I make my corrections by imagining that the thoracic spine is a stick that must be stretched as tall as possible but never shrunk. People with attractive postures walk and move with their spines straight. But for a photographic pose, that is not enough. Proper posing requires us to take that straight spine and stretch it even higher. There are three techniques I use to stretch the spine for posing:

- I ask my subjects to try to raise the back of their heads as close as they can to the ceiling, or to the sky if we are outdoors. Specifying the *back* of the head is important, because if you specify the front of the head, most subjects will tilt their chins up. We don't want that—we want the back of their head higher without affecting the position of the chin. This technique also works well when you are trying to elongate the cervical spine.

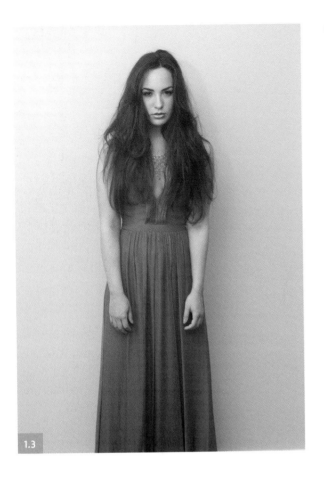

1.3

- Breathe in as much as you can, and you will feel yourself straighten up and stretch. Breathing out usually creates the opposite effect. I always ask my subjects to breathe "in" deeply, and when they are past the halfway point of their breathing-in capability, that's when I take the photo. The reason for this is to get that confident, inflated look that breathing in provides. However, it must be within a person's breathing comfort zone. Making the effort to gasp for a bit more air to breathe in does not look very flattering. So don't wait until the top of their breath to take the photo.

- I ask my subjects to simply drop their shoulders down toward the ground and back by a couple of inches. Moving the shoulders two inches or so back is important to expand the chest. Not only does it place more emphasis on the head, but it also makes your subjects appear confident and strong.

Let's take a look at some examples of how our discussion of the thoracic spine affects the look of our poses (**Figure 1.3**). This photo exemplifies many violations of the principles described above. I'm not going to discuss the position of her arms just yet. To keep things simple and to the point, we will only look at the parts of the pose that we have already discussed. First, if you look carefully, her head is not being stretched toward the ceiling; in fact, her neck is actually shortened. Second, the shoulders are not being pushed back a couple of inches as described in technique 3. This is causing her to look sluggish and disinterested. Third, her thoracic spine is pretty straight but not stretched. It must be stretched!

Don't be satisfied with a straight spine; take the extra effort and ask your clients to stretch their backs to make themselves taller. There are many more issues with this pose that we will discuss in later chapters.

PROPER POSTURE

Stand up and try to imagine something pulling the back of your head toward the ceiling. Drop your shoulders toward the ground and, finally, breathe in. You felt good doing it, didn't you? That's proper posture for a photograph. Do this every time you point your camera to a person's face and the quality of your posing will change forever!

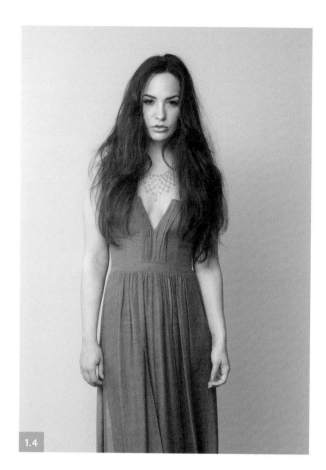

1.4

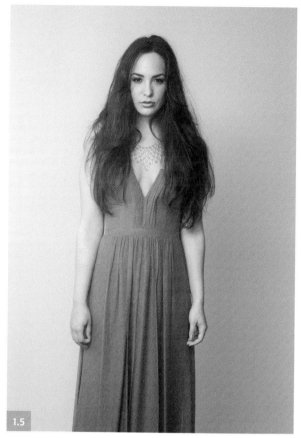

1.5

This next example (**Figure 1.4**) has rectified many of the issues with Figure 1.3. Here, her shoulders were dropped toward the ground, the thoracic spine has been stretched, and the back of her head has been pulled up toward the ceiling. However, her shoulders are still not two inches back. This oversight is causing her upper body to compete for attention with her head. The pose is good, but not good enough. Let's just make that small correction of the shoulders, positioning them two inches back.

Even though it's subtle here (**Figure 1.5**), you can see that by her pulling her shoulders back just a bit, this adjustment automatically puts more emphasis on her face. Her shoulders, especially her right shoulder, are no longer competing for attention.

THE LUMBAR SPINE

The lumbar spine is located behind the hips. Photographically speaking, it is a very interesting part of the spine due to its exaggerated curvature. The location of the lumbar spine is of particular interest when we are posing people, because it works with the hipbones.

The hips are largely responsible for making a woman look elegant and sexy. I call the lumbar spine "sexy central." If you want to make a woman look beautiful and sexy, you must pay special attention to what this part of the spine is doing.

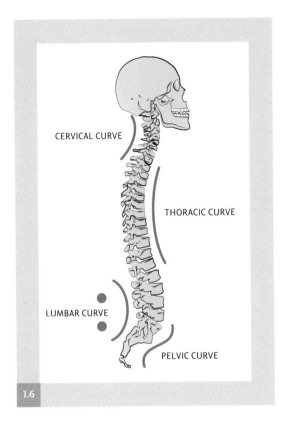

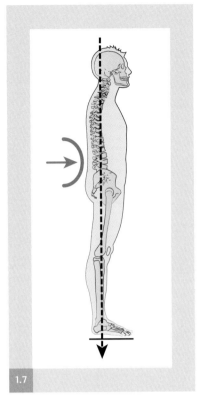

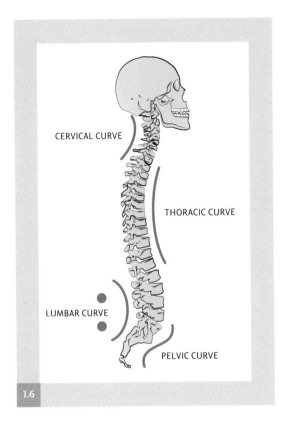
1.6

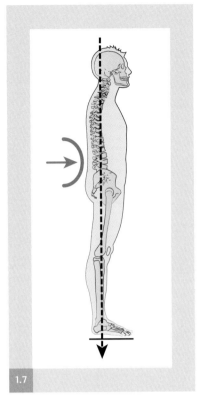
1.7

Look at **Figure 1.6** and notice the curvature of the lumbar. It resembles a sideways happy face—or it will help you to remember, "If it looks happy it's sexy; if it looks flat it's bad." At a minimum, the lumbar should always be curved at its natural position. For posing, however, we need to exaggerate this curvature a bit more to bring the best out of our subject. This is why posing is hard work. If your subject is not getting tired, you are probably not posing him/her correctly.

As photographers, it's tough for us to pay attention to everything that is going on to make a great photograph. Usually we focus on the light, as we should, or other photography techniques. But even if you plan everything else right, if you forget to pay attention to the lumbar spine, no one is going to like the photo. The photo will fail.

The lumbar spine gives the body shape, and it plays an important role in making a person look thinner, regardless of the body type you are working with. **Figure 1.7** is a great example of how the lumbar looks when it is flat. As you can see in Figure 1.7, that small part of the spine flattens the whole body, and it greatly reduces our ability to give the body curves. As you recall from Figure 1.6, always remember that this part of the spine should look like a sideways happy face.

Let's take a look at two examples of two beautiful women sitting. One will have her lumbar curved properly; the other will have it straight. **Figure 1.8** shows a candid photo of a workshop model sitting flawlessly on a bed. She looks glamorous and elegant because of the way her spine has been posed. Although you can't see her spine from this angle, her lumbar is curved beautifully. This is giving her the curves necessary to create a well-posed sitting photo.

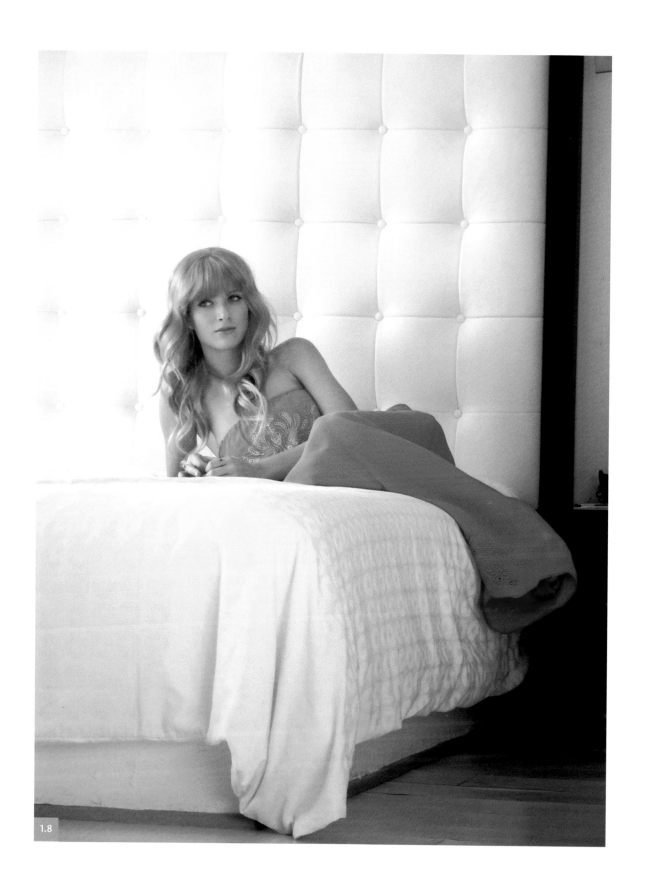

1.8

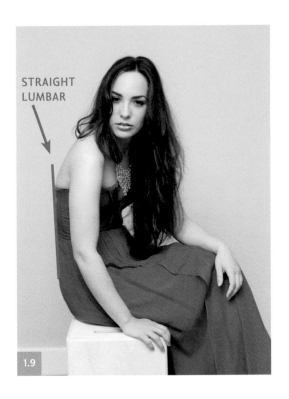

STRAIGHT LUMBAR

1.9

Now compare that to image **Figure 1.9**. This is a beautiful woman photographed incorrectly. She doesn't look nearly as elegant or glamorous because of the way she was posed. Her lumbar is straight, and therefore, she looks sluggish with bad posture.

For sitting and lying down poses, it's a bit trickier to check the lumbar curvature, but if the subject is standing it's quite easy, especially if the subject is posing in front of a wall. There should be a clear gap between the wall and the lower spine. This is true for men and women. A good way to check if the gap is right is to make sure that your arm fits nicely between the wall and the lower back. I don't recommend that you try this unless you have permission, but you can still eyeball it.

Let's take a minute to examine why a photo is working. **Figure 1.10** clearly shows the gap test you should make when posing a subject against a wall. This gap is easy to see, since it is against a flat surface; the lumbar should be just as curved regardless of the circumstances. Also notice how nicely this lumbar gap defines her waistline. This is essential for creating a slimmer look. In Figure 1.10, the subject is standing up,

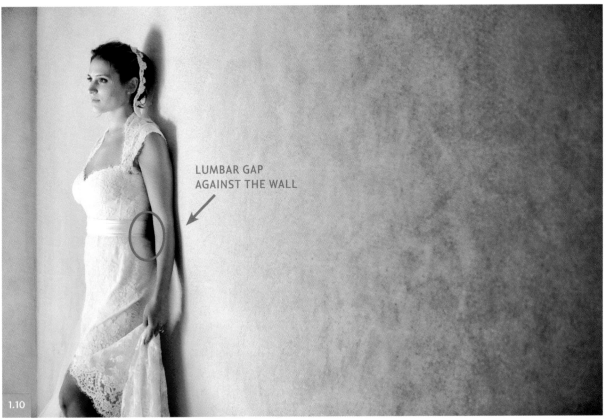

LUMBAR GAP
AGAINST THE WALL

1.10

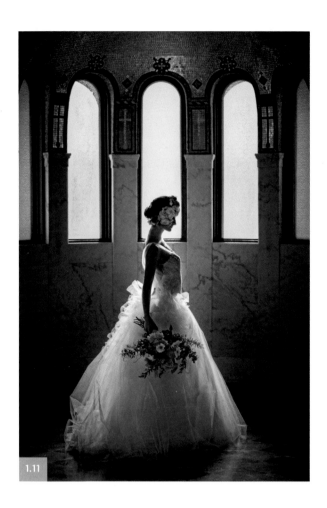
1.11

FLASH CARD

To remember how each part of the spine affects poses, think of it this way:

Cervical Spine: Directs the head to where you want to focus the viewer's attention. It should be stretched as much as possible to elongate the head.

Thoracic Spine: Responsible for posture. It also should be elongated as much as possible. Creates confidence and strength. Subjects should breathe in to achieve a more confident look.

Lumbar Spine: Responsible for slimming someone down. It should always be curved. It creates a sexy quality to a pose.

but this technique is equally effective at making someone look their best whether they are sitting, standing, or lying down. **Figure 1.11** clearly shows the importance of curving that lumbar to create a sexy and pleasing body shape. Try to imagine what this pose would have looked like had I not asked my client to curve her lumbar at all.

POSE ANALYSIS

Becoming more and more aware of your posing strengths and weaknesses will and should be part of your weekly routine. It is essential for your growth as a photographer to become very familiar and comfortable when posing your subjects. To get to this comfort point, I recommend you do a weekly posing analysis of your latest photo shoots. Pay special attention to the photos where you tried to create a good pose but for some reason it did not work out. Below is an example of some analysis I did to give you an idea of how to go about this weekly reinforcement.

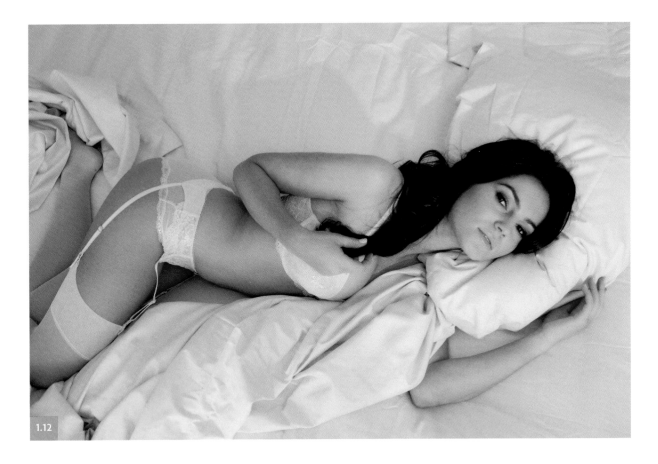

1.12

DEVELOPING AN EYE FOR DETAILS

Based on the material covered in this chapter, there doesn't seem to be anything wrong with the pose in **Figure 1.12**. But it's easy to recognize that she is not filled with confidence. Her face is absolutely beautiful, and so it demands your attention. Putting her beauty aside, however, the pose is not accentuating her beauty.

The first thing to notice is that her thoracic spine is not as tall as it should be. I know this, because the pose is lacking confidence and strength. Second, the back of her head should be farther from her collarbone. Third, she is clearly not breathing in. If she were, her body would be more stretched and her chest would be more inflated.

I chose this photo for the pose analysis, because it's easy to become distracted by someone's beauty and miss the details of the pose that are working—or not working. This photo also makes you realize that although the pose looks fine, it is not *great*. It has much room for improvement.

Just as it is important to develop a keen eye for pose issues, it's equally important not to create issues where there aren't any. In **Figure 1.13**, you can see how the cervical spine was used to tilt the head of the bride in the proper way. It also draws your attention to her mother putting on her shoes. The tilt of her head is well done because she could have easily hunched her back to bend over, but she didn't. Her posture here is impeccable,

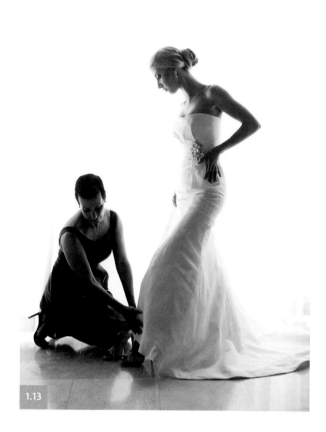

1.13

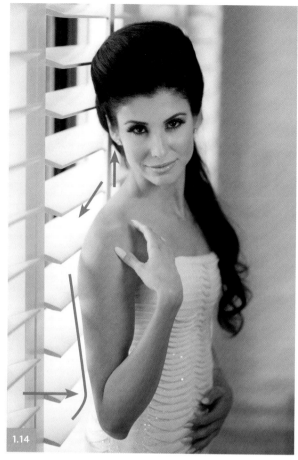

1.14

which is why she looks so tall and glamorous. Her lumbar is curved beautifully and her thoracic spine is as straight as an arrow.

In **Figure 1.14**, the subject has every section of the spine properly posed. It appears to be a simple portrait of my client. But now that you have read this chapter, you can appreciate all that goes into properly posing someone. Not only does she look elegant and flattering, but the pose seems effortless.

Beginning with her lumbar, it is clearly curved, because her lower back is not touching the blinds. Look down her thoracic spine and you can see that it is perfectly straight. Her shoulders have been dropped to put less attention on the shoulder and more attention on the face. Her cervical spine has been pulled up toward the ceiling, exposing as much of her neck as possible. And, at the same time, the cervical spine was used to pivot her forehead toward the camera to give the face a stronger presence. Last but not least, the photo was taken as she was breathing in. This ensures further stretching of her body and gives the overall pose a more engaged feel.

FOCUS YOUR ATTENTION

It goes without saying that there is quite a bit to keep track of when creating a pose. Don't let this overwhelm you. When I was learning about posing, I focused on one or two aspects at a time. On your first shoot, try focusing on curving only the lumbar. Next, make it a point to pay close attention to the thoracic spine and keep it absolutely straight. Then, shoot work on the cervical spine, and so forth….

ON YOUR OWN

Now that you've finished reading the chapter, try to analyze the following poses completely on your own (**Figures 1.15–1.18**). I will not discuss these photos or give you the answers. The purpose of this "On Your Own" exercise is for you to learn to look at an image analytically. Separate yourself from any self-doubts, and just do it. Review the chapter if you have to. Use the space provided or a notebook to write down what you see that looks right or wrong about the poses. Your answers should be based only on the material covered in this chapter—don't worry about anything else. If you belong to a photography group, take this book with you and create a discussion group to share your answers and listen to what everyone else says. Have fun and enjoy the process.

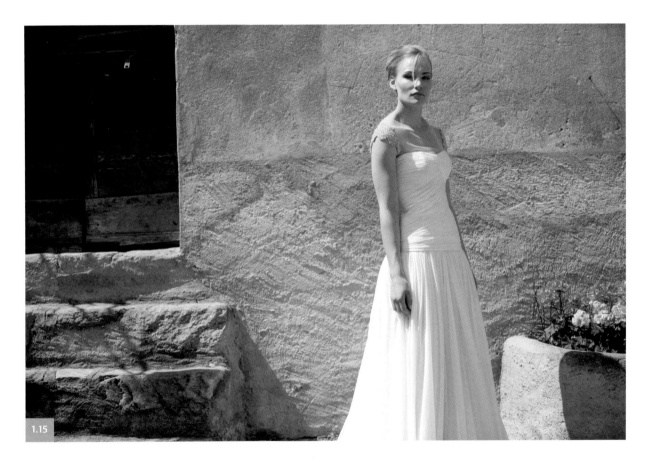

1.15

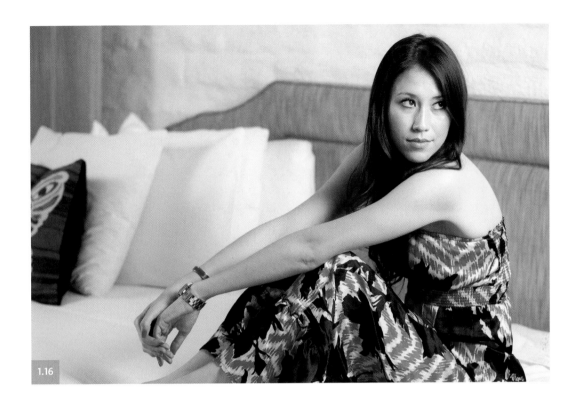

1.16

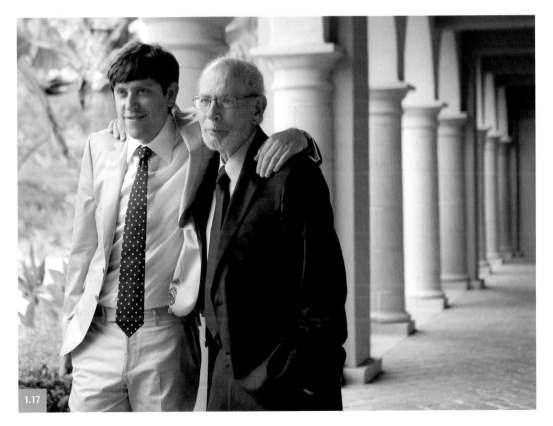

1.17

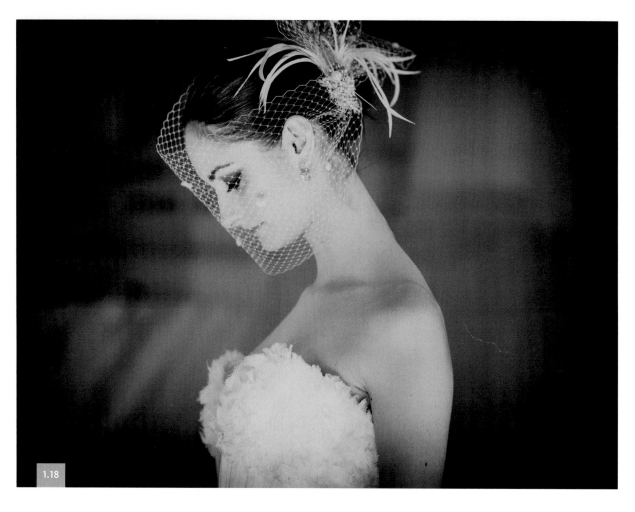

1.18

ANALYSIS

2

WEIGHT DISTRIBUTION AND ITS EFFECT ON POSING

LIKE EVERYTHING ELSE in photography, posing is quite subjective. People pose their clients or family members based on ideas they have or photographs they have seen. But for most people, understanding why some poses work and others don't is a different thing altogether.

We instinctively want our subjects to look relaxed, and when something about a pose triggers a warning flag, our brains will reject it. This happens more often than you think. We want to see poses that simply flow, and if they look static or flat, we subconsciously reject them. If the pose flows, however, we feel at ease when looking at the photograph. One of the secrets of posing people is creating a weight distribution that produces an aesthetically pleasing, flattering photograph.

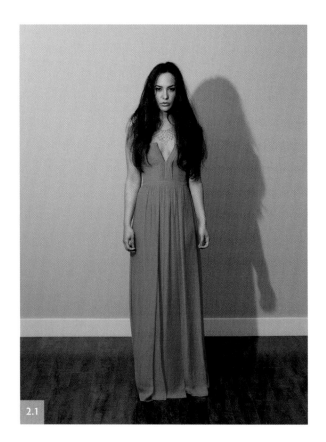

2.1

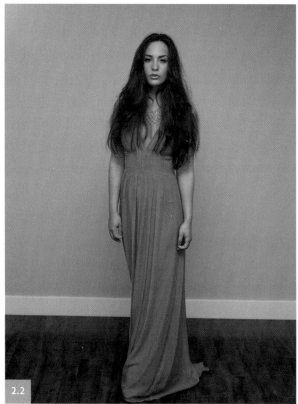

2.2

SHIFTING THE BODY WEIGHT
AND CROSSING THE FEET

By shifting the body weight of your subjects, you automatically create more curves and enhance those that already exist. A second benefit of such shifting is the stance's resulting look of relaxation. When a person's weight is distributed equally between both feet, either they can look stiff or they can look childlike, innocent, or playful.

Children like to stand squarely on both feet, because they feel comfortable in that position. So if you are photographing kids, asking them to spread their weight equally between both feet might be a good idea. That's not as true for adults. Adults often worry about their weight, and in photographs, they want to look as glamorous and as thin as possible. Shifting the body weight to one foot, usually the back foot, achieves just that.

Figure 2.1 is an example of equally distributed body weight on both feet. It's easy to see that the pose looks stiff. Even though the body's natural curves are all there, the photo takes on a block-like feel, which minimizes those curves. Compare photo Figure 2.1 to **Figure 2.2**. As a result of simply asking the subject to put her body weight on her back foot and cross the other foot in front, her body takes on a very different look.

I purposely asked her to keep everything else stiff and let her arms hang down by her sides to highlight the effect that shifting the body weight to the back foot has on the pose. Pay

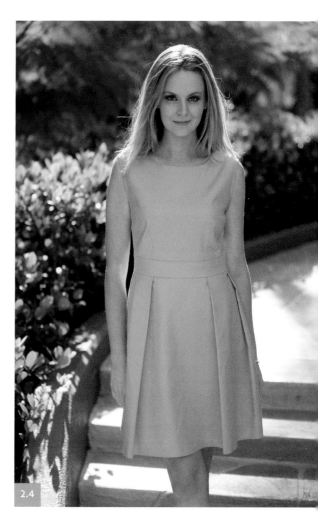

special attention to the hips. Notice how her right hipbone moved higher than her left. This shift is responsible for bringing out the curves in her body.

A good reference point is to imagine two straight lines emanating from each foot (**Figure 2.3**). If those two imaginary lines eventually cross paths, then you are distributing weight correctly. During a workshop, I wanted to demonstrate the same technique of focusing just on this body weight shift and keeping everything else normal. The portrait of Jessica (**Figure 2.4**) is as simple as it can be. The only element making this portrait work is nothing more than shifting her body weight to her back foot and crossing her other foot.

As you study this photo, notice how there is zero tension in her body language and that she appears relaxed and in her element. She does not look as if she was trying too hard, nor does she appear uncomfortable. This technique works equally well for men.

Take a look at **Figure 2.5** and imagine what this photo would have looked like had the groom been standing with equal weight on both feet. To me, it would look as if someone had told him what to do, and he was just following instructions. But when he follows my instruction to cross one leg over the weight-bearing leg, the feeling of the pose changes

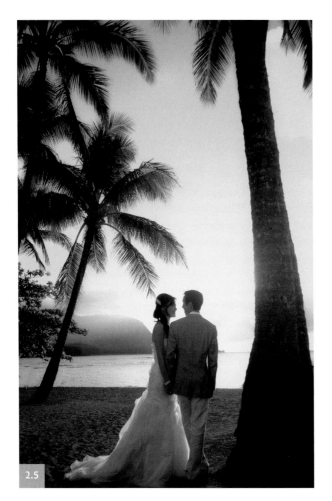

completely. Now his body language matches the relaxed Hawaiian landscape around him. Simple, very effective, and my favorite!

One thing to keep in mind is that these techniques work for posing everyone. Some readers might point out that these examples involve weddings, and that they do not photograph weddings. My answer is always the same: People are people whether they are wearing a tuxedo or a leather jacket and jeans.

To prove this point, take a look at image **Figure 2.6** of my good friend Mike Colon during a trip to Italy. So that he would appear relaxed and in his comfort zone, I quickly asked him to cross one leg over the other. That was it. Even if he had stood there for two hours, he would have still felt comfortable in that pose. Remember, the clothes someone wears or the occasion do not change or affect the posing principles discussed in this book.

2.7

2.8

2.9

SHIFTING THE BODY WEIGHT AND NOT CROSSING THE FEET

This technique is effective when posing men or when you want a woman to look strong. It has a fashion flair to it, and you'll find it useful when photographing high school seniors or while on a fashion shoot. To execute this technique properly, the body weight is shifted to the back foot and the toes point in a direction where the imaginary lines will never cross.

The most important aspect is to bend the knee of the front leg in the same direction as the toe. If you forget this last step, the pose will look contrived. As the knee bends forward, the stiff pose automatically transforms into a relaxed and comfortable look. To help visualize the toe direction, look at **Figure 2.7** and notice the red lines you must visualize. Those two lines should never cross paths. Also, although my knee is not 100 percent visible, it is still clear that my knee is bent toward the toe on my right leg.

If you happen to find a prop on which you can rest a foot, such as the one in **Figure 2.8**, the general feel of the pose will stay relaxed but will have a more assertive undertone. You can use this assertive pose to your advantage to make someone who looks weak appear

When using this technique of lifting the knee with a prop, be sure not to exceed a 45-degree angle from the thigh to the ground. For example, in **Figure 2.10** the line of the thigh creates a 45-degree angle with the floor. To keep the pose effective, 45 degrees would be the maximum you would want to use. If you pose someone with his/her foot on a prop so high that the angle exceeds 45 degrees, you will discover how awkward this looks. Note in photo Figure 2.9 how her knee is bent at less than 45 degrees.

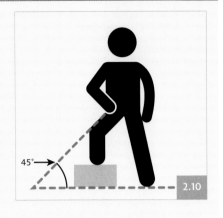

strong or someone strong appear even stronger and self-reliant. It is a great tip for portraits with a fashion flair!

In **Figure 2.9**, I decided to use this technique for Arden. Her clothes look well fitted and fashionable, so this was a perfect opportunity to give her an even higher boost using posing techniques. Notice how the body flows and radiates confidence. All this is possible, because there is a prop under her right leg lifting her knee. The pose depends on this weight distribution to be effective. Without the prop, she probably wouldn't be able to bend her body this way, and if she tried, it would look very uncomfortable.

Here is an example of my analysis of a pose based on this particular technique. **Figure 2.11** at first glance looks normal—just a group of guys hanging out and posing for a quick photo. But with more careful analysis, you will begin to pick up on small nuances.

For example, notice how the second guy from the left looks great. His pose is strong and he looks relaxed. Now turn your attention to the first guy from the left. He appears a bit awkward, and there is tension in his pose. Compare that pose to the sixth guy from the left. His body language is quite different. Here's the key step: We know that the body language of these three men differs, but why? By asking yourself this question and looking for answers in the photograph's clues, your understanding will drastically improve. Trust me.

Look again at the man on the far left (**Figure 2.12**, callout #1). His toes are actually pointed toward each other, so if you were to draw that invisible line extending from the toes of each foot, the two lines would eventually cross. This is a big no-no when posing men. Although his torso looks fine, as with the rest of the group, his foot position tells us another story. He seems timid and shy instead of assertive.

The second man has the best pose of the group. He is doing everything right. First of all, his toes are not pointed toward each other (callout #2), so the invisible lines from his toes would never cross. Second, his body weight rests mostly on his back leg, allowing the right leg to relax. Third, his knee on the relaxed leg (callout #3) not only is bent, but is pointed toward his toes. Put all of these clues together and you have a great pose.

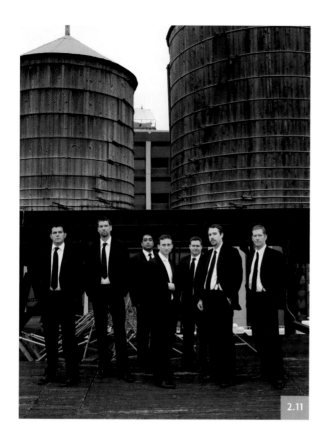

2.11

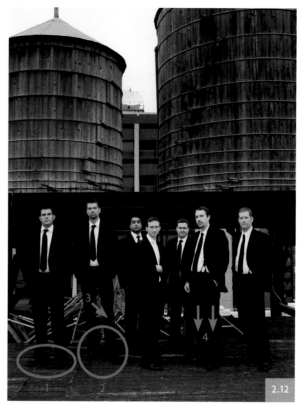

2.12

The sixth guy from the left is pointing his toes correctly, but his body weight is distributed equally between both feet. This puts more emphasis on the stomach, because it's closer to the camera, as you can see in the photograph. Go back to the second man from the left, and you will see clearly how shifting the body weight to the back foot forces the hips away from the camera. This puts more emphasis on his chest and not on his stomach. Returning to the sixth guy, notice how the pose (callout #4) forces his knees to be perfectly straight. It doesn't look nearly as relaxed as the second man.

For a group portrait, it is perfectly normal, if not preferable, that everyone have a different stance. The portrait is more interesting to look at, because a bit of their personalities shows through in the way they stand. But keep in mind how the way the weight is distributed and the direction the toes are pointing; this information can completely change how a person is perceived in the photograph.

REVIEW YOUR IMAGES

I realize it can be difficult to keep track of so much while you are in the photographic hot seat. One of the best ways to take a concept and store it in your long-term memory is to take the time to go over your photos and look for the concept you just learned. Be specific, focusing only on that one posing element. Let's say, for example, that I'm trying to memorize this technique of shifting the body weight but not crossing the feet. Take a look at a photo that shows many feet, such as a wedding party photo or a family photo. Become a keen observer of the small details that make a pose work and, more importantly, learn to quickly notice why a pose fails. I do this every week for every single wedding I shoot.

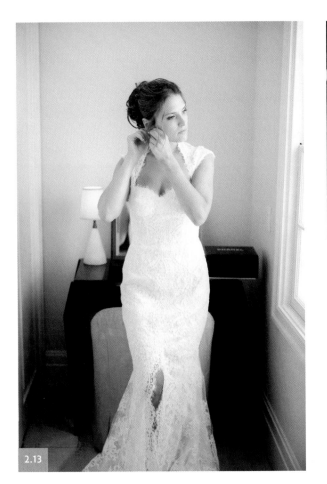

2.13

2.14

WEIGHT DISTRIBUTION SITTING DOWN

The principles discussed regarding weight distribution do not change for subjects who are sitting down. The major difference is that when a subject is standing, the body weight is on the feet, and when the subject is seated, body weight is distributed to the buttocks. One major advantage of placing the body weight on the buttocks is that it deemphasizes the stomach region and instead emphasizes the legs and torso. When the subject is seated with good posture, the legs and torso are actually closer to the camera than the hips. This advantage is evident in **Figure 2.13**. You also notice that even though she is seated, her back is perfectly straight, her lumbar is curved, and her legs are crossed. Crossing the legs this way showcases her right leg, making the photo very feminine, beautiful and sexy.

For **Figure 2.14** I applied the same technique as Figure 2.13 but in a more exaggerated way. I knew that placing body weight on the back leg is preferable due to the relaxed look it yields, so why not try the pose sitting down? Notice that I had Brittany sit on the edge of the step with most of her body weight on her left buttock. This makes her thigh visible as in Figure 2.13, but it is more exaggerated. Again, this move emphasizes her femininity. You would not want to bring the leg over like this when posing a man.

ON YOUR OWN

While writing this book, I scheduled countless photo shoots to provide relevant photographs for each chapter's learning objectives. I did not care about making each shoot into a production, nor did I bother using an amazing landscape for each shoot. I simply wanted to create posing problems for you to find (**Figures 2.15–2.20**). As I previously suggested, get together with a photographer or a group and discuss the photos based on the material taught in this chapter and the preceding chapter. Remember that sometimes I include photos that do not really have anything wrong with them. Don't fix it if it's not broken, right? Have fun!

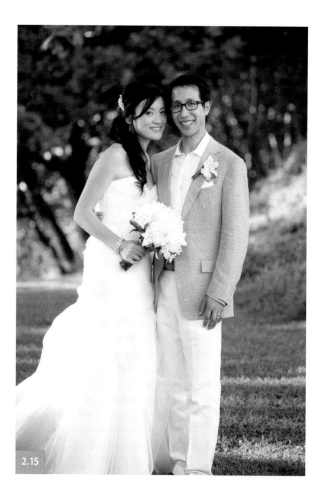

2.15

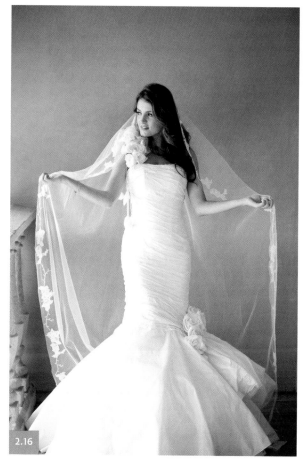

2.16

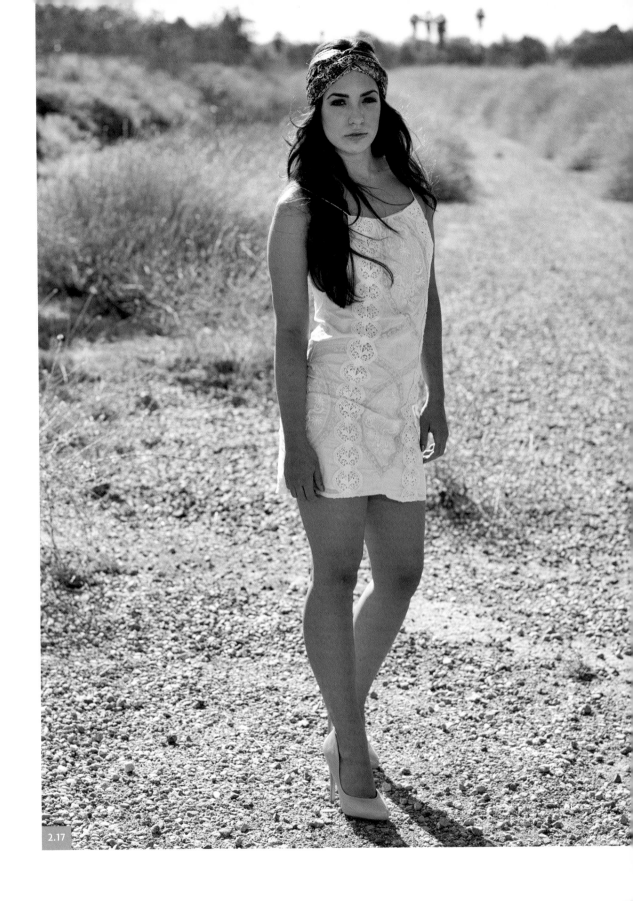

2.17

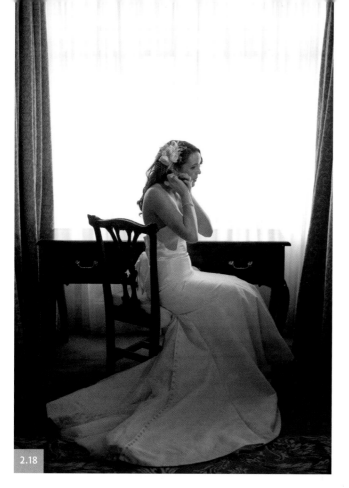

2.18

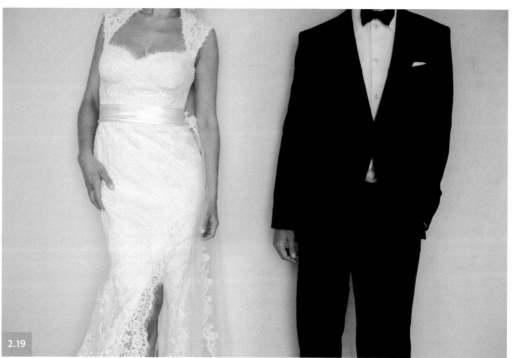

2.19

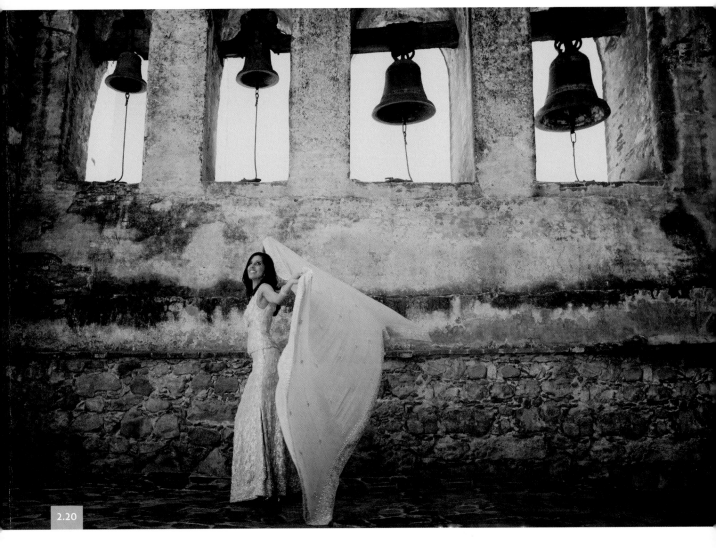

2.20

ANALYSIS

3

JOINTS AND 90-DEGREE ANGLES

IT'S OFTEN SAID that the first step in resolving a problem is knowing what the problem is. For some years, I was frustrated not understanding the problem with my posing technique. Photo shoot after photo shoot, I could not figure out why my subjects looked tense instead of relaxed. And why did I feel uneasy when viewing my photographs?

The culprit was my lack of knowledge about how 90-degree angles affect a pose. I never paid attention to this, and it took me many photo shoots to figure it out.

By their nature, 90-degree angles create great strength. Think about Greek or Roman architecture; all the columns stand at 90-degree angles relative to the ground. That's because 90-degree angles can support the most weight, and it's by far the strongest angle in architecture. In this chapter, we will explore how we can use this information to our advantage when posing our subjects.

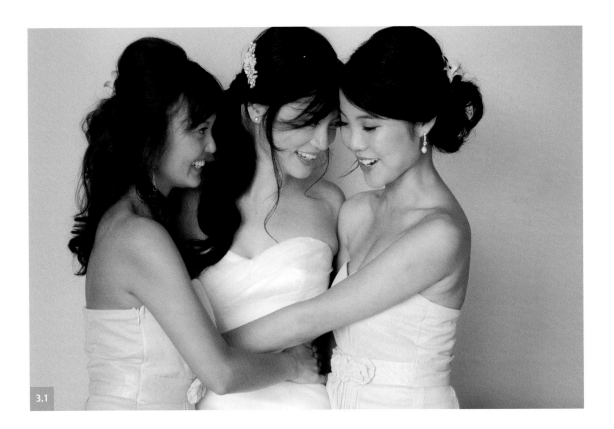

3.1

BENDING JOINTS TO AVOID STIFFNESS

Fluidity lies at the core of a good pose. Fluidity is achieved when the viewer's eye can travel through a pose without interruption. In **Figure 3.1**, for example, everything is fluid starting at the top. But as you work your way down the pose, you bump into the arm of the girl on the right. Her arm is stretched out as far as possible in front of the rest of the girls in the photo. As a result, the arm acts as a barrier. Her arm is completely stiff and it creates a serious break in the fluidity of the photograph.

Compare Figure 3.1 to **Figure 3.2**. Here, I took the time to very gently bend every joint from head to toe. Even though her arms are in front of her body, they are not a distraction because her joints are elegantly bent. Most importantly, her arms are not positioned at a 90-degree angle but are closer to 45 degrees, making the photo even more fluid. We will look into this later in the chapter.

STIFF JOINTS

It is unnatural for your joints to be perfectly straight. To prove this, try a quick experiment. Stand up straight and just let your arms dangle naturally. Notice how your elbow is slightly bent. Now move your arms to make sure they are perfectly straight. Do you notice how much effort that takes? If the body doesn't want to be in a particular position, it will take great effort to force it, and it will appear very unnatural on your photos. Remember: Don't fight the body; instead, go with it. When people get nervous, they stiffen their joints. Don't let them!

That said, there are occasions when creating stiffness in the joints might not be a bad idea—for example, when photographing an avant-garde style photo or a strong fashion pose. When viewers see such a photo, the pose's unnatural feel triggers a subconscious sense of discomfort, causing them to stop and take a look at the photo and, therefore, see the clothes.

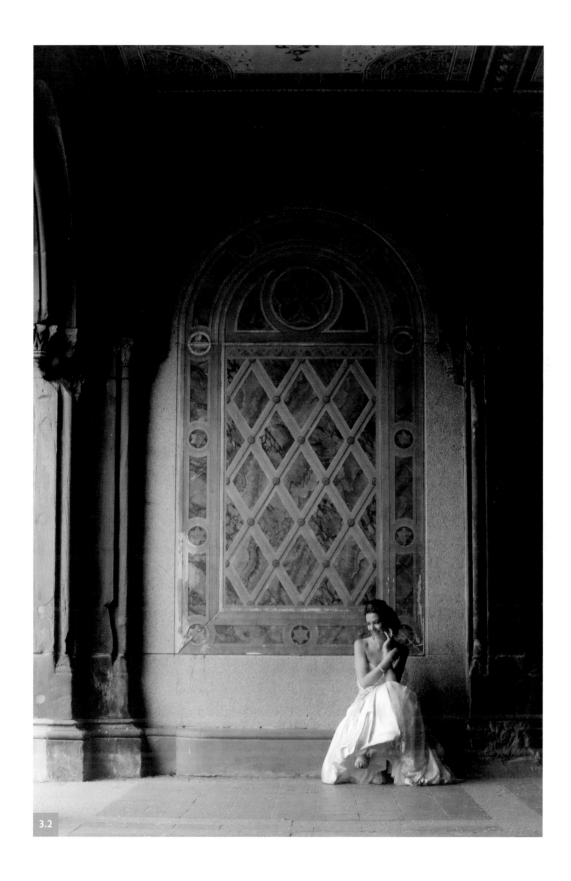

3.2

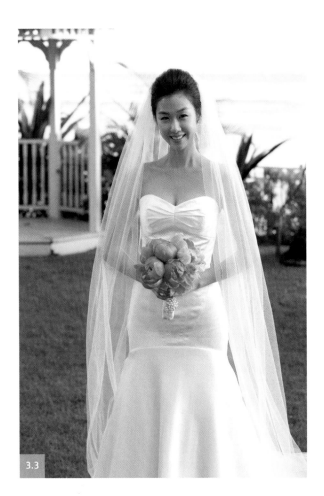

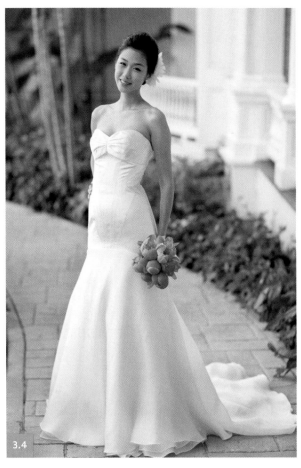

90-DEGREE ANGLES ON ARMS

In a pose, a person's torso should be open to the viewer and free of distractions. This allows for an inviting photograph. Block this area or distract from it, and the result will be a defensive pose. Any distracting elements in the torso region also will take away attention from your subject's face. Because 90-degree angles command our attention, the photographer must be aware of them when posing the arms, since they are at the same level as the torso region. Bending your subject's arms at a 90-degree angle is a tool you need to understand. It's neither good nor bad; it creates a specific look, that's all.

There's one consistent "rule": If either of your subject's arms is bent at a 90-degree angle, it must be resting on something. It should not be bearing its own weight or, even worse, holding something that adds to that weight. Otherwise, the pose will simply not look very elegant.

Consider **Figure 3.3**. Although it is quite normal for a bride to hold flowers, the arm angle is too abrasive. The flowers also are blocking much of her waistline. This creates the impression that the flowers are more important than the bride. Compare Figure 3.3 to **Figure 3.4**. By asking the subject to lower the flowers, we get rid of the abrasive 90-degree angle of the arms and display her waistline beautifully.

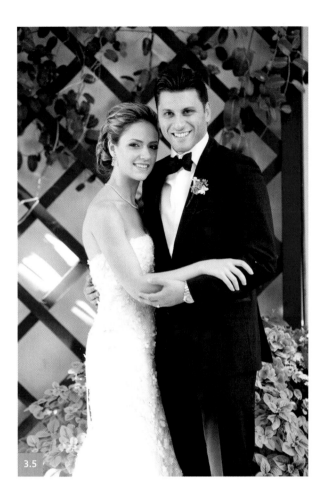

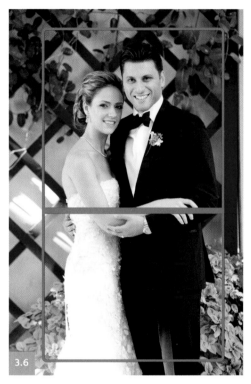

ARMS AT 90-DEGREE ANGLES WITH COUPLES

When posing two people together, such as a couple, keep their faces and torso regions free of distractions. Arms can be tricky in such situations. If posed wrong, they create a barrier between the viewer and the couple, and the photograph will suffer.

Figure 3.5 clearly exemplifies this issue. Here, the arms of the bride and the groom are positioned at 90-degree angles. The result creates a barrier across their bodies. This strong horizontal line cross their bodies right in the middle. The result vertically splits the pose, as you can see in **Figure 3.6**.

To correct this visual split, we bring the woman's elbow in between the two so that the arm creates a V (**Figure 3.7**). This creates a frame around the upper chest area and their faces. Notice how the elbow bends relative to their bodies and draws your attention to their faces, as noted in **Figure 3.8**. This move corrected the barrier issue in Figure 3.5. However, the bride's arm is still at a 90-degree angle, introducing a strong visual element in a pose meant to be romantic. Because 90-degree angles suggest strength, avoiding such angles in a woman's pose will convey a more traditional sense of femininity.

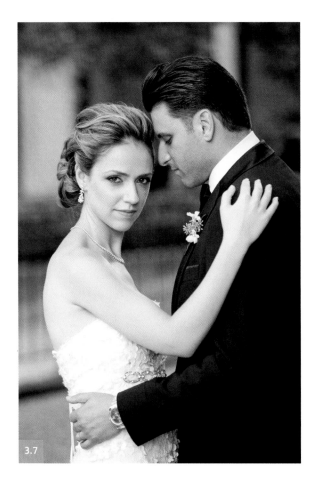

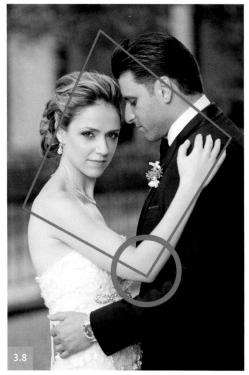

3.7

3.8

As the photographer, you must know what you are looking for in a pose. If you want to create a strong pose instead of a fluid one, then go ahead and bend the arms at 90-degrees. But be aware that if you do this, the face of your subject(s) must be so attention-grabbing that it commands more attention than the arms. Otherwise, your viewer's attention will wander to the wrong place. It's a balancing act.

USING 90-DEGREE ANGLES TO SCULPT EITHER A STRONG OR A FINESSED POSE

I realize this technique can be difficult to visualize, so let's look at an example. **Figure 3.9** was taken during a stylized fashion shoot to showcase the white jacket. This is a situation when you can use 90-degree angles to your advantage. I wanted to show strength, so I bent the model's arm at a 90-degree angle. In the spirit of keeping the entire pose strong, I also arranged her hair on her face just above the nose to create a sense of mystery. The result is a striking face combined with a strong and dominant torso region. With this example you can see that if you know your angles and the attributes they bring to the pose, you can use them to convey your vision perfectly.

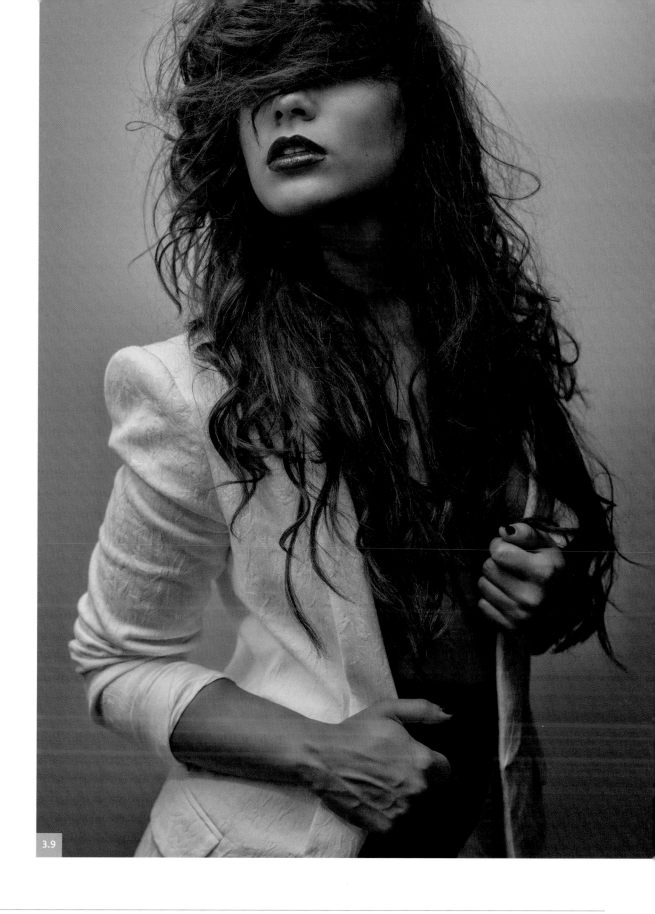

3.9

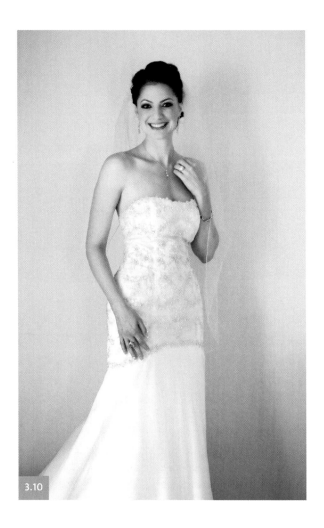
3.10

- If you place your subject's arms at a 90-degree angle, make sure the arm is resting on something. If he or she is holding an object without such support, it will amplify the awkwardness of the pose.

- Ninety-degree angles convey strength and command attention. Use them if you want the pose to look strong and to draw attention away from the face. Minimize them if you want a fluid pose and want to make your subject's face the focus of attention.

- Acute angles (less than 90 degrees) are sharp, high-energy angles that are very effective for fashion shoots or when a dynamic pose is desired.

- Obtuse angles (greater than 90-degrees) are peaceful and tranquil. When used in a pose, they convey a romantic, flowing energy.

Let's compare Figure 3.9 to **Figure 3.10**. As with the previous image, I posed a single female subject. But that's where the similarities end. In one photo, the pose is powerful and dynamic; in the other, the pose is elegant and soothing to the eye. In the wedding photograph, the pose places much more emphasis on her face. The styles of the images are polar opposites, and the way the arms have been bent is responsible for most of the differences. Using skill to pose instead of the "hoping to get lucky" method will serve you well.

90-DEGREE ANGLES ON THE WRISTS AND FINGERS

As photographers, we can feel overloaded by all the tasks we must keep track of during a shoot. We don't want to appear insecure or so obsessive-compulsive that we don't get anything done either. But as professionals, we should at least be aware of the potential posing issues that can arise in any given shoot. If you spot problems in time, you can fix them. If you don't, they can cause you headaches later.

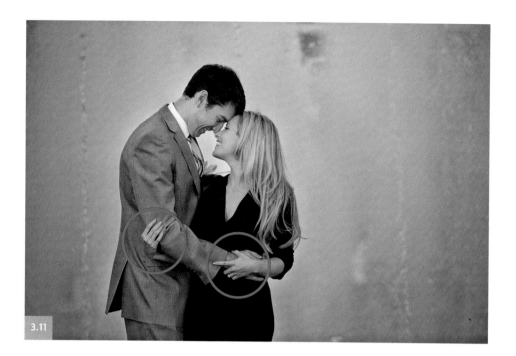

3.11

One of the issues that can sneak up on you is the angle of the wrists. In the heat of a shoot, we photographers can become so locked on our subjects' faces that we forget to look at other key parts of the body. Simply put, 90-degree wrist angles look bad. Avoid them at all cost. **Figure 3.11** illustrates what happens when the wrists are bent at a 90-degree angle.

I didn't notice this while I was taking the photo because I was focused more on the subjects' candid expressions. Their smiles were genuine for that split second. I took the photo at that magical moment, and I am glad I did. Yes, her right wrist is bent at 90 degrees. It's unfortunate, but it is far more important not to get so caught up with these small details that you are not able to capture something special. Once we become aware of such issues, we can do something about them if time allows. I would also like to call your attention to her left hand: Her index finger and thumb are approaching a 90-degree angle. This is another problem that sneaks up when posing subjects. The tip of the thumb should always be closer to the index finger. They should not be touching, but an inch or two apart will look natural. If the index finger and thumb are at a 90-degree angle, it will resemble a gun.

THE NATURAL CURVATURE OF THE WRIST AND HAND

With one of your hands, make a fist. Keep that fist tight and hold your arm straight out in front of you. Now release the fist and any pressure in your hand. Notice how at the moment you released the pressure, your hand dropped and the fingers relaxed. Take note of the natural curvature of your wrist when your hand is relaxed. That's the way your subject's wrists and fingers should be posed.

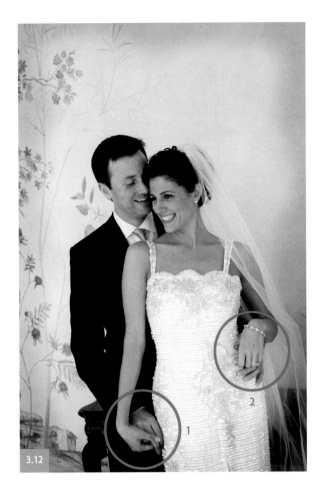

3.12

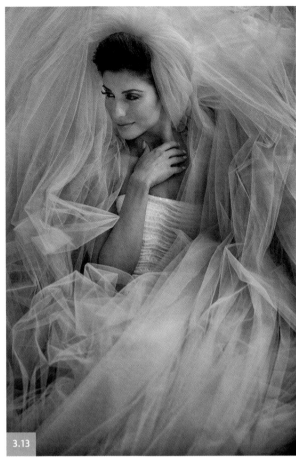

3.13

Remember that hands direct a viewer's attention, so pay close attention to them. If the hands are posed badly, they can make a perfectly good photograph useless. Take a look at **Figure 3.12**. For the most part, it is a beautiful photograph. But her hands are just a mess. Look at callout #2. Not only is the bride's left wrist bent at an awkward 90-degree angle, but so are her fingers. I have a hard time enjoying this photograph, because the hands are so distracting! In contrast, **Figure 3.13** is a well-executed position for the wrist and fingers. When the hands are well posed, it will bring great elegance to your photographs.

ON YOUR OWN

Based on this chapter and the previous ones, do these exercises (**Figures 3.14–3.19**) by yourself or have group discussions with other photographers. Be sure to take notes as you discover what is wrong and what is right with each photograph. Remember, you should only base your analyses on the material covered in this chapter and the ones preceding it. Have fun!

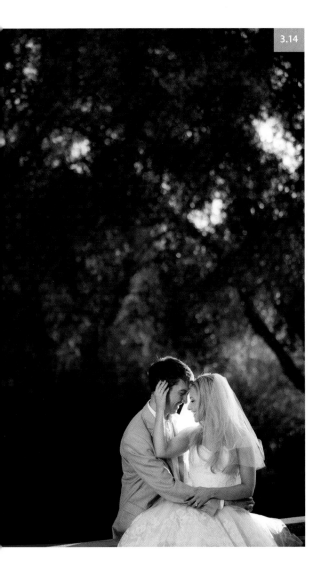

3.14

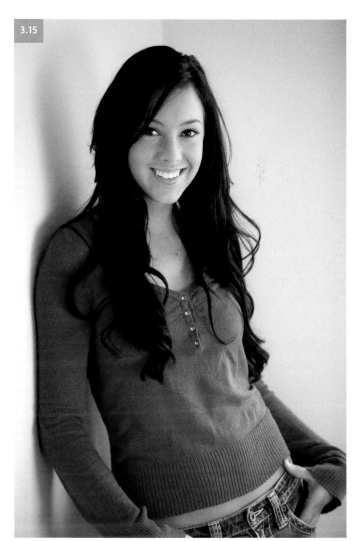

3.15

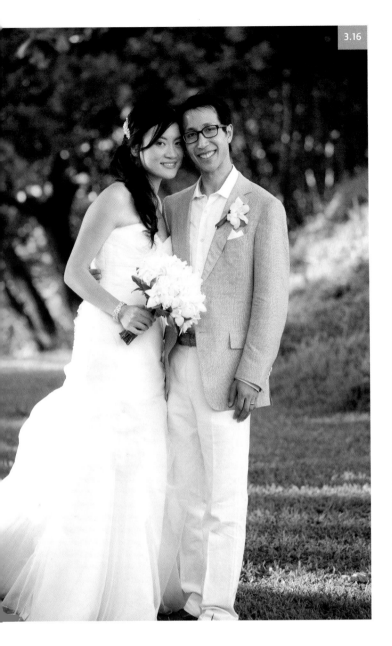

3.16

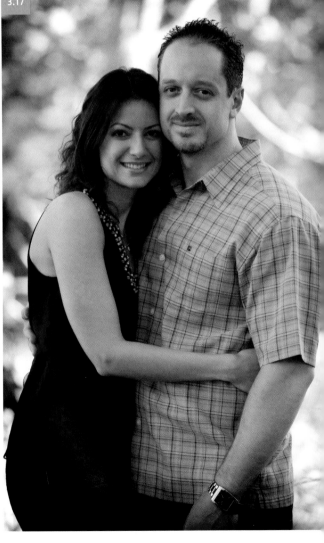

3.17

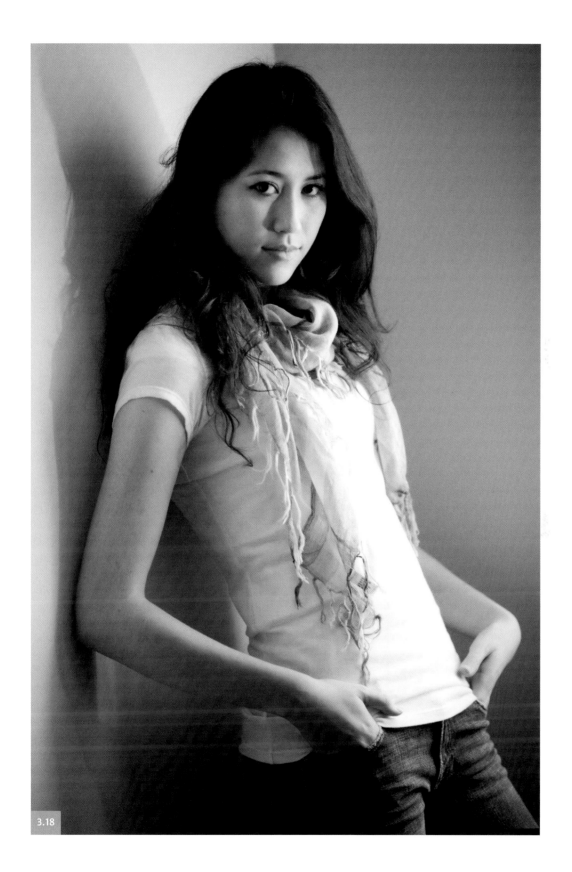

3.18

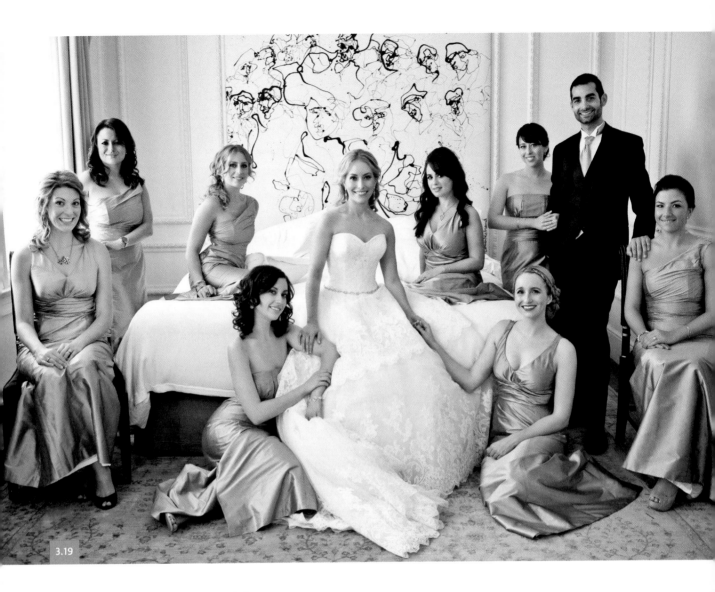

3.19

ANALYSIS

4

THREE-POINT CHECK COMBINATIONS

PHOTOGRAPHS CANNOT TALK, but they can still communicate. You experience various emotions depending on the energy the photograph casts on you. Some people can explain that energy, and others cannot. It is undeniable, however, that there's something we all feel when looking at a photograph of a person. Why does that happen?

The reason we feel a connection or a lack of one when looking at a photo of a person is because each of us has amassed an enormous database of human interactions since we were born. We have all observed the body language of people when they speak to us. We also have experienced that subtle gaze when someone is attracted to us, or the body language of someone interviewing us for a job. We learn to associate different feelings with different body languages.

As we grow up, we learn to differentiate a strong and confident body language from a flirtatious one. Photographers can create very distinct energies and looks in a photo by focusing specifically on the head and torso. They only need to use three parts of the body: *the collarbone, the chin,* and *the eyes.*

To simplify the charts I have put together on the following pages, we will consider only two options for posing these three parts of the body: facing you, or not facing you. By combining these three with the two posing options,

you will be able to create any feeling you desire. Later in this chapter, we will also introduce the option of moving your subject's chin up or down, and tilting the head toward the higher or lower shoulder.

As photographers, we must be conscious of the body language of our subjects. Yes, we could take hundreds of photos of our subject, until we find a particular result we like. But why not be conscious of what type of responses we want from our viewers and simply execute? In this chapter, we will explore every combination we can create using only the collarbone, the chin, and the eyes, along with whether they face the viewer.

3-POINT COMBINATION CHARTS

The charts that follow might appear a bit complicated, but they aren't. They simply represent the various posing combinations that you should be aware of. Don't force yourself to memorize these charts. It is far more effective to identify the combinations using your own work and become aware of the energy you feel with certain combinations. The process is similar to learning a language.

You can force yourself to learn French at home on your own, or you can move to France and immerse yourself in the language. Which approach do you think would be more effective at helping you become fluent in French? The goal is to be able to think in the language you are speaking so that the sentences flow smoothly and the language becomes second nature to you. The same principle applies to these charts.

FLASH CARD

Visual emphasis is always given to the point facing the camera. For example, if the collarbone and chin are not facing the camera but the eyes are, then greater emphasis is given to the eyes and less emphasis to the body and chin. This is a great combination for beauty or boudoir.

Depending on your angle, if you tilt your subject's chin to any direction you will expose the jawline. This should automatically cause you to adjust your lighting to chisel the jawline as much as possible. Do so by using lighting to create as much separation as possible of the jawline and the neck.

To help you visualize, look at **Figure 4.1**. There should be a distinct shadow line where the jawline meets the neck. This photo of me was taken by my great friend Jerry Ghionis at his house in Beverly Hills. Notice that by turning my chin to my left and turning my eyes toward the

4.1

camera, greater emphasis was placed on my eyes, but it left my jawline exposed. Jerry then made adjustments to my position relative to the light to create that perfect shadow where the jawline meets the neck. The final result is a portrait where the eyes of the subject are emphasized and the jawline looks chiseled.

Another point to keep in mind is your subject's bone structure and whether he or she has a double chin. This is important because different combinations with the right lighting can drastically change, for the better, a person's appearance. Always notice the direction of light for all of these portrait combinations. With experience, you will develop a repertoire of combinations you will be proud of.

WORKING WITH THE 3-POINT CHARTS

This section shows how I use the charts. By attaching a certain feeling or energy to a specific combination, I begin to naturally memorize the results of each chart. First and foremost, I associate the collarbone, chin, or eyes facing the camera with forming a strong connection with the viewer. Those points not facing the camera form a weaker connection with the viewer.

I also think of posing the head perfectly straight as a tool to toughen character and a tilt of the head as a tool to soften it. So, if the body is facing you and the chin and eyes aren't, I consider that body as having a strong connection but the eyes and face a weak one. You probably will not find promotional photos of professional boxers tilting their heads. That subtle tilt will make them appear less tough.

The strongest and most personal combination is when all three points are facing you and the head is perfectly straight. These are quick reference words to help me memorize what would happen if, for instance, I tilt the head or if I turn the collarbone away from the camera. Assume for a second you would like to create a strong pose for your subject but you want to soften it a little or make it less aggressive. In that case, you would turn the collarbone, chin, and eyes toward the camera but ask the model to tilt her head to either side.

Let's go through some examples of how the charts work and how to best use them to maximize our understanding of posing.

Figure 4.2:

- Collarbone facing the camera (strong), chin facing the camera (strong), and eyes facing the camera (strong).
- Head is straight (tougher).
- Energy: All three points are facing the camera in this portrait. Because of this, the subject appears strong and very much in your face. She is connecting with you in a very direct way. Her body, her face, and her eyes are all on you, the viewer. It is fair to say that a pose like this would be normal if you were having a conversation with her. Therefore, positioning all three points toward the camera makes the feel of this portrait very personal. Children often pose themselves in a very symmetrical way, giving this pose a possibly innocent energy. Because of the high connection level, this could be a good choice for a senior portrait or for a fashion portrait.

FLASH CARD

Tilting the head:

- If the subject tilts the head toward his/her higher shoulder, it will appear more feminine.
- If the subject tilts the head toward the lower shoulder, it will appear more masculine.

4.2

Figure 4.3:

- Collarbone facing away from the camera (weak), chin facing away from the camera (weak), and eyes facing the camera (strong).

- Head is straight (tougher).

- Energy: Both her body and her chin/face are turned away from the camera, and only her eyes are connecting with you. Because there is nothing else competing for attention, her eyes dominate with a seductive undertone. Her chin is facing the same direction as her collarbone, indicating that she could have been having a conversation with someone else and she quickly turned to look at you. This pose is a good choice for boudoir photography or when the subject wants to appear sexy and seductive, yet elegant and classy.

Figure 4.4:

- Collarbone facing the camera (strong), chin facing away from the camera (weak), and eyes facing away from the camera (weak).

- Head is straight (tougher).

- Energy: With only her collarbone facing you, the attention is directed to what she is wearing. There is not a great deal of personal connection here. But, compared to other combinations, this one is much more dynamic and high energy because this combination poses the collarbone and chin in opposing directions. If the collarbone and chin had been facing the same direction, the energy would be much calmer and harmonious, because she could easily have turned her eyes toward you and acknowledged your presence. But she didn't, so she appears illusive or aloof. Therefore, this combination is great for a fashion shoot, where the connection with the clothes is more important than with the person wearing them.

Figure 4.5:

- Collarbone facing away from the camera (weak), chin facing away from the camera (weak), and eyes facing away from the camera (weak).

- Head is straight (tougher).

- Energy: All three of the key points are turned away from you. This pose does not feel personal at all, and there is no connection with the viewer. It does, however, provide you with a quick glance of who she is and what she looks like, but her personality is subject to interpretation. The lack of connection with the viewer makes this combination a great choice to depict a powerful person or a leader. When the collarbone is facing one way and the chin the other way, it creates a highly dynamic pose. The pose feels energetic instead of passive. It resembles movement instead of rest. This combination also elongates the neck, making the person tall and elegant. Because of the impersonal nature of this combination, many ancient Roman sculptors used this combination to sculpt the busts of their leaders.

Figure 4.6:

- Collarbone facing the camera (strong), chin facing the camera (strong), and eyes facing the camera (strong).

- Head is tilted toward lower shoulder (softer, but with a more masculine feel).

- Energy: This is an example where all three points have a strong connection with the viewer, but the simple act of tilting the head automatically softens the image. However, this tilt is toward the lower shoulder, giving the photo a more masculine and confrontational energy. Compare Figure 4.6 with the following photograph, where the tilt is toward the higher shoulder.

4.7

Figure 4.7:

- Collarbone facing the camera (strong), chin facing the camera (strong), and eyes facing the camera (strong).
- Head is tilted toward higher shoulder (softer and with a more feminine tender feel).
- Energy: Not only is the energy in this photo strong, but you also connect with her feminine side. The only change from Figure 4.6 was tilting the head toward the higher shoulder. This is why I believe it is so important that photographers be aware of what the results will be calling out posing directions to clients. You should know the answers to such questions as how the energy of the pose changes by tilting the head, turning the body to the side, and so forth. I know this is hard work, but it is worth every ounce of energy when you have a client in front of you and you are a master at what you do. That feeling is amazing!

COLLARBONE, CHIN, AND EYE COMBINATIONS

The chart combinations on the following page provides you with every possible combination of the three points: the collarbone, the chin, and the eyes. They are meant to be used as a reference guide/study guide. They do not include head tilts or raising the chin up or down; those optional tools can be used with the charts.

If, for example, light were coming from above, you would raise your subject's chin toward the light source. This would illuminate the face evenly, getting rid of unflattering shadows. Keep in mind that opposing directions create energy, whereas same directions create harmony. For example, if the collarbone is facing camera left, the chin is facing to the right, and the eyes are looking back to the left, this would be a high-energy combination. If all three points were facing the same direction, however, it would create a greater sense of harmony and calmness.

	FACING YOU	AWAY
Collarbone	X	
Chin	X	
Eyes		X

	FACING YOU	AWAY
Collarbone		X
Chin	X	
Eyes	X	

	FACING YOU	AWAY
Collarbone	X	
Chin		X
Eyes	X	

	FACING YOU	AWAY
Collarbone		X
Chin		X
Eyes	X	

	FACING YOU	AWAY
Collarbone	X	
Chin		X
Eyes		X

	FACING YOU	AWAY
Collarbone	X	
Chin		X
Eyes	X	

	FACING YOU	AWAY
Collarbone		X
Chin	X	
Eyes	X	

	FACING YOU	AWAY
Collarbone	X	
Chin	X	
Eyes	X	

	FACING YOU	AWAY
Collarbone		X
Chin	X	
Eyes		X

	FACING YOU	AWAY
Collarbone		X
Chin		X
Eyes		X

	FACING YOU	AWAY
Collarbone	X	
Chin	X	
Eyes		X

Become familiar with how the combinations affect the energy of the poses. Do it naturally and slowly so that you can remember each one. Once you have a good grasp of a few combinations, start adding chin direction, up or down, and tilting the head toward one of the shoulders. After becoming familiar with a few combinations, ask yourself what kind of energy you want, and what part of your subject you would like to feature. Then come up with a combination to give you exactly that. Remember to enjoy the process, and do not force yourself to memorize the charts in one sitting.

4.8

APPLYING THE 3-POINT COMBINATIONS

This chapter's previous photos were chosen to demonstrate various concepts. The following photos come from actual photo shoots where I applied these techniques based on the energy I wanted to portray in my photographs. I hope that after reading this book you will pose with intent, instead of just guessing and throwing posing directions around in hope that one looks good. I do not want to sound harsh, but if you intend to use photography as a way of making a living, then you must photograph skillfully for the survival of your photography business.

After considering Laura's clothing and hairstyle (**Figure 4.8**), I thought an aggressive and powerful pose would do the most justice to the overall styling. So I used the same technique as Figure 4.5, where none of the three points face the camera, and the collarbone and chin point in opposite directions. Although I label the points not facing the camera as weak, I'm referring to a weak personal connection with the viewer, not weak as in fragile. This distinction is important.

The fact that none of the three points face you makes this photo impersonal, so you connect with her more as a statute than as a friend. I placed her hair over her eyes to add to the mysterious nature of this pose. With her eyes hidden from the viewer, the photo leaves more of her personality to your imagination.

The beautiful bride in **Figure 4.9** had one of the most unique wedding dresses I'd ever seen. There was no question in my mind that I needed a three-point combination to showcase the dress without it competing with her face. The answer was for her collarbone to be facing the camera and her chin and eyes facing away. This combination impels you to admire her dress without her eyes "demanding" that you look back at her. You can clearly see how turning her face away from the camera softens the connection with her eyes. I added a subtle head-tilt toward the higher shoulder to make the pose appear more feminine and elegant.

For the photo in **Figure 4.10**, I wanted the opposite effect of Figure 4.9. In this case, I still wanted to feature the dress, but I also wanted to keep a strong personal connection with the bride. The best three-point combination was easy to choose: All three points should face the camera.

4.9

4.10

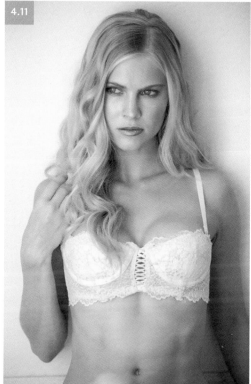

4.11

This three-point combination in **Figure 4.11** with the collarbone and the chin facing the camera and the eyes turned away is rarely used, but it can be very effective. It's one of my favorite combinations when doing a boudoir photo shoot. The energy here is sensual yet personal. Her eyes are not connecting with you, but she can feel your presence and accepts it because her body and chin are directed toward you. To me, this is the perfect three-point combination to create a balanced mix of aloofness and warmth. I know that sounds like a contradiction, but that is the best way to describe the energy in this photo.

ON YOUR OWN

Examine the following photos (**Figures 4.12–4.15**) with a group or another person and go over the combinations used and the energy they project. Be specific, as I was in the previous examples. Discuss, compare notes, and learn from each other.

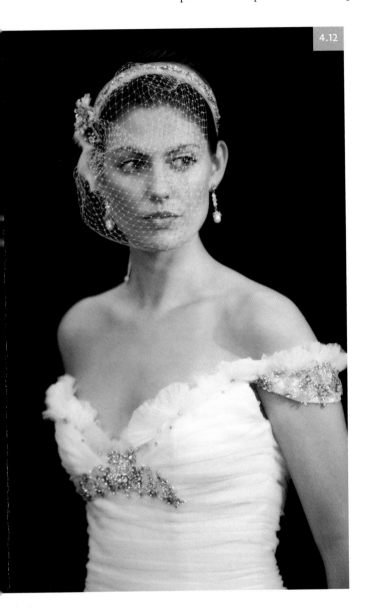

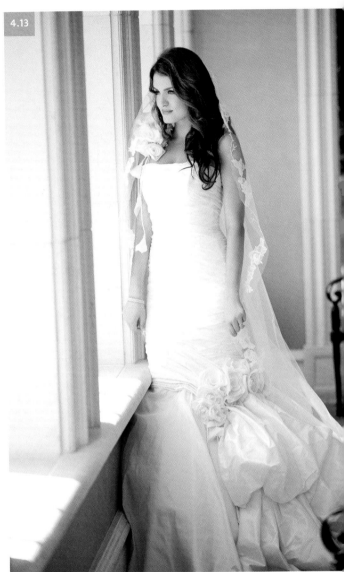

4.14

ANALYSIS

5

CREATING GAPS WITH THE LOWER BACK AND ELBOWS

IN PHOTOGRAPHY, paying attention to the little things can make a big difference. For example, consider gaps, which are the spaces created by bending our elbows and arching our lower backs. Gaps make people look thinner.

Moving our elbows away from our bodies creates a clear definition of where the waist ends. If our subject's arms are straight down and not engaged, the width of each arm is visually added to the width of the body, making it appear much wider.

At the beginning of my career, I remember moving my subject's arms and legs in different combinations with no idea of what I was doing. But I felt like a photographer because I was calling out a lot of posing directions. That approach, however, did not give me the best results.

Out of 200 images taken at a portrait shoot, I would give my clients ten photographs, and they would ask me to edit only three to five of them. That's how few they liked, three to five out of 200. If that sounds like what you do, it is happening because you are not posing with a purpose.

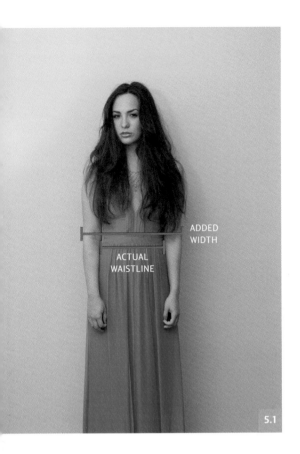

ADDED
WIDTH

ACTUAL
WAISTLINE

5.1

For every direction you give your subjects, you must know how the body will look and react to that direction. Work on this, and you will see a transformation in your work. Attention to these little details makes all the difference!

THE GAP EFFECT

Creating gaps when posing your subjects is one of the most important ways you can make them appear slimmer. This holds true regardless of the body type. Both arms do not need to be bent or engaged; only one is necessary to give the viewer of the photograph a glimpse of the waist.

This becomes even more important when there are low-contrast colors between the arms and the waistline. For example, if your subject is wearing a blue sweater with blue sleeves, there will not be much contrast between them. If your subject's sleeves are a different color than the waist, however, then there's a clear contrast. In such cases, bending the elbow to show the waistline is still important, but not as crucial as when there is little difference between them.

In **Figure 5.1**, Laura is wearing a blue sleeveless dress, which creates a clear contrast between her arms and waistline. Despite this contrast, you can see how much wider she appears with both of arms hanging down. Not only does she appear wider than she really is, but she also looks disinterested, bored, and not connected with the photographer.

CREATING GAPS THAT LOOK NATURAL

As important as gaps are, especially when posing women, it is equally important to create poses with gaps that look natural and effortless. In Chapter 3, we discussed the different energies angles bring to a pose. With this in mind, you can harness the desired energy from the angle of the arm to create natural-looking gaps.

The key is to give the hands something to do. Getting your subject's hands involved usually means bending the elbows, so make sure you choose angles based on the energy you want. Then finish the pose by arranging the hands in a position that makes sense. They could be holding an object, resting on something, or gently caressing a part of the body, such as the heart, to bring attention to it. Any of these options will bend the elbow and create a natural gap at the waistline. Here are some options I use to create such gaps using the hands.

Figure 5.2 shows an example of what *not* to do. As you can see, the bride's hands are not engaged, and her arms hang straight down, giving her a stiff look. The biggest problem is that the veil and the dress are the same color, reducing the contrast of where the waistline

ends. The pink wall helps create some contrast, but the layers of the white veil are showing more white than pink. This creates a subtle illusion that she is wider than she really is. To fix this, we need to increase the contrast between the pink wall and her white veil.

In **Figure 5.3** I asked the bride to face the camera, put her arms on each side, and gently lift her hands up to get a subtle bend of the elbow. Because the angle of the arms is greater than 90 degrees, the pose appears elegant. Having engaged her hands, I created that much needed gap between the pink wall and her white dress, clearly defining her beautiful waistline.

The photograph in **Figure 5.4** has obvious challenges to consider, but the very solutions to these problems created good results. I asked the bride to rotate her torso slightly toward the camera, making the dress visible from the side as well as the front. That also exposed her lower back. In such circumstances, remember to create the largest possible gap by arching the lower back, as explained in Chapter 1.

Her hands also needed to be engaged and the veil smoothed to better show the pink wall through the mesh. To solve both problems, I used the veil to give her hands something to do and to showcase her waistline through the gaps created by arching her back and moving her arms away from her body.

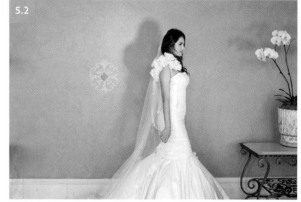

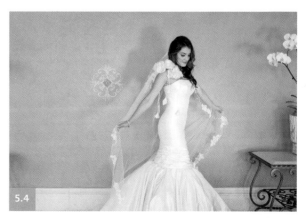

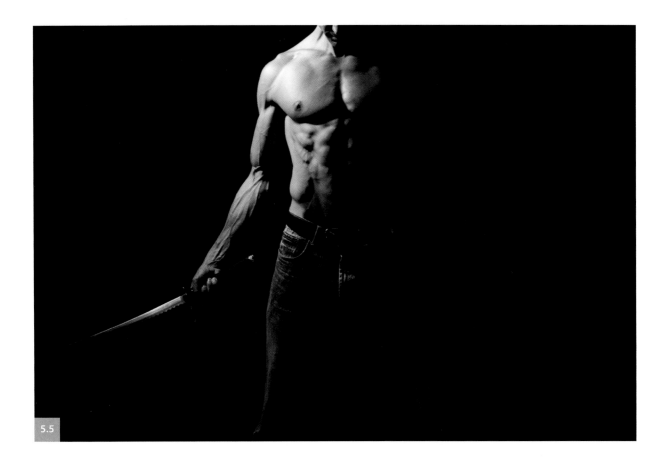

5.5

USING LIGHT TO AID THE GAPS

Whether the gap is large or small, it will always improve the appearance of your subjects by making them look thinner. However, by using precision lighting the photographer can also emphasize the gap. You only need to show the waistline from one side of the torso. If the other side is blocked by an arm or is too dark to see, our brains will visualize the entire waistline based on the visible side.

Figure 5.5 is a perfect example. During a photo shoot with a martial artist in Los Angeles, I envisioned the portrait with dramatic lighting. That usually means strong directional light. If you look at this image, you can see how the lighted side provides your brain with the information it needs to predict what the side in darkness looks like.

His swords were used as props, but they also gave me a reason to move his arms away from his waistline in a natural way. The gap between his elbow and his body also shows his fit waistline. If a viewer asks, "Why are his arms there?" the answer is, "Because they are holding swords." Such questions might seem silly, but anticipating them is an important key to making a photo look natural.

During many photo competitions, I see photographs where there's a gap between the elbow and the waistline but the arms are floating around, doing nothing. Before you push that shutter button, make sure you have a clear answer to the question, "What are the arms/hands doing?"

USING WALLS TO AID THE GAPS

Figure 5.6 shows a similar technique as Figure 5.5, but this time the subject has a wall to lean against. Walls are very important elements to keep in mind, because they make creating clear gaps much easier. Remember to make sure that the waistline is not touching the wall and that it is slightly turned away from the camera.

This is because any object that is closer to the camera will appear larger and any object farther from the camera will appear smaller. So we always want to turn the waistline away from the camera. The gap here is clearly defined because the subject is leaning against the wall with his upper back. The two points close to the wall or making contact with it should be the upper back and the buttocks. The lower back should be arched to stay clear of the wall.

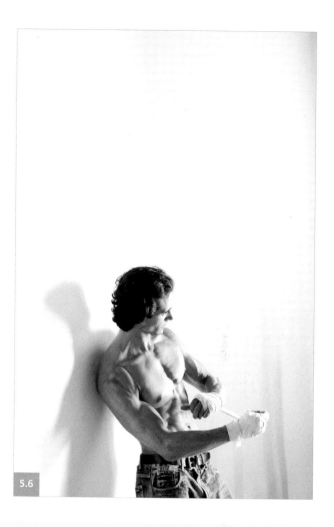

5.6

FLASH CARD

- Clearly define where your subject's waistline ends without adding any extra width with the arms.

- Move the arms away from the waistline, and place them in a position that makes sense.

- Keep the arms engaged.

- Only one side of the waistline needs to be clearly visible.

- The amount of color contrast between the arms and torso should be considered when determining the appropriate gap size in the pose.

- When posing a subject against a wall, bring the waistline or hips away from the wall to create a defined curve in the body. Position them slightly away from the camera to make the hip region appear more slender.

- When posing women, create an "S" curve with a big contrasting gap between the lower back and the background. This is done by curving the lower back as much as possible. The position of the upper torso can then be manipulated to determine how aggressive the curves of the "S" curve will be.

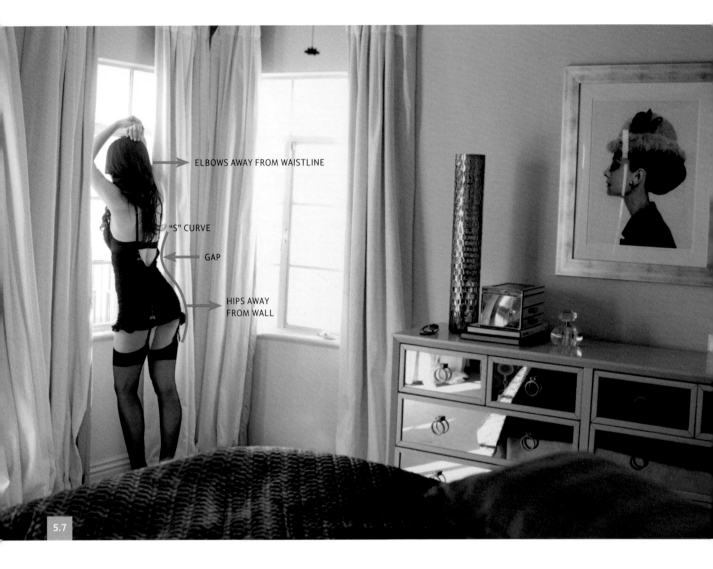

ELBOWS AWAY FROM WAISTLINE

"S" CURVE

GAP

HIPS AWAY
FROM WALL

5.7

THE "S" CURVE

Figure 5.7 is just another example of how to use a wall to maximize a woman's elbow-waistline gap. Although there are multiple points of contact or near contact with the wall (knees, chest, elbows, and head), the key remains the same: The hips are turned away from the wall as much as possible without looking awkward. This simple action gives her bottom a very sexy and curvy look, as shown by the callout. The curve of the body created when correctly executing this technique is known as an "S" curve. This is one of the most influential and sought-after techniques when posing women.

ON YOUR OWN

5.8

5.9

5.10

5.11

ANALYSIS

6

THE HAND/ARM CONTEXT SYSTEM (HCS)

DURING A PHOTO SHOOT, do you find yourself asking, "Now, what do I do with the hands?" Throughout my career, I have had the pleasure and privilege of teaching fellow photographers around the world about the art of people photography. I always ask my students to name their major headaches when posing people, and the responses have been overwhelmingly similar. The two most troublesome issues (and part of my motivation for writing this book) are:

- What to do with the hands
- Facial expressions

With this chapter, I hope to put an end to the ongoing frustration of what to do with the arms and hands.

WHY ARE ARMS AND HANDS SUCH A PROBLEM?

The root of the problem is the considerable meaning we give hands and arms. Arms can be used to show love, but they can also be used to fight. We use our arms to convey a vast variety of emotions. We have been trained since we were children to read the body language of those around us. This gives us the subconscious ability to attach meaning to arm and hand placement combinations, and react accordingly. Besides the face, no other part of the body has as much influence on how we perceive others than hands and arms. There are endless ways to pose them, and each movement, no matter how small, can significantly change the look and feel of the portrait we are trying to create. Talk about risky business!

THE HAND/ARM CONTEXT SYSTEM (HCS)

I created the Hand/Arm Context System, or HCS for short, to help me make sense of the countless variations in which individuals can position their arms and hands. I found it hard to remember all of the hand/arm positions I had seen in magazine and billboard photographs. I would try to memorize every photo that inspired me, hoping I would be able to recall them during a shoot. After a while, I ended up just as confused as when I first started, and all the combinations just blended together.

My HCS consists of:

- One common denominator (free the waistline)
- Three key execution concepts to always keep in mind
- Five ways in which the hands and arms can be used (context)

The HCS works by giving the hands/arms a context or purpose when considering a pose, instead of memorizing hundreds of hand/arm placement combinations. We focus on how the viewer will subconsciously perceive the image based on the five ways in which we can give the hands and arms context. This method requires a shift in thinking because it forces you to see the arms and hands of your subjects not as parts to pose, but as tools to influence the viewer's attention. The HCS method also gives the hands purpose and context within the pose so that they complement rather than distract from your subject.

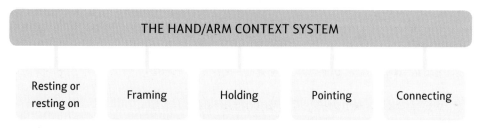

Most importantly, remember that we must free the waistline to reveal our subjects' true shape. If you fail to do this, the width of your subject's arms alongside the waist will make your subject's waistline appear much wider than it really is. By moving the arms away from this area, we reveal the true width and curves of our subject's waistline. But as soon as we move the arms away from their naturally dangling position beside the torso, we need to know the answer to the million-dollar question: "What do I do with the arms?"

The arms and hands need to have purpose in the image. If they don't, the part of our brain responsible for decoding what we see will detect the aimless hands and categorize them as major distractions. So what do we do? Most photographers solve the issue with two standard "go-to" poses: Ask men to put their hands in their pockets, and women to put their hands on their waists.

To be fair, there is absolutely nothing wrong with either option. But why limit the hands and arms—one of the most effective and versatile ways to communicate visually—to merely two poses? Instead, you can combine any of five ways to give the hands context within the pose. For example, a particular pose could use the arms to hold an object and to frame another.

BREAKING DOWN THE HCS

Before we tackle the HCS approach, I want to first give you a quick explanation of its parts. That will help you see the system's big picture. As you read each description, try to imagine an example and create a variation of it. Let's start with the three Key Execution Concepts; after that we will explore in greater detail each of the five options for giving the hands context, as shown in the HCS diagram.

THE THREE HCS KEY EXECUTION CONCEPTS

The three main concepts involved in this system are:

- Only one hand/arm needs to be posed.
- Hands/arms can work together or balance each other.
- Hands can be inviting or defensive.

1. Only one hand/arm needs to be posed

While deciding on an appropriate position for your subject's hands and arms, you won't find it necessary to pose both arms. You certainly can, and in fact it is recommended. But as long as one hand is positioned with a purpose, the other is free to stray, or even better, the arm can simply hang by the torso, and the pose will *not* suffer for it. This is great news!

2. Hands/arms can work together or balance each other

Working together: I want you to visualize each arm as being one half of a frame. With this in mind, you can arrange both arms to frame a person's face. The purpose of framing is to focus your viewer's attention on a particular area within the photograph. Arms working

together in this manner will simulate a full frame around the subject's face, or any other part of the body, and strengthen the visual effect. This is a very effective technique when used creatively. Be careful not to bring attention to the wrong part of the body, and be aware of what you want to frame before you start posing your subject's arms.

Balancing each other: Arms working together form a complete frame around a specific area, but arms working in opposing directions can bring a sense of balance to a pose. This technique is recommended when you wish to direct your viewer's attention to two different parts of the body. For example, one arm could frame the face, and the other could frame the hips. One arm is up and the other arm is down, in perfect balance!

3. Hands can be inviting or defensive

The last of the HCS execution concepts deals with the energy hands emit based on their position relative to the camera. Hand gestures are very important and universally understood. When posing the hands, every detail matters.

Inviting: Generally speaking, if the person being photographed has the back of his/her hands facing the camera (with the fingers pointing toward the person), we sense that as an inviting gesture.

Defensive: On the other hand, if the person's palms are facing the camera (with the fingers pointed away from the person), we sense that as a defensive move.

THE FIVE OPTIONS IN THE HCS

Now let's explore the five options for giving the hands context:

1. Hands resting or resting part of the body on the hands

Resting the hands: One way to give the hands/arms context or purpose when they are moved away from the waistline is to simply have them rest on something. Remember, for the most part we have to worry about only one of the arms, not both. One arm could be dangling freely while the other arm is resting easily on an object. The object you choose to rest the arm on has to be at a comfortable height based on the context of the pose. Too high and it will look awkward; too low and your subject will need to lean toward the object to reach it. To put it simply, the resting arm must be resting on an object that makes sense, appears effortless, and looks comfortable.

Resting part of your body on the hands: The other choice for this option is to rest part of your subject's body on the arms or hands. For example, the head could be resting on the hands. Another way to think of this is to use the arms or hands to support your subject's weight when leaning past his/her center of gravity.

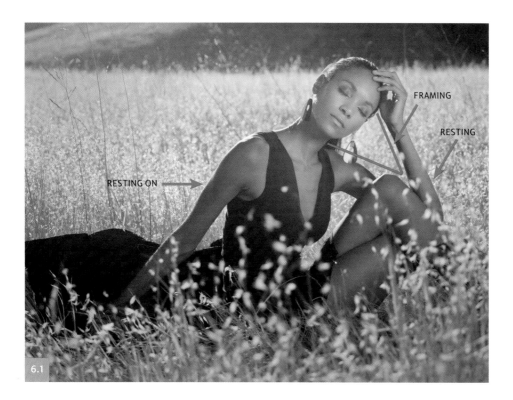

FRAMING

RESTING

RESTING ON

6.1

Figure 6.1: I chose this image first, because it required using the two techniques mentioned above to create this pose. Clearly, Tiffany has a beautiful face and Tony Yanez, the makeup artist, did a superb job. I knew instantly that I had to use framing to bring attention to her face and stunning makeup. Inspired by the gorgeous sunlit grass, I thought it would be a good choice to have her sit on the grass and use one of her arms as leverage (a technique I'll refer to as *resting on*). So, I asked Tiffany to sit and rest comfortably on her right arm to relieve the tension from her core.

I still needed to use one arm to frame her face. To accomplish this, I asked her to lean forward until her left hand could rest on her head, thus creating the frame. To put the final touches on the pose, I had to lower her left elbow to a natural place where it would make sense. Her left leg knee made a perfect resting place. I asked her to lean forward even farther, until her elbow could rest on top of her knee. This move achieved two purposes: it framed her face with one arm and she looked peaceful doing it.

- **Goal:** Frame her face while sitting.
- **HCS methods used:** Framing and resting on, and resting.
- **Execution:** Hands balanced each other. Both hands were posed. Fingers positioned with an inviting energy.

Figure 6.2: For this assignment, the tone and strength of Daniel's upper body clearly had to be featured. But I did not want to use the typical "strong man" pose that I have seen too many times. A candid approach seemed more suitable. After I work out, I often lean my body against a wall while I catch my breath, so I thought this idea would work well for this portrait.

I asked Daniel to face the wall as if he was exhausted from a workout. To make the exhaustion more believable, I asked him to rest some of his body weight on his right arm above his head. From my angle, I did not want to cover his face with his other arm, also up against the wall, so I just let it hang. This is a great example of posing only one arm. Also notice how his back is perfectly straight and his head is pivoted from the top of the spine, as explained in Chapter 1.

- **Goal:** To feature his arms and upper body in a candid way.

- **HCS methods used:** Resting on.

- **Execution:** Hands balanced each other. Only one arm needed to be posed. Fingers positioned with an inviting energy.

Figure 6.3: Moving the arms away from the torso to reveal the waistline can be done in different ways. Here, one arm is crossing in front of the body with her left arm behind the right arm. As you can see, both reveal the waistline. My goal for this photo of my wife Kim

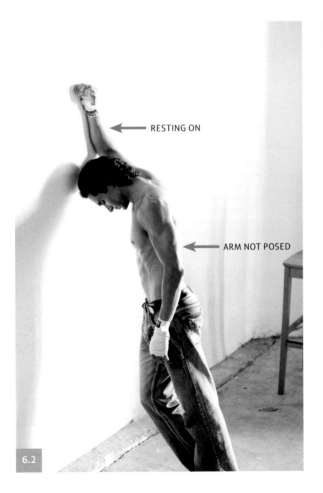

RESTING ON

ARM NOT POSED

6.2

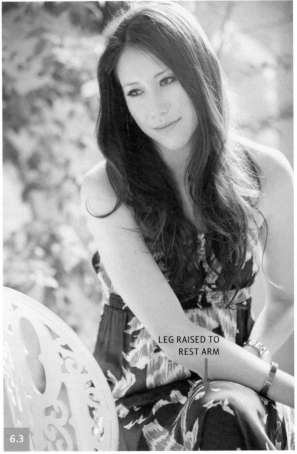

LEG RAISED TO REST ARM

6.3

was to create a flattering pose that appears not to have been posed at all. Both my wife and I prefer relaxed, informal portraits, so to create this relaxed and candid type of pose, I usually choose resting or resting on as my HCS choice. The pose looks comfortable, because both arms are resting on a place that makes sense. The key to this restful look is to raise the leg high enough to give the arm a convenient place to rest on, as you can see here.

- **Goal:** Candid but flattering portrait.
- **HCS methods used**: Arms resting.
- **Execution:** Hands working together. Both hands were posed. Although fingers are not visible here, you can still determine that the fingers positioned are posed with an inviting energy by looking at the position of the arms.

Figure 6.4: This photo illustrates an important point when posing a subject's hands and arms. Although most of her right arm is not visible in this photograph, it is actually responsible for much of the pose. The reason this pose works is because she is resting part of her body weight on my lighting case, as shown in **Figure 6.5**. This is why the HCS works so well. Using the arms as leverage gives you the means to create interesting poses that otherwise would not be possible. The posing options of the HCS are limited only by your creativity and imagination.

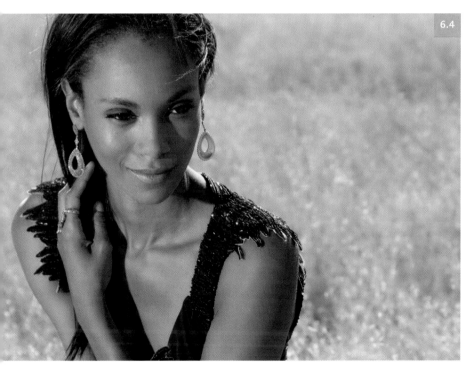
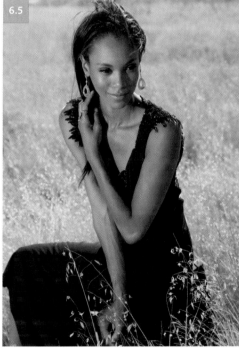

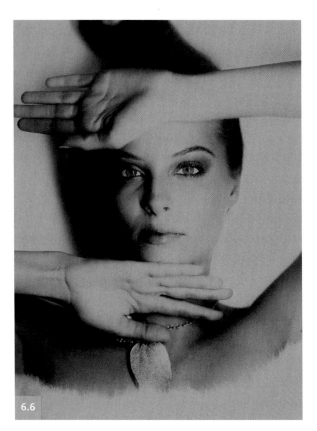

6.6

2. Framing

Framing is a technique designed to draw the viewer's attention to what's inside the frame. In photography, many objects can be used to create the illusion of a frame. When it comes to the human body, the very shape of our arms allows us to frame something, with each arm representing two halves of a picture frame and the elbows being the joining corners. So, if you want to bring attention to your subject's face, you can bring your subject's arms up and fold the forearms over the head to create an "arm" frame around the head. The same technique could be used to frame a person's torso, or any other part of the body, for that matter. It's simple to execute and evokes a strong response from the viewer to the area you, the photographer, chose to enclose. Although one arm is enough to bring attention to that part of the body, both arms working together to form a complete frame will make it that much more riveting.

Figure 6.6: For this image, I asked model Sydney Bakich to frame her face with the palm of her hands to the camera. My purpose was to create a visual contradiction. To make a photo more interesting for the viewer, use visual contradictions. They will be your best friends. Here's what I did: I posed Sydney on the ground and used a Hasselblad 100mm f/2.2 lens to give the image an intimate feel. But the hands framing her face tell a different story. The fact that she is framing her face no doubt visually isolates her stunning eyes and lips from the rest of the photo—as if she were telling you what she wanted you to notice the most. The angle from where this portrait was taken is certainly inviting, but the hands are posed in a defensive way, ready to protect her face if you get too close. That is the contradiction. I encourage you to use the visual psychology taught in this book to create contradictions in your work. It will make the most common photo much more intriguing to see.

Figure 6.7: This photo of Travis was taken for an actor headshot. Both arms were used here to frame his face. Naturally, the arms in an up position couldn't possibly be comfortable. The arms also need an excuse to be up there, so I placed my background pole over his head for him to have something to grab. It is interesting to notice how the frame formed by his arms is higher above his head than it is beside it, unlike most frames. The arms are quite versatile, and as long as there is a reasonable excuse for the arms to be there, you could pretty much get away with anything.

- **Goal:** Strong but still relaxed pose with a powerful emphasis on the face.
- **HCS methods used:** Framing.
- **Execution:** Hands working together. Both hands were posed. Fingers not visible.

Figure 6.8: I had the pleasure of photographing model Iti during one of my workshops in the beautiful city of Tallinn, Estonia. As soon as I met her, I was captivated by her stunning

facial features. Her angelic face and the elegant shape of her eyes propelled me to create a soft and vulnerable pose that would celebrate her exceptional bone structure. To do this, I knew I would use her arms to frame her face.

The difference here is that although both hands are by her face, I placed one hand by her lips and the other by her eyes. This forces you to pay attention to her entire face. Remember that the viewer's eyes will follow the hands, so by placing one hand on each side of her face, the eyes will move from left to right. Furthermore, the hands placed one higher than the other (as will be explained in further detail in Chapter 9) also force the viewer's eyes to travel up and down, giving the position of the hands a more elegant look. Her fingers were posed pointing toward her to invite the viewer to glance at her face. Most importantly, her elbows are kept down to ensure they do not create a distraction.

- **Goal:** To showcase Iti's striking facial bone structure and features.
- **HCS methods used:** Framing.
- **Execution:** Hands working together. Both hands were posed. Fingers positioned with an inviting energy.

Figure 6.9: The HCS approach to posing people's hands and arms is equally suited for men and women. The purpose for this fashion shoot was to showcase the clothing and jewelry

6.9

6.10

pieces designed by the winners of the popular TV show "Project Runway." By studying the nature of the pieces involved, it is easy to see that the charm the model is wearing on the right side of the vest did not need any help standing out. It is a large silver charm placed over a black vest, so the contrast is already there. I thought it would be better to focus on the necklaces.

The solution was to position one hand by the unique car necklace to bring attention to it. Next, the model had green eyes, an unusual trait, so I thought it would be effective to use his left arm to frame his face. His fingers were angled down to point toward his eyes. To keep the pose looking relaxed, I had him rest his left arm on his left leg. The two arms are working in opposing directions and give the photo a great balanced feel.

- **Goal:** To showcase the clothing, accessories, and his green eyes.
- **HCS methods used:** Framing and pointing.
- **Execution:** Hands balanced each other. Both arms were posed. Fingers positioned with an inviting energy.

Figure 6.10: Making sure this pose would work required a bit more thought. Still, all the key ingredients of the HCS approach are there. The challenge was that I wanted the arms to frame her face but be above her head instead of next to it. Holding the weight of both arms above the head requires much perceived effort, because there is nothing for the arms to hold on to, as in Figure 6.7. To fix this issue, I used the high-energy/dance move

technique discussed in greater detail in the next section, "Holding." For now I'll keep it simple.

It is based on the idea that "perceived effort" in a pose can be counterbalanced by having the model do a high-energy movement, as if caught in the middle of a dance move. This is precisely what was done here. The model Tiffany moved her hips quite drastically to simulate a dance move and thus gave the arms permission to be up over her head.

- **Goal:** To frame her face with both arms over her head.
- **HCS methods used:** Framing.
- **Execution:** Hands working together. Both arms were posed. Fingers positioned with a defensive energy.

Figure 6.11: Unlike in Figure 6.10 the arms in this photo were comfortably resting on the hips. Because the arms had a place to rest, the high-energy pose technique mentioned earlier was not necessary. The perceived effort required for the arms to be where they are here is minimal. Therefore, the hips can be in a more normal position. Both arms are working together to create a complete frame around her torso. A full frame brings the viewer's attention to her beautiful figure.

- **Goal:** To frame her body and dress with both arms.
- **HCS methods used:** Framing.
- **Execution:** Hands working together. Both arms were posed. Fingers positioned with an inviting energy.

Figure 6.12: In this case, the model is standing up with her arms tightly framing her face, bringing your attention right to it. Because her eyes are closed, making her appear

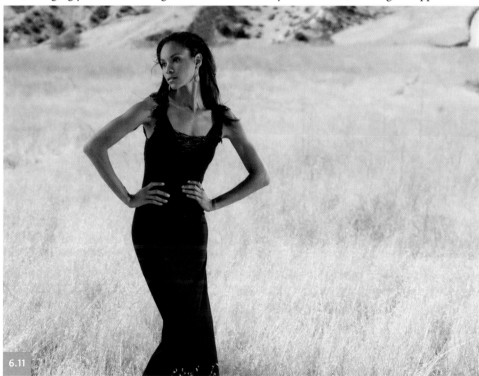

6.11

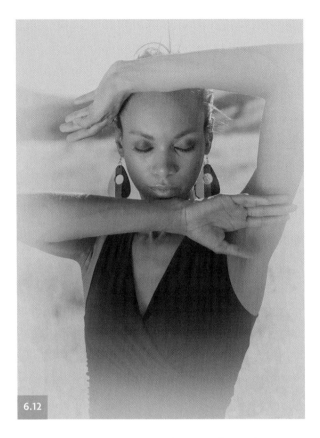

6.12

vulnerable, I had her turn her hands (with her fingers pointed away from her) in a defensive position. This creates an interesting energy, evokes emotion, and subconsciously forces you to look at the image to investigate the overall feel of the portrait.

- **Goal:** Rigid, standing pose with a powerful emphasis on the face.
- **HCS methods used:** Framing.
- **Execution:** Hands working together. Both hands were posed. Fingers positioned with a defensive energy.

3. Holding

In photography, having a subject hold an object is a powerful tool that we can use to our advantage. Giving the hands something to hold automatically gives them permission to be just about anywhere.

Let's say, for example, we want our model to have her arms straight down. We have already established that this would force the brain to see the dangling hands as useless and a distraction. Now, put a purse in one of the model's hands and everything changes. This time, the brain will see the hands as a tool responsible for holding that purse. The hands now have a purpose, and they are no longer a distraction.

Keep in mind that if your subject is holding an object, such as a purse, with the arm bent at an angle greater than 90 degrees (obtuse angle), the object will not draw as much attention away from the face. This angle will enable you to make the photo about your subject who happens to be holding a purse. But if the arm holding the purse is bent less than 90 degrees (acute angle), the energy of the photo will transfer more to the purse itself, instead of the person holding it.

This is because of the "perceived effort." Holding something with your arms sharply bent (acute angle) requires much more effort than holding something with your arms straight down. The viewer's brain automatically wonders, "What is so important about that purse or object that it is worth the effort to hold it up so high?" Such poses tend to force the viewer to pay more attention to the object. However, there is one exception to this rule.

If the photo of the person holding the object is caught in the middle of a high-energy pose, such as a dance move or a jovial jump, then the person can hold the purse or object pretty much anywhere without the brain reacting to it. This is because the duration of any poses in such high-energy moves is usually extremely short—and the brain doesn't see it as a position that would tire the arms. So if you want to have the purse over your subject's head without drawing attention to it, simply have your subject jump as she swings the purse above her head.

Figure 6.13: Holding an object is a great way to give a model's hands an excuse to be where they are. Just remember when using the "holding" HCS method to keep in mind the perceived

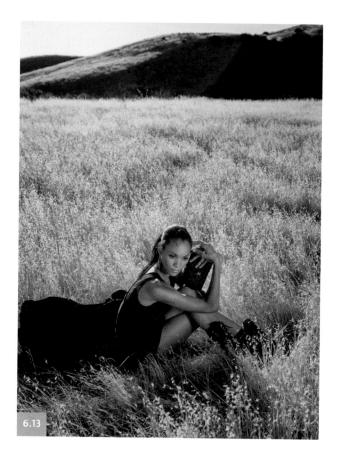

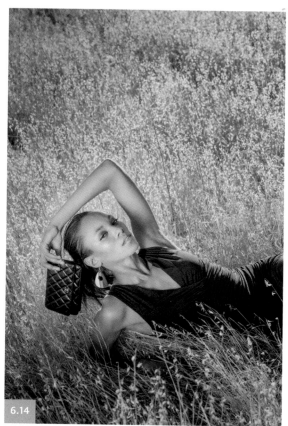

effort of holding that object. For example, in this photograph featuring the Chanel purse, I wanted to go for a candid feel when Tiffany held the purse. Her arms are resting on her legs; this means the perceived effort to hold the purse is low. Low perceived effort usually means less importance is given to the purse. To rectify this issue and increase the viewer's attention on the purse, I had Tiffany frame it with her right arm. The result is a candid way of holding the purse, but it still places strong emphasis on the product by combining holding with framing.

- **Goal:** Candid photo of Tiffany holding the Chanel purse.
- **HCS methods used:** Holding and framing.
- **Execution:** Hands working together. Both hands were posed. Fingers positioned with an inviting energy.

Figure 6.14: Compare this photograph with Figure 6.13. In both photos, the model is giving her hands context by holding the purse. The difference is the perceived effort holding it. In this case, the model is not resting her hand on anything while holding the Chanel. She is carrying the entire weight of the purse and her arm in that position. You can imagine that this pose could become tiring. That is exactly why the viewer's brain will ask, "Why is that object worth that level of effort and discomfort?" To find the answer, you must look at the purse. That is the goal of all advertising photography—for you to look at the product!

It is worth noticing that although the model is holding the purse with her fingers, they are still soft and bent naturally. This is imperative! If the fingers were posed in a rigid manner,

or one finger was randomly sticking out, it would completely shift your attention to the fingers, instead of the product.

- **Goal:** High perceived effort photo of Tiffany holding the Chanel purse.
- **HCS methods used:** Holding and framing.
- **Execution:** Hands balanced each other. Both hands were posed. Fingers positioned with an inviting energy.

Figure 6.15: I had just purchased this beautiful Leica M6 camera from my wife's coworker. I have always been a big fan of the superb details that Leica builds into their M series cameras, so my goal was to take a candid photograph featuring the exquisite design of the Leica.

To showcase the camera's beauty, I combined holding and framing. To achieve this, I asked Kim to hold the camera in a natural position, as if she were looking at the knobs and dials on top of the camera. This gives the hands purpose and context. Both her arms are working together to create a full frame around the camera. The final touch was to have Kim looking at the camera to further focus the viewer's attention on it. This works well, because when people look at a photo of a person, they always want to know what that person is looking at. Notice that even though the photo has bright colors and a beautiful bright landscape—much brighter than the camera for that matter—your attention still travels straight to the camera.

- **Goal:** Candid photo of Kim holding and featuring the Leica M6 camera.
- **HCS methods used:** Holding and framing.
- **Execution:** Hands worked together. Both hands were posed. Fingers positioned with an inviting energy.

Figure 6.16: I needed a creative way to photograph the elaborate designs of Anita's henna art. In so many photos, the bride simply turns her arms and hands toward the camera to

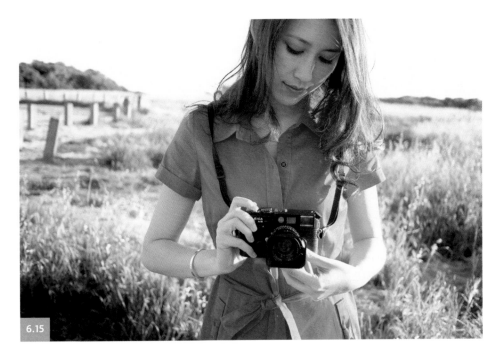

6.15

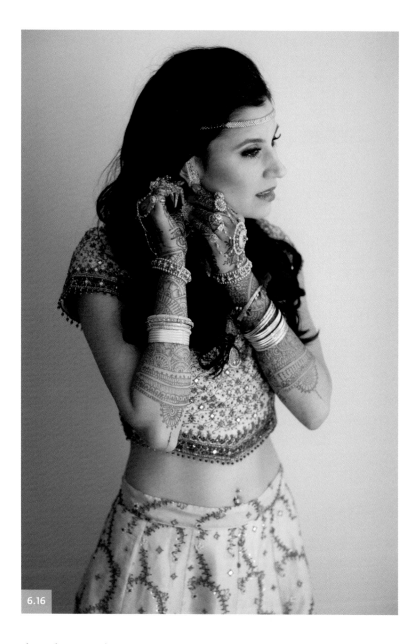

6.16

show the artwork, so I was determined to display the henna designs in a candid way. First, I needed to give the hands and arms context—an excuse to be where they were. What better way than to have her hold her earrings? This forces her arms to be bent at the perfect angle to show off the beautiful henna designs on her arms in natural way.

- **Goal:** Candid photo of Anita featuring the henna designs on her arms.
- **HCS methods used:** Holding.
- **Execution:** Hands worked together. Both hands were posed. Fingers positioned with an inviting energy.

Figure 6.17: This photo is a great example of one of the easiest and most common ways to pose a woman wearing a dress. This happens to be a wedding dress, but the method works

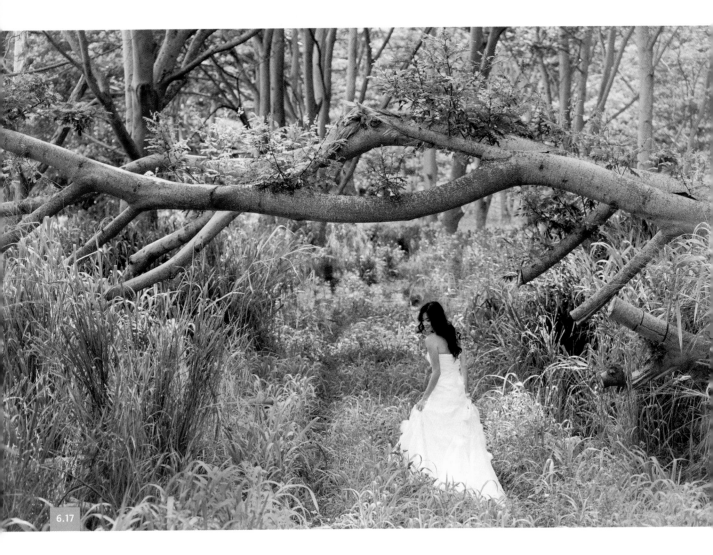

6.17

just as well with any dress. To keep her hands from dangling, simply ask the subject to slightly hold up her dress. This pose achieves two things: her elbows bend, and her hands have something to do. As the saying goes, "two birds with one stone." Be careful about how high she holds up her dress, since this will affect the angle of the arm. Too high, and her elbow will be bent at 90 degrees, creating a barrier and, consequently, a distraction.

- **Goal:** Give the bride something natural to do with her hands.
- **HCS methods used:** Holding.
- **Execution:** Hands worked together. Both hands were posed. Fingers positioned with an inviting energy.

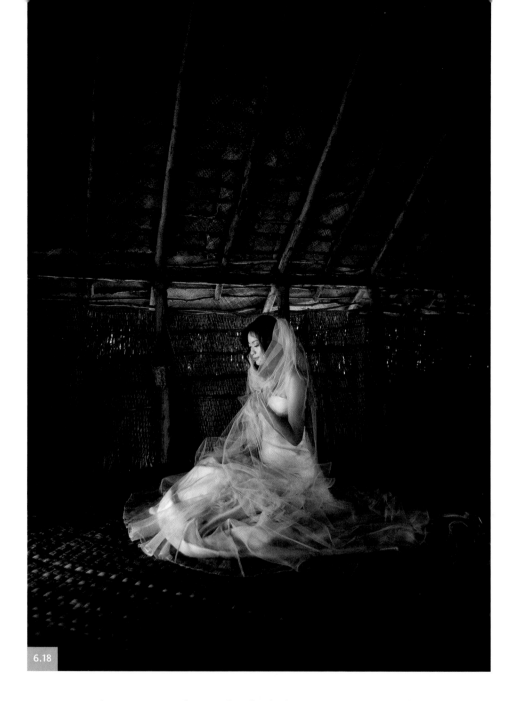

6.18

Figure 6.18: This image was taken on the island of Kauai, Hawaii in a small hut in a tiny village that no longer exists. The hut was too low to stand up in, which is why I had the bride sit down. To engage the hands, I asked her to hold her long veil in front of her, close to her heart. Then I adjusted the veil near the bride's head to frame her face with it.

- **Goal:** To engage her hands by creating a frame around her face using the veil.
- **HCS methods used:** Holding.
- **Execution:** Hands worked together. Both hands were posed. Fingers positioned with an inviting energy.

6.19

Figure 6.19: I love this image because of its melancholic and romantic nature. The part that I find interesting is that the hands are largely responsible for what makes this photo work. First, the bride's eyes, although closed, are pointed toward the hands. Second, the hands are perfectly framed by the window curtain at the back of the room. These two points give the hands great importance.

My first concern was that this photo was going to be a partial silhouette, so creating gaps between the parts of the body to give them definition was very important. I noticed that she was wearing a bracelet, so I asked her to take it off and put it back on again. But I had to be more specific than just "put it back on." I positioned her arms myself to make sure that one arm was lower than the other from the perspective of the camera. This would ensure the clear definition of each arm in the silhouette. The hint of the dress on the right gives the suggestion that she has a big day ahead of her, so I had her close her eyes while she puts on the bracelet to show her reflecting on the meaning of the events that were about to unfold. The lesson to be learned here is that the way you decide to pose hands has to coincide with the overall feeling and energy you are looking for in the photographs you take.

- **Goal:** To engage her hands with an action that evokes emotion.
- **HCS methods used:** Holding.
- **Execution**: Hands worked together. Both hands were posed. Fingers positioned with an inviting energy.

4. Pointing

It is no surprise that we use our fingers to point at something we want people to notice. We have been doing this since before we could walk. Our fingers have always been used as pointing devices. Best of all, regardless of where you are in the world, people will universally understand and know what to do when you point your finger. They will react by looking at whatever is in that direction. This is a powerful piece of information when posing people, because where the fingers go, the viewer's attention will follow.

Remember that the face automatically commands the most attention, but the fingers are always a close second. In a photo where both the face and the subject's hands are showing, people looking at your photo will always turn their attention to the face first, and then, without a doubt, their attention goes to where the hands are. Equipped with this knowledge, you can choose exactly what part of your subject's body you want to showcase.

If, for example, you are photographing a model with an emphasis on the makeup, bring the hands up to the face. If you would like more of the viewer's attention to be on just the lips, have the model's fingertips gently point toward the lips. People will follow the fingertips like a dog chasing a cat. Fingertips can be used to subconsciously bring the viewer's attention to a model's purse, simply by placing her hand near the purse with her fingers softly pointing toward it. The best way to remember this is to think of hands as having two distinct parts: the hand and the fingertips. Think of it this way: The position of the hands will direct your viewer's attention to a general area, and the fingertips will pinpoint exactly where you want the viewer to look.

6.20

Figure 6.20: We all know that fingers have always been used for pointing. When a person points at something, you can't help but look in the direction of the finger. It's an instant reaction. This HCS technique is no different. During a shoot, I noticed Laura's lips were absolutely stunning. Out of the five available HCS choices to give the hands context, I quickly picked pointing and framing to draw the viewer's attention to her lips. I covered her eyes with hair to ensure that her eyes would not distract people. I then used her fingertips to do two jobs: to point and to frame her lips.

- **Goal:** To strongly feature Laura's lips.
- **HCS methods used:** Pointing and framing
- **Execution:** Hands worked together. Both hands were posed. Fingers positioned with an inviting energy.

6.21

Figure 6.21: This is a powerful example of how the hands can engage viewers and have them feel a connection with the subject in the photograph. Even though you probably don't know the model Tiffany, you feel as though she is inviting you into her life. The reason for this is largely based on the way her hands are positioned. The hands are framing the heart, the fingers are positioned toward her, giving and inviting energy, and her fingers are also pointing toward the heart region softly and delicately.

Any time you pose the female model's hands around the heart region, you will be rewarded with a similar result. In this case, one hand is posed higher than the other, but both hands can also be at the same height. The trick is to position the hands to frame the heart. The possible combinations to achieve this are endless, and I encourage you to take this example and create 10 or more variations of the hands gently framing the heart. Try it with the model standing, laying down, sitting, and so forth. Position the hands closer together or farther apart from the heart. Just don't block it. Use your imagination and enjoy the process.

- **Goal:** To frame the heart by gently pointing the fingers in the heart's general direction.
- **HCS methods used:** Pointing and framing.
- **Execution:** Hands worked together. Both hands were posed. Fingers positioned with an inviting energy.

Figures 6.22 and 6.23: I thoroughly enjoy using the hands and fingers to put the final touches on this portrait. Hands are sensual and beautiful, and if posed right, they add a tremendous amount of meaning to any image. Posed wrong, and your photo will fail.

These two photographs are an example of how much the hands contribute to the feeling of a photograph. Notice how the fingers are gently pointing toward the lips. The position of the hands and fingertips evoke much of the emotion that you might feel when looking at this image. Unlike in Figure 6.20, I didn't use the model's fingers to frame the lips. This is pure pointing. You can see how powerful the pointing option of the HCS can be.

- **Goal:** To evoke emotion and bring attention to the model's lips.
- **HCS methods used:** Pointing.
- **Execution:** Hands worked together. Only one hand was posed. Fingers positioned with an inviting energy.

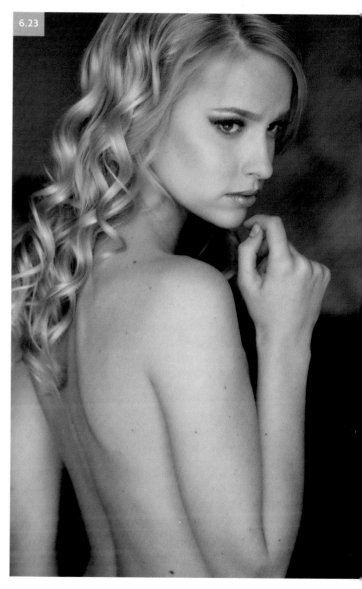

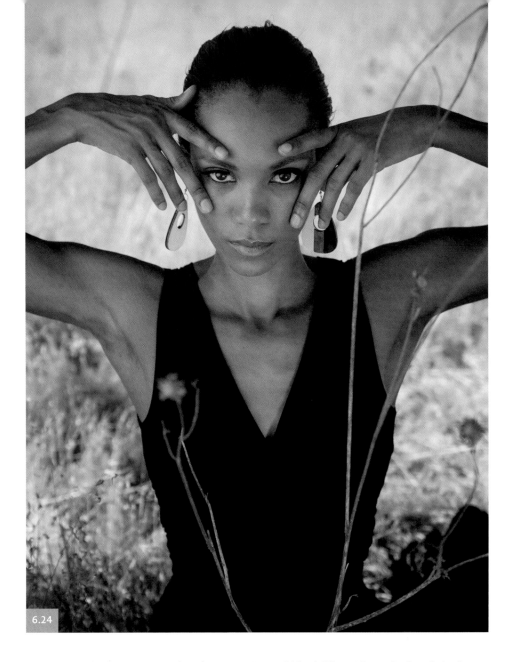

6.24

Figure 6.24: Try to imagine what this portrait would look like without the hands in the frame. You probably would notice her dress and earrings, as well as her beautiful eyes. Now, turn your attention to the image as is. You immediately looked straight at her eyes, right? You can't help it, because she is framing and pointing directly at them. The makeup artist, Tony, did a great job with the smoky eye makeup, so I wanted to feature them and call all your attention to her eyes. As photographers, we decide where the viewer's attention will go. Be selective and execute that vision.

- **Goal:** To bring most of the viewer's attention to Tiffany's eyes.
- **HCS methods used:** Pointing and framing.
- **Execution:** Hands worked together. Both hands were posed. Fingers positioned with an inviting energy.

5. Connecting

Touching is the act of connecting. When you gently touch another person's shoulder, you are connecting with that person. Connecting through touch is one of the most primitive and instinctive human interactions. It is the way we bond with others.

When looking at a group photo where everyone is connected to each other through touch, you will inadvertently feel a sense of strong camaraderie between them. The tool of choice to show human connection through touch is… you guessed it, the hands and arms.

In many cases, a connection between men is made with the arms. One great aspect of touch is that it can be effective between, for example, two guys, two friends, father and daughter, siblings, lovers, etc. In other words, if connecting people through photography is what you want to do, then touch can be used to connect anyone who is in front of your camera, regardless of the relationship between them. Connecting can also be done with an individual, but it is best suited for two or more people.

Figure 6.25: Few photos that I can think of portray the power of connection through touch better than this photo. Knowing how strong telling a story through touch can be, you will be more sensitive to these moments and compose the shot to focus the viewer's attention right on that connection.

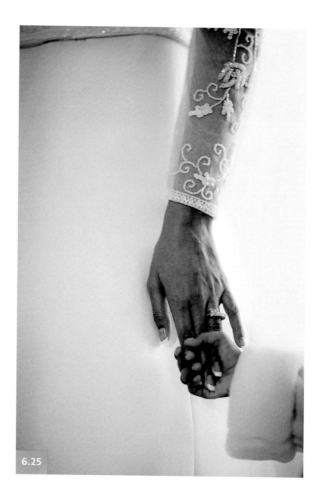

6.25

Remember what I said before. Know what you want to show and crop accordingly. Creative cropping is one of the most underused yet most powerful tools in your arsenal. Take a minute to study this photo.

Ask yourself what kind of bond you think these two people have. Judging only by the way the bride is touching the little girl's hand, what kind of person do you think this bride is? By going through the process of answering these questions, it will make you more aware of the variety of emotions different kinds of touch can communicate. The body language of the touch itself can give you many hints about the connection between the people involved.

- **Goal:** To show the connection between the bride and the flower girl through the use of touch.
- **HCS methods used:** Connecting through touch.
- **Execution:** Hands balanced each other. Only one hand was posed. Fingers positioned with an inviting energy.

6.26

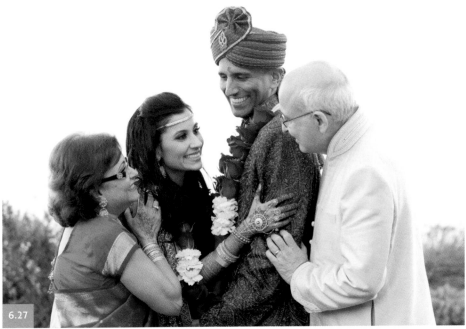

6.27

Figure 6.26: Here is a typical family photo during a wedding. It shows the faces of the people in the group, but that's as far it goes. This photo fails to communicate anything about their relationships. What's missing here? The hands! They are not engaged at all. There is no connection between them through touch. Most of their hands are just kept to themselves.

Compare this image with **Figure 6.27**. There's a world of difference! Every person here is connected to another by touch. You even get a sense of their personalities and relationship.

- **Goal:** To create a connection to each family member.
- **HCS methods used:** Connecting through touch.
- **Execution:** Hands balanced each other. Only one of their hands was posed. Fingers positioned with an inviting energy.

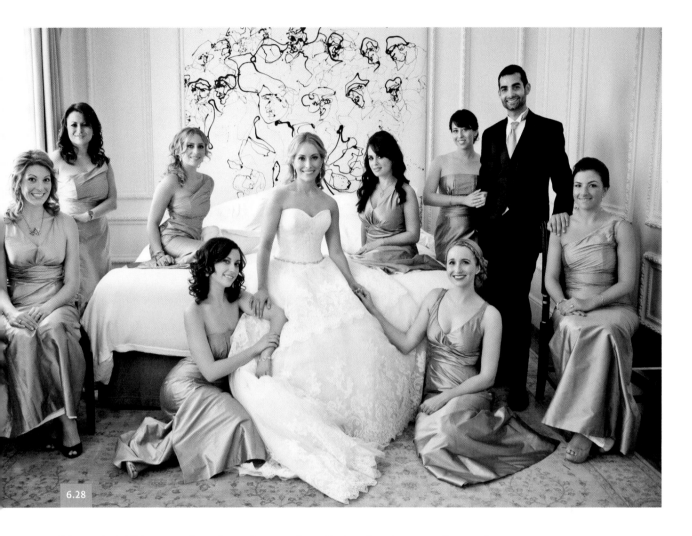

6.28

Figure 6.28: This group photo has to be one of my all-time favorite group shots and an example I use when teaching students how to create a connection between people in a group scenario. This technique of "connecting" is invaluable if you are a portrait or family photographer. Parents buy photos that show not only what the family looks like but also the connection between each of them.

For this example, notice how much friendship and love shows between the people who are connecting with others through touch. Notice the difference in perceived feeling in the places where connections are being made. For example, the bride's right hand is on the bridesmaid's arm, whereas her left hand is touching the other bridesmaid's hand. Notice how the woman on the right is creating the connection by wrapping her arms around the man's right arm, instead of holding his hand. Last but not least, look how the man in the photo is making the connection with the woman to his left by gently placing his left hand respectfully on her shoulder. Each of these different places where a connection is made tells a different story. With time, dedication, and practice, you will become an expert at what kinds of connections you want to create and how to achieve them.

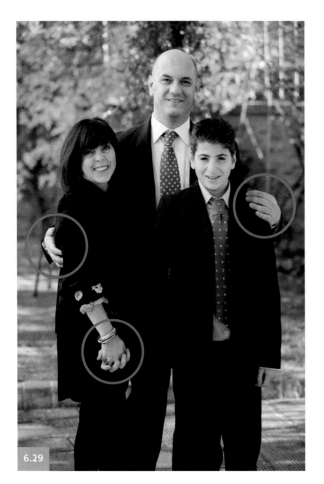

Figure 6.29: This is a family photo of Italian friends I had the pleasure of photographing in the old city of Cortona, Italy during my friend Kenny Kim's wedding. The portrait was taken very quickly, as we made our way to the car that would take us to the ceremony. Because it was a family portrait, I immediately chose Connecting as my HCS tool of choice. To make sure everyone had a connection to each other, I had Max (the father) stand in the middle and wrap one arm around his wife Cristiana and his other arm around his son Freddy. So far everything looked good, but there was no connection between Freddy and his mother Cristiana. I asked Freddy to hold his mom's hand to complete the circle and create an enduring connection.

SOMETHING TO THINK ABOUT

As mentioned at the beginning of this chapter, the Hand/Arm Context System was one of my biggest motivations for writing this book. After feeling the pain of numerous, frustrated photographers worldwide, including myself, about how to for once and for all tackle the concern of posing the hands and arms, I was extremely motivated to share with you the HCS idea that I created to help myself deal with this never-ending issue.

HCS gives you five ways to give the hands context and purpose so that the brain sees them as a complement to the image and not as a distraction. And there are only three execution concepts that you need to learn. That is a total of eight items to master, which surpasses trying to memorize thousands of hand and arm positions. The examples in this chapter are only a representation of hundreds of combinations available. But the good news is that all the combinations fall within the HCS.

I suggest that you take a closer took at fashion and portrait magazines. Notice the ads for such items as makeup, watches, clothing, and jewelry. For every photo you see in the magazine spreads, go through the HCS list in your head. Now that you have the HCS in place, it is up to you to create amazing photos using your own vision. Enjoy the learning journey, always keep pushing, and reap the benefits from knowing what you are doing instead of guessing and hoping.

ON YOUR OWN

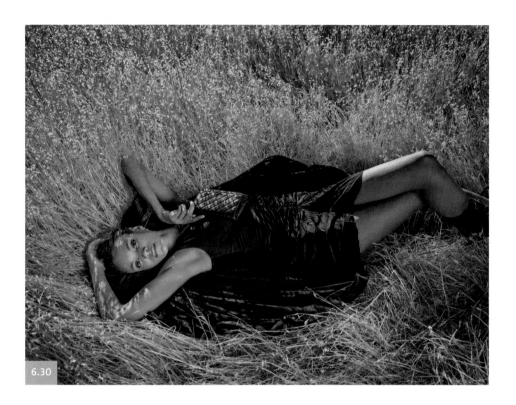

6.30

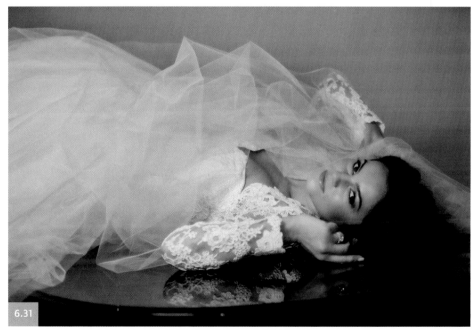

6.31

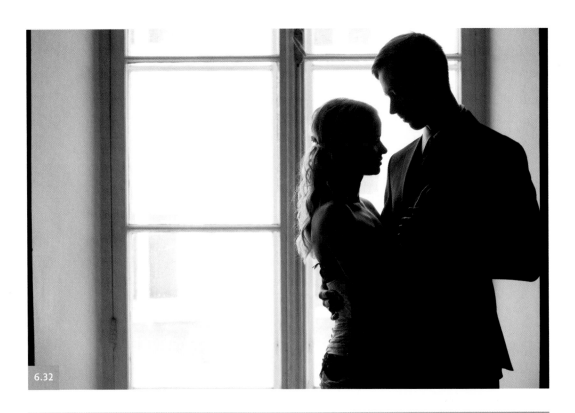

6.32

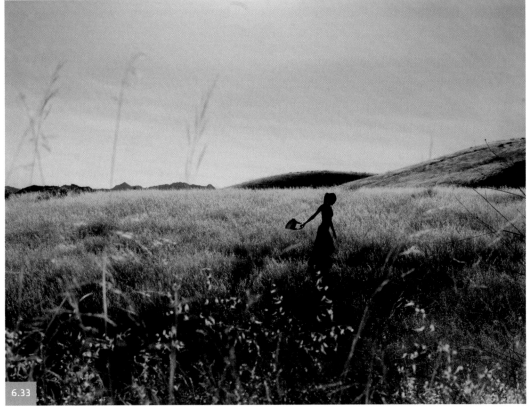

6.33

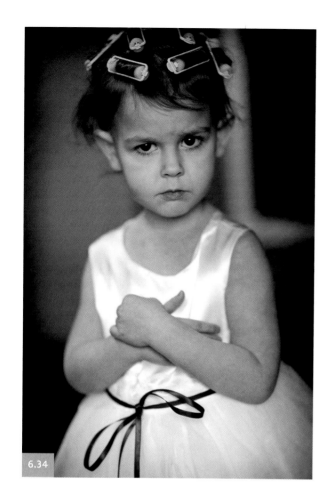

6.34

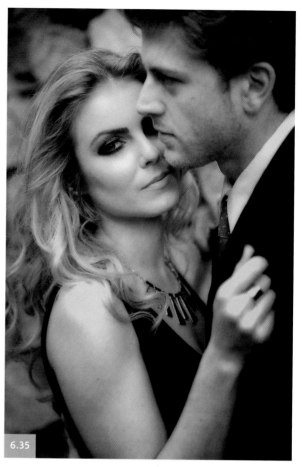

6.35

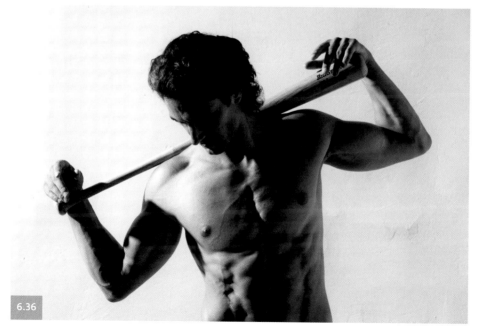

6.36

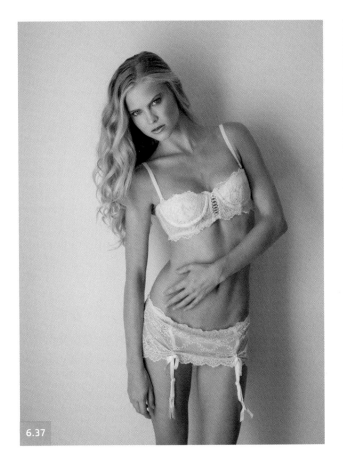

6.37

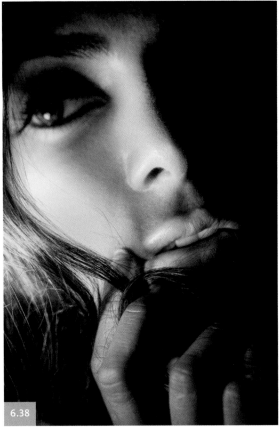

6.38

ANALYSIS

7

STYLIZING HANDS AND FINGERS: ADVANCED TECHNIQUES

IN THE PREVIOUS CHAPTER, we discussed giving the arms and hands context so that our brains do not see them as major diversions. This chapter will focus in depth on the positioning of the hands and fingers for both genders. I will suggest poses that make a woman's hand appear more feminine and a man's hand appear stronger and more masculine. Remember that these are suggestions and not rules. You can follow them, change them, or break them if the pose will benefit from your decision.

Fingers are such a small part of our body, yet in photography they can cause so much trouble. The simple reason is that fingers posed wrong create such a distraction that it will draw attention away from a subject's face. Fingers often force us to look at wherever they are pointing, and they also can tell the viewer whether the person in the photo is relaxed or stressed. Hands can also make an ordinary headshot into something quite special. **Figure 7.1** would not be such an impressive portrait if it weren't for the model's hands and fingers gracefully framing her face.

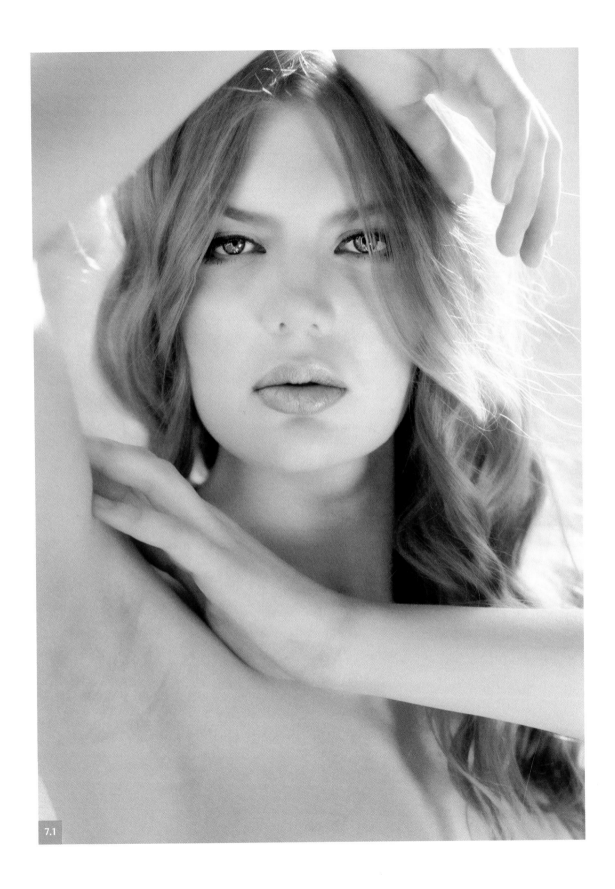

7.1

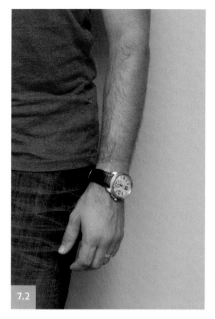 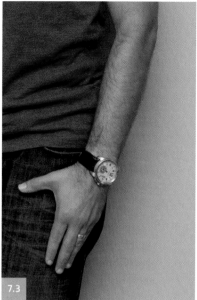 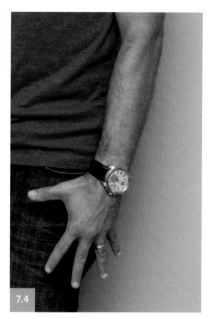

POSING MALE VS. FEMALE HANDS

Photographers need to take different approach when posing a woman's hands and a man's hands. The differences are subtle, but you should know them. The photos above show you some of the most common issues with hands for both men and women.

Figure 7.2: This shows the correct hand and thumb position. Notice that the gap between the tip of the thumb and the index finger is about one inch. Two inches apart is still reasonable, but any more and the width will begin to attract negative attention. The rest of the fingers are curved naturally and the whole hand appears relaxed.

Figure 7.3: The thumb is too far from the index finger. The angle between the thumb and the index finger is almost 90 degrees, which is never good. The fingers are rigid and tense.

Figure 7.4: Again, the thumb is too far from the index finger. The hand is completely tense. All the fingers are pointing in different directions, creating a distraction.

FEMALE HAND SUGGESTIONS

- Female hands should look elongated, graceful, and relaxed.
- Fingers visible to the camera should be shown from knuckle to fingertip and should be elegantly curved.
- All fingers should point in the same direction, with a subtle gap equally spaced between them.
- Wrists should not appear broken. Wrists should be either straight or naturally curved.
- Whenever possible, it is preferable that the side of the subject's hand face the camera.

7.5

When posing a woman's hand, try to avoid showing the back of the hand to the camera, especially if the female subject's fingers are not very visible. If the fingers are tucked into the hand, it will resemble a fist, which is not very feminine or graceful. Compare Figure 7.1 to **Figure 7.5**. The body language portrayed in these two images is poles apart. Notice that by showing the back of the hand to the camera and tucking in the fingers, the hand appears to be tough and masculine. This is clearly not recommended for women, although it could work in your favor if you are going for a masculine/powerful look. Because this was an editorial fashion shoot, the so-called "rules" were broken to force you to pay

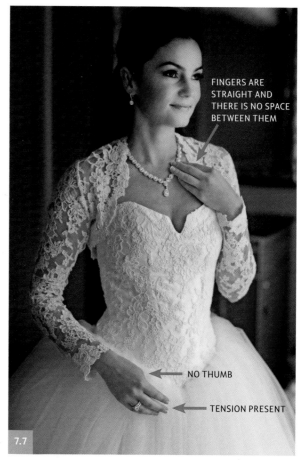

FINGERS ARE STRAIGHT AND THERE IS NO SPACE BETWEEN THEM

NO THUMB

TENSION PRESENT

7.6

7.7

attention to the photo. The position of the hands helps create anticipation, and since you can't see her face, the pose gives you no choice but to wonder what she looks like. Be aware that the smallest details will elevate your skill level from an amateur to a pro.

For example, turn your attention to **Figure 7.6.** Can you detect the problem? Take a minute to study the image and go through the list of the five suggestions for posing women's hands listed above. Here is the breakdown of this image: Her right hand is elongated, relaxed, and graceful. It is posed on its side and the fingers are perfectly curved. All the fingers are pointing in the same direction, and the hand does not have any visible tension.

Now, look at her left hand. The hand is caressing her hair, so it is posed with context, as described in the HCS in Chapter 6. But for this particular beauty portrait, the entire width of her left hand is visible. Notice how much more you stare at her left hand than her right hand, even though her right hand is next to her face. The issue can be easily fixed by slightly turning her hand counterclockwise so that her pinky finger is the first to show, or it is closest to the camera. Go through this process often with your photos. It will greatly help you become aware of the little things while you are still shooting.

Figure 7.7 violates many of the five posing suggestions. The right hand looks tense, and although the thumb should be visible, it is not. When a finger should be visible and it isn't there, it is a major irritation, because the viewer is trying to figure out where that finger

7.8

went. The fingers of her right hand are not elegantly curved; in fact, they are straight and rigid. The thumb also does not show on the right hand, and there are no subtle gaps between the fingers.

In the likely event that the woman's hands are holding something to give them context, the five suggestions can still be followed. Naturally, the object that the woman is holding should be light enough so that it doesn't cause visible tension in the fingers, since holding something creates the potential for a lot of problems, such as awkwardly bent fingers. Go through the list while you are posing your subject. Eventually, this list will become second nature and you will be doing it without even thinking about it.

Figure 7.8 is an example of how hands holding something are correctly posed. At first glance, the first thing you might notice is how elegant the portrait is. The pose, from the body, head, expression, hips, arms, and hands, appears effortless, and nothing breaks that harmony. As I was posing the bride for this portrait, I knew that the wrists were going to be my greatest potential issue.

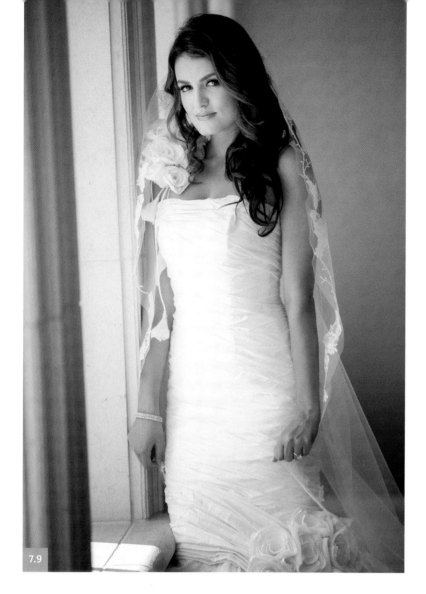

7.9

I took great care that she hold the veil delicately, paying close attention to each and every finger. I adjusted her wrists so that they would be bent just enough to keep her arm continuous. Bent any farther, and the wrist would violate suggestion No. 4, that the wrists should not appear broken. Now that you have seen an example of a correctly posed hand holding something, let's look at a similar photo in which the hand was posed incorrectly.

In **Figure 7.9,** the hand breaks the flow of the image. The fingers holding the veil are posed similarly to Figure 7.8, but this time the fingers are curved inward too much, creating the shape of a fist. Also, the wrist was bent upward past the point of comfort. Try bending your wrist this way, and you will quickly find out how much effort it requires.

One way to have the hands hold something skillfully is to have the model pinch it with the thumb and middle finger, and let the other fingers relax. Although the thumb is doing the pinching, the joints will still be gracefully curved. This technique works well when holding a dress or a veil. It is unfortunate how a simple oversight with the hands can completely destroy the flow of an otherwise beautiful photograph.

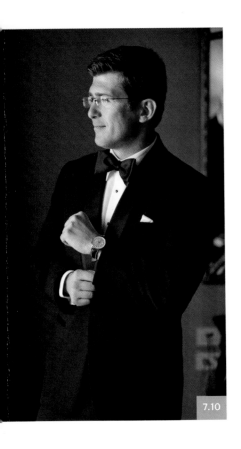

7.10

MALE HAND SUGGESTIONS

- A man's hand should appear wide, strong, and relaxed. See Figure 7.2.
- Having the back of the hand face the camera is preferable, but the hand seen from the side also works well. See Figure 7.2.
- Fingers can be curved more than a woman's hand, and even making a relaxed fist is acceptable. See Figure 7.2.
- Fingers should all be pointing in the same direction, or it will create a distraction. See Figure 7.4.
- A small gap (similar in size between fingers) or no gap at all is acceptable for men. See Figure 7.2.
- When not holding onto an object, the thumb should not be more than three inches from the index finger to avoid approaching a distracting 90-degree angle between the thumb and index finger. See Figure 7.3.

When posing men's hands, you can take more liberties than when posing women's hands. Men's hands, for example, can be made into a fist and face the camera, as you can see in **Figure 7.10.** This will show strength and will make the hand broad, which is desirable. However, the hands should always be relaxed. No tension should be detected in any finger, even when a hand is making a fist. A common issue you will find when posing men is the likelihood of spreading their fingers too far apart. Be aware of this so you can correct it when you see it, and trust me, you will see it.

Hand in the Pockets

The most common way to pose a man's hand is to simply ask him to put it in his pocket. When I entered photography competitions such as the Wedding and Portrait Photographers International (WPPI) 16x20 print competition held in Las Vegas every year, judges would keep pointing out the displacement of my subject's fingers. I quickly made the decision that I would take more time and effort to know exactly how I would pose the hands and fingers.

I remembered asking my clients if they would just put their hand in their pocket. Then, I realized that I was not being specific enough in my instructions. Most men have a tendency to put four fingers in the pocket with the thumb hanging outside. Although the viewer can assume that the reason why he/she doesn't see the fingers is because they are inside the pocket, the very fact that the brain has to question the pose makes it a distraction. Leaving just the one finger outside the pocket looks very strange, as **Figure 7.11** shows.

In my opinion, the best way to handle this situation is to simply put the whole hand in the pocket, as shown in **Figure 7.12.** Putting all the fingers, including the thumb, inside the pocket minimizes the risk of a finger peeking out. **Figure 7.13** is a prime example of the improvement we see when placing the whole hand in the pocket. The black tuxedo jacket would create a high-contrast background for any fingers popping out of the pocket, so this photo required specific directions on how to pose both hands.

I encourage you to do the same. Don't be complacent about giving general directions and hoping it all works out. If you take the time to learn the material in this chapter and carefully implement the suggested poses, you will substantially increase the number of great photographs that you take.

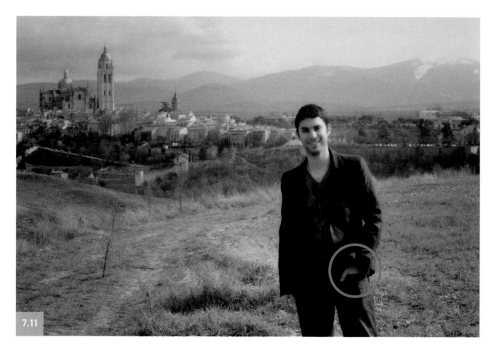

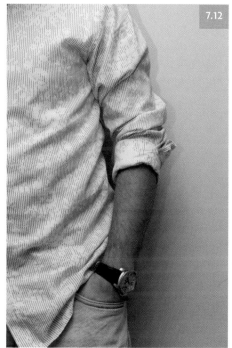

7.14

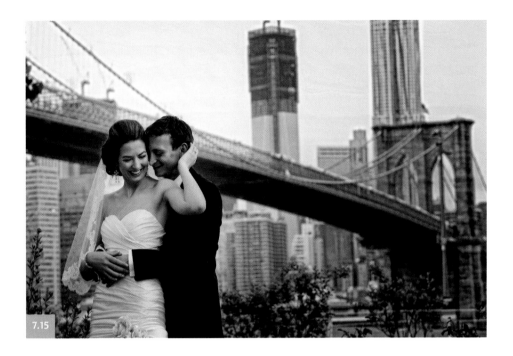

7.15

POSING COUPLES' HANDS AND FINGERS

It is imperative that, as photographers, we arrange the hands and fingers of couples correctly. Posing couples is about capturing a personal connection between them. The photo is a candid moment that tells a story and speaks to the viewer about who they are.

Let's begin by looking at **Figure 7.14**, a photo in which the hands are posed correctly. If you recall my earlier suggestions on how pose the hands, you will quickly see why this photo works. The serene, quiet moment the couple is experiencing is intact, even though all of their hands and fingers are showing. The woman's hand is elongated, and there is a subtle gap between each finger. Their thumbs are close to the index fingers, and the couple's fingers are all pointing in the same direction. Most importantly, there is zero tension present in both of their hands.

FINGERS PILED ON TOP OF EACH OTHER

If you decide to pose a couple, and one person is behind the other, it is most likely that the couple will put their hands together. If this happens, you must make sure that you cannot see every finger. They will form a cluster, and your brain will be distracted trying to count all the fingers that are mingled together. To avoid this issue, use one hand to cover the fingers of the other.

In **Figure 7.15**, although the couple's hands are on top of each other, I placed the bride's hand in such a way that it blocks almost all of the groom's fingers from view. Now that you see the bride's hand and very little of the groom's hand, the viewer's attention focuses on their facial expressions. Let's see what happens if you forget to block the other person's fingers.

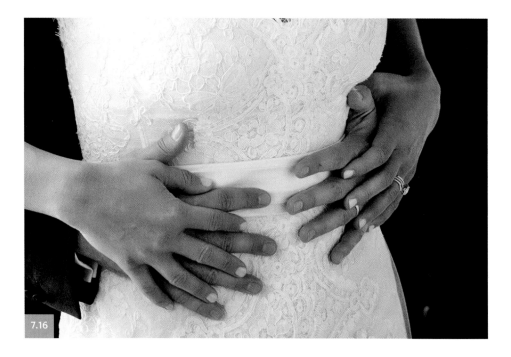

Figure 7.16 is the worst-case scenario. One person's fingers are actually in between the other's. The gap between each finger also is too wide. Be sure to keep this in mind the next time you are working with a couple. Take your time to see every aspect of the pose before you push the shutter button.

HOLDING HANDS

As I mentioned in the previous section, when one person's fingers are next to the other person's fingers in a photo, it's quite distracting. Yet when a couple is holding hands, it is more than likely that they will interlock fingers.

Gripping the hand is another common problem when a couple holds hands. To keep the hands looking soft, the photographer must make sure that they are together, without any interlocking or gripping. The best way to determine whether the hands are well posed is if one person moves gently away from the other, their hands should come apart effortlessly. Any gripping or interlocking will create some tension, and the hands will not come apart as easily as they should.

Figure 7.17 is an example of the fingers interlocking. Notice how the fingertips of each person are curved until they touch the back of the other's hand; particularly notice the groom's thumb. If this happens, it should be a red flag for the photographer. In this scenario, not only are there interlocking fingers but gripping as well. If you were to separate the couple gently, the tension in their interlocked fingers would prevent them from smoothly breaking apart.

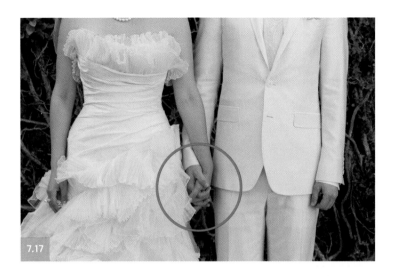

7.17

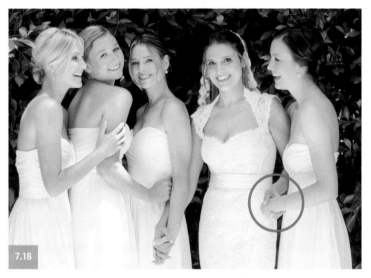

7.18

Gripping can be easily detected in **Figure 7.18**. Notice the callout. The bride's fingers and thumb are actually wrapped around the bridesmaid's arm. At this point you are probably asking yourself, "So, why did Roberto take this photo?" I took the photo because, in my opinion, the candid expressions on all the bridesmaids' faces trump perfection in the hands and arms.

Imagine that I had made the bridesmaids laugh and look beautiful, as they do in this photo, and then, I had them stop laughing and reset the whole pose because I noticed an imperfection in the fingers. Photographers must be aware of these posing issues so we notice and fix them, if we can. But we should never let perfectionism about these little details prevent us from doing our job. It's a balance! Capturing a great moment or a priceless expression is more important than anything else.

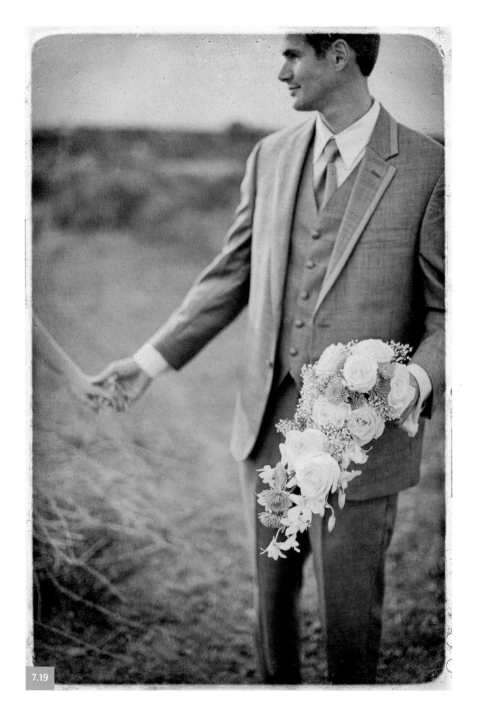

7.19

A proper hand-holding position can be seen in **Figure 7.19**. Notice how tenderly and gracefully the couple is holding hands. There is no trace of tension in any of their fingers. There is no gripping, because the fingers are not wrapped around the other person's hand. The groom's thumb cannot complete the grip, because his thumb is placed gently on the center of the back of her hand, nowhere near his other fingers. Compare Figure 7.19 to the strong grip in **Figure 7.20**. You can see now how much tension is evident in their hands.

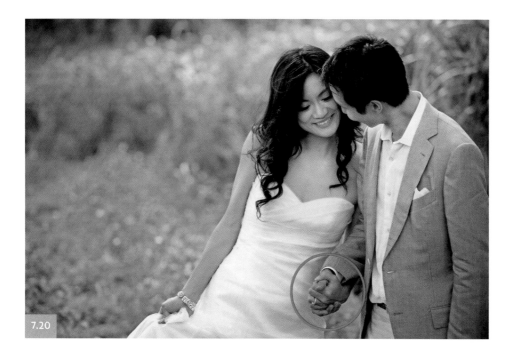

7.20

USING THE HANDS TO BLOCK A DOUBLE CHIN

For anyone, it can be dreadfully embarrassing to be seen in a photograph with a double chin. Nobody wants that, yet many of us do have a double chin. When photographing a single person, we can hide a double chin by raising his/her chin a little, shooting from a higher angle, and using a long lens to compress the face.

But when photographing a couple, we cannot always use those techniques. This is when the hands and fingers become important. We can use a woman's caress as a disguise to hide a person's double chin. But it must be done correctly, or it will backfire. Hands draw attention to themselves, so when using this disguise technique, keep in mind that the hand should be placed right under the chin with the fingers pointing toward the neck or the ears, preferably the ears. Also remember these tips:

- Follow all the finger-posing suggestions listed at the beginning of this chapter to avoid bringing unwanted attention to hands.
- The hand cannot be covering the man's face, and the fingers should not be spread too far apart.

Figure 7.21 is an example of the disguise technique done properly. Notice the woman's hand is in the perfect position to hide the man's chin without blocking his face, and it appears to be nothing more than an innocent caress. Her fingers are soft and spread just wide enough. Clearly, this man does not have a double chin, but if he did, this technique would conceal it in a very natural way.

Figure 7.22 is another example of this technique but with a very different pose. In this case, you can see how both hands are engaged in the pose. One hand is gently on top of his, welcoming his touch, and the other hand is caressing his face and naturally blocking

his chin. Although this pose is well done, it would have been slightly better if her hand on his face were a little farther down so that her fingers would be pointing to his ear and not the back of his neck.

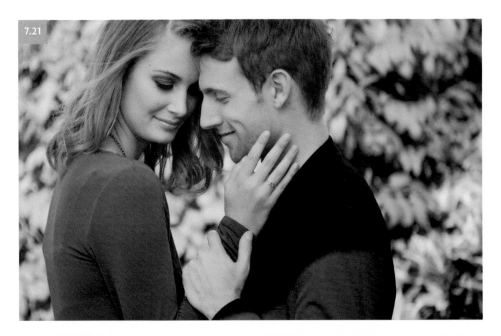

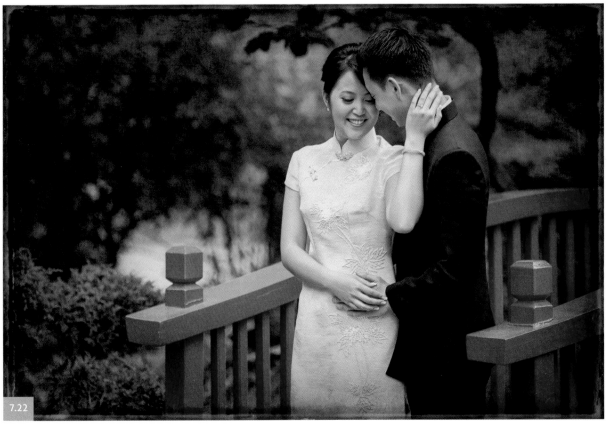

ON YOUR OWN

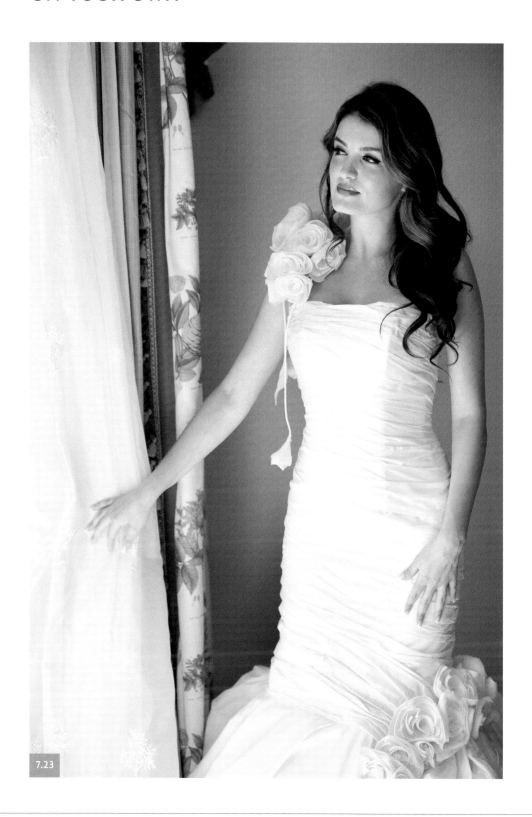

7.23

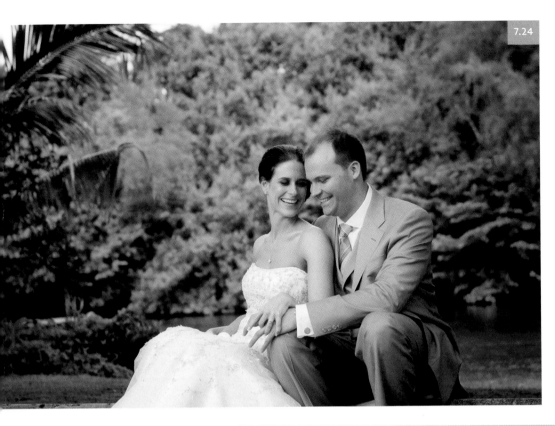

7.24

7.25

7.26

7.27

ANALYSIS

8

ORIGIN OF HANDS AND FINGERS

THIS CHAPTER WAS WRITTEN for those of you with a burning desire to fine-tune your images. We will be discussing the issue of what I like to call the "creepy hand." Whether you are an amateur or a professional photographer, a model, a bride, a mom, or a dad, we have all been inclined to place our hands around the shoulders or hips of others when posing for a photo. It seems like a perfectly normal reaction, and it is, but it looks aesthetically awkward in a photograph.

As a result of this action, you'll see random hands or fingers coming from different places with no clue as to their origin. To maximize the quality of your photograph, these distractions must be minimized, and, if possible, eliminated. Use this chapter to become aware of the "creepy hands" issue during photo shoots. It is a minor adjustment to make, but pushing yourself to be tidier and more aware of these small details will have a considerable impact on your work.

8.1

WHEN THE ORIGIN OF THE HANDS IS VISIBLE

Take a minute to study **Figure 8.1** carefully. Most likely, you are drawn to the active and joyous pose and to the facial expressions of the bride and groom. You might also notice the beautiful pattern of trees in the background, creating a perfect backdrop for the couple. There is probably one aspect of this photograph that you did not notice or pay any attention to: the hands.

The hands are clearly visible, but they all make sense. Each visible hand has context and a purpose for being there. Also, it is clear where each of the visible hands come from. There is absolutely no doubt that the arm picking up the veil is the bride's and the hand wrapped around the bride's waist is the groom's. Pretty much every aspect of posing the hands/arms and fingers covered in this book is well represented in this photograph. A well-executed arm/hand position does not attract unwanted attention. The hands, arms, and fingers are simply there. All the viewer's interest is on the couple and the composition of the photograph, as it should be.

Hands without clear origins can occur on either side of the subject's body: the side facing the camera and the side facing away from the camera. This chapter focuses primarily on the side of the subject's body facing away from the camera. That's the side where most of these problems originate.

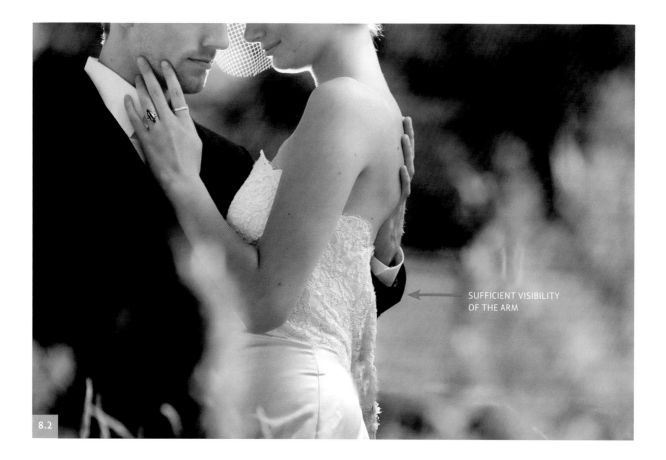

SUFFICIENT VISIBILITY
OF THE ARM

8.2

In Figure 8.1, the hands issue was handled very well. It is easy to see why the side of the body facing the camera is not a problem. You can quickly make the visual connection between the groom's right hand and his right arm. But the bride's right hand could have potentially wrapped too far around the groom's left shoulder, making her hand, but not her arm, visible to the camera. That would have introduced an unconnected hand coming out of his back. Definitely not ideal!

Fortunately, I spoke to the bride about this issue before I took the photo to prevent it from happening. Take a look at **Figure 8.2**. When I originally posed this couple, I saw the groom's hand, but his entire arm was hidden from the camera. His hand was all by itself, without a clear origin. To solve this issue, I simply asked the couple to rotate their bodies clockwise, until more of his arm was visible to the camera. That way, it was obvious that the hand on the bride's back belonged to the groom.

There's no need to show the whole arm; just show enough arm to make the connection between the hand and the arm. Remember, the brain is very picky. If something is "off" or it doesn't make sense, the brain instinctively tries to figure out the strange situation. Then all of the viewer's attention focuses on the problem, rather than on the people in the photograph.

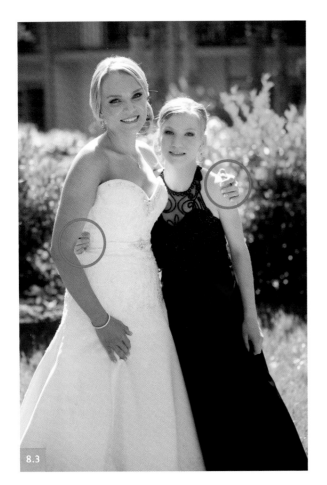

8.3

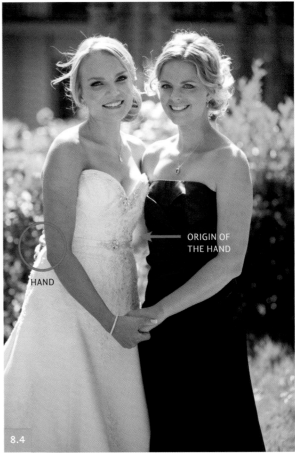

ORIGIN OF
THE HAND

HAND

8.4

HANDS PLACED ACROSS ANOTHER PERSON ON THE SIDE AWAY FROM THE CAMERA

The problem of hands without clear origins is so common in photography that we must be constantly diligent to avoid it. It is human nature to wrap one's arms around loved ones. So let it happen—but make the necessary adjustments to ensure that it looks natural. And just keep in mind that when a couple is hugging that there will be cases where, depending on the photographer's angle, there will inevitably be one hand without a clear origin. This will be discussed in Chapter 9. For now, let's take a look at two images. One image has the "no origin" problem, and the other illustrates how to solve the issue.

First the problem image (**Figure 8.3**). The embrace between the bride and her niece is candid and real. But this does not mean that you should ignore the issue with the hands. Both the bride's hand and the niece's hand have no visible origin, because their own bodies are blocking their arms from view. We need to see at least a portion of both arms to make sense of the hands. In a situation like this, the solution is to simply move the hands just enough so that they are completely blocked from the camera's view.

The other solution (**Figure 8.4**) to this problem is to create a gap between their bodies just wide enough to show a portion of the arm of the hand in question. In this example, I made a small adjustment to their pose to obtain a clear view of the bridesmaid's arm. I know this sounds strange, but now the hand wrapped around the bride has an arm attached to it. It makes sense, so our brains do not see it as a red flag, and we can focus on the relationship of these two women portrayed in the photograph.

When done properly, the results can be very pleasing to the eye. Keep this in mind when photographing anyone, from two people to a family portrait. Notice in **Figure 8.5** how only the hands on the side facing the camera are visible to the viewer. All the other hands are neatly tucked away. Imagine that the woman on the right had put her right hand over her dad's shoulder farthest from the camera (his right shoulder). That would have introduced a hand where there should be only faces. It would, in my opinion, ruin the portrait.

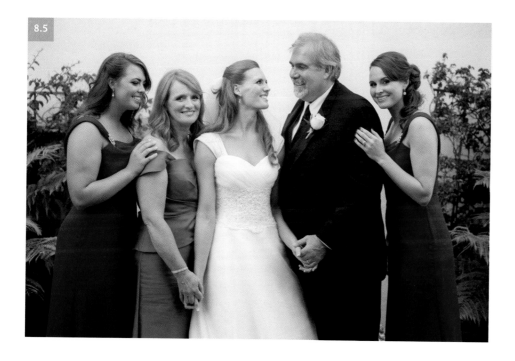
8.5

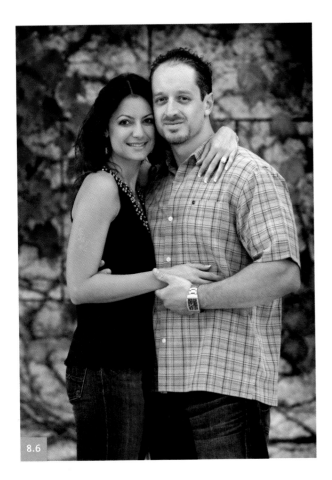

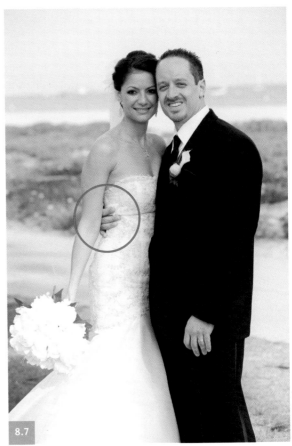

Figure 8.6 further illustrates how distracting the hand over the shoulder can be. There is not enough separation between the couple or enough contrast between her left arm and the wall to make sense of her left hand randomly appearing over his shoulder. In fact, even the groom's right-hand fingers should have been completely tucked behind her arm.

Figure 8.7 has the same issue as Figure 8.3. I am showing you this photo to emphasize how frequently this issue occurs. Whether your subjects are children or adults, expect them to put their hands over people's shoulders or across waistlines with the fingers seeming to appear from nowhere.

Okay, so now you are probably wondering how you're supposed to capture a great photograph without getting bogged down in the details of the pose. My approach has always been the same: a good moment or expression always trumps posing perfection. However, the more we are aware of these little mishaps, the better chance we have of doing something about them. The issue of the creepy hands should not be ignored. If you are on vacation and you ask a stranger to take a photo of you and your spouse, you probably will appreciate and use this chapter's techniques to improve the photo. After all, the stranger's not going to tell you to hide your hands behind your spouse. And at your next shoot, be aware of creepy fingers and do something about it. Your photos will look better!

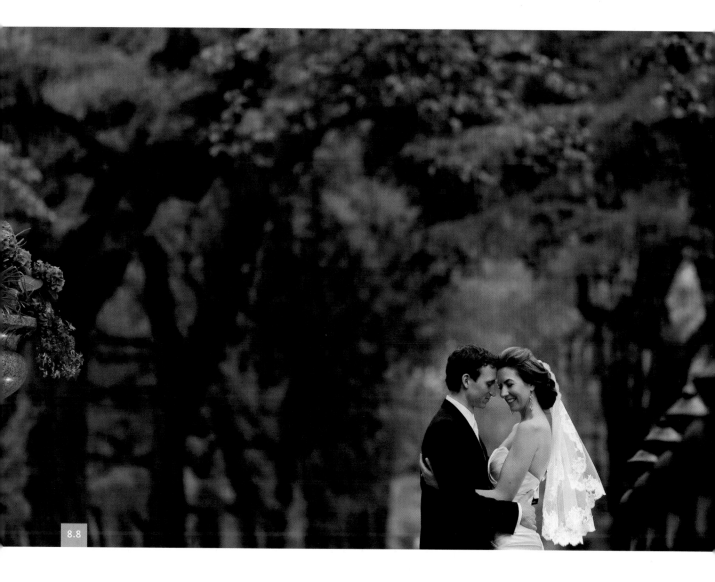

8.8

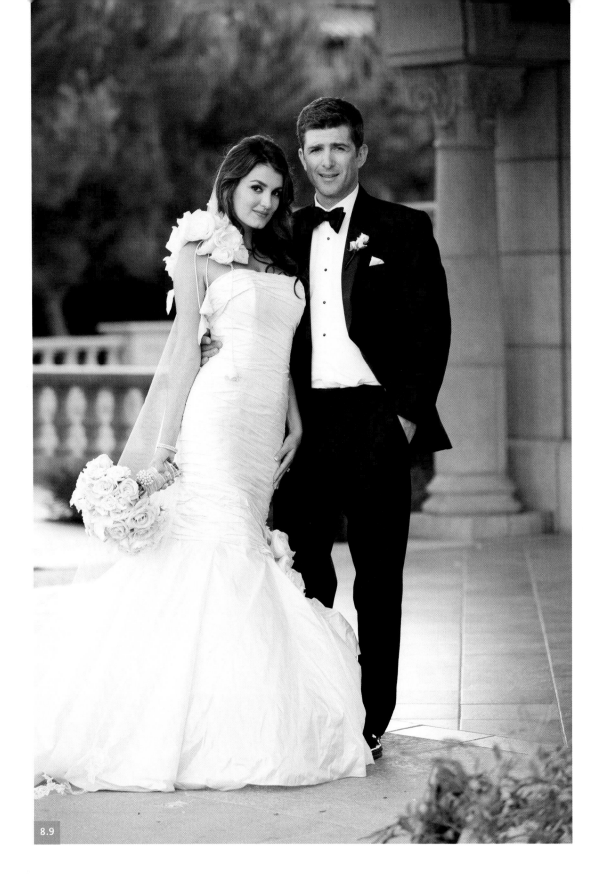

8.9

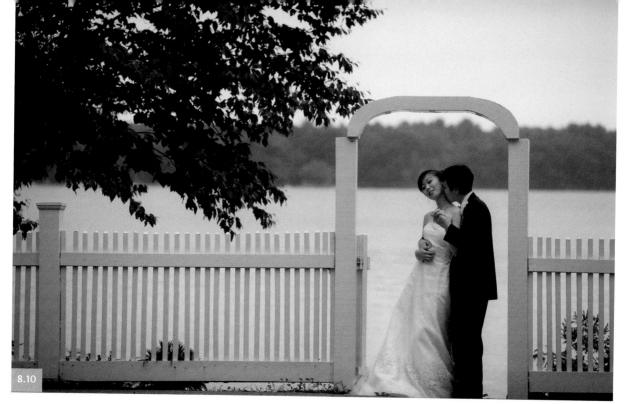

8.10

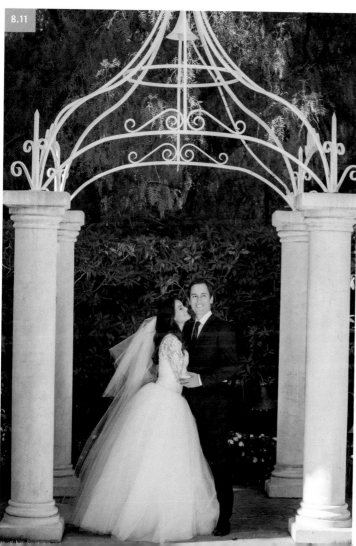

8.11

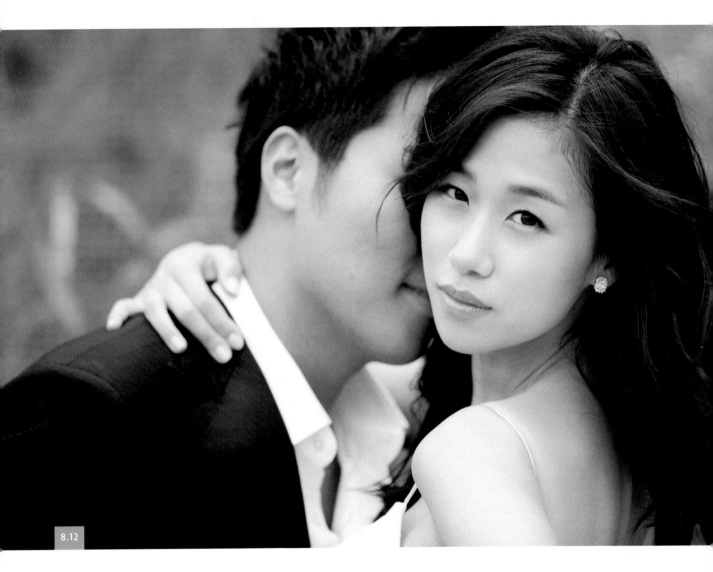

8.12

ANALYSIS

9

AVOID MIRRORING

THE PHOTOS THAT APPEAR the most natural and believable are ones in which one of the subject's hands or feet is posed higher than the other. In other words, the arms or feet are *not* "mirroring" each other. Chapter 6 discusses how a hand has the power to attract the viewer's attention more than most other parts of the body. If this happens with just one hand, imagine both hands working together.

The purpose of this chapter is to fine-tune the position of hands when they are posed near the same part of the body. For example, if your subject has his/her hands near the face, consider placing one hand higher than the other. In most cases, if you place your subject's hands around his/her face and the hands are at the same height, the viewer will focus on the hands rather than the face. You can use the same technique when posing a man and woman hugging, since they'll tend to rest their hands on their torsos. By being aware of these issues, you can make more informed decisions when posing hands.

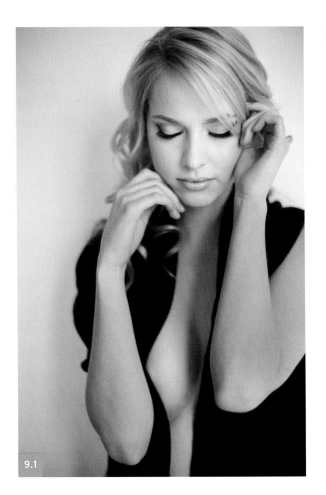

9.1

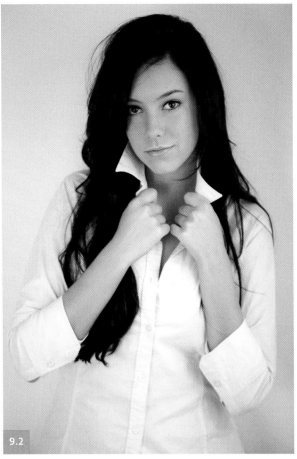

9.2

ONE HAND HIGHER THAN THE OTHER WITH INDIVIDUALS

In Chapter 6 we discussed framing as a way to give the hands context. But to create a graceful or elegant frame around the face, we must position the hands at slightly different heights. To compare, take a look at **Figure 9.1**. We've already discussed the finger positions, so let's just focus on the vertical positions of the hands framing her face. Imagine her right hand (the lower one) at ear level, like the other hand. Not to sound harsh, but it would look a bit like Dumbo ears, right? This is why it's worthwhile to consider lowering one hand or raising the other. It still creates a frame, but one that's more visually appealing.

When both hands are at the same level, it gives a very different feel to the photograph. Most of the time, it appears as if the subject was just following directions from the photographer. To demonstrate this point, in **Figure 9.2** I had the model place her hands at the same level near her neck. The pose appears forced, and the hands bring unwanted

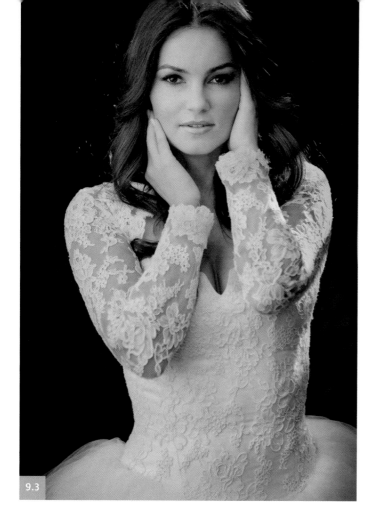

9.3

attention to her neck instead of her face. Even worse, the model is expending so much energy posing that it cheapens the photograph.

Figure 9.3 is an example of this technique applied to a bridal portrait taken at the Beverly Hills Hotel. As I said earlier, the posing techniques discussed in this book are equally effective with all types of people photography. The technique here is no different.

I lowered the bride's right hand to give the image the elegance it deserves. Had I lowered her left hand down to her lips like the other hand, it would now be a photo featuring her lips and not her. By posing one hand higher than the other, it balances the frame around her whole face, rather than just her mouth, ears, or eyes.

Study **Figure 9.4.** This photo was taken for the designers of the TV show "Project Runway," so the emphasis had to be on the model's clothing. Notice how the model's right hand brings attention to the design of the shirt, and his left hand is resting candidly on his leg about 8 inches lower than his right hand. This combination of hand positions creates three main points of interest: his cropped face, the designer shirt, and finally his jeans. The points of interest are spread vertically through the frame, giving the photograph balance.

Just to demonstrate the influence hands have on our attention, I created a quick composite of the same image. I cloned his right hand and moved it to the same level to create a quick composite (**Figure 9.5**). How did you react to this image compared to Figure 9.4?

Did you look down at his stomach, as I did, and wonder if he has a stomachache? I know it sounds a bit comical, but that was my instinctive reaction. That's precisely how I would hold my stomach if it hurt. I was so concerned about his "pain," I forgot to notice the shirt. It is remarkable how much the energy of a photo changes with such a minute adjustment.

ONE HAND HIGHER THAN THE OTHER WITH COUPLES (MIRRORING)

Now that we've established how much impact different hand positions can make, let's explore this idea when posing couples.

9.6

9.7

ELBOWS NEAR THE SHOULDER

With individuals, this technique creates a better spread of the photo's points of interest. With couples, having one hand higher than the other will make a hug or an embrace look believable, not posed.

When a person hugs a loved one, one hand is normally placed by the waist and the other by the upper back. Doing this allows you to feel more of that person. It feels more complete. But when a photographer asks a couple to hug, they shut down that intimate embrace and replace it with a more artificial hug.

Figure 9.6 is the result of hugging on cue. Notice that both of their arms are at the same level. Even though they are nice and tight and you can see that they love each other very much, the energy still feels as if they were asked to hug by a photographer. This photo also has other issues, such as the bride's elbow being the closest object to the camera. But for now, we are only focusing on the visual effect or feeling when the arms are at the same height. Something appears off.

Figure 9.7 appears much more harmonious. The difference, of course, is that both the bride and groom's hands are at different heights. By lowering the bride's left hand, we

9.8

cleaned up the image and lowered her elbow as well. Now you can see their faces clearly without an elbow in the way. More importantly, though, their embrace no longer appears to be an act for the camera. Instead, it feels as if they were having a moment alone, and a loved one saw them and respectfully interrupted their moment to take a quick photo. The embrace feels real.

ELBOWS NEAR THE STOMACH

The second most common position where couples put their hands when posing is with their arms mirroring each other in front of their stomachs. This issue was discussed earlier in the book, but for this chapter's purposes we will address it in greater depth. **Figure 9.8** showcases this exact action.

The couple's camera-side arms are at the same height, creating a barrier across their bodies. It also visually splits the upper body from the lower half. Neither of these two consequences looks appealing. You'll also notice that the groom's right hand is popping out of her lower back with no visual connection to his right arm.

To remedy these posing matters, I first moved them in front of a less distracting background. I then asked the groom to turn his body toward hers. I placed her hand over his left shoulder, making sure that her elbow faced the floor. Lastly, I repositioned the groom's left hand to gently rest on her waistline. With those corrections (**Figure 9.9**), I created three points of interest that balance the photo beautifully. The first point of interest is their faces (top and middle of the frame), the second is the bride's right hand (middle right of the frame), and the third is the groom's left hand (bottom left of the frame).

9.9

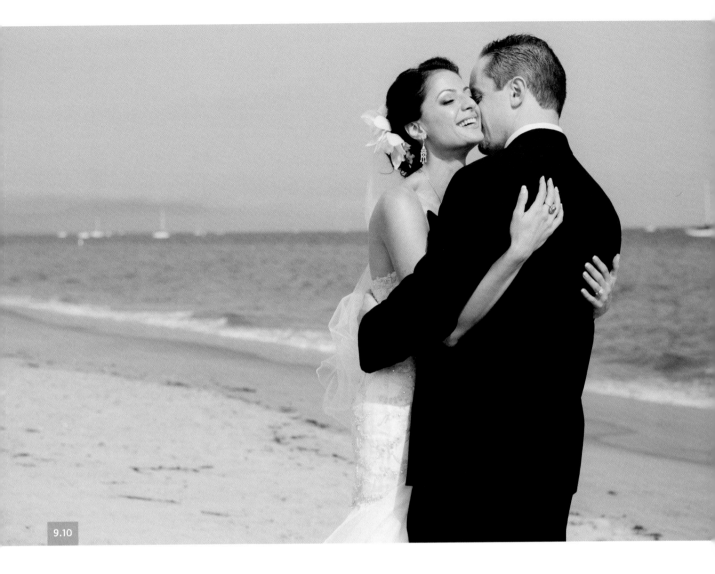

9.10

HUGGING

Hugging a person provides the perfect trap to fall into arm mirroring. If you simply hug someone with your arms at the same height, you wind up mirroring each other. For a more realistic hug, as shown in **Figure 9.10,** simply make sure that the visible hands are at different heights. That subtle difference is all that's needed to break the effect of mirroring. The only problem in this photograph is that the bride's left hand has no arm visually attached to it. In cases like this, I don't mind the floating hand. From many camera angles, there's no way around it. In my opinion, the advantages of having the bride's hands in different positions on the groom's back create a more romantic-looking hug and far outweigh the issue of the floating hand.

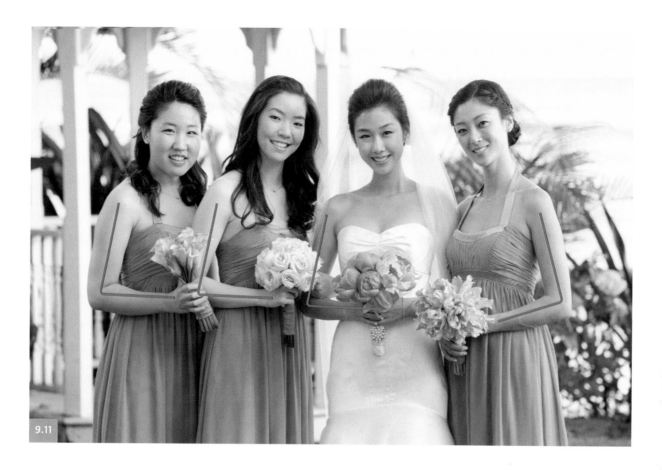

9.11

WHY YOU SHOULD AVOID MIRRORING IN GROUP PORTRAITS

The appeal of a variety of hand positions is most apparent in group photographs. From family portraits to wedding party photos, if you stay away from mirroring the hands and feet, your portraits will look more natural and spontaneous. In fashion photography, of course, you might deliberately call attention to the photo by mirroring every part of subjects' bodies. But aside from fashion or dance photography, you probably want to avoid mirroring.

Figure 9.11 clearly displays the effects of mirroring in a group setting. The women in this photo are all bending their arms at nearly the same angle. Even worse, that angle is 90 degrees. There is no denying that the photo appears staged. It is missing that spark that can elevate your work above that of other photographers.

The concept of mirroring does not apply just to feet, hands, and arms. It includes heads and torsos as well. Notice how all the bodies and heads of the guests face the same direction. Except for their faces, they are almost replicas of each other. The bride is the only person positioned a bit differently. Let's compare the photo to one with no mirroring.

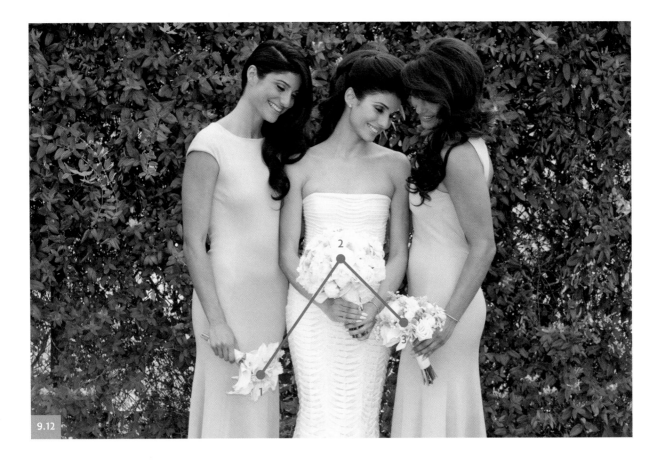

In **Figure 9.12**, I placed the flower arrangements at different heights and positioned each body at a different angle. I also posed the subjects' heads to point in different directions instead of looking straight at the camera. Lastly, I said something to make them react with a laugh or a candid smile. Even the way each is holding her bouquet is different. This photo has more heart to it, evokes more emotion, and tells you something about their relationships. Now that we have covered the benefits of avoiding mirroring in a small group, let's apply this technique to a larger group of people.

Figure 9.13 shows each individual from head to toe. So it was important to make sure that the feet, bodies, arms, hands, heads, and expressions were all different from one another. Hard work, but the results are well worth it. Naturally, issues surface with posing so many people, each reacting differently to what I said to coax a response. For example, there is a hand appearing out of the man's shoulder on the left side of the photo. Don't worry too much about posing perfection. With a photo as fun and unique as this one, no one is going to care much about that loose hand.

By being aware of the effects of mirroring or not mirroring parts of the body, you can push yourself to create something different—something people notice and are willing to pay for, such as **Figure 9.14.** If you do decide to mirror your subjects, at least you are doing it intentionally and not from lack of knowledge. That makes all the difference!

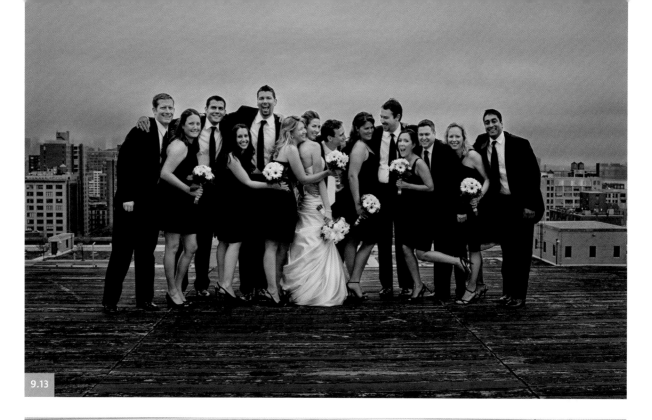

9.13

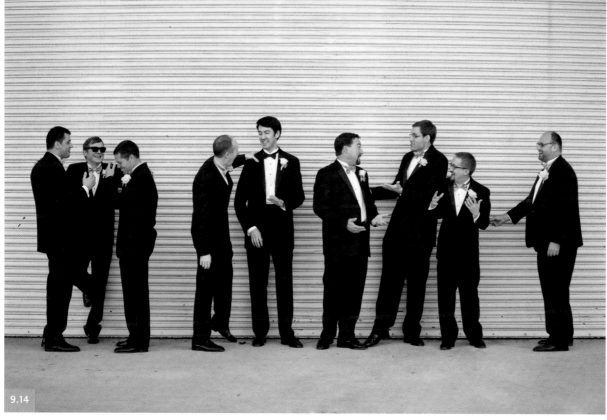

9.14

ON YOUR OWN

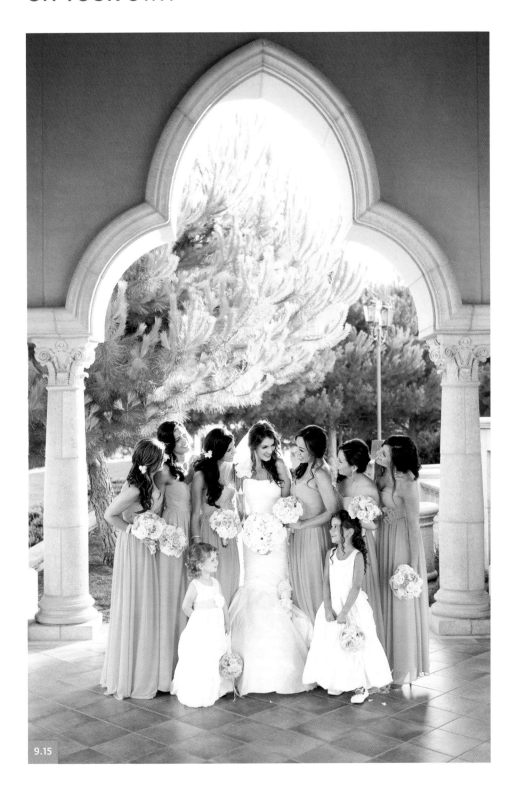

9.15

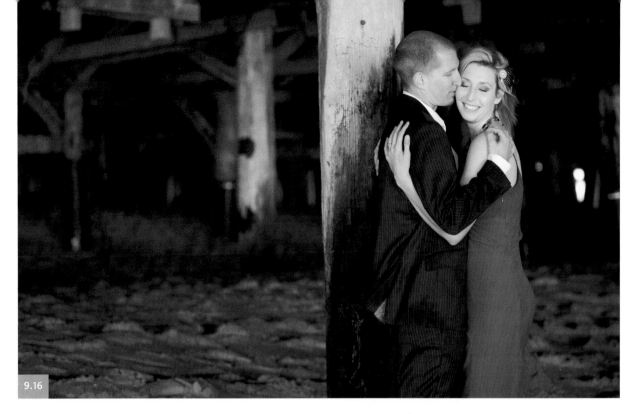

9.16

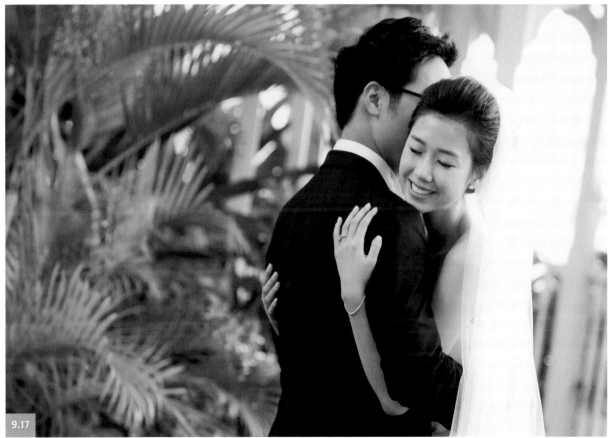

9.17

9.18

9.19

ANALYSIS

10

INTERACTION AND PLACEMENT OF SUBJECTS

THIS CHAPTER COVERS a topic that, to be honest, is difficult to explain. The reason is that photography is very subjective, and what makes sense to some people might not make sense to others. This chapter focuses on two related and subjective topics: where your subjects are placed within the frame and their interactions in that position.

I'll explain the reasons why I instantly reject a photograph or accept it as a truly captured moment. Feel free to agree or disagree. In fact, I challenge you to explore the images in detail and come up with your own opinions. I purposely chose photos for this chapter that I once considered good but now find quite embarrassing.

These photos were taken during my first year as a photographer, and I had no concept of what was believable with respect to how my subjects interacted with each other. By *believable*, I mean an interaction that, at first sight, you accept as natural or possible. The core of the interaction problem arises as soon as we create distance between people in a frame. When a couple holds each other, for example, we accept that as a hug, a kiss, or an embrace. But if the couple is not making physical contact, we can run into trouble in creating a believable interaction.

10.1

No one taught me how to bring harmony to the positions or interactions of my subjects within the frame. It took years of reflecting on my work, analyzing mainly foreign movies, and constant researching to realize what I was doing made no sense. Only then could I do something about it.

In the years I have served as a judge for photographic competitions worldwide, the interaction and placement of subjects plays a major part in my initial reaction to an image. Creating meaningful and believable interactions will also be the main reason why clients hire you over someone else, regardless of your rates or where you live. Let's dive in.

A FIRST LOOK AT THE IMPACT OF INTERACTION

Take a look at **Figure 10.1** and **Figure 10.2**. What was your first impression? Both photos involve a couple interacting, yet the two could not be further apart. In my opinion, Figure 10.1 draws you in where you feel and relate to the powerful moment between the couple. It also makes you wonder what is happening that would warrant such a strong response.

The other looks corny and simply not natural (Figure 10.2). The interaction appears to be a product of a photo shoot gone horribly wrong. From the artificial smiles to the way they are looking at each other, I failed as a photographer to create an authentic interaction between them.

10.2

In most cases when two people's faces are so close together that they are invading each other's personal space, it will look phony and awkward if both are looking into each other's eyes. To make it believable, one person only has to look away, usually downward. This is one of the reasons why Figure 10.2 looks so fake.

REACTING TO VARIATIONS ON PLACEMENT AND INTERACTION

During a photography assignment, I constantly gauge how the subjects in front of my camera are reacting to my directions. Then the day after the wedding or assignment, I study the photographs I've taken. The key to getting the most out of your photo study is to focus on only one aspect of your work. For example, many times I focus on the believability of the interactions. This way I can block out lighting, hands, fingers, spine, and so forth and ask my brain to concentrate on one area. Studying your images in this way makes it much easier for your brain to handle the job with precision. To demonstrate this, let's look at four images.

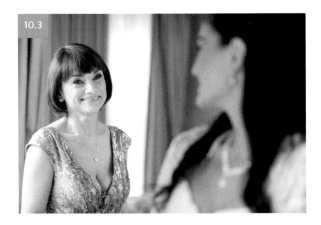

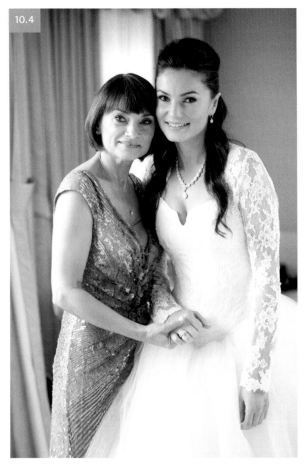

Figure 10.3: This photograph was inspired by movie filming techniques. It works by placing one person in the foreground (closer to the camera) and another in the background (farther from the camera). The person in the background is in focus, reacting to the person out of focus in the foreground. In this case, they are looking at each other. A more emotional technique would have the out-of-focus person *not* look at the in-focus person. That might create the feeling that the mother of the bride was reacting to how radiant her daughter looks and perhaps reminiscing about her daughter when she was a little girl. Whether one person is looking away or they are looking at each other, both interactions are believable and packed with storytelling qualities.

Figure 10.4: The purpose of this type of photo is to have a record of two people at an event together. In these photos, which we all take, both parties stand side by side and look straight at the camera. To bring more interaction to this type of photo, I placed the pair very close with their hands touching and their heads together. This brings some interaction to an otherwise standard, insignificant pose.

Figure 10.5: This photo illustrates the core message of this chapter. To bring more interaction between the bride and her mother, I asked the mother to close her eyes and gently lean her forehead on the side of her daughter's head and, once there, to breathe in. However, I asked the bride to continue looking at the camera. This was my mistake.

In an unposed interaction of this sort, the bride would not be looking at the camera. She would be connecting with her mother, not the photographer. If you take a second to study the image, you will probably agree with me that it's confusing. To understand the mismatch, take another look.

The mother is sharing her feelings, in an ordinarily private moment, with a photographer she has just met.

She is very vulnerable. Imagine yourself crying right now. If someone you had just met pointed a camera at your face, would you cry and look at the camera at the same time? I don't think so. Most likely, you would use your hand to cover your face. Nobody wants to feel so exposed, let alone be photographed. Though the mother is not crying in this photo, she is just as vulnerable. The bride would instinctively feel this powerful emotion from her mother and react in kind. Instead, the bride is not connected to her mother but to the photographer. That's the mismatch and why this interaction fails.

Figure 10.6: Feeling that disconnect in Figure 10.5, I quickly adjusted their interaction. I asked the bride to also lean her head gently toward her mother and close her eyes. Shutting down the sense of sight triggers the other senses to kick into overdrive and allows us to be more sensitive to our surroundings. This resulted in a candid and heartfelt smile from the bride, reciprocating the loving energy from her mother. That is precisely the art of interaction!

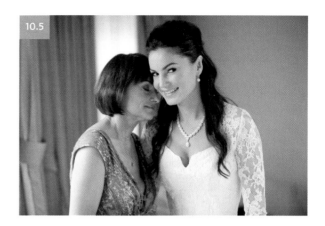

FLASH CARD

When a person in front of your camera is vulnerable and emotional, the other person in the photograph should be vulnerable as well. Otherwise, there will be a broken link in their connection. Emotions should match.

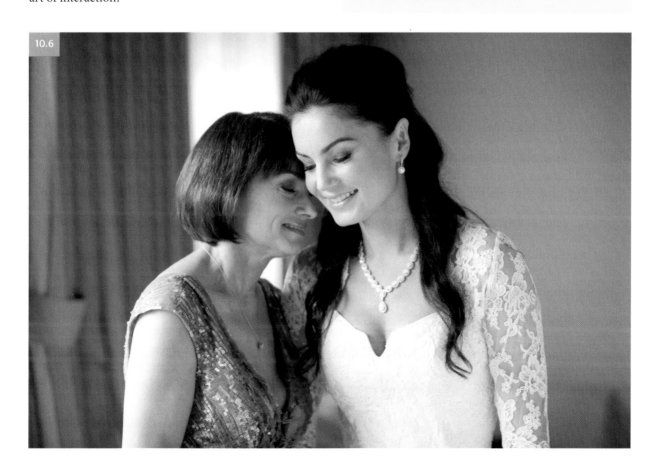

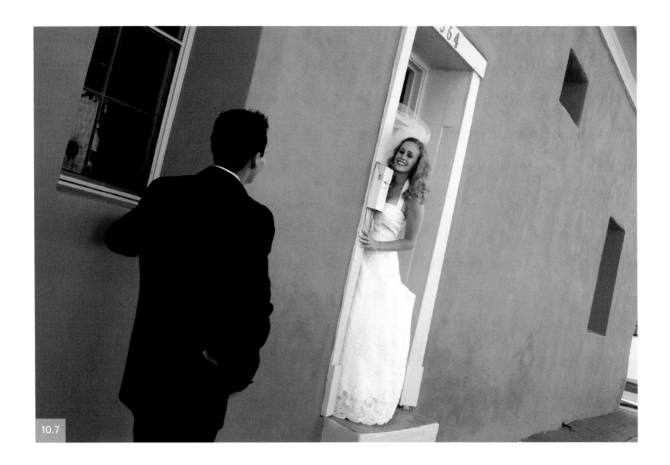

10.7

WHEN BOTH SUBJECT PLACEMENT
AND INTERACTION FAIL

There's no better way to see the importance of this topic than to show you some unfortunate photos I made for clients in my first year as a photographer. During that time, the thought of subject placement and interaction did not cross my mind. I was too busy posing and shouting out random ideas to stop and think about whether what I was doing made any sense.

As painful as it is to show you these photographs, I do so with the hope that you do not make the same mistakes. Let's walk through my thoughts and questions as I try to make sense of photos that failed in both interaction and subject placement. As you read my questions, try to answer them yourself. If your answers feel too far-fetched or even comical, then you will become more aware of the issues addressed in this chapter.

Figure 10.7: At first sight, the question that comes to mind is, "What's going on here, and why are they standing there?" My answer: I have no idea why they are standing there. It doesn't make sense.

In terms of the subject placement, perhaps the groom is having a casual chat with his bride. If that is the case, why is he so far away? Why not just go up to her and chat with her at a normal distance like anyone else? Why is she hiding behind the door? Again, I have no idea. Perhaps she is grounded by her parents and not allowed to go outside. No matter how hard I try to come up with a credible story about this particular subject placement, I fail. I could go on satirizing the photo, but you get the point.

A variation of this pose that I see again and again puts the groom in the background, usually 5 to 10 feet behind the bride with his arms crossed, checking her out while the bride is in the foreground looking at the camera. I am not sure why this pose caught on and became so popular, because the subject placement and interaction doesn't make any sense. If the bride and groom are married, why is he checking her out from a distance? That's just creepy. He should be right behind her, embracing her with his arms. Remember this is all subjective. So be aware of these scenarios and make sure that they work from a logical standpoint.

Figure 10.8: I understand the woman's placement in the frame. Her stance and body language suggest she's timid, maybe a bit insecure, and she is quietly admiring her boyfriend. But the man's position and, particularly, his interaction leave me almost speechless.

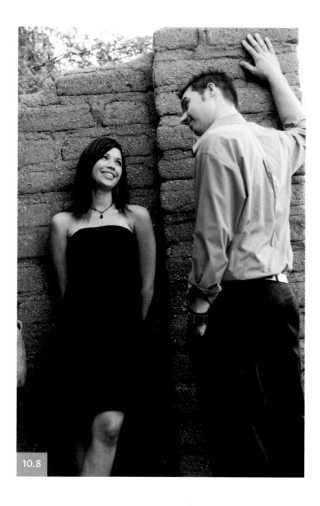

10.8

There's no scenario that I could play in my head that can make sense of his interaction with her. If they were having a conversation, why is his right hand up against the wall above his head? There is no reason or purpose for this. With equal weight on both feet, his stance is not as relaxed as hers. His facial expression is both silly and threatening. They seem to like each other, yet he appears to have no intention of making physical contact with her.

Judging by the lack of contact, the scenario that seems to make the most sense is they actually don't know each other. He sees her from a distance and decides to go up and talk to her. She is flattered at first but quickly becomes guarded. With his dominant and somewhat threatening stance, he is creeping her out. But she plays along with an artificial smile to get this awkward situation over with as soon as possible. Is that the story you want your photos to tell? I don't think so.

10.9

Figure 10.9: Photographing groomsmen in the middle of the road is not uncommon. But why on earth are they squatting like that? There's no reasonable explanation that would warrant normal people squatting in the middle of the road wearing tuxedos, unless nature called and there were no restrooms in sight. I am aware of how this sounds, but we must think about the interaction of our photo subjects and ask ourselves if a logical explanation exists for their placement and actions.

Figure 10.10: Take a look at this wedding party and make a quick comparison to Figure 10.9. This photo is meant to be a portrait of the most important friends in the groom's life. The portrait is casual, some men are out of focus, and they are all smiling. But take a closer look. The men are not just smiling, they are reacting in their own way to something that I said. The key words here are "in their own way." This means that their interactions are real. Now look at subject placement.

The men are scattered around, and they fill the frame nicely. That's because I told them where to stand. But the fact that they are scattered around at different angles, some with their hands in their pockets and some not, gives this subject placement a casual feel.

The story for this photo could play out like this: A group of men are hanging around having some good fun. Suddenly, the hired photographer interrupts their fun to take a quick casual portrait. The men pretty much stay where they were, except that they all crowd a bit closer together and turn to the camera. The photographer remarks about something he overhead them laughing about earlier, and the men react with laughter. The photographer takes the photo. Both the subject placement and interaction make complete sense, and the story is easy to understand.

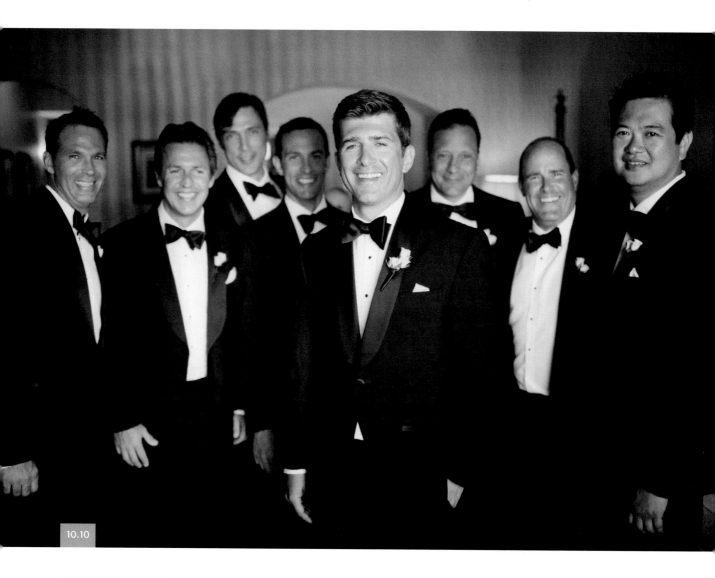

10.10

FLASH CARD

Here's how to handle an invasion of personal space during a pose: When individuals or a couple have their heads very close to each other, at least one of the people involved should turn his or her head away to make the pose look authentic and less awkward. Or you can exploit the awkwardness and wait for them to start laughing before taking a photo of their genuine expressions.

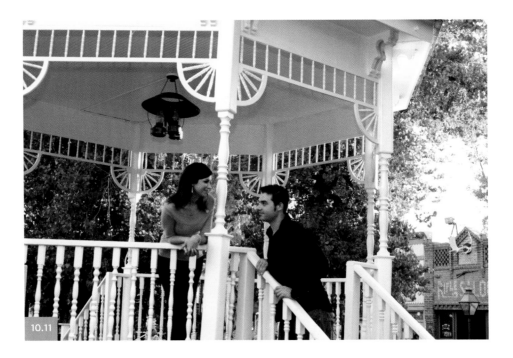

Figure 10.11: I picked this photo because it screams cliché. The gazebo, the poses, and their interaction are all corny. But it doesn't have to be that way. Despite the overused gazebo, this photo could be salvaged.

The woman's stance suggests that she has been there for a few minutes, and she has found a comfortable, relaxed position. But the man is only halfway up the gazebo steps. He suddenly stops, plants his hands on the railing, and just starts staring at her in an unsettling way. The fact that he is fixed at this midway point creates confusion from the viewer's point of view.

Perhaps he could be walking down the steps or up the steps toward her. Or he could be in the gazebo standing next to her, admiring the view while having a casual conversation. Any of these options would be better than what he's doing and prevent this awkward interaction. All I know is that it is unlikely that two people who love each other would stand and look at each other like this. It simply looks like the cheesy result of an inexperienced photographer trying to do something clever.

At the beginning of my career, I would ask couples with their heads close to each other to either kiss or to look at each other. That was it! The results were tacky images, such as Figure 10.2. If you forgot what that photo looks like, it is worth taking another look to refresh your memory.

I am not sure why it took me so long to realize this, but when two people's heads are so close to each other, it is unnatural for them to stare into the eyes of the other person. Most likely they will start laughing. In the years since, I've learned to use this reaction to my advantage to create an honest and candid interaction when a couple enters each other's personal space.

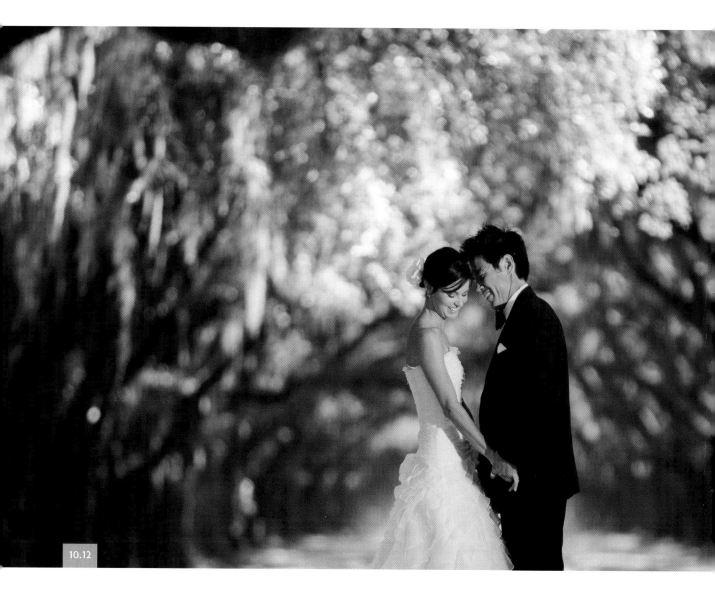

10.12

Figure 10.12: This photograph was taken of my friends Angie and Darin in the beautiful town of Savannah, Georgia. It feels real because she's turned her face away from his. Most people turn their heads and faces down, as they laugh at the awkwardness of the moment. There are two main ways to handle this situation.

Have one of them turn his/her head away and make them laugh, or have them get really close to each other and stare into each other's eyes. Don't push the shutter button yet. Wait for the awkwardness to get the better of them. When they react with genuine amusement, take the photo. The result will look like this.

STORYTELLING THROUGH SUBJECT PLACEMENT AND INTERACTION

Next, let's consider the photographic frame. We can pose people to the left, right, top, or bottom of the frame, and in the foreground or background. Individuals or groups should be joined together somehow, and their relative positions in the frame should be part of a story.

For example, imagine a photo in which a father is buying tickets for a county fair ride while looking to his right to keep an eye on his little daughter. The father is positioned in the background of the frame. In the foreground, you see his little girl holding a giant lollipop and staring with awe at the Ferris wheel. By the subject placement, we can conclude that the man is the father of the little girl and he is buying tickets to go on the Ferris wheel. The little girl is spellbound and ecstatic that she'll soon be riding it with her dad.

In this example, the subject placement tells one story. However, you can have two or three stories happening simultaneously in a frame, as long as they are connected. In fact, the connection linking all the stories together should be very clear. Viewers of the photograph should not have to stretch their imagination to figure out the link between the stories.

Unfortunately, I often see photos from fellow photographers in which there is a story in the background and an unrelated story happening in the foreground. The two stories are not harmonized, so the subject placement and interaction are disjointed.

Before you place someone in the foreground or background, ask yourself if your subject placement is helping to tell one cohesive story or is linking stories together. What is the connection between the story in the foreground and the story in the background? How are they interacting with each other within the frame? These kinds of questions will force you to think about how all the players within your frame come together as part of the story.

ON YOUR OWN

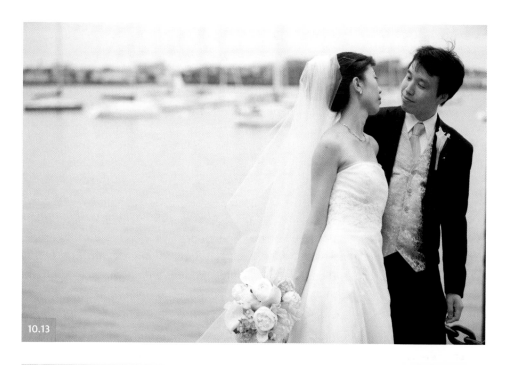

10.13

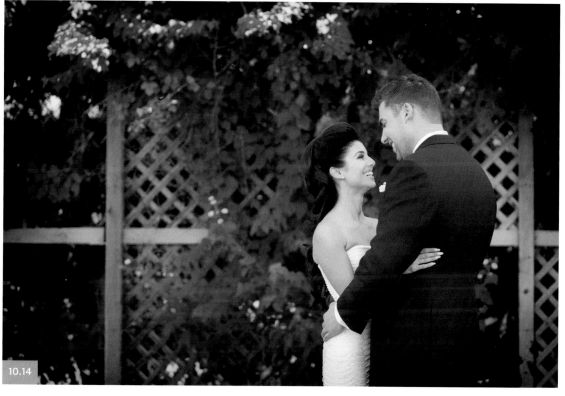

10.14

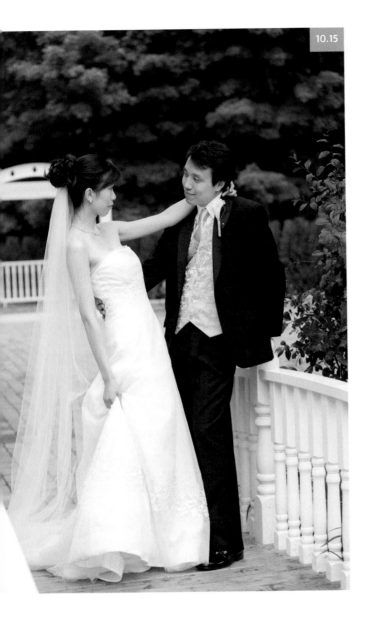

10.15

10.16

10.17

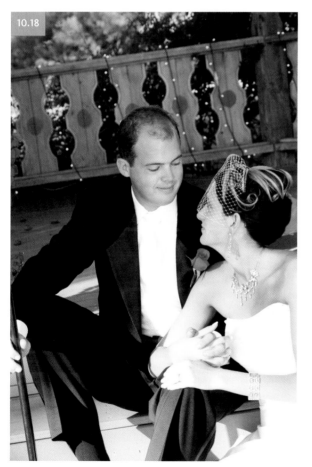

10.18

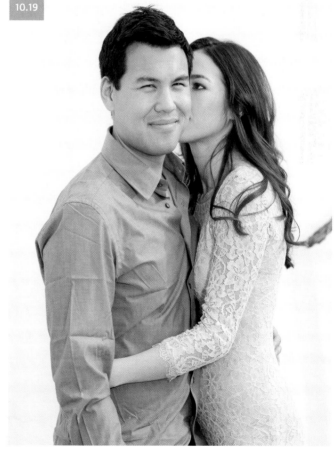

10.19

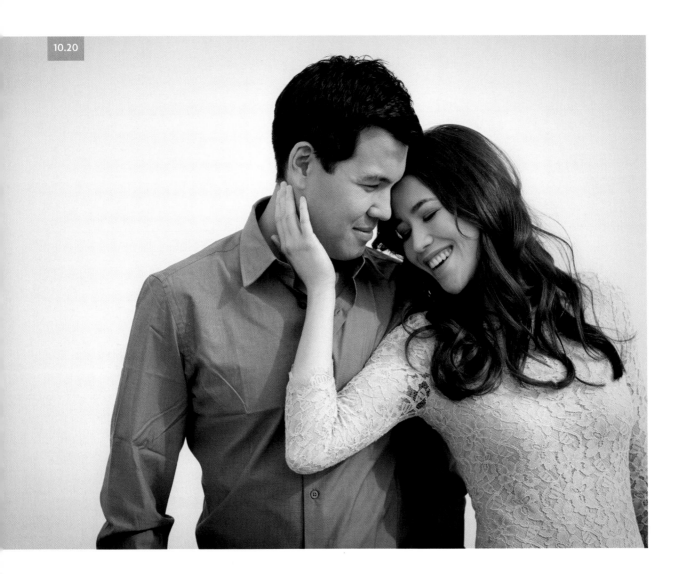

ANALYSIS

11

POINT-OF-CONTACT CHECK

AFTER DILIGENTLY EXAMINING my photographs, I realized that during portrait shoots I didn't consider from what angle my lens was striking my subjects and what part of the body was emphasized as a result. For example, imagine that a person is sitting on a chair, and you, the photographer, are kneeling on the floor directly in front of that person. If you were to point your camera at your subject from your position on the floor and take a photo, the first point of contact would be your subject's knees.

This shooting angle relative to your subject's position will give more importance to the knees than any other part of your subject's body. That's because the knees are the closest objects to the camera at that angle. Generally speaking, your subject's eyes should be the closest object to the camera, because the eyes are the soul of an image.

As you choose an angle from which to photograph, it helps to visualize this point of contact. That way you can make corrections to ensure that your subject's eyes remain the closest part of the body to the camera. This is not always possible, but you can adjust the pose or your shooting angle to reduce the distance between their eyes and that point of first contact with your subject's body.

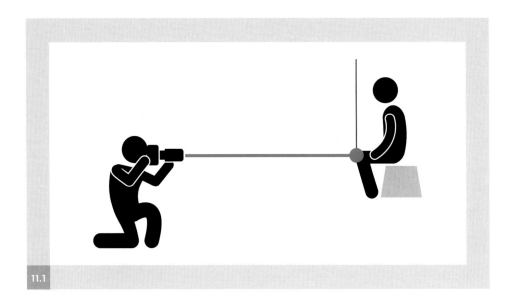

11.1

UNDERSTANDING THE POINT OF CONTACT

We started with a concise written explanation of the point-of-contact concept. Now let's look at some illustrations to help you visualize the concept. The red dot that you see in the illustrations represents the point of first contact. The blue line represents an invisible plane meant to show you just how far that point of first contact is from the subject's eyes.

Figure 11.1 illustrates a common mistake or problem that photographers make. Notice that from the angle the photographer is shooting, the point of first contact is the subject's knees. Using the blue line, you can also determine how far the subject's eyes are from that point of first contact. If that blue line kept moving to the right, it would contact the subject's head next, after the knees. So, from this shooting angle, the model's knees are the most important part of the image, and the head is the second most important part. This should not be the case, unless you are trying to bring more attention to the knees rather than the eyes.

Figure 11.2 is nearly the same image as Figure 11.1; the only difference here is that we corrected the point of first contact. The photographer is in the same position, and the shooting angle hasn't changed. By having the person lean toward the camera, however, the blue line now makes contact with the eyes, hands, and knees at the same time. That's how easy it is to correct for the point of first contact meeting the wrong part of the body. Remember that the blue line is always perpendicular to the shooting angle. This is very important, because it can help you adjust your shooting angle.

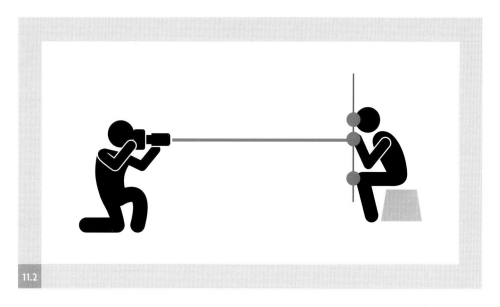

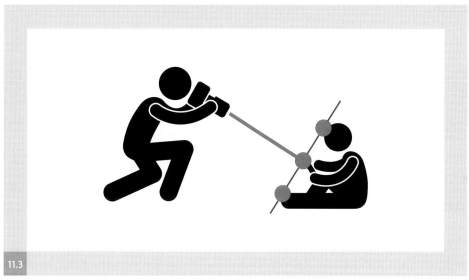

Figure 11.3 clarifies how you should choose your shooting angle. Knowing that the blue line is always perfectly perpendicular to the shooting angle, you can use this concept to position yourself in a way to ensure that it always includes the eyes. In this example, the subject's feet are the closest part of the body to the photographer, the hands second, and the head third. To correct for this, the photographer is shooting down at the subject so that the subject's head, hands, and feet are on the same invisible plane of the blue line.

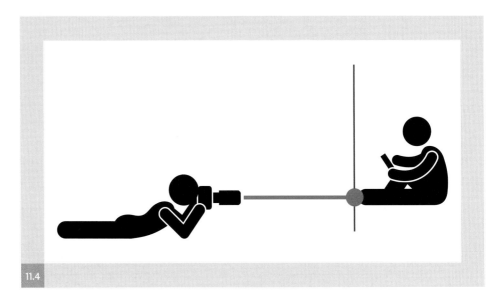

11.4

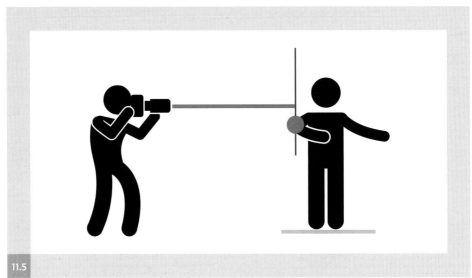

11.5

If the photographer fails to see how the invisible plane of the blue line meets the subject, the result will be a heavy emphasis on the subject's feet (**Figure 11.4**). If your intention was to emphasize the shoes or socks, then this angle is ideal. This will be very distracting, however, if your photo was meant to be a portrait. All you need to remember is that in a photograph, the part of the body closest to the camera will be given more visual importance and emphasis.

Figure 11.5 is an example of something that's more difficult to notice. When people hug, their elbows often stick out as they place their arms around the other person. If a photographer is shooting this hug from the subject's side, the point of first contact will be the elbow, making it too prominent. To remedy this, always ensure that the people hugging have their elbows pointed toward the floor, not toward the camera. Because the elbow is so small relative to the body, it can sneak up on you and slip by unnoticed. Do not let that happen to you!

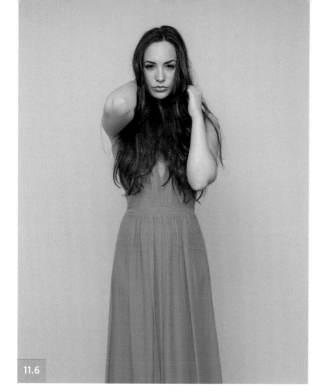

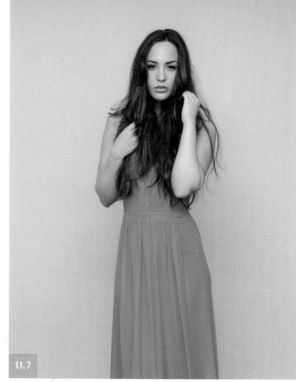

UNDERSTANDING CORRECT SUBJECT EMPHASIS

At this point, we have established a good understanding of how we must alter our shooting angle to emphasize the subject's eyes. Let's examine some troublesome areas that often surface during photo shoots.

ELBOWS EMPHASIS

Because of our anatomy, elbows can easily be overemphasized. To move our arms and hands, we usually use our elbows, so be alert when asking models, brides, or anyone else to place their hands somewhere for a pose. Doing so may bring the elbow in front of the face, giving the elbow primary emphasis.

For the example in **Figure 11.6**, I simply asked Laura to bring her hands up toward her hair. Then, I waited for her to do what I had asked. Laura lifted her arms and reached for her hair, just as I had asked. But what happened to her right elbow? The elbow is now jutting far out toward the camera and dominates the photo. As the point of first contact, Laura's right elbow must have been extended at least 10 inches in front of her face. That is far too much. The solution is to be more specific when giving posing direction. You can say, "Laura, could you please bring your hands up toward your hair but keep your elbows pointed toward the floor?" The result of these instructions can be seen in **Figure 11.7**. What a difference, right? Now we have a portrait of her face instead of a portrait of her elbow.

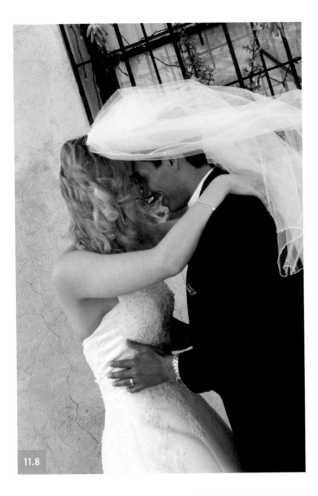

11.8

During one of my first weddings, I remember asking the bride to put her arms around her husband. Directions such as this are simply not specific enough, and your clients will fall into a posing problem, as happened in **Figure 11.8**. This is a common problem when a person hugs another. The elbows always seem to stick out toward the camera. There is probably a good 12–15 inches between the bride's right elbow and her eyes. I try to minimize this distance as much as possible. Usually 6–8 inches is as far as I'm willing to go. I should have asked the bride to keep her elbow down, or to tuck her arm inside the groom's arm so that the palm of her hand was touching his upper back.

Photos that fail hold a treasure trove of information. Pull out the rejects from any photo shoot and study them. Why is it a reject? What could you have done better? What did you say to your subjects that resulted in a failed pose? It takes time and dedication to extract this information. But if you do, you will be much better prepared to deal with issues on the fly and under pressure.

For example, during an engagement photo shoot, I asked the couple to tenderly embrace. Before I even finished my sentence, I remembered what I had learned from Figure 11.8. Sure enough, my clients embraced, and their elbows protruded everywhere. In fact, you could see very little of the woman's face, because their arms dominated the photo. I took the photo to keep the flow going, but knew I had to be more careful about the tricky elbow. A few minutes later, I stopped them to take another portrait photo. This time, I was ready to deal with this difficult part of the body. The result is **Figure 11.9**.

SHOULDERS EMPHASIS

In a contest as to whether elbows or shoulders cause greater problems, elbows win by a landslide. Shoulders are pretty much fixed in their position and cannot become wider than they are. Elbows, on the other hand, can move out from an adult's body by more than 12 inches, making them more of a threat in keeping the emphasis on a subject's eyes. Still, shoulders do cause problems, so they are worth a short mention.

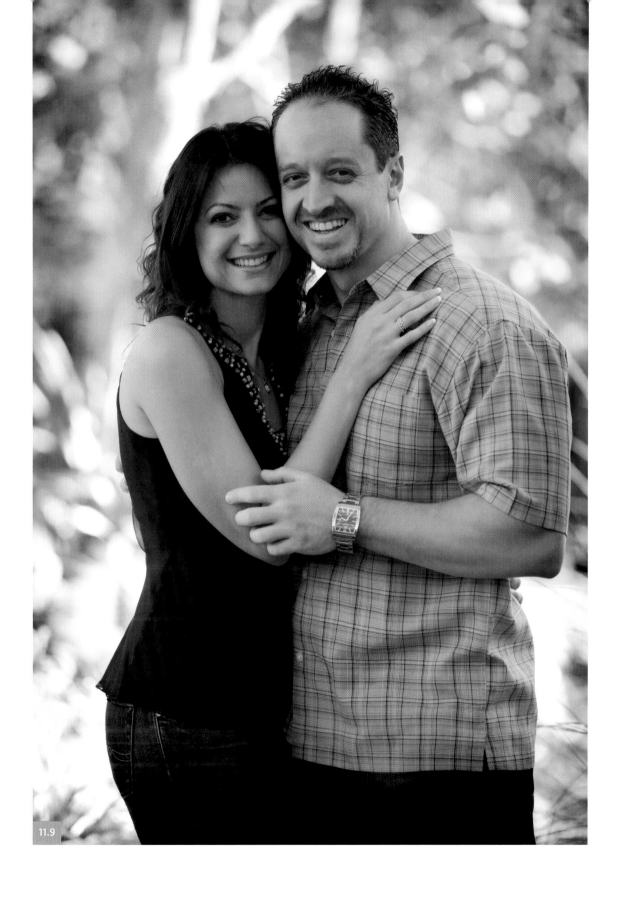

11.9

11.10

11.11

Looking at **Figure 11.10**, you can easily see how shoulder position can be a bit of an issue. Even though Arden's face is the brightest part of the image and in focus, her shoulder is about 7–9 inches closer to the camera than her eyes. In addition, her eyes are tilted away from the camera, and her face is leading with her chin. This puts the emphasis on her shoulder first, her chin second, and her eyes third. The eyes could have claimed second place if I had asked her to pivot her forehead toward to the camera. I could have also addressed the shoulder issue by asking her to lean her upper body toward the camera, leading with her head.

This is precisely what I did for **Figure 11.11**. Her shoulder is now a bit farther from camera view, which reduces its emphasis. Her eyes are now leading her face toward the camera, and she leans her upper body toward the camera. These small movements can make all the difference. Practice these movements by photographing members of your family. Start with poses that emphasize the wrong parts of the body, and, little by little, address one issue at a time until it is perfect. With practice, you will do it without having to think about it.

LEGS EMPHASIS

Like elbows, the legs can pose a great challenge when you want to emphasize a subject's face. Legs can stretch out far from the body. If not careful, you could end up with a photo such as **Figure 11.12**. The subject emphasis here is decidedly off. Her sitting position, and the angle from which I am photographing her, puts too much emphasis on her legs.

This photo has several other problems. For example, her spine is not straight. For the purpose of this chapter, however, try to focus only on how the angle from which I'm shooting could have been better and how her pose could have minimized the distance from the point of first contact to her eyes.

Because I love learning from my earlier mistakes, I am now better equipped to handle these challenging situations. For instance, a month before writing this chapter, I had a similar situation with a seated model. This time, I handled it a bit differently. The result is **Figure 11.13**.

Keeping in mind the importance of proper subject emphasis, I made sure that her knees pointed up and not toward the camera. Also, I kept her upper body straight as an arrow, and I asked her to rotate her left shoulder more toward the camera. This allows you to see more of her chest and less of her right arm. Then I had her lean her entire upper body just a touch toward the camera. Finally, I raised my shooting angle enough to ensure that the invisible plane perpendicular to my lens would encounter her face first and her body second.

These are the kind of decisions you can expect to make if you keep yourself aware of exactly where the point of first contact will be on your subjects. Figure 11.12 was taken with no regard to the point of first contact, whereas in Figure 11.13 I paid close attention to the effects of subject emphasis.

ON YOUR OWN

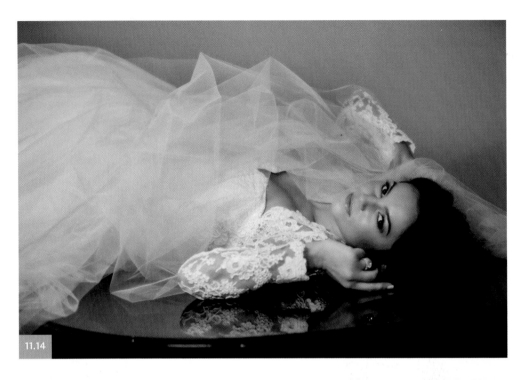

11.14

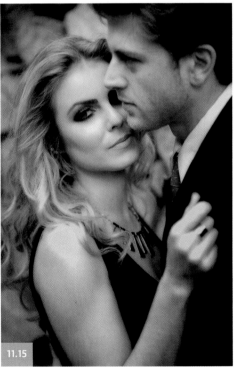

11.15

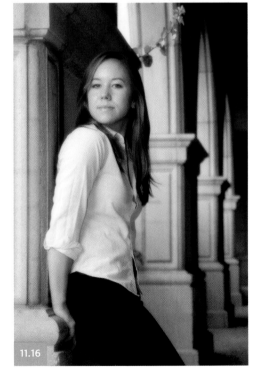

11.16

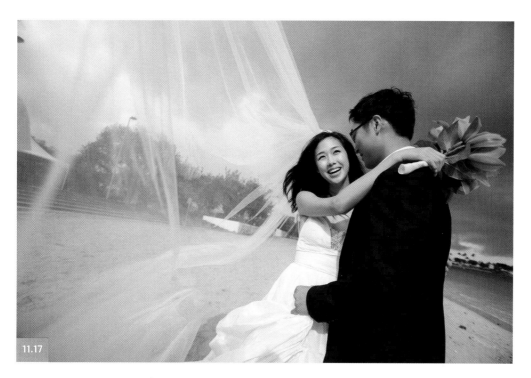

11.17

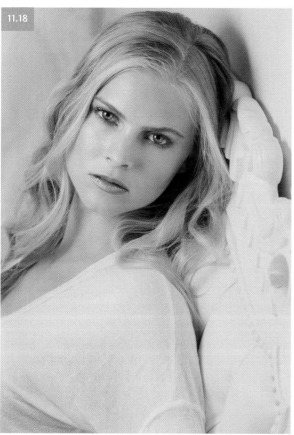

11.18

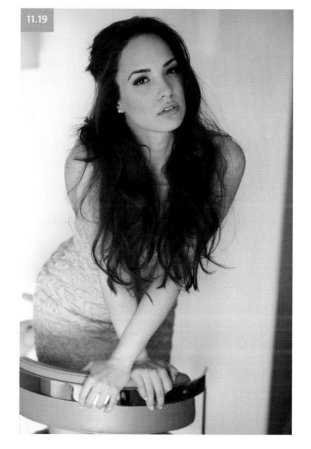

11.19

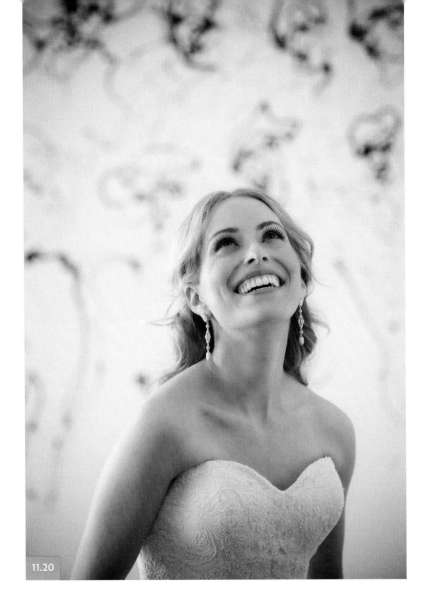

11.20

ANALYSIS

12

BALANCING THE SUBJECT RATIO

THIS CHAPTER DEALS MORE WITH posing couples than individuals or groups of people. Even if you don't pose couples, however, read the chapter carefully because its principles should be on your mind whenever you are holding a camera.

Here's the theory behind this chapter: When posing couples, the proportion of their torsos visible to the camera should be somewhat similar. The key to remembering this is to ask yourself, "How much of each of their torsos do you see from your particular camera angle?" Is one person blocking 90 percent of the other person's body? If so, adjust the pose, or change your camera angle to create a more equal ratio. I always try to keep the visibility ratios as similar as possible. When this is not possible or when I'm trying for a different look, I might allow a person to block 70 percent of the other person's torso, leaving 30 percent of the blocked body visible to the camera. In most cases, any more than that means the photograph will suffer.

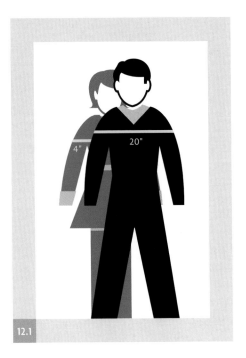
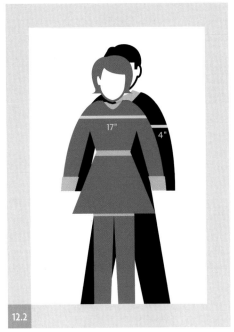

This balance becomes even more important when a man is blocking a woman. A woman's upper body is usually smaller than a man's, so blocking part of her body accentuates the problem. As you watch people interact and move around, the subject ratio can be difficult to notice. But freeze the positions in a photograph, and the discrepancy becomes evident. In short, whether a woman or a man has the smaller build, the larger person probably should not be blocking the smaller individual. The proportion of their torsos visible to the camera should be similar to keep the pose harmonious. For a visual reference of this issue, look at the following illustrations.

Figure 12.1 is clearly off balance. The man is blocking most of the woman's body, leaving only a small percentage of her upper body visible to the camera. If you wish to pose the woman behind the man, take a few steps to the left so that you can see more of the woman's body, or ask the couple to rotate (in this case, counterclockwise) so that more of the woman's body is visible.

Figure 12.2 is the same scenario, but this time the woman is blocking most of the man's upper body. This situation is more acceptable, because the man's torso is usually larger than a woman's torso. Blocking this much of his body still creates a balance problem, though it is better than the other way around. In either case, it is easy to ask the person being blocked to move in a direction that allows the camera to see more of him or her.

Figure 12.3 shows a balanced visual. Keep in mind with these illustrations that the couple is facing the camera straight on, but you can have them rotate toward each other and still keep the ratio similar. In this case, if the woman rotated her body toward the man, and the man remained facing the camera, the result would be off balance. The entire width of the man's torso would be visible, and practically none of the woman's would show since she is posed sideways.

The solution is to crop tightly to place more emphasis on their heads and less emphasis on their bodies. Here's an example. **Figure 12.4** shows a man standing straight toward the camera and a woman in profile. You can see by the silhouette how much of a discrepancy this creates— not a bad thing, just a discrepancy. Remember that photography is subjective. You may love that look, and if you do, then do it. To me, this example looks like a photo of a man with a woman next to him who appears to be more of an afterthought.

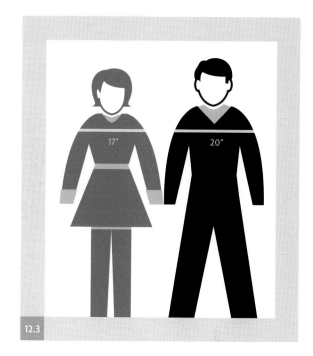

12.3

Cropping tighter, as shown in **Figure 12.5**, reduces the amount of their bodies visible to the camera and places more emphasis on their heads. This technique brings balance to an otherwise off-balance pose. More often than you might think, creative cropping is the ideal solution.

12.4

12.5

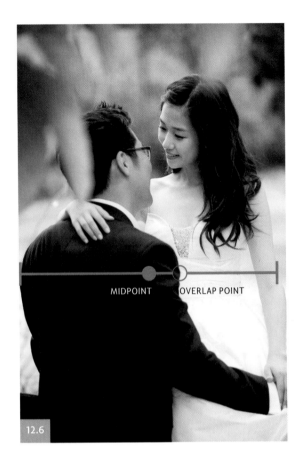

12.6

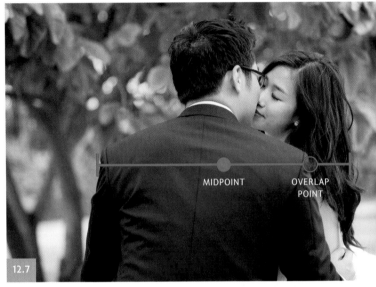

12.7

FINDING THE MIDPOINT AND OVERLAP POINT

When photographing couples, I use the concept of the midpoint as a general guide to choose my shooting angle. To understand the midpoint, see **Figure 12.6**. The red line is an imaginary one I draw as I'm photographing to determine the midpoint of the combined widths of my subjects. Once I have determined their total width, I eyeball the midpoint.

The next step is to find the overlap point, indicated by the light blue line. This line can be determined by the point where you can begin to see the blocked person's body. Based on this photo, the overlap point is near the middle of her chest. Once I have these two reference points, I simply try to keep them close to each other. If I do, the pose will be well balanced between the two people. If I don't, one person will be blocking most of the other person's body. It's as simple as that.

Let's look at an example where the midpoint and overlap point are too far apart. In **Figure 12.7**, the groom is blocking about 80 percent of the bride's body. The midpoint between the two is almost in the middle of his back. Notice how much distance there is from that midpoint to the overlap point, where we can start to see the bride's upper body. The blue line is almost all the way to the right of their combined widths.

To fix this, I could do two things. I could move to the right and get more of the bride's body in the shot, or I could have them rotate clockwise. Either option will bring more balance between the two people. The ratio does not have to be 50-50, but in most cases, it should not be 80-20 either.

MAKING ADJUSTMENTS TO THE POSE BASED ON THE MIDPOINT

Keep in mind that these reference points are only a guide to help you balance a pose between two people. In fashion photography, which has no rules, you can pretty much do whatever you wish as long as the clothes are well lit. But even then, it is important to keep balance in mind.

Like most of you, I place my subjects in a pose, and then I begin to make adjustments to it. Nowadays, I know what to look for, but very early in my career, I did not adjust my poses much. I was afraid to interrupt my clients, and I lacked the confidence to stop shooting, observe the details, and adjust the poses as necessary. The results were a disaster, to say the least.

Figure 12.8 is an example of what my poses used to look like. Notice the midpoint and overlap points, the stiffness in their bodies, and the hands. Just about everything about this photo is wrong. Beyond the groom's hands, it's the unbalanced subject ratio that wrecks this photograph. Take a moment to study the image and decide what you would do to fix the subject ratio.

The first thing you probably notice is how intrusive the groom's right shoulder is. The groom should be rotated clockwise to bring the overlap point (blue line) to the right, closer to the midpoint. This adjustment also gets the shoulder out of the way of the bride's face by rotating it farther from the camera. The bride should also be moved a bit to the left to reveal more of her body.

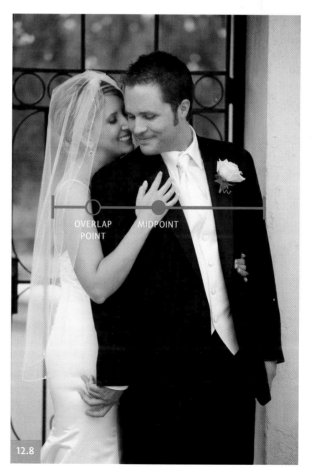

12.8

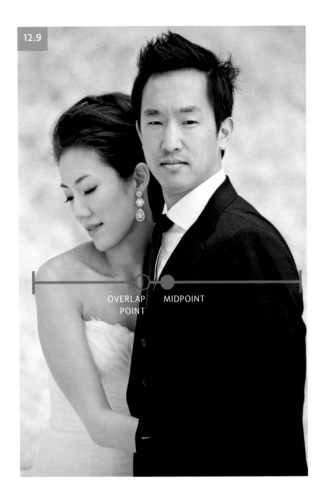

12.9

OVERLAP
POINT

MIDPOINT

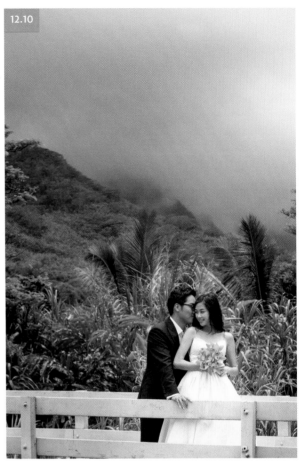

12.10

You can see an example of these sorts of adjustments in **Figure 12.9**. The midpoint and the overlap point are now much closer together. The pose in both photos is similar, but in Figure 12.9 the pose has been corrected and it looks much better than Figure 12.8. In fact, Figure 12.9 was taken only a couple of years before I began writing this book. Taking the time to study failed photos gives you the opportunity to harness their learning potential.

Many times a pose looks pretty good but could be improved by using the information in this chapter. Being aware of the midpoint and overlap point during the posing process will help you to know exactly what can be done to get the most out of the pose.

For example, during a wedding in Hawaii I stood across a busy street with a long lens to achieve the perspective I was looking for (**Figure 12.10**). The distance meant that I couldn't make adjustments to the pose very easily. As the couple moved, they ended up in this pose and kept it for a while. Do you see the resemblance to Figure 12.8? It is almost the same pose but reversed, with the bride blocking the groom and her shoulder in his face.

I decided to stop shooting, walk across the street, and make all the adjustments necessary to make sure that I would not repeat Figure 12.8. **Figure 12.11** is the result of the adjustments. I kept the groom pretty much in the same place, but I rotated the bride's body clockwise. Much better!

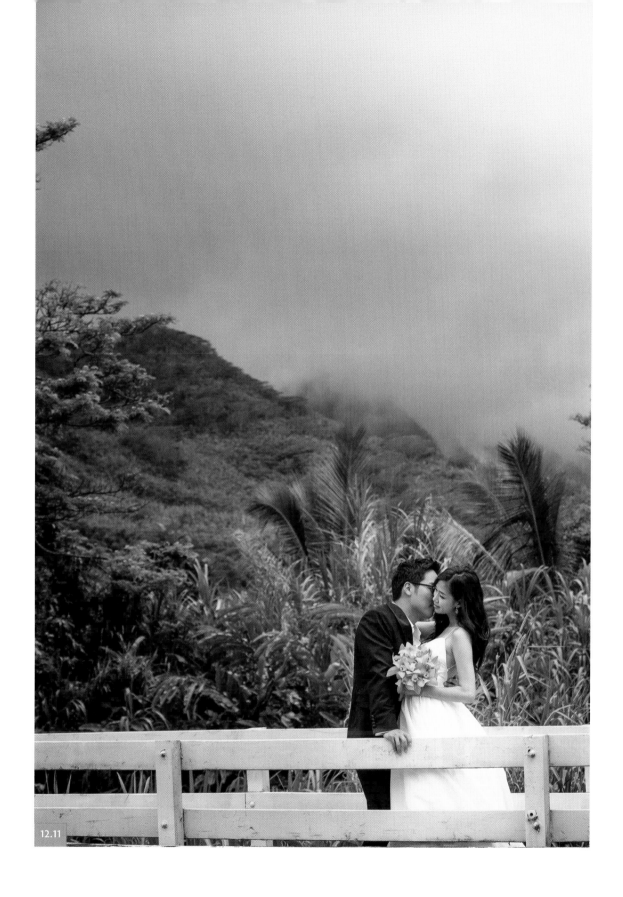

12.11

Try to visualize the midpoint and the overlap point in Figures 12.10 and 12.11. Do this often to make this visualizing process second nature to you. The subject ratio will often come in handy. I am glad I thought about the subject ratio during one of my engagement shoots. **Figure 12.12** was a direct result of keeping the subject ratio in mind and visualizing the two reference points quickly so that I could pose my subjects properly as well as choose my shooting angle. When you feel as if you don't know where to stand during a shoot, often the subject ratio can help you to decide.

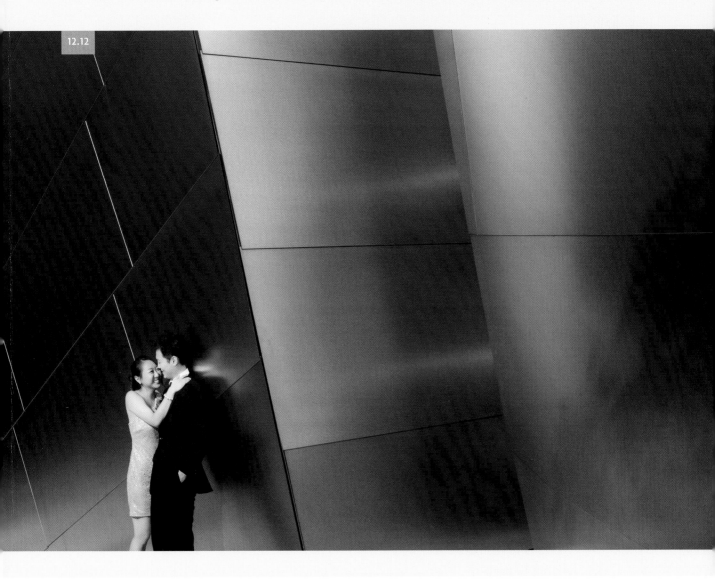

12.12

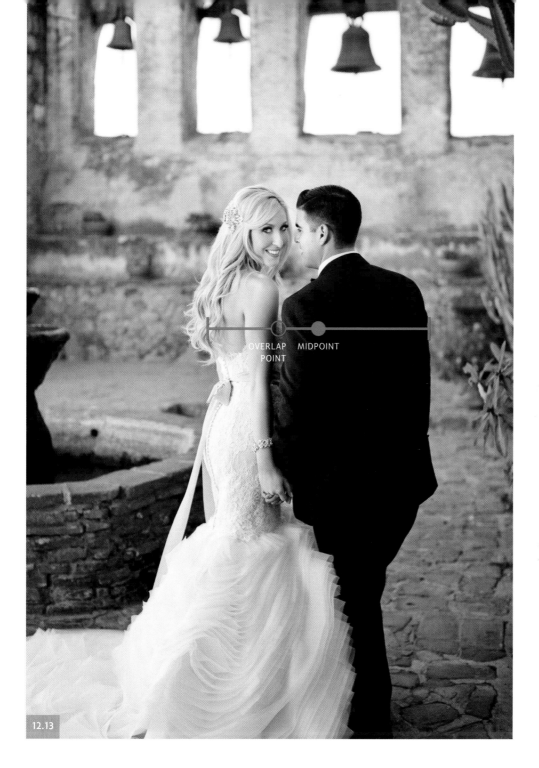

OVERLAP POINT MIDPOINT

12.13

Regardless of the pose or whether your clients are facing toward or away from you, use the subject ratio reference points to help you execute the photograph. **Figure 12.13** represents a very different pose, but as you can see, the principles still apply. The two reference points explained in this chapter have been responsible for much of the success of my images. I hope they'll help you just as much.

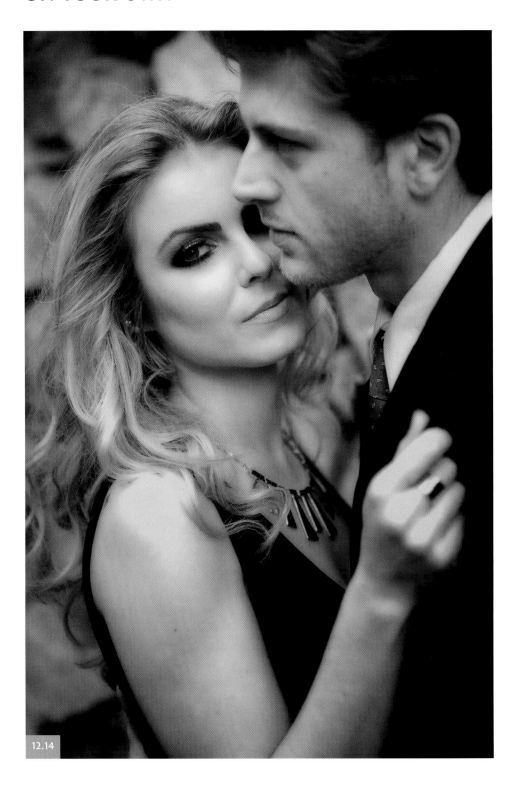

12.14

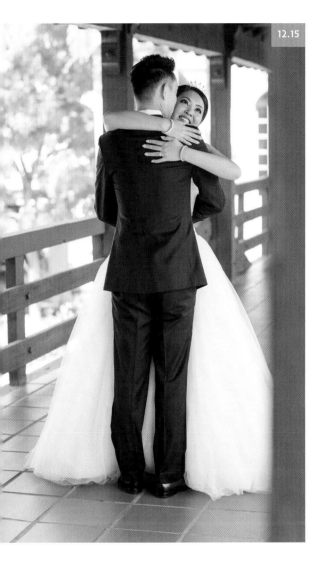

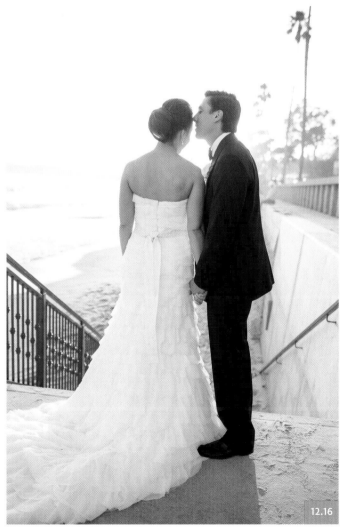

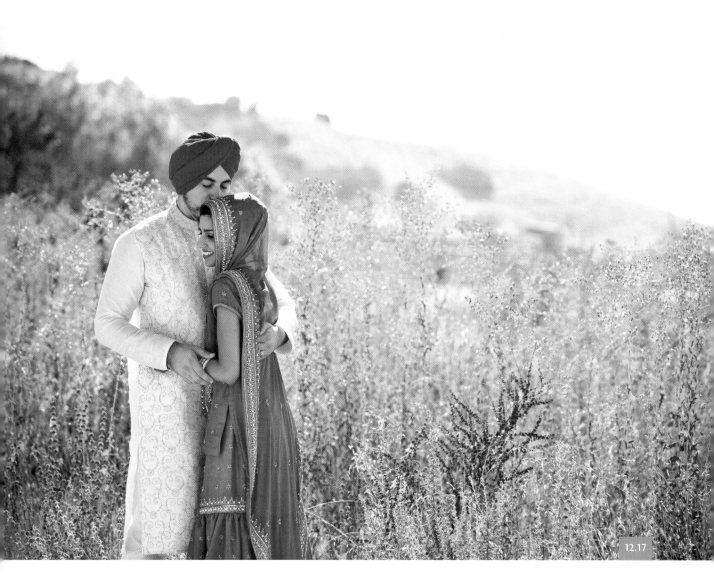

12.17

ANALYSIS

13

THE NOSE X-FACTOR

VISUAL AIDS THAT ARE EASY TO REMEMBER are a lifesaver when photographing under pressure. I have created simple and easy-to-remember visual aids to help me when I'm working, particularly on a photo shoot. This chapter deals with one of these visual aids. When photographing couples, I find that whenever their noses point directly at each other or run parallel to each other, the moment will appear phony.

To ensure that I keep my eye on this issue, I imagine a straight line projecting from the noses of my subjects. If their noses are pointed toward each other or are parallel to each other, I tilt the head of at least one person to make sure that those two lines intercept, creating an "X"; hence, the name of this chapter. By creating an intersection between the two noses, the pose will be well on its way to being candid and natural. The key concept is to be aware of the energy placement between the couple. If the direction of their noses cross each other, the energy will be directed toward the two of them; other-wise the energy goes elsewhere.

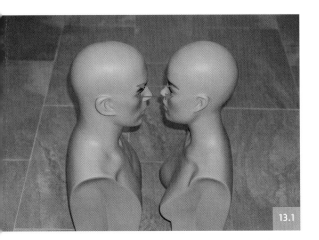

13.1

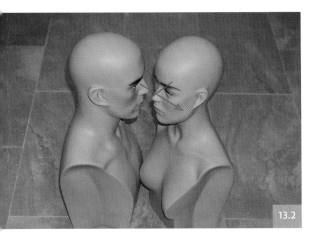

13.2

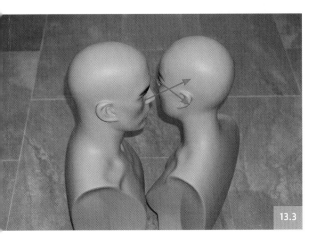

13.3

NOSES POINTED TOWARD EACH OTHER

It is not often that a couple has a tender moment where their noses are pointed directly at each other, especially when looking into each other's eyes. It's simply not natural. It confuses me when I see photos in which the photographer has tried to create an authentic moment but has mistakenly posed the clients with their noses pointed straight at each other.

To show you what I mean, I posed two mannequins to enable you to focus purely on their face positions, without the distraction of facial expressions. **Figure 13.1** makes it clear why this position appears awkward. There is no reason why two people would naturally position their heads directly in front of each other when they are so close. If they were about to kiss, then one or both of them would tilt their heads slightly. Otherwise, their noses would collide.

Basically, the only reason two people would be positioned this way is because they were posing for a photographer. When was the last time you stood so closely in front of someone's face that the tips of your noses almost collided? The best way to handle this head position is to have at least one person, or both, tilt their chin down toward the floor. Posed this way, their foreheads would be the point of contact, and not their noses.

The solution (**Figure 13.2**) to Figure 13.1 is to simply turn one head, or both, slightly so that the direction of the noses intercept and form an "X" shape. For this example, I only turned the female head to the left (counterclockwise). Keep in mind that if you do choose to have your couples kiss, most men will try to position their heads behind the woman to hide from the camera.

The example in **Figure 13.3** is practically the same as Figure 13.2, the only difference being that the female head has been turned to the right (clockwise). I wanted you to see the difference in the energy emitted from both combinations. In the very rare instance that I have my couples kiss, it would be done with the man's face in front of the woman's. But that's just my preference.

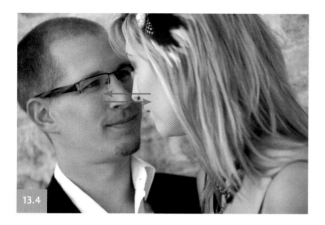

13.4

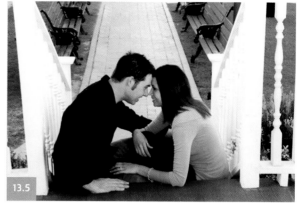

13.5

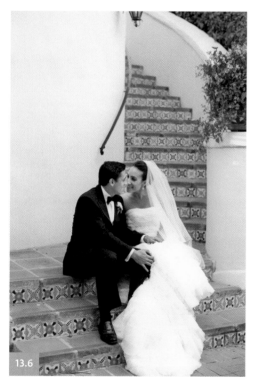

13.6

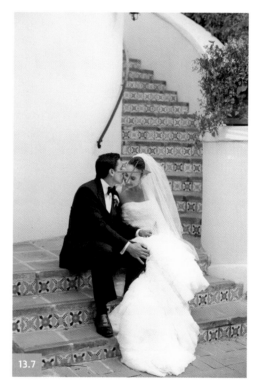

13.7

Figures 13.4–13.6 are examples of poor results. At first glance, your brain will automatically presume that something is off and reject the idea that these are candid photos. The energy emitted when the noses are in this position creates a sense of a fake pose staged for a photographer.

By having the invisible lines projected by their noses cross each other, as in **Figure 13.7**, the photo now has the characteristics of a true moment happening between two people. I had the groom kiss her on the cheek, while the bride tilted her head toward him as a sign of acceptance. The kiss on the cheek serves as the excuse I needed to adjust their noses. Coming up with an excuse that makes sense will make a big difference in the proper execution of this technique.

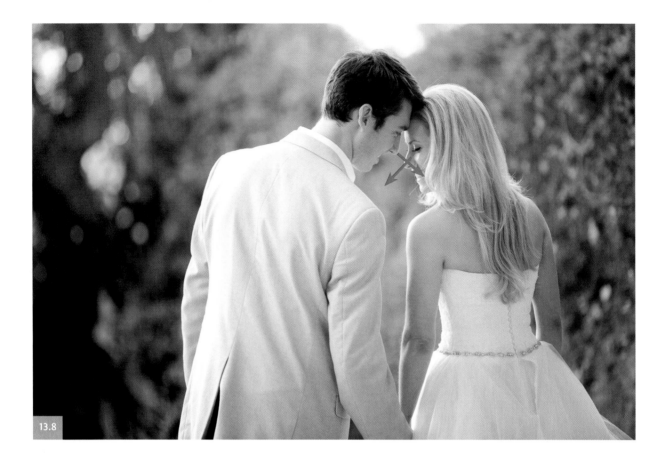

NOSE X-FACTOR VARIATIONS

If the couple's noses are pointed toward each other, as in the previous examples, the best way to correct this and create a genuine pose is to have your couple point their noses down at about a 45-degree angle. At least one of them should look elsewhere, usually downward to lower the eyelids.

Moments before I took this photograph (**Figure 13.8**), the couple's noses were pointed directly at each other. I corrected the pose by asking them to tilt their heads down and for the bride to look down toward the floor, instead of at the groom. The tilt of the heads creates another variation of the Nose X-Factor. As long as both are not looking directly at each other, the pose will have a candid feel to it.

Figure 13.9 is a very different photograph using the same technique. Whether strangers or family members, people point their noses toward each other when chatting. By forming an "X" with the direction of a couple's noses and positioning their heads very close together, we create a sense of romance instead of conversation. Notice the feel of **Figure 13.10**. To create this romantic moment, all I had to do was tilt their heads so that their noses created an "X."

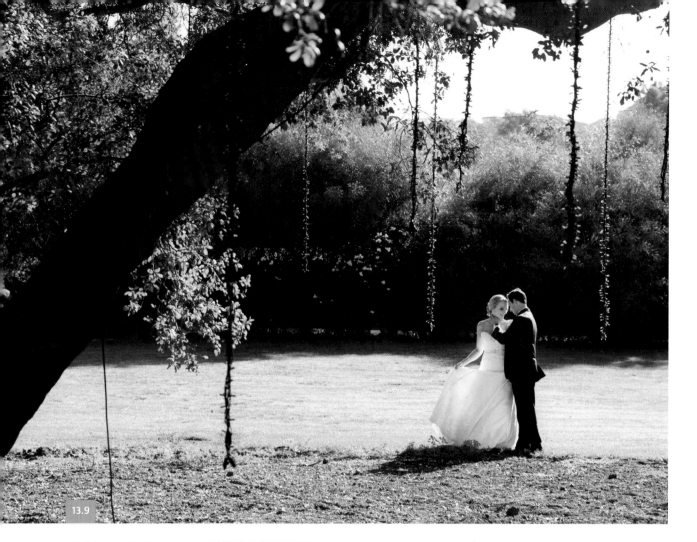

13.9

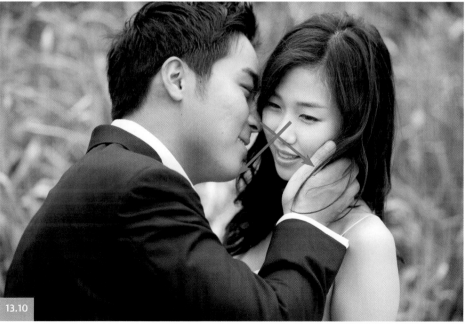

13.10

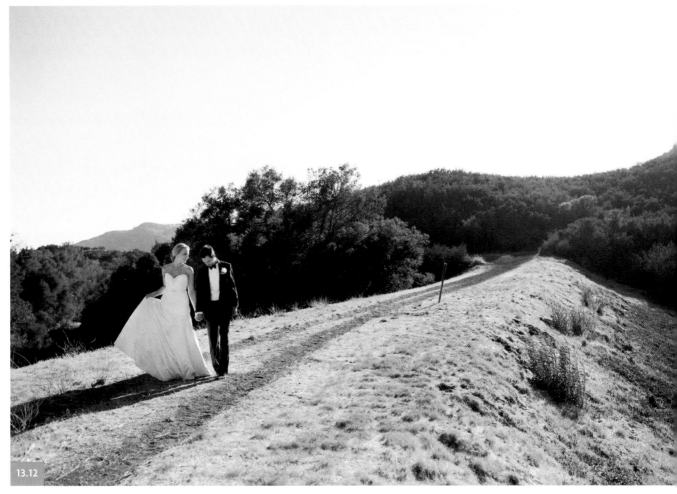

This concept of the Nose X-Factor can be applied in any scenario. Even when a couple is simply walking, as in **Figure 13.11**, this pose can give the impression that it is staged. If the directions of their noses cross while they are walking, as in **Figure 13.12,** then the overall feel of the pose is that you caught them in a candid moment.

NOSES PARALLEL TO EACH OTHER

More problematic than noses pointed at each other is when noses are actually parallel to each other. Most photos that you would consider to be phony or old-fashioned are posed this way. We have all seen photos of the man standing behind a woman with his arms wrapped around her, while they both turn to the right looking into the distance. In that pose, the couple's noses run parallel to each other.

In photography, there are always exceptions. I have seen some photographers execute a pose in which the noses are parallel to each other, and it looks quite nice and elegant. But that's rare. For that reason, I diligently avoid these types of poses. Looking at some examples will help you see how the energy placement changes depending on the direction of the noses.

Figure 13.13: In this position, the noses are clearly parallel, so the energy is placed more on where they are looking, rather than on each other. A simple turn of the head toward the other person would improve the image.

Figure 13.14: Changing the camera angle does not change the energy placement. Though the camera angle shows the mannequins in profile, their noses are still parallel. The energy remains on whatever is going on in front of them, instead of on each other. Many old-fashioned photographs use some variation of this example.

Figure 13.15: In this example, all I did was turn the female mannequin toward the male, allowing their nose paths to cross. This may be a subtle movement, but it makes all the difference. It puts the energy of the moment on them and nothing else. If the noses were turned slightly away from each other, the energy emitted by this head position would be more in tune with a photojournalistic undertone. Fashion photos of a man and a woman often use this technique to make the pose look casual and keep your attention on the clothes they are wearing.

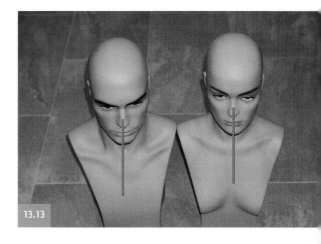

13.13

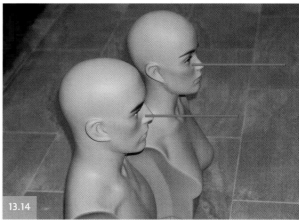

13.14

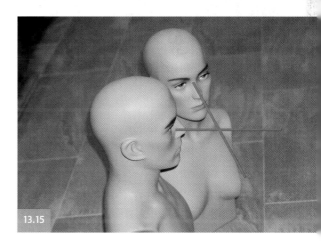

13.15

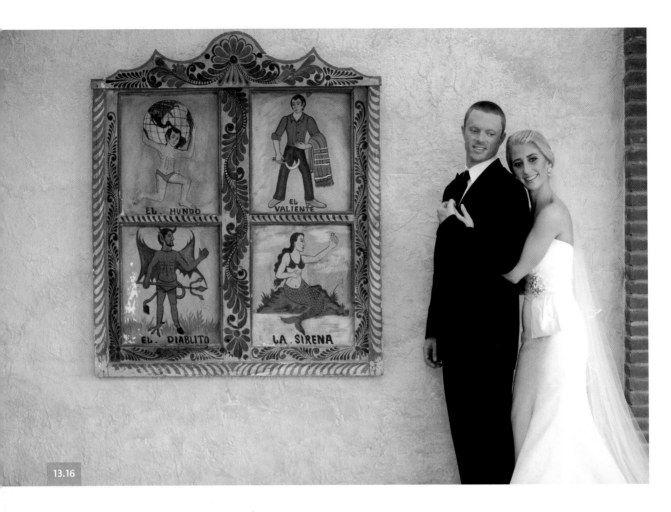

13.16

Figure 13.16: This photograph was taken at a destination wedding in Mexico. During the posing process, the bride and groom's noses approached being parallel to each other. The very fact that their nose paths are even close to being parallel automatically makes this image seem staged. This could have been fixed by rotating the groom counterclockwise and allowing him to turn his head more toward the bride.

FLASH CARD

The direction of a couple's noses should not be pointed straight toward each other, nor should they be parallel to each other, regardless of the camera angle. By doing so, you run the risk of making the photo appear inauthentic and old-fashioned.

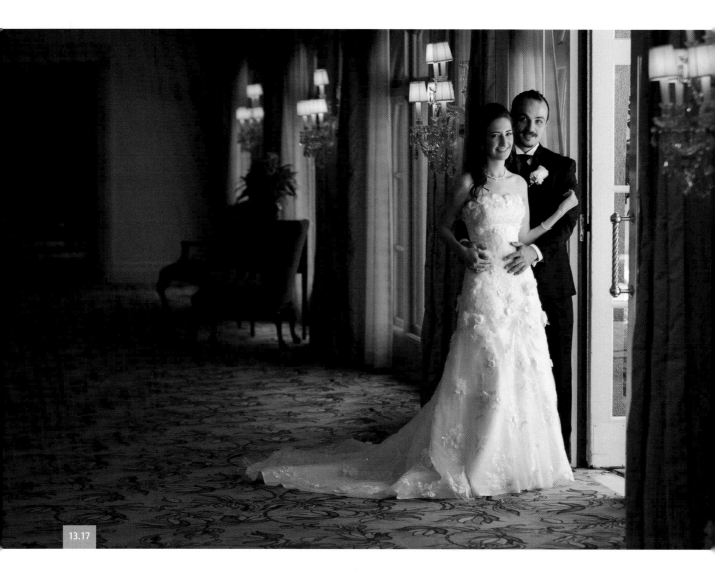

13.17

Figure 13.17: This photograph has the same problem as Figure 13.6. Although the paths of their noses are not exactly parallel, they are close enough to render the photo inauthentic. Most of the energy is going toward the photographer, when it should have been a nice moment in which the couple is engrossed with each other. Turning their noses toward each other and posing the eyes carefully would have accomplished this.

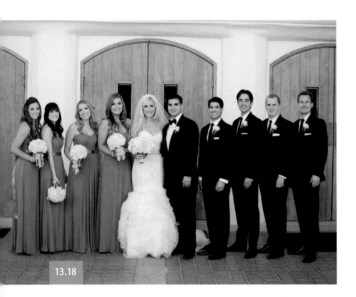

13.18

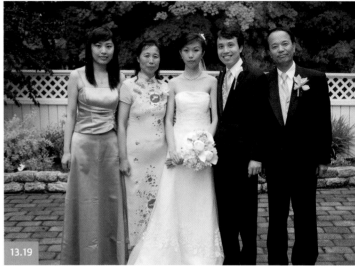

13.19

CREATING SPONTANEOUS GROUP PORTRAITS BY IMPLEMENTING THE NOSE X-FACTOR

The X-Factor technique discussed in this chapter plays an essential role when you're trying to create a more dynamic group photo. You can implement this technique with any group of people, from family portraits to wedding parties. Crossing the nose paths of the people in the group photo in different directions will yield a much more stimulating photograph than the traditional pyramid-style group pose in which everyone looks straight at the camera.

In many cases, especially in traditional family portraits, the family might want to have everyone point their head toward the camera so that each individual is equally visible. But if I were taking the traditional family portrait, I would place everyone close together and pose each person in a different way. Posing individuals in layers—where some people are standing, some are sitting, and some are kneeling—will create interest, and the photo will be intriguing, even though everyone's nose is pointed straight at the camera.

Now that we have considered style, let's focus on using the Nose X-Factor to create more dynamic group photos. This technique works especially well when the individuals in the group are posed very close to each other. If individuals are posed more apart, use your best judgment to determine whether the photo looks natural. At the very least, this technique will give you options when posing a group. The more tools in your toolbox, the better, so let's dive in.

Let's begin with the hackneyed, traditional group pose that most photographers fall back on. We've all seen **Figures 13.18** and **13.19** before. Everyone stands next to each other, turns to the camera, and smiles. This is a dependable way to take a clean photo of everyone involved. Is it exciting? Not by a long shot.

Notice in both photos that everyone's nose is pointed toward the camera. Let's compare these portraits to a few using the Nose X-Factor. In **Figure 13.20**, I drew the callouts so

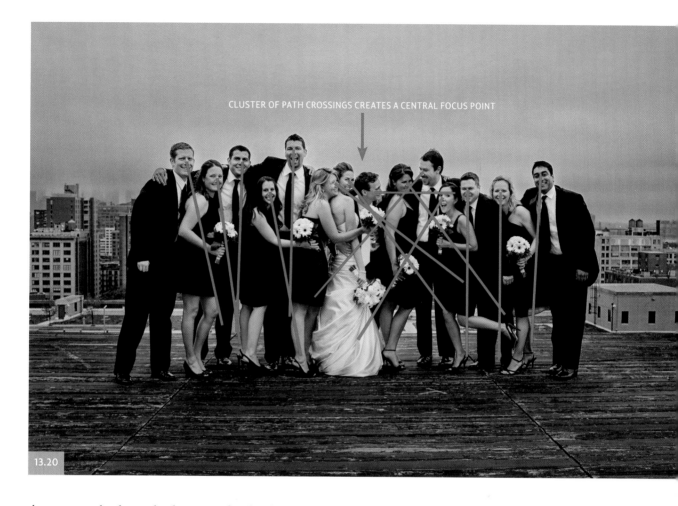

CLUSTER OF PATH CROSSINGS CREATES A CENTRAL FOCUS POINT

13.20

that you can clearly see the direction of each subject's nose and how my posing affects the feel of the photograph. There's more to this than meets the eye.

I positioned each of their heads to draw your eye to where the bride and groom are standing. I did this without being too obvious about the pattern. The key is to trick the viewer into thinking there's no pattern. There must be just enough randomness within the pose to confuse the brain. And there must be enough intention and organization to draw the viewer's attention right to where you want it. It is a sensitive balancing act.

To best describe what happens if the nose direction pattern is too obvious, think about that infamous and overdone photo where the photographer asks the bride and groom to kiss while the wedding party looks on, pointing their fingers at them. The pose is not only a cliché, but it uses a clear nose direction pattern the viewer's brain will quickly pick up. The result is not exciting and not unique.

You can see the solution to breaking the nose direction pattern in Figure 13.20. I asked the people on the sides to point their noses at or look toward the camera. To draw the viewer's attention to the bride and groom, I began to cross the nose paths of the people surrounding them. People subconsciously look where others are pointing or facing, so I'm using this fact to my advantage. Because the people at the edges of the photo are turned toward

the camera, the nose path crossings are confined to the middle where the bride and groom are standing. This subtlety puts the viewer's attention where you want it—on the bride and groom.

This concept may seem complicated, but it's not. All I do is create a cluster of path crossings zigzagging around my main subjects. Then I simply break that zigzag pattern, usually at the edges. This technique can be used in many ways, and it allows a photographer to be very creative.

HOW TO SPOT AN X-FACTOR OVERSIGHT

Even with my best efforts, sometimes I make mistakes, and I did not notice this particular one until it was too late. But by looking through my photos after the fact, I was able to spot the issue and vowed not to let it happen again. Study **Figure 13.21** and try not to look at **Figure 13.22**. Can you spot the pattern quickly?

Notice how everyone is turned toward the center with the nose paths of bridesmaids to the right of the bride all crossing those of the bridesmaids on the left. The fact that I can easily describe the pattern is the problem, and it's precisely what we are trying to avoid. Although the expressions of all the ladies are lovely and candid, the photo failed to add that extra spark of spontaneity that separates the good from the great.

After evaluating the composition of this pose, I realized I should have turned the nose direction of the bridesmaid standing behind the taller flower girl. See Figure 13.22. Had I turned the lady's head (identified by the callout), I would have successfully broken the obvious pattern. The nose directions of the bridesmaids on the left and right of the bride are crossing each other, framing the bride. That's the good news, so we can leave them alone.

But the bridesmaid identified by the callout is very visible and is not contributing anything unique to the pose. However, she is in the perfect position to break the pattern of all the bridesmaids looking toward the bride. And because she is standing next to last, she has someone else to look at.

A good option would have been to turn the head of that bridesmaid toward the bridesmaid on the end. But I failed to see this, and although the photo is quite good, it could have been much better. If this is confusing, think of it this way. There's a clear pattern in the photo. I should have found a way to break that simple pattern by strategically turning some of the bridesmaids' heads away from the bride. That adjustment would have created a more spontaneous-looking photograph.

A WORD ABOUT STYLE

Photography is subjective and your photographic style is a personal choice. Keep in mind that I wrote this chapter to help bring loving energy toward couples and spontaneity to group portraits, instead of allowing that energy to dissipate. I have found that most people react more warmly toward photos of couples and groups when the photographer carefully applies the techniques taught in this chapter. However, feel free to experiment and see what clicks for you and your clients.

13.21

OVERSIGHT

13.22

ON YOUR OWN

13.25

13.26

13.27

ANALYSIS

14

SUBJECT EMPHASIS

PROPER SUBJECT EMPHASIS must work in conjunction with posing. Placing your subjects in a great pose and then not drawing the viewer's attention to them would be counterproductive. In a successful photograph, the pose creates a sense of flow and harmony with the main subject's body, and proper subject emphasis draws the viewer's attention via lighting or composition directly to your subject. This will, in turn, make it very clear that your well-posed subject is the most important element in the photographic frame, regardless of the photograph's other elements.

To help myself with this matter, I created a three-point reference guide for use during photo shoots. This ensures that my main subject is always the most prominent element in the frame. With so many distracting elements in our environment, it helps to have a go-to system to isolate your subject:

- The subject should be at least as bright as the brightest point in the frame.
- The direction of light should influence part of the pose.
- Use framing, leading lines, isolation, contrasts, repetition, or size to make the subject the most prominent element.

No doubt a photographer with a unique or creative vision could ignore any of these guidelines and still achieve a spectacular photograph. For example, there are times when a photographer could throw the main subject out of focus to create a certain story. Or perhaps the main subject might be in silhouette and so not as bright as the brightest point in the frame. In fine art or abstract photography, photographers can use their imagination to create whatever they envision, and it is up to viewers to interpret the image however they see fit. But outside of that realm, these three guidelines will help push photographers to successfully emphasize their main subject(s) in new, exciting, and creative ways. Let's explore each of these reference points in detail.

THE SUBJECT SHOULD BE AT LEAST AS BRIGHT AS THE BRIGHTEST POINT IN THE FRAME

Our attention is drawn to bright things. In any scene, the brightest areas always demand more attention than the middle or darkest areas. What does this mean to a photographer? Unless you want a full/partial silhouette or your clients in front of a white wall or the sky, your main subject should be as bright as or brighter than the brightest points in the scene. Otherwise, your main subject will not be able to compete with the brighter spots and consequently will become lost in the frame.

This issue happens more often than you might expect, even among experienced photographers. The reason is that there are countless decisions a photographer must make for a single photograph. It is easy to miss the brightness levels occurring in the scene and on your subject.

Figure 14.1 is an example of a common oversight. Although I am standing close to the camera, your attention will most likely wander to the top left of the frame. The buildings are illuminated by direct sunlight, and the sky is pure white. The fact that those bright buildings are far away from me doesn't make any difference. The emphasis in this photo is still on the brightest part in the scene, and I am clearly not the brightest.

Many times, you can't do much to compete with the bright sky. In those cases, find a natural reflector, such as a wall or anything else reflecting light toward your subject for fill. Or bring along an actual reflector. For example, in **Figure 14.2** I was posing in front of a bright sky in Rio de Janeiro, Brazil. But there was a large white wall in front of me acting as a natural reflector, providing some fill light. I also set my camera's exposure to retain detail in the bright sky. This keeps the emphasis on me, and the sky's natural brightness has been tamed.

14.1

14.2

14.3

MATCHING THE BRIGHTNESS LEVELS TO KEEP EMPHASIS ON THE POSE

During a wedding assignment, I noticed the beautiful light outside coming into a relatively dark room. In **Figure 14.3**, what makes this photo so elegant and beautiful is the quality of light showering the bride posed in a photojournalistic style. Keep in mind that the bride is wearing a white dress that could easily be overexposed. The bride is positioned at the exact distance from the window to ensure that she is just as bright or slightly brighter than the door to the right of the frame, but not so bright that her dress would be overexposed or, worse, blown out. This is precisely why this chapter is so important. By keeping this brightness level reference point in mind, her elegant pose becomes the crown jewel of this photograph. A great pose with inferior lighting and minimal emphasis is pretty much useless.

Figure 14.4 presents a more challenging example. In this case, the sunlight peeked through the trees and partially illuminated the fountain and the trees throughout the scene. The gardens at the Beverly Hills Hotel almost make you feel as though you are lost in a jungle. However, I realized that the spotty lighting would distract from my clients' pose.

14.4

Keeping in mind that I only had to match the luminosity or brightness levels, I positioned an off-camera flash with just enough power to match the spots in the scene illuminated by the sun. Had I not kept in mind this reference point, my clients would have been too dark or far too bright. Either way, the pose would have suffered.

Figure 14.5 contains several items that affect the brightness level reference point. Before pressing my shutter button, I always consider the three subject-emphasis reference points. I noticed that the white orchid, white marble countertop, and the specular highlights of the accessories on the shelves were all brighter than Kristen.

Originally, I was going to use only natural light for this portrait, but this would have resulted in Kristen being darker than those items. This would, in turn, take emphasis away from her and the pose we worked so hard to create. The solution was to use external light strobes and a large umbrella to soften the light on her face. I needed only enough power on that strobe to make Kristen's brightness levels at least as bright as the orchid and the marble counter-top. The viewer can now appreciate the way her face, upper body, and hands are posed.

14.5

THE DIRECTION OF LIGHT SHOULD INFLUENCE PART OF THE POSE

I find this concept to be a great help when I can't think of a pose. Paying close attention to the direction of light can help you decide how part of the body should be posed. For example, in a window light situation you would want to turn the subject's body away from the light source and the face toward the light. Not only will doing so give the body a more flattering and slimming look, but it will also make the subject's face the brightest point.

Other times, the light source could come from above, such as a skylight or lights placed higher than your subject. In this case, you would also want to turn your subject's face up toward the light, and then pose the rest of the body. Let the light be your guide.

Even in midday sun, you could achieve gorgeous images by posing your subject's face up toward the sun to illuminate the face evenly and to eliminate the unflattering harsh shadows that can occur in such portraits. Most photographers run toward the open shade in midday sun. You, on the other hand, can use the harsh light to your advantage by allowing the light to influence how you pose your subject.

In fact, around midday is my favorite time for shooting outdoor portraits. I love the high intensity of the light because it gives you the most options. With some simple tools, such as a reflector and a diffuser, you can soften the harsh sunlight and place the light exactly where you want it. Who wouldn't want to have these options? In the following examples, I show you how I use the direction of light to influence part of the pose.

Figure 14.6: This photograph was taken in a tiny remote village on the island of Kauai. The hut-like house had a tiny entrance about 3 to 4 feet high. You can see by the red callouts how the light rays spread inside the hut. This told me that I had to pose my client sitting or kneeling. Otherwise, her dress would be fully lit, but her face would be outside of the light spread and so would be in darkness. I needed her entire body and face to be within the spread of the light. Once this was done, I began posing the rest of her body. The takeaway here is that the light became my guide for the pose.

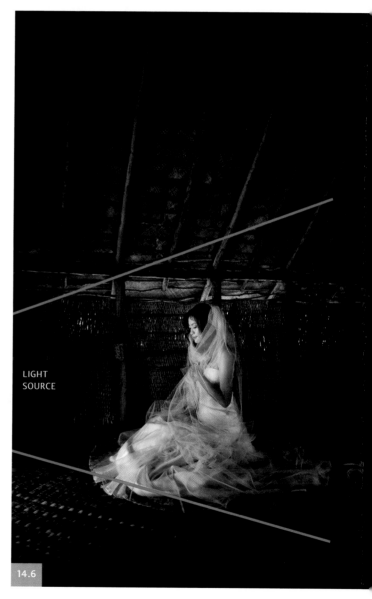

LIGHT SOURCE

14.6

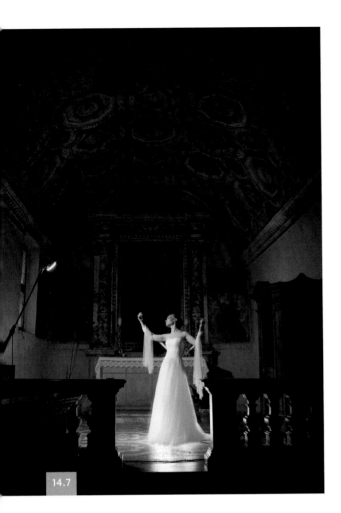

14.7

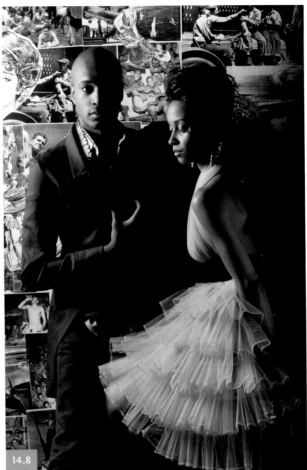

14.8

Figure 14.7: I purposely left this photo with my lighting assistant visible on the left so it would be easy for you to see where the light was coming from. The sunlight coming through the window on the left side of the building was not powerful enough to travel the distance to the model. The solution was to pose the model as if the window light was the main light source, and then add light using an LED continuous light source. You can see how the model's body was posed away from the light but her face was tilted up toward it. The model tried to be a bit dramatic with her arms for fun, but the structure of the pose still depended on the direction of the light.

Figure 14.8: This is one of the best images I found to illustrate this point. Every part of the pose here was pretty much based on the light coming from the left. I posed the male model against the wall and closer to the light source. He was close enough that the light falloff on his face was immediately based on the *Inverse Square Law of Light*, which states that the intensity of light is equal to 1 over the distance squared. This falloff resulted in a split lighting situation that looks great on a man but not always great on a woman. Therefore, I posed the woman farther away from the wall, while making sure that the male model would not block any of the light illuminating her. Then, I posed her head directly toward the light so that the center of her face would be illuminated evenly.

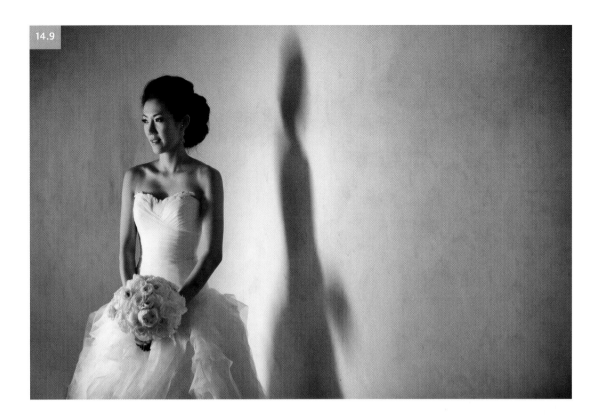

Figure 14.9: Sometimes the simplest of poses is the most effective. I chose this photo because the quality of natural light was so impressive that I wanted nothing to detract from it. I needed a pose that would allow the light to be the star of the show. The principles are the same; the body is slightly turned away from the light and her face was turned toward it. I often use this photo during my workshops and seminars to illustrate just how important it is to prioritize light and to always search for the best quality of light before anything else.

Figure 14.10: It is also worth discussing what happens when the light source is high up, as in this case. My client's face was tilted way up to receive the proper illumination on the different parts of his face. If I had posed his face with less of a tilt, the position of the light would have created black circles under his eyes. For the most part, in a situation in which the head is tilted sharply up, it is best to pose your subject with eyes closed. This photo also would have worked well if I had kept his head up and pivoted his chin toward the light. This technique works better when posing women than men, which is the reason I kept his head perfectly centered in this photo.

14.11

Figure 14.11: Most photographers run the other way when they see an area illuminated by harsh directional light. With experience, you will see how dealing with light just means altering the pose so that the subject's body and face are illuminated in a certain way. The best thing to keep in mind is that harsh light can be used to create a unique look.

Unlike soft light, harsh light will reward you with a dramatic look to your portraits that cannot be replicated by any other quality of light. The gorgeous black and white portrait in Figure 14.11 is a perfect example of this. In the late afternoon, the sun's rays peeked through the window, illuminating the steps with direct sunlight. I was walking with a group of students during one of my workshops in Los Angeles (organized by Junebug Weddings) when I spotted this hot spot on the marble steps.

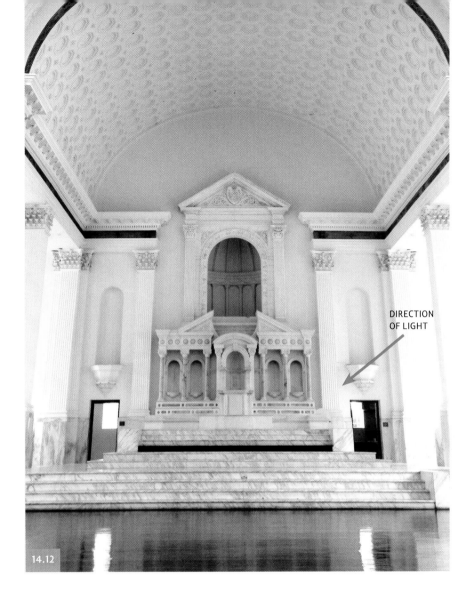

DIRECTION OF LIGHT

14.12

Knowing that this was an opportunity, I quickly asked model Dylan Quigg to lie down on the floor with her head to the right side and her feet facing left. The reason for this position is that the rays of light were coming from the right side of the room, as shown by the callout (**Figure 14.12**). At first glance, the light was so harsh on her that you would think it would be a mistake to proceed. But that was not the case at all. All that was necessary here was to adjust her pose to the light, instead of the light to the pose.

I posed her arms so they would be illuminated by the sunlight. The excuse I used for this arm pose was to ask her to gently move her veil away from her face to clear her neck and cheeks. Then I asked her to arch her back, as explained in Chapter 1, to give her body more curves. Lastly, and most importantly, I asked Dylan to tilt her chin toward the light until the dark shadows under her eyes disappeared. Once all that was set, I pushed the shutter button. This is a prime example of how natural light influences the way you pose a person. When using strobes or any kind of controlled studio light, you can position clients wherever you want, but with natural light, you must surrender to it, and pose accordingly.

USE FRAMING, LEADING LINES, ISOLATION, CONTRASTS, REPETITION OR SIZE TO MAKE THE SUBJECT THE MOST PROMINENT ELEMENT

Subject emphasis is the main tool photojournalists use to tell their story. A skilled photojournalist will use the objects in the environment to frame a moment, isolate someone's expression, or guide your eyes where they want you to look. Photojournalists do this mostly with a hands-off approach. They don't move the objects; instead, they move themselves to create a frame.

Portrait photographers can use the same compositional elements as photojournalists, but rather than bringing the viewer's attention to a story, you use them to bring attention to your well-posed subjects. Unlike photojournalists, a portrait photographer can move things around to frame or isolate your main subject. Remember, there's no purpose in spending time and effort meticulously posing your subjects if nobody can see them because they're hidden among all the distractions in any given environment. Achieving this is easier said than done.

The solution requires knowing what to look for to better isolate your subjects. It takes proper and deliberate practice to develop an eye for subject emphasis through composition techniques. You can also use various layers of subject emphasis through composition. For example, you can use only contrasts, selective focus, and size to focus attention on your subject. When there are three or fewer compositional elements to emphasize your subject, I call it *simple emphasis*.

Other times, you may choose to combine more compositional elements—lighting, framing, contrasts, leading lines, and size—to bring more emphasis to your subject. This would be a much more complex photograph. Whenever four or more compositional elements work together to emphasize the subject, I call it *compound emphasis*. Compound emphasis is not necessarily better than simple emphasis—it's just a different choice.

Depending on the photo and your vision, either one may be best to make that photo come alive. However, compound emphasis requires much more skill and practice to execute correctly than simple emphasis. To make this point clear, let's take a look at a couple of photos of the same person (model Monique Victoria) to compare the visual effects of both techniques.

14.13

SIMPLE EMPHASIS

For the photograph in **Figure 14.13**, I wanted complete emphasis on the intricate beading detail of this stunning dress, designed by Armine Bespoke in Los Angeles. Therefore, simple emphasis was the best choice. I posed Monique to radiate elegance and to accentuate her curves to showcase the gown's fit. Once I had the right pose, I used a clean, single-color wall as a backdrop. This choice isolates Monique from any distracting elements. Then, I used size to make sure that she was the largest element in my frame. Finally, I used selective focus to emphasize Monique, not the wall. That's all. Three compositional elements (simple emphasis) beautifully showcased Monique, the pose, and the dress.

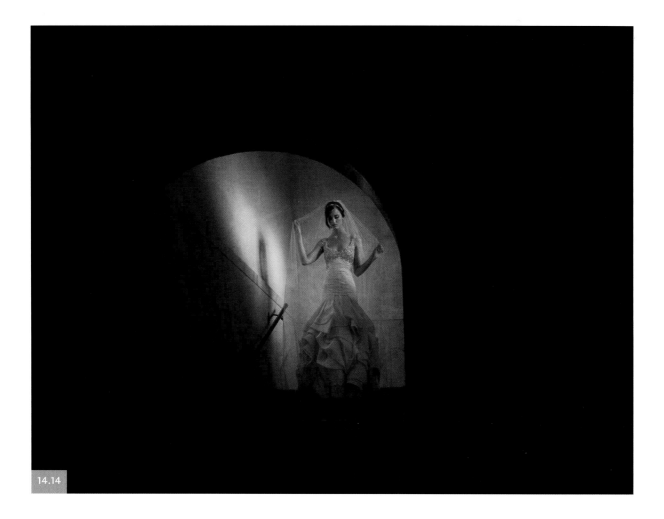

14.14

COMPOUND EMPHASIS

Now that we've seen how simple emphasis can be used to bring total focus to a pose or a dress, let's explore the visual effects of compound emphasis.

Figure 14.14: The goal for this photograph was to show how the dress looked during natural movement. Although this particular photo uses a wedding dress, the technique works the same way if you are shooting fashion. At first glance, it is clear that a lot is going on here. Most likely, the first compositional element you may have noticed is the use of framing. The handrail to the left of the image guides your eye straight to Monique. This is using leading lines. The brighter portion of the image where Monique is standing creates contrast with the darker arch surrounding the image. From where she is standing, there's nothing behind her competing for our attention. Therefore, we are using isolation. Lastly, I used selective focus to bring critical focus only to Monique and nothing else. It took five compositional elements to create that compound subject emphasis. Notice how Monique is not the largest element in the frame; the dark arch is. This provides information about the place and it works in harmony with Monique.

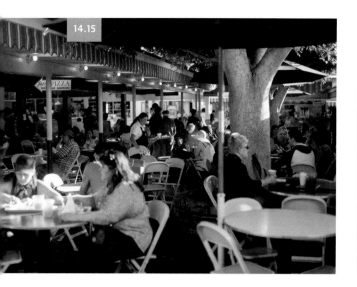

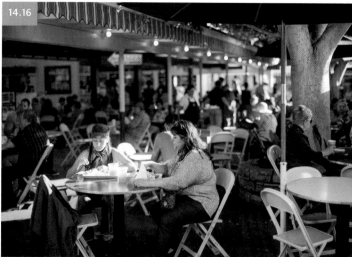

I used two completely different approaches with the same person wearing the same dress, and both were effective for different reasons. Push your creativity to create your own versions of simple and compound subject emphasis. This will require you to slow down and think before you shoot.

OTHER VARIATIONS FOR ISOLATING THE MAIN SUBJECT

Unless you are shooting in a studio environment where all the elements can be controlled, you will have to pay considerable attention to subject emphasis before you click that shutter button on location. Consider **Figure 14.15**. At first glance, you might ask yourself, "Who is the main subject in this photo?" This photo represents a perfect example of why subject emphasis is so important. The numerous colors, shapes, textures, objects, and people depicted in this photo leave you completely confused about what you are supposed to look at.

Now turn your attention to **Figure 14.16**. By using selective focus, I was able to give you some help about who my main subject is. Selective focus allows you to isolate your subject—the woman with the gray sweater and red purse—from a busy environment with many competing elements.

Figure 14.17 is a behind-the-scenes photo during a glamour shoot in New York City. I wanted to isolate model Sydney Bakich from any plumbing pipes, wall textures, windows, and so forth. To do this, I simply placed a black, foam board behind her. Now, I have completely isolated Sydney from any distracting elements, and the resulting image is **Figure 14.18**. This is a good example of using simple emphasis.

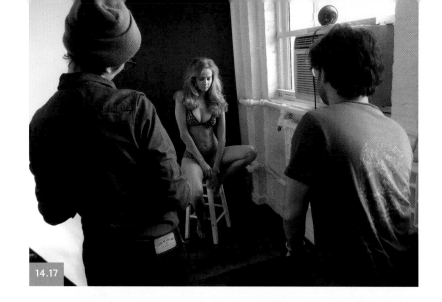

14.17

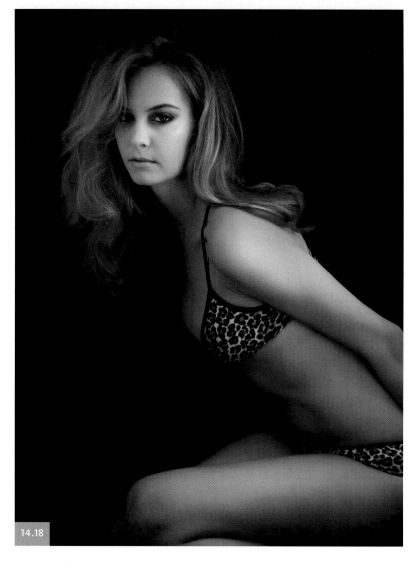

14.18

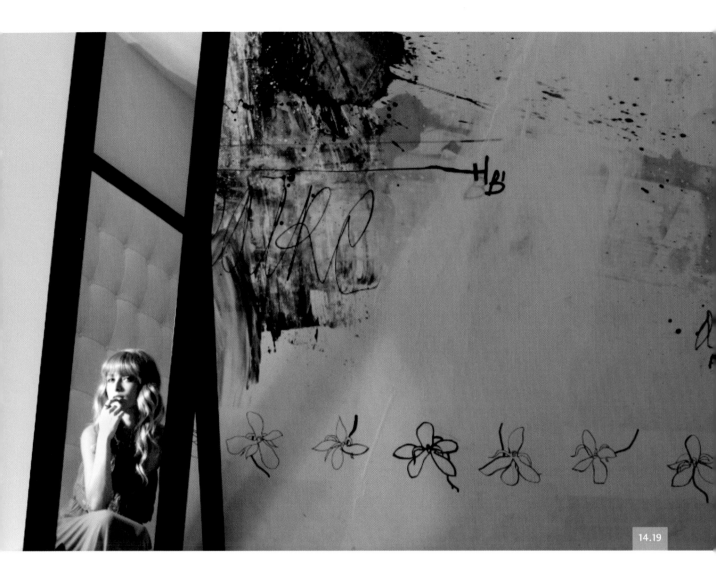

For comparison, consider **Figure 14.19**. It was taken in Cancun, Mexico, during another boudoir/glamour portrait shoot. This time, I wanted to use the elements in my surroundings to creatively bring attention to Shevelle, despite the different textures and objects in the room. A compound emphasis was necessary to achieve my goal. I moved the mirror around to capture a reflection of Shevelle; the repeating flowers near the bottom of the painting draw your eyes toward her. The mirror's frame is also being used to form a clear frame around her. I used an off-camera flash to make sure that she was the brightest element in the entire frame.

I could go on using my photographs to show you the various ways to create a compound or a simple subject emphasis, but I believe you have enough guidance to create your own. Now that you are aware of the two choices and their effects on an image, you can decide which options will best suit your vision or purpose. When you look at fashion ads, ask yourself if the photographer used simple or compound subject emphasis to showcase the clothing and whether it was effective at communicating what the brand is about. By doing this, you will quickly develop an instinct about which options work best for any given shoot.

ON YOUR OWN

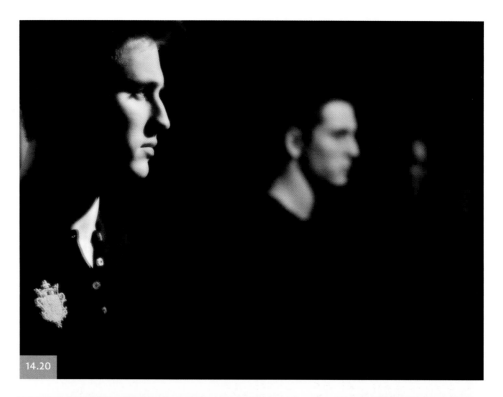

14.20

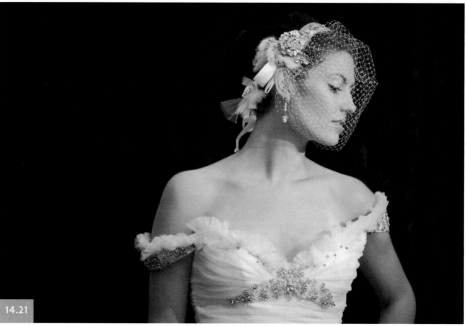

14.21

14.22

14.23

14.24

14.25

ANALYSIS

15

POSING WITH MOVEMENT, FEELING, AND EXPRESSION

THIS CHAPTER IS ABOUT putting the finishing touches on a pose. Without the material covered in this chapter, the people you pose run the risk of looking rigid, forced, and worst of all, unnatural. I place photographs in which the photographer intervened to pose his/her subjects in three main categories:

- Portraits in which the subjects are looking straight at the camera
- Portraits in which the photographer attempts to create a "photojournalistic" moment but fails to create a natural look and the subjects appear to be just following the photographer's directions
- Portraits in which the photographer creates a portrait that appears so natural that you totally connect with the moment without seeing a hint of the photographer's influence

Most photographs fall into the first and second categories. Why is that? It's because beginning portrait photographers find it much easier to have their subjects look straight at the camera essentially all of the time. It is, after all, what we have been trained to do since we were children. When someone points a camera at us, we subconsciously look at the camera and smile. This smile has become well known as our "camera smile."

Let me be clear: There's nothing wrong with the first category. Having our subject look at the camera is what creates a clean portrait, but doing so with a natural smile is another matter. A natural expression requires people skills, a savvy sense of humor, and a great sense of timing. Without these qualities, asking people to smile will yield a fake smile in all your photographs.

As a photographer, you'll encounter the second category when you venture beyond the "look at the camera" stage, attempt to create a "photojournalistic" feeling in your photographs, and fail. I put quotes around photojournalistic because the term is usually reserved for photos where the photographer captured a moment without altering the scene, expression, or any other part of the photograph. In its purest form, most people in a true photojournalistic photo were never aware they were being photographed. This style strives to capture the purest of human expressions and a wide range of emotions. Many true photojournalists risk their lives to capture such photographs.

Naturally, as portrait photographers our clients are well aware of our presence. But we can respectfully borrow the feeling of a photojournalistic photograph and apply it to our posed portraits to achieve candid expressions. This is easier said than done. To do it well, photographers must work on their people skills to break through the defensive barriers people naturally put up. Our subjects need to feel completely at ease for them to project their true selves when being photographed. For these reasons, and many more, once photographers leave the comfort of having subjects always look at the camera, they often gravitate to the second category.

I hope this chapter can shorten your learning curve and boost your photography from category 2 to category 3, which I call *posed photojournalism*.

POSED PHOTOJOURNALISM

The term *posed photojournalism* is obviously an oxymoron. As I mentioned before, the term photojournalism means that a photographer does not alter anything about the photograph. I personally love the movement and real expressions of photojournalism. Unfortunately, I cannot wait for my clients to fall into a perfect pose while having the most beautiful expression on their faces at the exact moment I happen to click my shutter button. When great moments happen naturally, I am perfectly capable of capturing them in their purest form. But, when time is not on my side I pose everything. If you do it right, you can combine the best of both worlds: a photojournalistic candid expression with movement, and a beautifully crafted pose photographed in great light.

To begin, here's a familiar scenario. During a photo shoot, as soon as we have our subjects in front of our lens we are ready to begin directing the subject's pose. We say things like "Shift your body weight," "Put your arms here," or "Turn your chin a little to the left." After we finish issuing countless directions, the pose looks completely rigid. Our subjects can barely hold on to all the pieces they were told to think about.

There's no flow to the pose, and just looking at the photo makes you feel tense. I know that feeling of frustration when you work so hard to pose someone correctly, and then

when you download the photos to your computer after the shoot, they all look completely unnatural. Read this chapter carefully and apply my recommendations at your next shoot. This is what has worked well for me and has given me the candid "photojournalistic" feel I crave so much in my posed photographs.

The key is to have a general pose in mind, show your subjects what you envision, and have them naturally move into that pose. By using movement to pose, you are automatically bringing to it a sense of fluidity. This technique might be effective to break the rigidness of a pose, but it also comes with its own set of challenges. Because you are allowing your subjects to move themselves into a pose, you will find that parts of the body settle into the wrong place and others fall into place just fine.

You must be able to anticipate which parts of the body are most likely to wreck your pose. I call these troublesome parts of the body *high-risk areas*. The other parts of the body that are important, but with naturally more forgiving poses, I call *low-risk areas*. Let me give you two typical scenarios: one where I am photographing a female subject for her modeling portfolio, and the other where I am photographing a bride.

EXAMPLE 1: POSING A MODEL WITH MOVEMENT

During a workshop, I was photographing model Monique Victoria from "America's Next Top Model." I wanted to pose her with glamour and finesse. The challenge was that we had to pose Monique sitting down. So, I first analyzed the basic pose for high- and low-risk areas. I know that when a person sits down, the risk of slouching is much higher than if the person were standing, so the spine is a high-risk area.

In **Figure 15.1** (on the following page) the red dots represent high-risk areas and the blue dots represent low-risk areas. The red dot on her torso marks a high-risk area because as she sits on the couch, her spine appears to be slouched. Remember in Chapter 1, I mentioned that slouching is never okay unless you are purposely trying to get a reaction from the viewer.

The second biggest concern is the height of her left elbow. It is so high that it's causing a major distraction and does not look very elegant. The other two red dots are on the hands because I need to make sure that her fingers are always soft and relaxed, as discussed in Chapter 7. Since misplaced hands can be so destructive to a pose, I always consider them high-risk areas.

Let's move on to the blue dots. The blue dot on her legs signifies a low-risk area, even though the current position of her legs violates the Point-of-Contact Check, discussed in Chapter 11. But by changing my shooting angle to a higher angle, I know I can put the emphasis back on her face and less on her legs. And it doesn't make much difference in this portrait if her left leg sits on top of her right leg, or vice versa. That makes this a low-risk area.

The blue dot on her arm is low-risk because although in this position it looks larger than it should, I know that this can be fixed by simply straightening her back. As she brings her chest closer to the camera to straighten her spine, it will automatically put more emphasis on her torso, and her arm will be less visible.

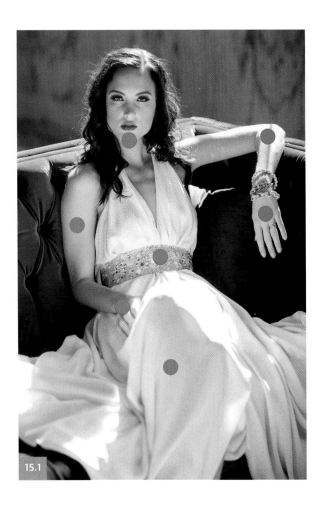

15.1

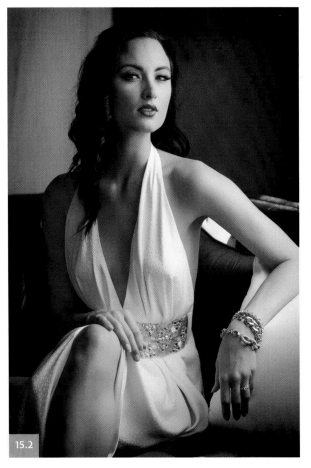

15.2

The blue dot on her face is there because a window on the right side of the photo provides beautiful light and a reflector placed on the other side of her face evens out the light on both sides. The dot means that the window light will not wreck the photo if she accidentally turns her chin left or right, since both sides of her face are evenly lit.

Once all the risks are determined, you can give more precise instructions to move your subject into the pose you envisioned. This allows the model to address the high-risk areas to make sure that she is posed perfectly. You can see the results in **Figure 15.2**. By listening to my precise instructions based on the low- and high-risk areas, Monique was more easily able to move into a beautiful and elegant pose. Take a minute to study how we addressed all the potential issues we discussed.

I know you are wondering how it is possible to think about all this during a shoot. If you try to learn all of this at once, it will certainly be difficult. That's why you do it little by little. As I said in my first book, *Picture Perfect Practice*, you cannot expect to master all of these aspects at once. With experience and solid practice, you will soon be able to determine the high- and low-risk areas of a pose without much effort.

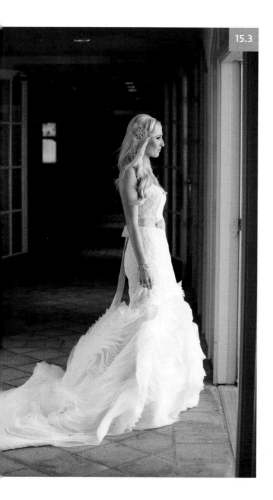

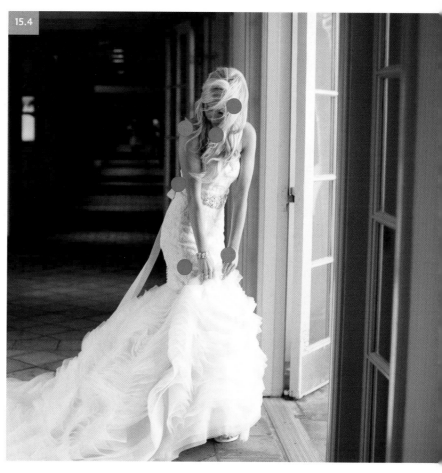

EXAMPLE 2: POSING A BRIDE WITH MOVEMENT

Now let's explore how to introduce movement to create a pose that appears to be photojournalistic, even though it was posed from head to toe. Although this example uses a bride, it doesn't matter whether she is a bride. The principles apply equally to anyone.

Let's begin by harnessing an opportunity that has been presented to us in **Figure 15.3**. There is a long, dark hallway with a door on the right leading to a patio of the Ritz Carlton in Laguna Niguel. Now, we have a few choices to make. We could take advantage of the beautiful light created by the doorway and simply pose the bride in front of it. As you can see, the pose looks static and dull. It has great light, but we need more than good light to create an amazing image. This is where posing with movement comes into play.

It makes sense to pose the bride as if she were preparing to walk through the doorway to the patio. The act of walking toward the door is the perfect excuse to create the movement we need to remove the lifelessness of the original pose. Next, we have to pose the hands. Since she is going to be walking out the door, it would make sense to use her hands as a tool to hold up her dress, as described in the Hand/Arm Context System in Chapter 6. The results of these changes are reflected in **Figure 15.4**.

This image also shows the problem areas I noticed on my first attempt to create this pose. The red dot on her right leg is crucial, because I needed to make sure that leg leads the step. When you're photographing women, it's advisable to bend the leg closest to the camera. There's a red dot on her back because when she reached down to hold up her dress, she accidentally curved her thoracic spine. There's an unacceptable hunch to her upper back. As for the red dot by her neck, I realized I had forgotten to ask her to elongate her neck to create a more glamorous pose. It appears as if she was ducking. The red dot on her hair is there because I cannot have a beautiful portrait of the bride if her hair is covering 80 percent of her face.

The blue dot by her right shoulder is a low-risk area because as soon as she straightens her back and raises her head to elongate the neck, her shoulder will automatically drop. In this image, her shoulder is far too high. The blue dot by her hands is there to make sure she doesn't make a fist when she holds onto the dress. If she does, however, it will not wreck the photo—unlike the sections marked with red dots. Having assessed the situation, I asked her to return and start walking toward the door again. This time, I adjusted my instructions based on the high- and low-risk areas. The final result is shown in **Figure 15.5**.

Sometimes I have to make mistakes as I am posing my clients before I can correct them. These photos are true examples of my thought processes and how I turn an ordinary photo with no wow factor into an iconic image.

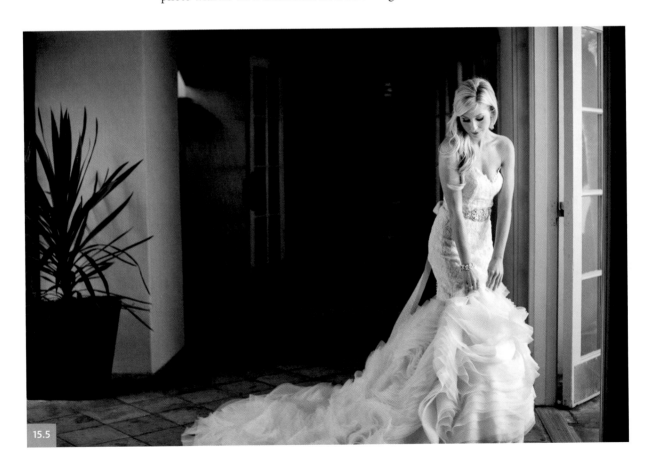

15.5

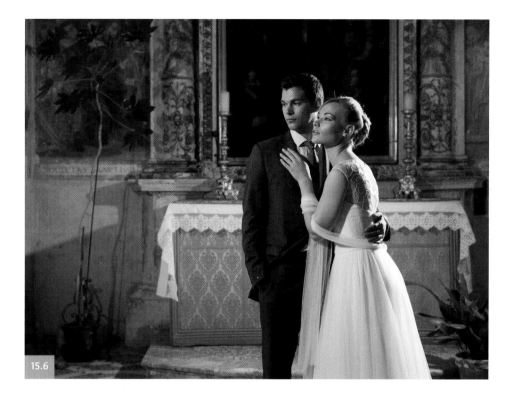
15.6

WHEN POSED PHOTOJOURNALISM FAILS

In the previous section, you learned how to create a photo that appears candid or photo-journalistic in nature. However, not every attempt is a success. For example, **Figure 15.6** did not turn out as planned. As soon as you look at this image, you realize that it looks staged. Sira's expression is a bit overdramatic, and the male model's energy does not seem to match hers.

It is just as important for your growth as a photographer to recognize when and why a photo fails as it is to be able to create images that look natural. This photo failed for several reasons. Both of their stances are too stiff, because they distributed their weight equally between both feet. As mentioned in Chapter 2, the pose would have appeared more relaxed had I asked them to shift their weight to one foot. Next, no part of their body is in motion. It looks as if they placed themselves in the pose and held it until the photo was taken.

This photo was taken during a workshop I was teaching in Switzerland. If I remember correctly, they were standing in this pose for more than five seconds because they were waiting for me to manually focus my Hasselblad camera. Had I pre-focused before I had them pose, the issue of holding a pose for too long would have been fixed.

Last but not least, their expressions are completely off because their eyes were not posed correctly. Eyes dominate any expression. I should have asked her to lower her chin and look at a spot on the floor near his feet. This would have placed her head and eyes in a better position to make the expression more believable.

The male model should have been facing her with his forehead pointed toward the side of her head. If the groom's head had been turned, it would have crossed their nose directions, as explained in Chapter 13. In fact, this photo violates one of that chapter's major points: Do not have the noses run parallel to each other. That's precisely what's happening in this example, which is why the photo seems a bit cheesy.

There are so many lessons to be learned from our mistakes. Do an analysis such as this on a few photos from every photo shoot, and you will learn and retain the lessons better than you can imagine.

FLASH CARD

Having your subjects hold a pose for more than three seconds will most likely result in a fake expression. For the most part, a genuine expression lasts only a couple of seconds.

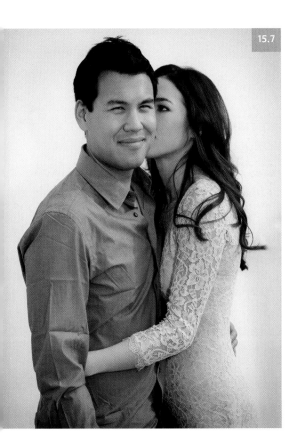

15.7

WHY POSING THE EYES IS SO IMPORTANT

There is nothing more important for a great expression than the eyes. If the eyes are looking in the wrong direction, they will derail the pose faster than anything else. For this reason, take the time to study how to pose the eyes. When I ask photographers from around the world what they do about their subject's eyes, most of them respond that they have never really thought about posing the eyes or haven't paid much attention to them. Considering that your subject's eyes can make or break a photograph, this always surprises me. To prove the point, let's compare two photos of my sister-in-law Sarah and her fiancé Neal.

Figure 15.7: This photo had great potential to be a keeper because everything is posed fairly well. But both pairs of eyes are posed completely wrong, which makes this photo almost painful to look at. It's not so bad that Neal is connecting with the camera, but Sarah being so close to his face with her eyes wide open is just awkward. I purposely posed them this way to leave no doubt in your mind how important posing the eyes can be.

15.8

Figure 15.8: Now for the real photograph. After taking the silly photo, I switched them around, and this time, I posed their eyes. I asked Neal to smile with his eyes closed and Sarah to look at a specific spot on the ground. The crucial next step was to make sure they locked their eyes on the specific spot I mentioned. No matter what I said or how hard they laughed, their eyes stayed fixed! This photograph is a testament to this technique. As a matter of fact, I did make them laugh, which makes their expressions real and their eyes under control. If Neal had opened his eyes wide open, as Sarah did in Figure 15.7, the photo would have been ruined.

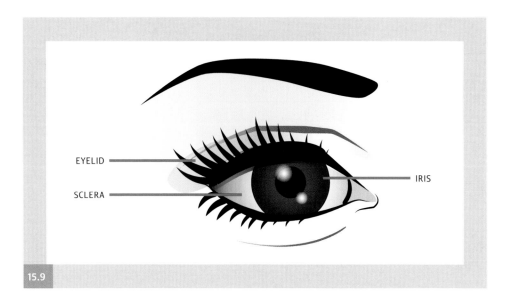

15.9

THE THREE PARTS OF THE EYE

For photographic purposes, we need to pay special attention to just three parts of the eye. These three areas are always on my mind during a photo shoot. Through different combinations of these three parts of the eye, our subjects can appear happy, seductive, surprised, thoughtful, angry, sexy, or charming. Before I click that shutter button, I ask myself if all three parts of the eyes are in the right place for the expression I'm seeking (see **Figure 15.9**).

THE EYELID

What you need to keep in mind with the eyelid is how open or closed it is. If, for example, the eyelids are fully open, the person will appear exceedingly focused, almost like a hunter about to claim prey. If the eyelids are halfway closed, the feel changes to a more seductive, glamorous, or romantic expression. A completely closed eyelid could symbolize a soft and thoughtful expression. If a person laughs, but feels shy or vulnerable doing so, they usually look down with their eyelids almost closed. See **Figures 15.10**, **15.11**, and **15.12**.

THE SCLERA

The sclera is the white part of the eye. It plays an important role in a photograph because if too much white shows with almost no iris, the person can look a bit like a ghost. It's not attractive to see 90 percent of someone's sclera unless you are doing a Halloween shoot. I have lost count of how many potentially great photos I have ruined because I did not pay attention to how much sclera was showing from my camera angle. Choose a camera angle that shows more iris than sclera; see **Figure 15.13**.

15.10

15.11

15.12

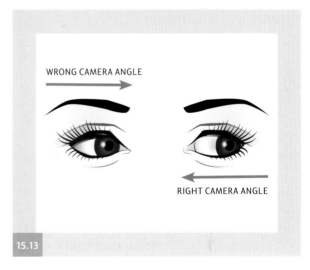

WRONG CAMERA ANGLE

RIGHT CAMERA ANGLE

15.13

THE IRIS

The iris is the colored part of the eye, as shown in Figure 15.9. When the iris moves up or down, the eyelid will move with it, but the iris can move independently of the eyelid when it moves left or right. This means that you can choose to have the iris look in different horizontal directions without altering the eyelid. When posing the eyes, I usually position the eyelids first, and then I address the irises. Being aware and deliberate about good iris positioning will pay off tenfold when you create the exact look and feel that you want.

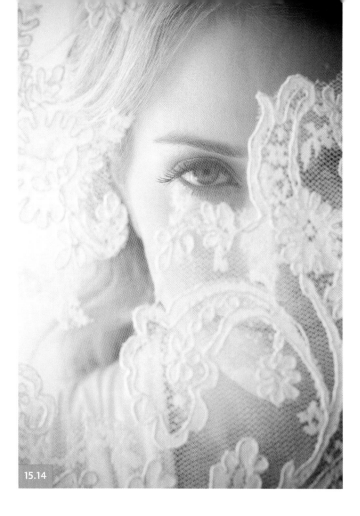

15.14

TECHNIQUES FOR POSING THE EYES

This section explores some powerful techniques I use to achieve a beautiful expression based on the look and feel of the eyes.

GIVE THE BRAIN A TASK

One of the most iconic images of my career is the photo I took during Brittany's wedding, which became the cover of my first book, *Picture Perfect Practice*. This photo was a success purely based on the posing of the eyes; see **Figure 15.14**.

To get that infinite gaze that is incredibly captivating, I first positioned her head a couple of inches below my camera angle. This forced Brittany to raise her irises to look into my lens, which in turn opened up her eyelids exactly right. Once in position, if I had simply asked her to look at the camera the look on her face would have been less than desirable. I needed her to mentally ignore that there was a camera with a large macro lens pointed straight at her face. The technique I used to accomplish this was to occupy her mind with an unrelated task.

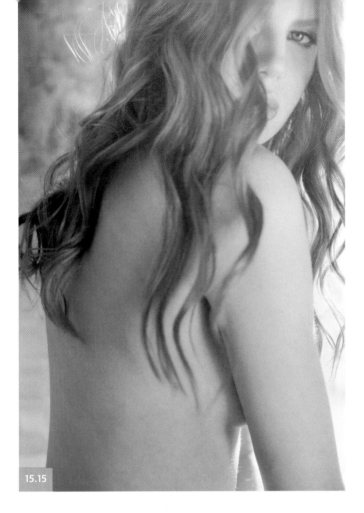

15.15

I asked her to look through my lens but not at my lens, and to tell me as quickly as possible when she saw the shutter open and close inside my lens. I told her it was going to be lightning fast, so she really had to focus 100 percent on this task, or she would miss it with a single blink of an eye. "Ready?" I asked.

As I slowly pointed my large 100mm macro lens at her face, concentration completely took over her expression. Her brain wasn't thinking, "I'm having a photo taken!" Instead, she forgot for a second about being photographed and completely focused her mind on her task. That shutter was opening and closing at a very high speed, and so it required her full attention. The results were glorious! It is one of my all-time favorite images.

The task you give your clients must be easy enough but also require their complete attention. During a photo shoot in Tallinn Estonia, for **Figure 15.15** I first positioned my lens well below the model's face to control how closed I wanted her eyelids to be. I know that if the eyelids are halfway closed, the model's expression will be soft and glamorous, instead of aggressive, which often happens if the eyelids are wide open. I covered one of her eyes with her own hair to add a sense of mystery and romance to the photo. Finally, to keep her brain busy for a second so she would forget about the photo shoot, I just asked her to stare down the barrel of my lens and watch the movement going on inside as the lens attempted to focus. That was enough for her eyes to go from "What am I looking at?" to this dazzling gaze in her eyes.

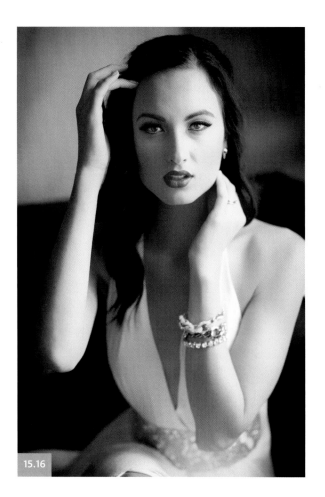

15.16

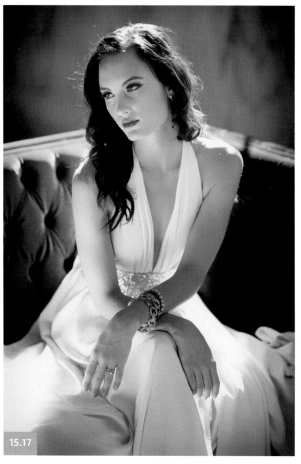

15.17

GIVE THE BRAIN SOMETHING TO COUNT

By giving the brain a quantifiable task, such as something to count, a different part of the brain called the *parietal lobe* is summoned. The look in people's eyes when they are in the middle of counting something cannot be easily replicated. You can feel how the whole world is ignored in order for them to fully concentrate. The way the brain handles counting is photographic magic! Let's examine why. We will compare two posed images taken seconds apart at the same location. In one photo, the model was asked to just look at the camera, and in the other, the model was given a counting task.

Figure 15.16: For this photograph, I posed model Monique Victoria sitting on a blue sofa. Once her hands, arms, neck, and head had been posed, I said, "Would you please look at the camera?" Looking at this image, you can tell that she is engaged at a low level. The task of merely looking at the camera is not challenging enough for the brain. The result is a photo where the viewer is only superficially intrigued by her physical beauty. There's no deeper engagement between the model and the viewer, almost as if we were seeing a posed mannequin in a store. We see what it is wearing and don't give it a second thought. Now, let's see what happens to this model/viewer relationship when the model is asked to count something.

Figure 15.17: Monique was still sitting on the same blue sofa as before, except this time her arms were posed resting on her legs instead of framing her face. Then, I asked her to count how many iron bars she saw in a fence outside. The fence was to her right, which is why she turned her head that way. Look at the gaze in her eyes. It makes you wonder what it is she sees that is so intriguing. There is a soulful sense to the photograph. She is in thought, but you don't know what she is thinking. Now the viewer can see more than just her beauty and relate to her as a human being. This is the magic of the brain's parietal lobe at work.

The same counting technique was used for **Figure 15.18**. I wanted this photograph to be intriguing on several levels. The dress, the flower arrangement, and her headpiece were all demanding visual attention. But I wanted her expression to have meaning as well. This photo is much more interesting than if she had just been looking at the camera and smiling.

15.18

HAVE YOUR SUBJECTS CLOSE THEIR EYES

Closing your eyes is almost like pushing the reset button for your expression. It is a brand-new start, a new way of looking at your surroundings. When the eyes are closed for a second, they seem to immediately rest, because when your subjects open their eyes again, their look is fresher and more aware. Why does this happen?

Well, the human eye can adjust to changes in luminance levels by a factor of 100,000,000 using the hypersensitive cells in the retina called rods and cones. It takes these cells only a second or so to determine the amount of light and make the proper adjustments. The good news is that this tiny window of time gives photographers just enough time to take a photograph of people in bright light with their eyes wide open without squinting. The size of the pupil is affected not only by how much light enters the eye but by mood.

If you become scared, angry, happy, frustrated, or surprised, your pupil size will change. Eyes physically react to what they see and how an individual feels. Most importantly, to have the eyes completely relaxed and cleared of any expression or reaction, you must take advantage of the short time it takes the eye to physically react to the environment and to your subject's mood. One great example of this technique at work is the photo on the cover of this book. See **Figure 15.19**.

I relied on this knowledge of the eye's behavior to clear all expression from Kristen's eyes. This was critical for the success of this photo. I did not want Kristen's eyes to convey anything about her mood. I needed to eliminate any chance viewers would relate to her in any way and instead see her almost as a statue or a character in a video game. To achieve this, I had to make sure every muscle in her face was completely relaxed. I wanted no telltale signs of human expression. This way, her lack of expression would completely captivate viewers as they try to figure out what about this photo draws them in.

Once the pose was set and her hands were positioned, I asked her to elongate her neck as much as possible without tilting her head. This was a tough position to hold, so there was natural tension in her body language. To release this tension, I asked her to slowly breathe in and out as she focused on relaxing all of her facial muscles. To eliminate all expression from her face, I asked her to close her eyes, open them slowly, and stare right through the barrel of the lens. It took a few attempts of closing and opening the eyes to get the perfect face, but at last it happened, and I couldn't have been happier. When I saw that photo on the back of my camera, I knew immediately it would be the cover of this book.

FLASH CARD

By having your subjects close and reopen their eyes, you can take photos of them facing bright sunlight and also reset their expressions. But you have only a little more than one second to take the photo before the eye's retina and pupil react to the bright light or to the surroundings.

15.19

15.20

15.21

BRINGING FEELING, MOVEMENT, AND EXPRESSION ALL TOGETHER

It is a bit of a dance to bring feeling, movement, and expression to a single photograph. Sometimes, two of them are perfect but the expression is not all there. To help you with this process, first think of the overall feeling you want in a photograph. Do you want the photo to feel candid, charming, sexy, seductive, innocent? If you don't have a general feeling in your head, how are you supposed to direct your subjects? After you have decided what feeling you are striving for, you will be better equipped for the second stage: movement.

Two questions should come to mind before directing your clients. First, does the whole body need to move to better achieve the desired pose, or should the subject actually walk into the pose? And second, could I just move a portion of the body? The answers to these questions will strongly influence the final result.

For example, in **Figure 15.20** it proved much easier to use motion to create that strong S curve from the subject's head to her waist. I asked her to move one leg forward as if she was about to take a step, arch her back, and tilt her head forward as if she was looking at the design on the floor. Try doing all of this while standing still and you will see how difficult it would be to make it appear effortless. But do it in movement, even if it takes you three or four attempts, and it all flows together.

The same principle was applied for **Figure 15.21**. Even though the model is standing on the same spot, there appears to be fluid movement in the pose. I first told her where and how to pose her legs, how to hold onto the jacket, how to place one hand higher than the other, and then how to bring her chin up. Finally I asked her to do it with her eyes closed until the last second, and then open them and look at my camera. Remember that it takes

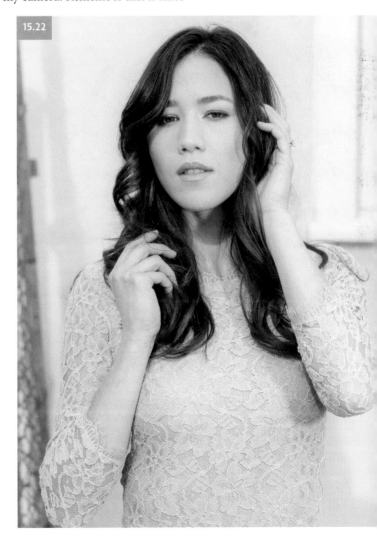

15.22

a few times to get it right. The resulting photo of Sydney Bakich is very fashion oriented, but it also has movement, grace, and fluidity, and best of all, it looks glamorous and effortless. Notice the beautiful expression in her eyes; that's the result of opening her eyes at the last second before the photo was taken.

When moving only part of the body, such as the torso, you must not neglect posing the feet, even though they don't appear in the photo. The way the feet are posed will always influence a person's upper body. The ratio of body weight distributed between both feet makes the difference of whether a pose looks effortless or rigid.

Figure 15.22 was posed thinking of the feet first. The biggest challenge here was the way Sarah's hands were posed and her facial expression. After I demonstrated how to pose her hands and fingers, I again asked her to close her eyes and look at the camera on my count to three. Sarah's feet and legs were posed but were not in motion. Only her upper body, hands, and head were moving into the pose.

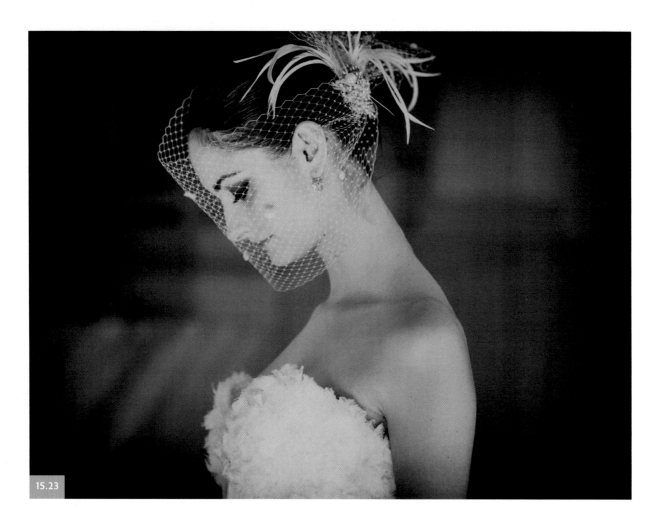

15.23

For **Figure 15.23**, the goal was to showcase the beautiful headpiece designed by Celadon & Celery Events and the elaborate detail on the dress designed by R-Mine Bespoke. As a consequence, there was no need to use the arms to frame the face. Hands draw attention to themselves, and all of the attention should be on the headpiece and dress, not on the hands. To create a pose that best met the goal, I first asked Dylan Quigg to stand with her left foot over her right and shift her body weight to her back foot. This shift allowed me to arch her lumbar, bring her shoulders as far back as she could, and balance her upper body by bringing her head forward. Moving her shoulders back let the dress show through and tilting her head forward elongated her neck and isolated the headpiece beautifully.

During a photo shoot in Switzerland, I was having a hard time achieving the feeling I wanted for **Figure 15.24**. The Swiss forest reminded me of a scene in which a startled deer spots a potential hunter in the woods. The deer would naturally feel exposed and vulnerable. To bring this theme into a photograph, I had to stop for a minute and think about how a woman would react if she found herself in a similar predicament.

The first, instinctive reaction would be to shield her body. I decided that her arms and hands would be used to cover herself, but the pose had to be done with her arms as

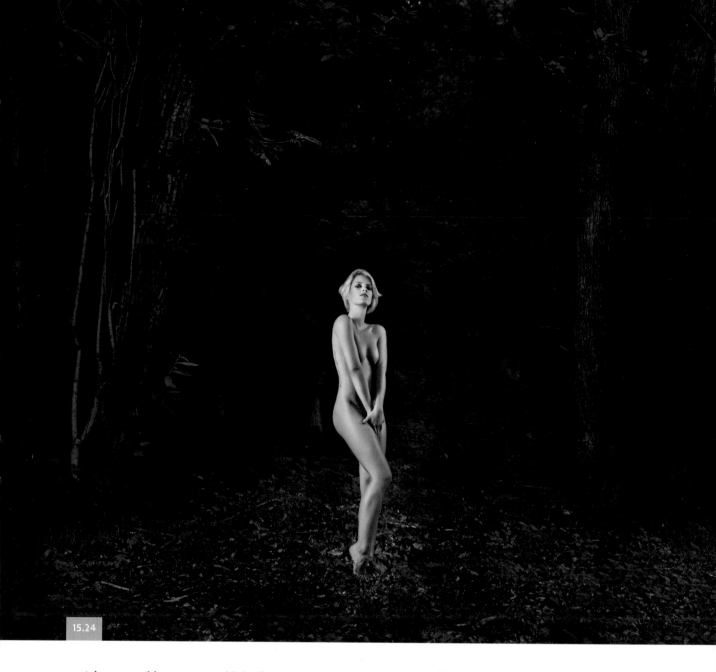

15.24

straight as possible, as you would do if you were trying to protect yourself. As explained in previous chapters, the leg closest to the camera should be bent. But, after a few attempts, something was still wrong.

The issue was the position of her chin. When her chin was down, she did not appear to be in high alert mode. But with her chin up, she looked perfect! To bring it all together, I asked her to walk a few feet into the pose with her chin down and eyes closed. When she walked almost to the marked spot where she would go into the pose, she raised her chin and opened her eyes with a sexy but still cautious expression. As usual, the effort paid off. By not rushing the photo, I was able to really hone in and craft it impeccably. This photo of Miriam in Switzerland has become one of my all-time favorite fine-art photographs.

ONE LAST WORD

It will take constant awareness of these three posing elements and much refinement to fine-tune your skills and to bring these elements together at every photo shoot. Trial and error will be your constant companion, but when all three concepts come together in a single photograph, it will not only bring a huge smile to your face but it will also give you a new sense of appreciation for the art of photographing people.

ON YOUR OWN

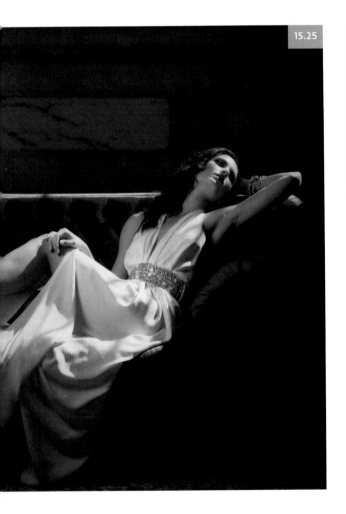

15.25

15.26

15.27

15.28

15.29

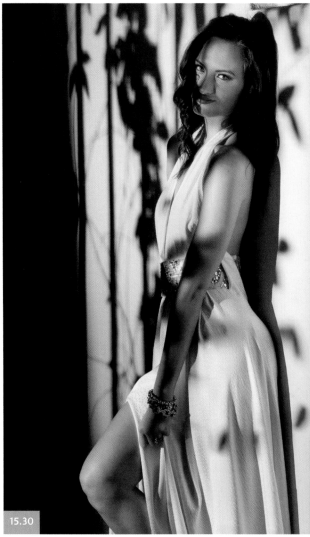

15.30

ANALYSIS

POSING COUPLES WITH THE PICTURE PERFECT POSING SYSTEM

P3S POSING CHART FOR COUPLES

TRADITIONAL	HIM BEHIND HER	HER BEHIND HIM
WALKING	KISSING	PLAYFUL/ACTION/ MOVEMENT
HOLDING HANDS	SITTING	TOGETHER SIDE BY SIDE
INTERPRETIVE	DISTANCE APART	HUGGING
FOREGROUND/ BACKGROUND	FACING EACH OTHER	KISS ANTICIPATION
FEATURING HIM	FEATURING HER	T-POSE

16

POSING COUPLES WITH THE PICTURE PERFECT POSING SYSTEM

IN MY PREVIOUS BOOK, *Picture Perfect Practice,* I wrote a brief explanation of each of the combinations in the couples posing chart. But for this book, the intricacies of posing couples will be approached from the Picture Perfect Posing System (P3S) taught in the previous chapters of this book. Fortunately, there's no need to reinvent the wheel when posing couples. You just apply the P3S to two people instead of one. Doing so will steer you 80 percent of the way to a great pose, with a few tweaks for fine-tuning. The other 20 percent is how you manage the couple's expressions, interaction, and energy. The energy that one person emits must be matched by the other. In other words, energy and expression must be compatible.

An effective photographer should always prioritize a true moment and a candid expression over trying to be a perfectionist about every aspect of posing. When photographing couples, keep in mind that a flawless pose is not the only consideration. You must take into account that the couple could

be playful, spontaneous, funky, or serious. More importantly, most couples do not want to be photographed as perfectly carved statues; they want their true personalities to show through in the photographs.

That being said, with practice and commitment, I believe you can both achieve a great pose and capture the couple's true personalities. Notice I said a *great* pose, not a *perfect* pose. To be effective at photographing couples, you must feel okay with some things going wrong with the pose in order to capture a wonderfully spontaneous moment. For example, you may see some tension in their bodies, their fingers may be piled together, or their body ratios may be out of balance. These are some examples of many missteps that can occur despite your best efforts. I know that the two most important aspects of a couple's pose are to obtain a great and genuine expression from both of them and to pose their hands and arms properly. Therefore, I allocate more of my posing resources to these two areas. Once these areas are established, I do my best with the rest of the pose, and if something still goes wrong, I'm fine with that. At least I know that my efforts contributed to the pose being 80 to 90 percent flawless. The rest is, and always will be, beyond your control.

REVIEWING THE POSES

In the following pages, I review the poses from the chart. Each review includes three subsections—Pose Foundation, P3S, and Tips—that will provide you with the necessary information about each pose.

- **Pose Foundation:** The photo in this section gives you a bare-bones visual reference for the structure of the pose and serves as a starting point. From there, you can use the P3S to begin styling the pose and make it your own. It is always a good idea to start the posing process from the ground up, which creates a systematic approach to help you leave nothing out. With practice, this systematic approach will become second nature, and you will be able to pose couples with greater ease.

- **P3S (Picture Perfect Posing System):** The P3S section examines oversights in the pose foundation photo and offers corrections to create a successful photograph. It also includes references to previous chapters so that you can go back and review relevant material. If you take the time to review previous chapters in this way, these posing points will be more ingrained in your brain than if you just read this chapter without referring back to the others.

- **Tips:** These tips will offer insight into what I have found works best for each of the poses, as well as some things to watch out for.

TRADITIONAL

Pose Foundation

A traditional pose (**Figure 16.1**) means different things to different people and cultures. However, for the most part a traditional pose is when a couple is close together and both are looking at the camera. This pose is a classic, because it is absolutely necessary for

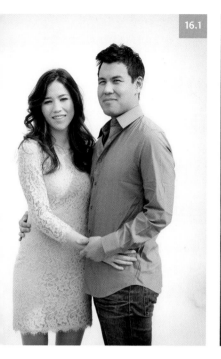

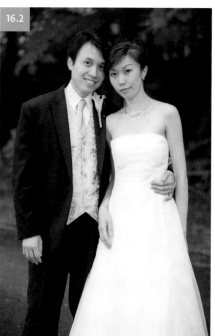

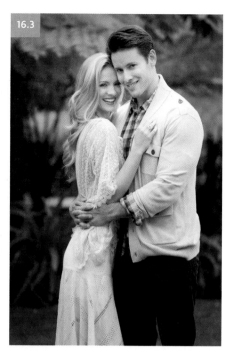

event photography, such as weddings, or simply for clean photos of any couple. Posing the couple correctly is important because, by its nature, it is a simple portrait where any flaws quickly become apparent.

P3S

In Figure 16.1 you'll note a few P3S oversights that are immediately obvious. For example, both of them are not distributing their weight on one foot more than the other. Therefore, their knees are locked, and the pose looks stiff (Chapter 2, "Weight Distribution and Its Effect on Posing"). Neal's right hand is coming out of Sarah's waist (Chapter 8, "Origin of Hands and Fingers"). Their interaction is neither relaxed nor genuine, and their heads are too far away from each other, emitting a defensive energy (Chapter 10, "Interaction and Placement of Subjects"). Sarah's right hand is bringing attention to Neal's stomach. Neal is in good shape, so it's no big deal in this photo, but it would be undesirable if your subject is not in such great shape (Chapter 6, "The Hand/Arm Context System").

In **Figure 16.2**, their heads are better positioned but everything else is completely out of control. You must be diligent at correcting these issues with the pose as you shoot. The couple in **Figure 16.3** have great interaction and expression. Their energy is very inviting and compatible. The hand and arm placement is in perfect position. But his fingers are piled or crisscrossing each other, creating a distraction (Chapter 7, "Stylizing Hands and Fingers: Advanced Techniques").

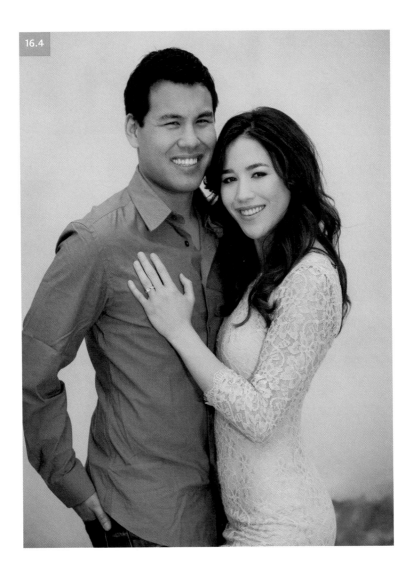

Figure 16.4 is the result of addressing most of the oversights previously mentioned. Both of their spines are straight, so they are not slouching. Sarah's lumbar spine is nicely curved, enhancing her feminine curves. Their energy is positive, inviting, and compatible. Gaps have been created to display both of their waistlines. Hands and fingers are well placed away from the stomach and are completely relaxed.

Tips

If you had to choose one pose to absolutely master, it should be the traditional pose. It is the most versatile of all poses. Make sure that the couple's energy is toward each other when doing this pose. This pose works well as a full body or as a half-body crop. Both of their facial expressions are clear to the camera, so it is especially important to strive for a great expression on both subjects. Since the hands are very visible in this pose, pay particular attention that the hands are engaged. Clean and equal intensity of light should be present on both subjects.

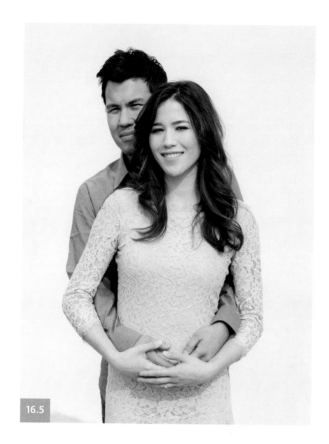

16.5

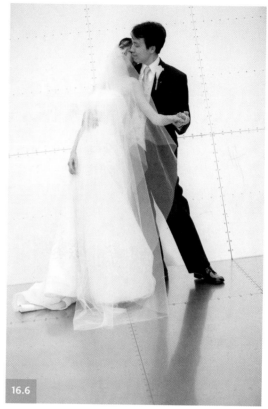

16.6

HIM BEHIND HER

Pose Foundation

As the name suggests, the bare bones of this pose are simple: the man is standing behind the woman. Naturally, the foundation pose in **Figure 16.5** is only a starting point. But from here, you can create countless variations that look much more dynamic and balanced.

P3S

The major oversight in Figure 16.5 is how much of Neal is being blocked by Sarah's body (Chapter 12, "Balancing the Subject Ratio"). The second most pressing issue is that Neal's expression does not match Sarah's happy expression; therefore, there is a lack of compatibility in their expressions, which is a big no-no when posing couples (Chapter 15, "Posing with Movement, Feeling, and Expression").

Figure 16.6 is suffering from more oversights than I can count, but let's list a few. Her spine is bent backward past the threshold point (Chapter 1, "Understanding and Posing the Spine"). Her stomach is the closest part of the body to the camera instead of her eyes (Chapter 11, "Point-of-Contact Check"). His right hand is coming out of nowhere around her waist (Chapter 8, "Origin of Hands and Fingers"). Their interaction is awkward (Chapter 10, "Interaction and Placement of Subjects"). There are more oversights, but I'll stop for the

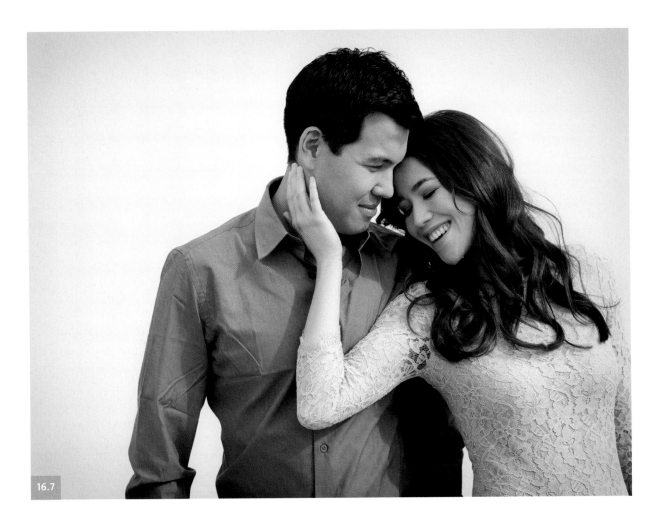

16.7

sake of your sanity. What was done right in the photo is that their noses are crossing, creating an X-Factor, and the ratio of each of their bodies showing to the camera is almost equal.

In **Figure 16.7**, most of these issues are addressed. The main thing you will notice is how nicely this pose can showcase their interaction with each other. Neal's right arm was separated from his body enough to show his waistline. Because this crop shows their upper bodies, it was also important to have a clear definition of Sarah's waistline by arching her back enough to show the white wall in the background. Their subject ratio is nicely balanced. Sarah's right hand is relaxed and elegantly posed without covering Neal's face, and all of her fingers are pointing in the same direction.

Figure 16.8 is another of many variations of this pose. In this example, I switched both of their hand positions to keep all hands engaged with each other. However, her left hand seems to be coming out of nowhere. As I said before, I'm fine with that because their expressions are genuine and the rest of the pose is absolutely beautiful. It takes quite a bit of effort for the couple to give you a genuine expression when they are both laughing and completely engaged with each other. Stopping the moment because Sarah's left hand

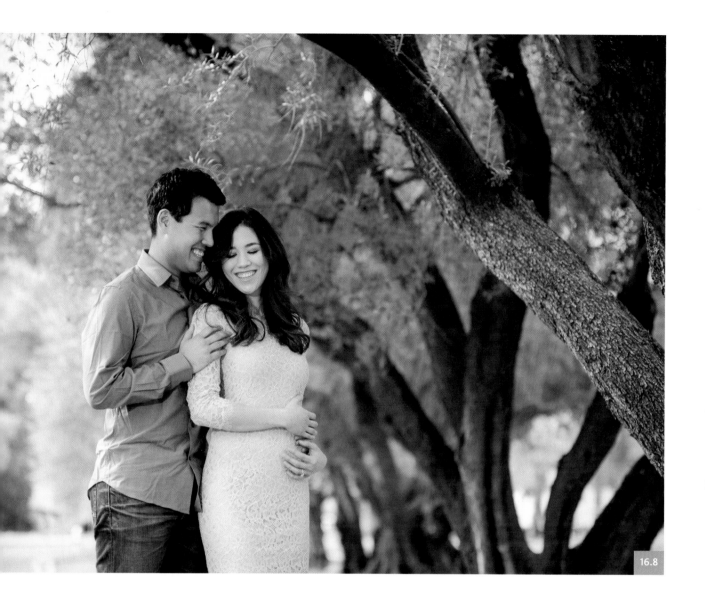

16.8

is positioned contrary to the teachings in Chapter 8 ("Origin of Hands and Fingers") would make the couple feel as if their efforts to give you a great expression was in vain. Furthermore, once you fix the hand the couple will dread having to re-create their genuine expressions. Unless you are working with professional actors, re-creating expressions seamlessly is difficult and uncomfortable for most people. Therefore, either attempt to fix the high-risk areas mentioned in Chapter 15, "Posing with Movement, Feeling, and Expression," before you push the couple for a reaction or accept a few imperfections to keep the flow of the photo shoot positive.

Tips

If the man is taller than the woman, most likely he will hunch his back to try to reach her face to kiss her. It helps to reach a higher part of her face, such as the forehead.

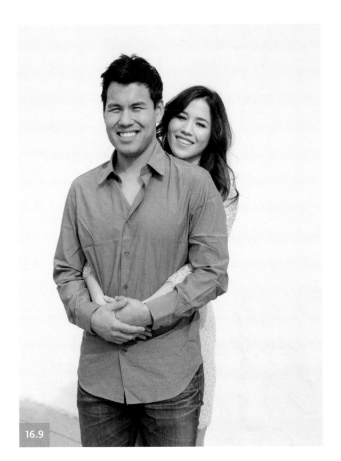

16.9

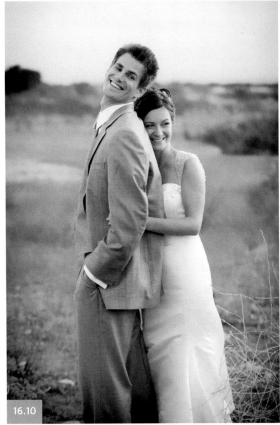

16.10

HER BEHIND HIM

Pose Foundation

The pose in **Figure 16.9** can be very charming, but it is more challenging to pull off correctly. A man's body is usually much wider than a woman, so it takes some finesse to balance the pose.

P3S

In Chapter 12, we went over the importance of balancing the subject ratio. Figure 16.9 illustrates the reason. We see all of Neal but very little of Sarah. A disproportionate ratio like this could make people look as if they were growing another head out of their shoulder. This photo also has their hands mirroring each other (Chapter 9, "Avoid Mirroring"). This is causing a pile of hands, all bringing undesired attention to Neal's stomach. As I said before, he is in great shape, but another person would not appreciate bringing so much attention to that area. You have to be careful where you place the hands.

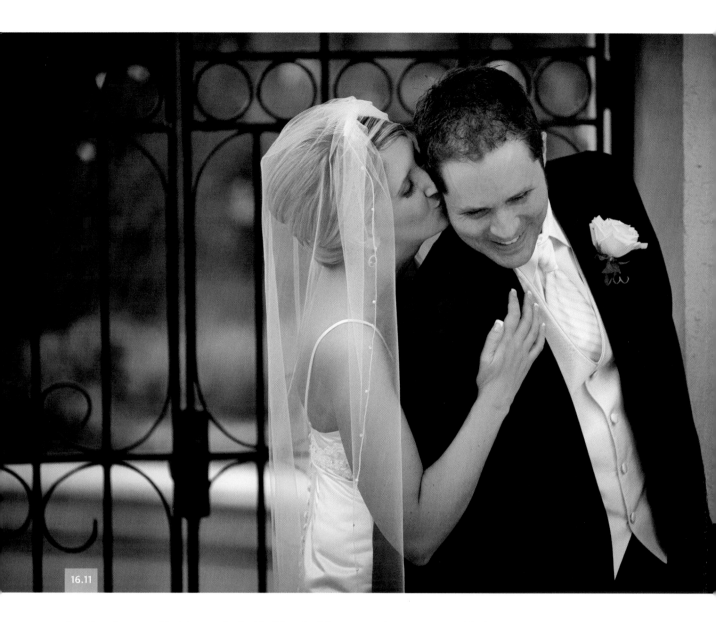

16.11

Another danger with this pose is the likelihood of the man trying to engage with the woman by turning his head past the threshold of comfort, as shown in **Figure 16.10** (Chapter 1, "Understanding and Posing the Spine"). To prevent the man from awkwardly turning his head, I usually have him look down toward the ground, as in **Figure 16.11**.

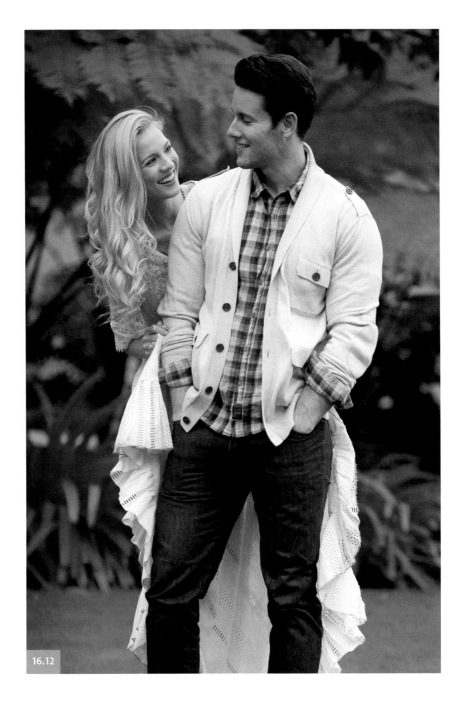

16.12

Another option is to create a playful look by having the woman wrap herself around his side and playfully engage with him, as in **Figure 16.12**. Or the photographer can take a fine-art approach and have the man look elsewhere while the woman engages serenely with the camera, as in **Figure 16.13**.

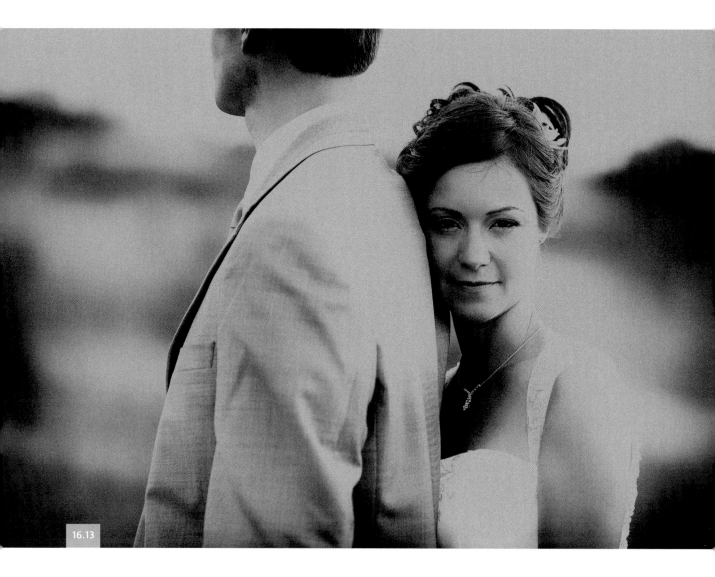

16.13

Tips

This type of pose works best with a tighter crop. A full body shot of her behind him increases the chances of the photo looking awkward. The legs and feet of the couple probably usually do not add much to this type of pose, so why include them? Keep in mind the subject ratio when attempting this pose, and watch for the man's head turning past the spine's threshold to engage his partner.

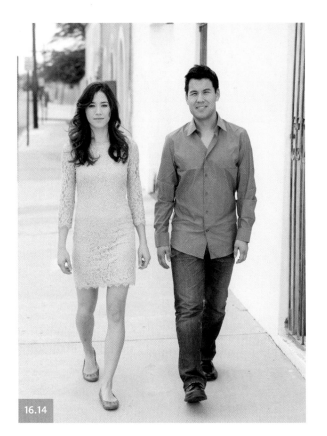

16.14

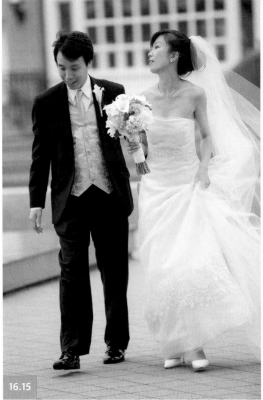

16.15

WALKING

Pose Foundation

Asking a couple to walk for a photo (**Figure 16.14**) is one of the most common types of poses photographers use. However, judging from the pure foundation of this pose, having people simply walk without any explanations can look rather stale and staged. There has to be some sort of interaction between them. Also, keep in mind that actually watching someone walking is not that strange, but freeze a walking couple in a photograph and all sorts of strange quirks rise to the surface. To achieve a great walking shot, you must take the time to stylize the walk so that it appears flawless and attractive.

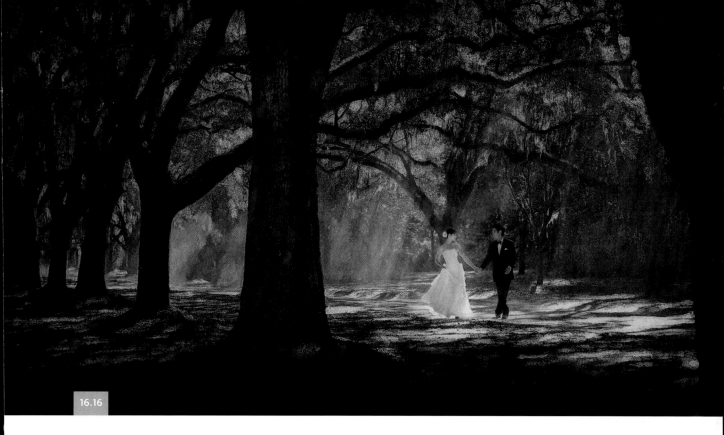

16.16

P3S

Before realizing that I had to explain to my clients how to walk so that it looks good in a photograph, the common results of a walking pose looked something like **Figure 16.15**. There is zero interaction between the couple (Chapter 10, "Interaction and Placement of Subjects") and his back is slouching (Chapter 1, "Understanding and Posing the Spine"). Nowadays, I ask my clients to walk as if they were walking on a thin line. To exaggerate this movement even more, I ask them to overlap their front foot over their back foot. This may sound like a strange request, but it looks good in photographs. To understand this action, see **Figure 16.16**. At least one of their heads should be turned toward the other, and there should be at least one point of contact, all while keeping their spines as straight as possible. Thanks to these pointers, now my couple's walking photos look more like that image and **Figure 16.17**.

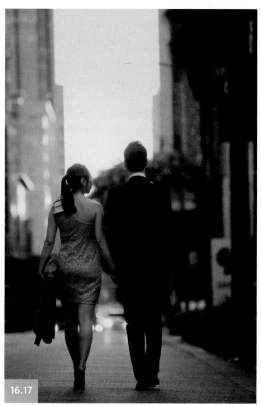

16.17

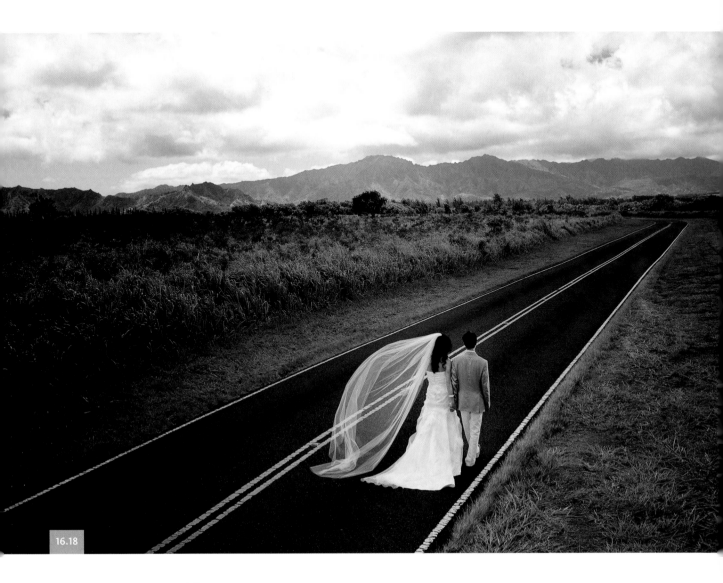

16.18

Tips

Having the couple cross their feet as they walk helps create a relaxed and natural walking photo. The couple does not necessarily have to be looking at each other. Try to avoid that. For example, one of them could look down while the other is tilting his or her head toward the other person, as shown in **Figure 16.18**. Any combination of this pose will increase your chances of producing a candid image. That's not to say that if they do look at each other the photo will feel fake. Of course not. In fact, in Figure 16.16 the couple is looking at each other. But the chances of the photo looking staged do increase. The point is to make sure that the interaction between the couple is real. If it looks fake or staged, redo it.

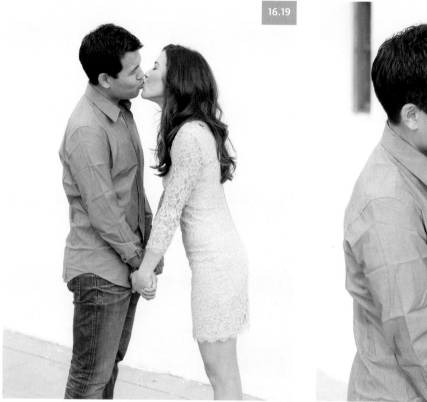

KISSING

Pose Foundation

If you have seen any of my seminars, you know my feelings about having couples kiss during photo shoots. If you haven't, I will cut to the chase: It's the most clichéd pose in the world. When photographers don't know what to do, they ask couples to kiss. Okay, now that I have that annoyance off my chest, let's analyze the pose in **Figure 16.19**. Kissing is a cliché when the couple kisses on the lips. However, if the man is kissing the woman on her upper cheekbone or forehead, it can look quite romantic. My issue with kissing is when the kiss is on the lips, not on other parts of the face.

P3S

There are times when your clients or the couple you are photographing request a kissing photo. If so, keep two major issues in mind. The first is kissing with "fish lips." Fish lips occur when you stick your lips out as far as you can. (I believe the proper term is *pouting* your lips, but fish lips is easier to remember.) Look at Figure 16.19; notice how much they are both pouting their lips. It looks unnatural. A more romantic approach would be to kiss with your lips at rest. If pouting is inevitable, keep it to a minimum. The second major issue with couples kissing occurs when one or both have their eyes open. That's just creepy. Not many people want to be stared at when they are kissing someone (**Figure 16.20**).

16.21

For an example of a well-executed kissing photo, look at **Figure 16.21**; here, you can see roughly the same amount of each of their faces (Chapter 12, "Balancing the Subject Ratio"). The hands must be engaged in a relaxed and non-distracting manner (Chapter 6, "The Hand/Arm Context System"), their eyes must be closed, and they should be breathing in to really feel the kiss. Other than that, try kissing a different part of the face. The best parts are the upper cheekbones and the forehead; see **Figure 16.22**. I find kissing the upper cheekbone much more romantic and tender.

Tips

I find that posing with the movement techniques discussed in Chapter 15 creates a more interactive kissing photograph. The kiss will look spontaneous and fun instead of forced. Also note that a kiss with the hands engaged near or on the face appears a bit more intimate, whereas a kiss with no hands in the frame appears more innocent or cute, especially when the couple is standing a bit apart and leaning toward each other to kiss.

16.22

16.23

PLAYFUL, ACTION, MOVEMENT

Pose Foundation

This is where posing can be fun, and you can let loose. These types of photos (**Figure 16.23**) are anything but perfect when it comes to proper posing, but they are essential for bringing a smile to your clients' faces. There are really no rules for these types of poses. The only thing you should watch out for is the lighting.

P3S

It is fun to see how the personalities of the couples show through when they are having fun and let go of their inhibitions. For example, look at Figure 16.23. I asked Sarah and Neal to do this silly pose and own it. The goal of this photo was to demonstrate being silly and fun and not care. Although there are more things wrong with the pose than I care to count, it doesn't matter. The photo still makes me smile. The best part is, if you knew Sarah and Neal you'd say, "That is so them!"

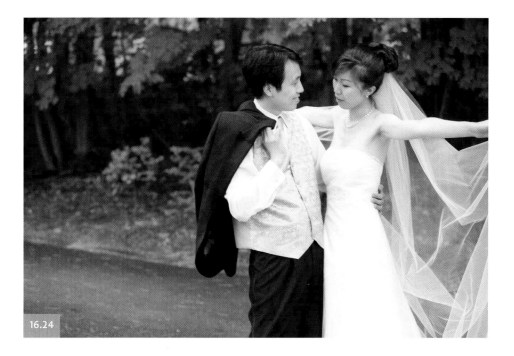

16.24

Bringing Your Posing Skills to the Fun

Let me show you why it is still important to apply your posing skills when attempting these fun type poses. I have discovered from experience that I can let go and understand that whatever happens, I can still use my posing skills to bring some order to the madness. Otherwise, the photo will look like a total disaster.

Many years ago, when I was first starting out I was photographing a lovely couple in Boston. The couple was fun to work with, and they were listening to everything I said to achieve the best photos possible. But unfortunately, my skills were not fine-tuned yet. It was during this time that I kicked my practices and aspirations for becoming a great photographer into high gear. This wedding was an eye-opener for me. After returning home and looking at the photos on my computer, I became quite discouraged. I thought to myself that I was just not cut out to be a photographer. I did not think I had the talent possessed by some of the photographers I admired. Later I discovered that talent had nothing to do with it. I just had to increase my knowledge of posing little by little. I had to focus!

Figure 16.24 represents what is supposed to be a playful photo. But I failed to visualize the photo in my head before I started shouting out posing directions. I would say, "Stand in front of each other. Play with your veil. Smile at her." None of the directions were specific. How is she supposed to hold the veil—with her arm completely straight or bent? Why is the groom holding his jacket over his shoulder, while the bride is playing with her veil? Why is she not interacting with him if he is smiling at her? These are the questions you need to notice as you're shooting.

If you want to avoid these issues, try to visualize the pose before you begin photographing. It will save you so much time and effort. After forcing myself to visualize photos before posing my couples, I began to be much more specific about how I directed my couples to take the pose I envisioned.

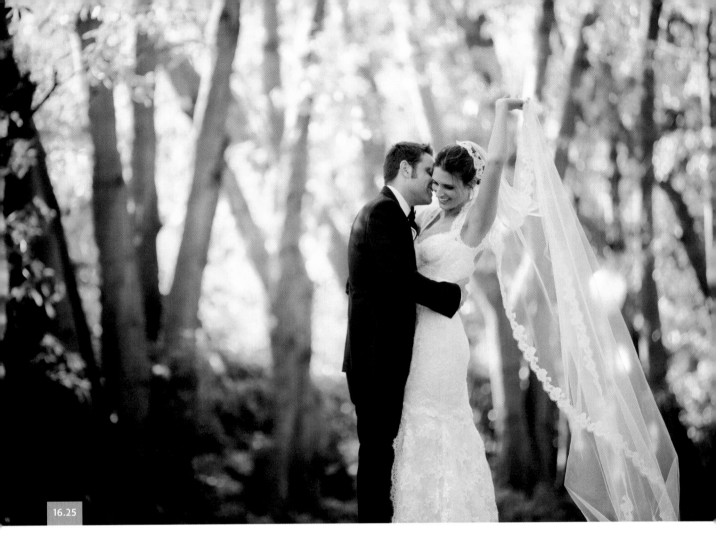

16.25

Figure 16.25 is a direct result of a second attempt at this dynamic and playful pose. The only difference between the two, besides being taken years apart, is that during the first shoot, I was shouting endless and pointless directions with no clue what the results of my directions would be. For the later session, I visualized this exact photo in my head, and then I executed it. Notice that the photo is fun, spontaneous, and energetic but still structured when attention was paid to their interaction. For action-based shoots during which the couple is in constant motion as the photographer shoots and clicks away, it helps to give them key pointers to keep in mind as they move, dance, walk, or jump.

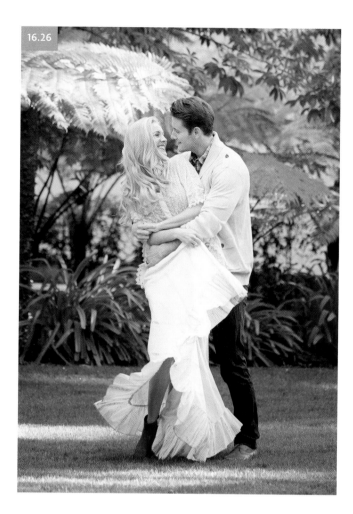

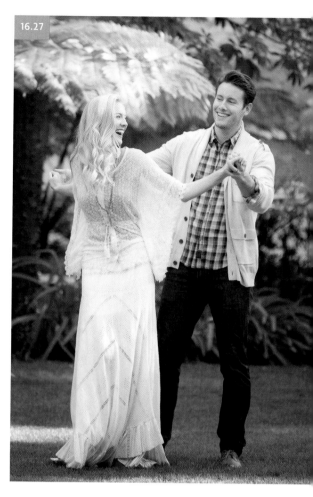

For example, **Figures 16.26** and **16.27** were both photographed as the couple moved and danced away. I instructed them to continue laughing out loud, keep their faces turned toward each other, and keep their hands engaged below the neck level. Remembering these three pointers gives you a higher yield of great photos with candid expressions—without having one's arm blocking the other's face, or one of them laughing but the other not. When it comes to any kind of posing, many common problems can be addressed before they occur during the shoot. That lets you focus your attention on creating a masterpiece instead of fixing mistakes.

Tips

I make sure that the couple is having fun but that their expressions remain compatible. For example, I can't have the woman smiling and having the time of her life, while it is clear the man is not enthusiastic.

A WORD ABOUT REENACTING CLICHÉS

To help photographers or photography enthusiasts to think creatively instead of falling into decades-old reenactment clichés, I felt compelled to write this section. There are many examples of these poses, and I accept that some clichés, such as dipping the bride, can actually look fine if well executed. There also are times when your clients request these cliché photos because they have seen them in a magazine or on the Internet. In such cases, I would say go ahead and take the photo, as unpleasant as it may be. Otherwise, you might upset your clients, and making your client unhappy will cause you more headaches than it is worth.

One of the most staged clichés is reenacting a proposal in which the man gets down on his knees and holds the woman's hand (**Figure 16.28**). But unless the proposal is actually happening, the reenactment makes no sense. To understand why, refer back to Chapter 10, "Interaction and Placement of Subjects." Many years ago, my client requested just such a photo. Because it was a request, I did it with a smile. But you can't help but wonder, "Why is he proposing if they are already married or almost married?"

It's my hope that photographers worldwide will try to retreat from such clichés as the proposal pose, and to a lesser extent, the couple kissing on the lips.

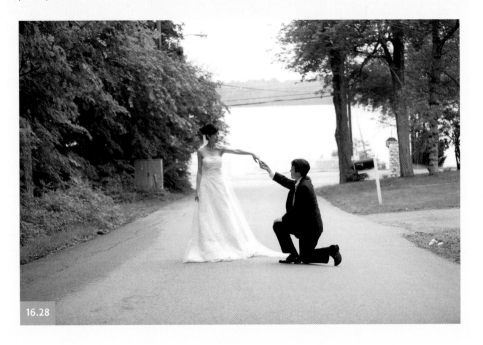

16.28

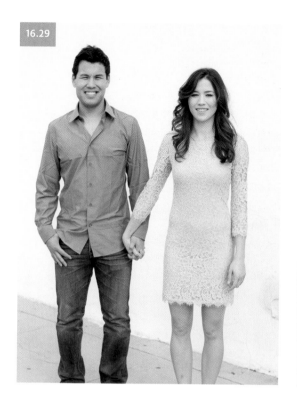

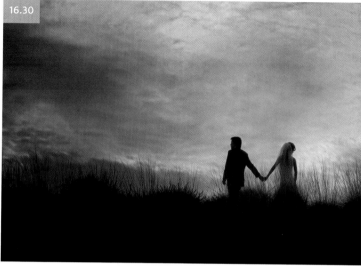

HOLDING HANDS

Pose Foundation

One of the greatest benefits of the pose in **Figure 16.29** is that it is so versatile. Holding hands creates a point of contact and gives the hands something to do, as you learned in Chapter 6, "The Hand/Arm Context System." This action would fall into the Holding category in the HCS. Holding hands is used along with most of the other posing categories in the posing chart. For example, you could have the couple sitting and holding hands, or they could be standing side by side holding hands. But like everything else in posing, there is a right way and a distracting way to hold hands. If the hands are posed badly, they bring unwanted attention to the hands. If you do it right, the handholding will look flawless, soft, and romantic. It will add a charming touch to the pose, while keeping the attention focused on the couple's faces, not their hands.

P3S

I posed Sarah and Neal this way in Figure 16.29 to demonstrate some of the most common issues that come up when couples are asked to hold hands without specific directions about how to do it. Notice how Sarah's wrist is at a harsh 90-degree angle (Chapter 3, "Joints and 90-Degree Angles"). Notice also how their fingers are interlocking. This is a form of piling fingers together (Chapter 7, "Stylizing Hands and Fingers: Advanced Techniques"). The hands should be held perpendicular to each other. See **Figure 16.30**, for example; if the couple's fingers are interlocked, simply loosen the grip by confining the finger overlap

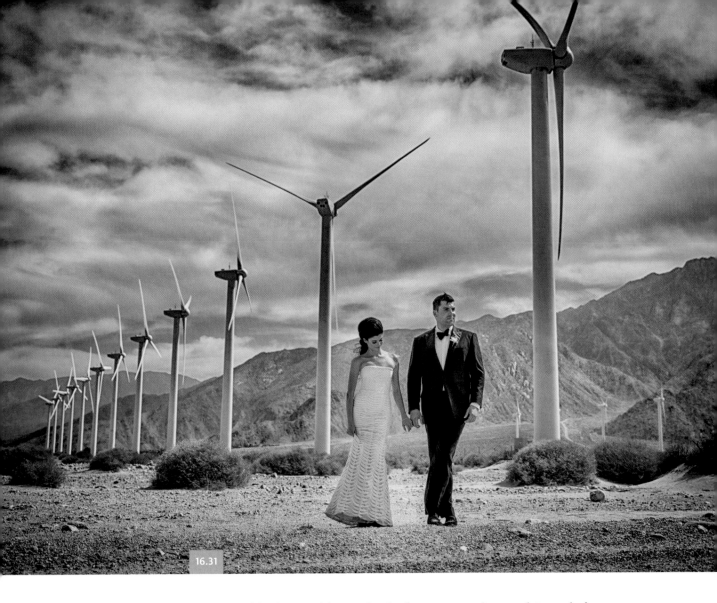

16.31

to the top of the fingers. If done right, the fingers are gently curved, instead of one person grasping the other's hand.

In **Figure 16.31**, I asked the bride to gently hold only one or two fingers. This way, the handholding gave the pose a sensitive feel. In **Figure 16.32**, notice how soft the grip is holding the hand. This is another example of the hands being posed perpendicular to each other without any signs of gripping, especially in the man's hand. Any sign of a man gripping his partner's hand will appear forceful.

Tips

Keep in mind that handholding should always appear soft and effortless. It takes energy to interlock fingers to where each person's fingertips touch the top of the other person's hand. So don't do it. You want to the grip to be so loose that if you were to gently pull them apart, the hands come apart with minimal friction.

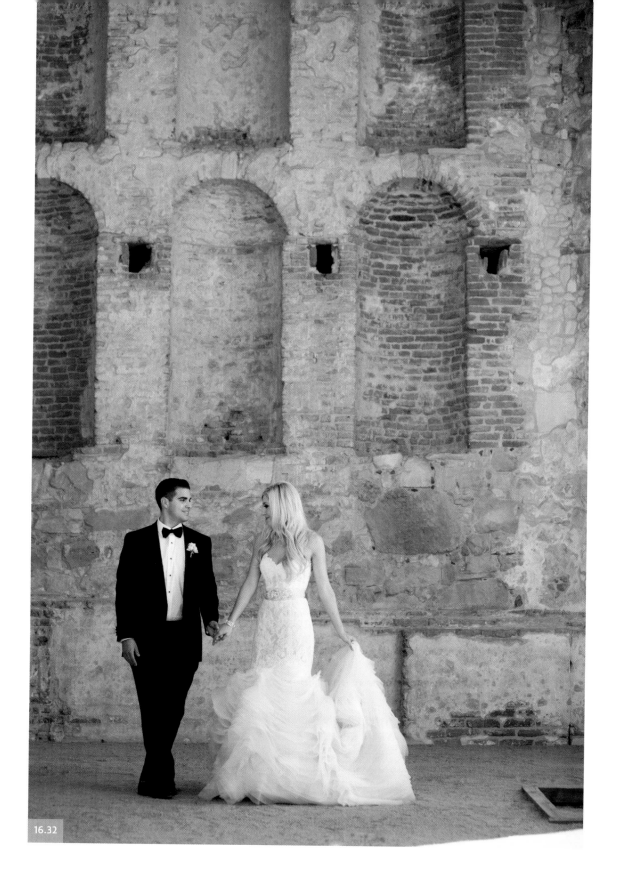

16.32

16.33

SITTING

Pose Foundation

Having couples sit for a photo (**Figure 16.33**) offers a refreshing perspective simply because it is different from the usual standing photos. Most people are photographed standing up, so when you see a photo of people sitting it subconsciously appears fresh. The main thing to watch for is that when people sit, they usually slouch. Most people do not have the best posture, so it is up to photographers to keep this in mind and make the necessary adjustments to prevent slouching of any kind.

Also, according to the point-of-contact check (Chapter 11, "Point-of-Contact Check"), when photographers point their camera at someone sitting, they run the risk that the couple's knees will be the closest thing to the camera. To remedy this, ask your subjects to keep their back as straight as possible and lean toward the camera. This will close the distance between the knees and your subjects' faces.

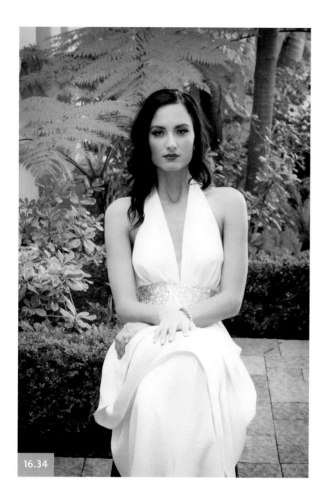

16.34

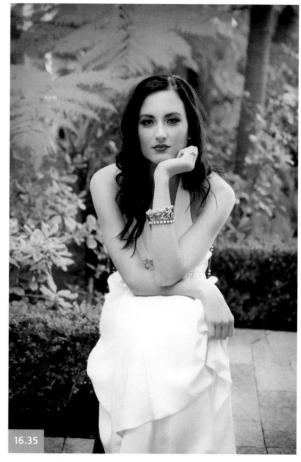

16.35

P3S

At first glance, when looking at **Figure 16.34** you think the photo looks fine. It's easy not to notice the way that she is sitting with her back leaning away from the camera, or that her knees are the closest object to the camera, which gives them more importance than her face. The issue can be quite sneaky.

Now compare Figure 16.34 to **Figure 16.35**. By asking her to keep her back straight and to lean toward the camera, I ensure that her face becomes more pronounced. These two examples are not of a couple, but it's easier to see the problem using one person. Use these techniques when posing couples, and you will be in good shape. You can refer to Chapter 11 if you need a refresher on this topic.

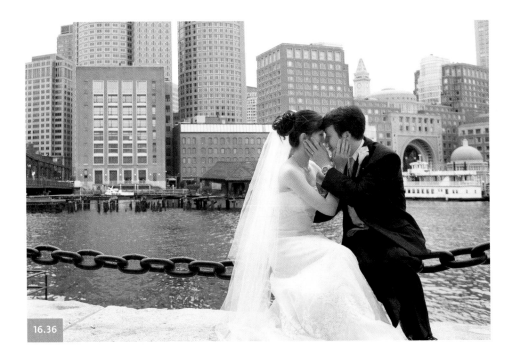

16.36

With seated couples, having a keen awareness of how the hands are positioned will help you complete the pose. Apply the knowledge you learned in Chapter 6, "The Hand/Arm Context System," to get the most out of your subjects' hands during a sitting pose. If you are not careful with the hands, you could end up with a photo such as **Figure 16.36**. It is unfortunate how many posing issues we must keep track of during photo shoots. But if you slow down and take the time to see every part of the body before putting your finger on the shutter button, the quality of your work will go from Figure 16.36 to **Figure 16.37**.

In this example, all four hands are engaged, their expressions are compatible (Chapter 15, "Posing with Movement, Feeling, and Expression"), the couple is sitting with their backs straight (Chapter 1, "Understanding and Posing the Spine"), gaps were created to show the outline of their waistlines (Chapter 5, "Creating Gaps with the Lower Back and Elbows"), and one of the bride's hands is posed higher than the other (Chapter 9, "Avoid Mirroring").

Tips

When people sit down, they automatically try to relax. People sit on a park bench to read, or they sit to watch TV. The association of relaxing with sitting can be a problem for photographers. We must put more energy into our voices, more so than when couples are standing. Otherwise, our subjects will relax too much and possibly slouch.

During a couple's photo shoot in Bel-Air, California (**Figure 16.38**), I asked the couple to sit on the trunk of their brand new Bentley (not recommended, by the way!). But the couple was willing to do it, and a Bentley's trunk is strong enough to hold their weight without denting it. I remember I had to almost scream as I was posing them to get them to straighten up and react the way they did. I posed the hands first; then I asked them to lean their bodies toward each other. Finally, I told the groom where to place his head. After that, it was all energy from me!

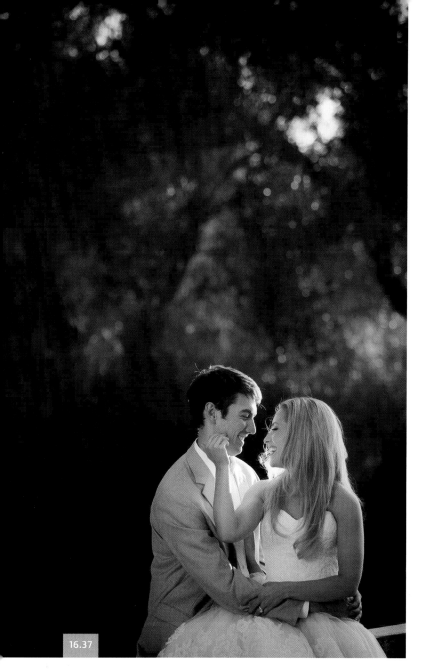

16.37

Nobody wants a boring sitting photo, so do whatever it takes to get a great reaction out of the couple. Another smart tip is to have the couple sit near the edge of whatever they are sitting on. This can prevent bad posture because they will have nothing to rest their backs against. They'll have to use their own energy to straighten their backs and sit up straight.

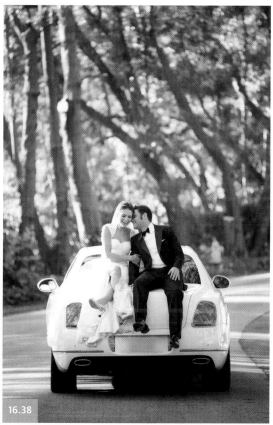

16.38

16.39

TOGETHER SIDE BY SIDE

Pose Foundation

The inspiration for the pose in **Figure 16.39** probably came from the famous modernist painting by Grant Wood titled *American Gothic*. At least this is the way I have seen photographers use the pose. However, this pose is quite versatile as well, and it can take many forms depending on your creativity. From the foundation photo, you can begin to build the pose. There are many variations you can play with. For instance, you could alter the position of the body, feet, and even where they are looking. This pose can look cute, romantic, or even avant-garde.

P3S

One of my favorite aspects of Grant Wood's painting is the couple's expression. They seem to have none. For **Figure 16.40** I found myself inspired by the lack-of-expression idea but with a twist. I placed the bride and groom next to each other, and had them hold hands. But then I asked the bride to hold her veil up as if to prevent the fabric from touching the ground (Chapter 6, "The Hand/Arm Context System"). To remove the rigidness, I asked the groom to shift his body weight to his back foot (Chapter 2, "Weight Distribution and Its Effect on Posing").

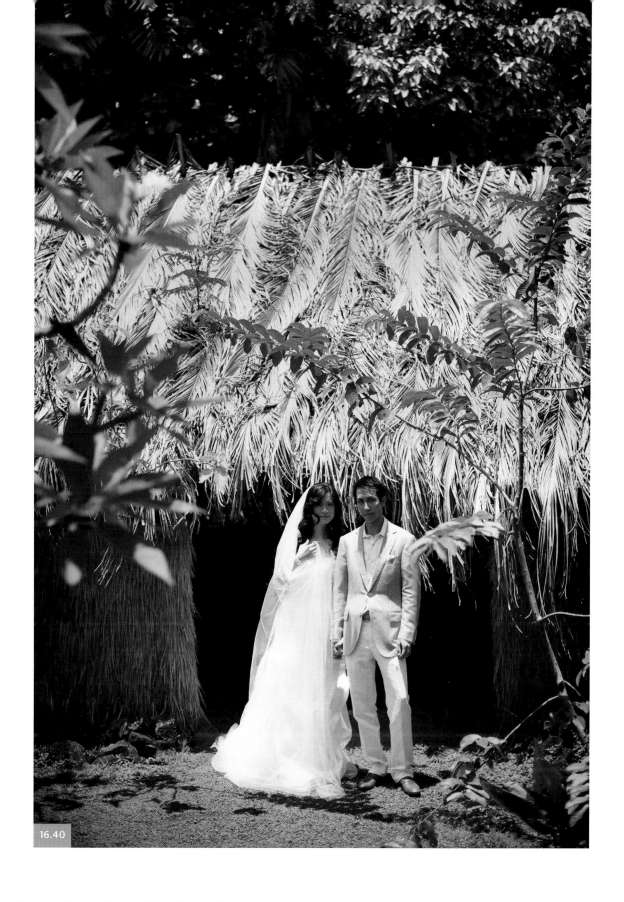

16.40

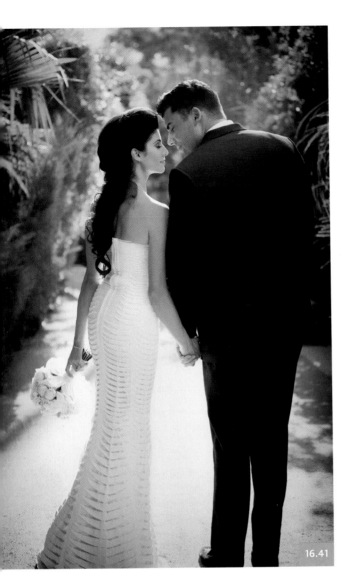

16.41

The setting of the little village in Kauai, Hawaii, was the perfect location to try this pose. This side-by-side pose offered a realistic interpretation of what villagers in the old days would do if a stranger-guest was allowed to take a peek into their lives. Although their expressions are almost nonexistent, you can pick up hints of their personalities. Yet they remain reserved enough for the overall image to be intriguing. On the other side of the spectrum, **Figure 16.41** offers a modern approach to the same type of pose. This time, there is an inviting and romantic interaction between the couple, and the photo is taken from the back, not from the front. The only similar aspect is that they are holding hands. What if one person faces the camera and the other does not? **Figure 16.42** illustrates what that arrangement would look like. Here, I could have asked the groom to look the other way, away from the bride. Changing the direction of their heads can offer a variety of looks that you can also try.

Cliché Warning: There are many clichés that photographers re-create because they have seen them before and are stuck creatively during a shoot. One cliché used in this pose (worth mentioning so that you can avoid it!) is the man standing up with a wide stance and the woman sitting on the floor next to him with her arms wrapped around one of his legs as if she was claiming it. If there is a reason why the woman is on the floor hugging his legs, then go for it; otherwise, the pose does not make much sense. It raises the question, "Why is she on the floor, and why is she seductively hugging one of his legs?" I have never been able to figure out answers to these questions. My intention for mentioning these clichés is to motivate you to think outside the box. It is hard to develop your own style if you resort to re-staging these overused clichés. Push yourself to develop your creativity.

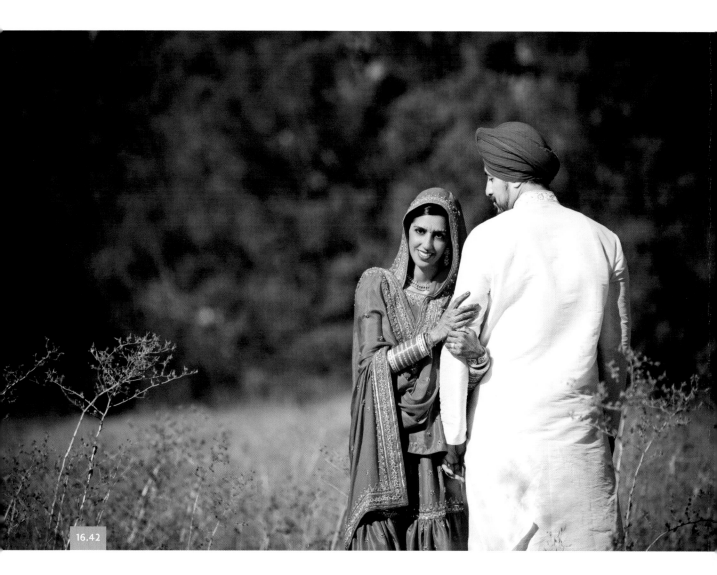

16.42

Tips

When choosing this pose, the biggest risks to the success of this photo are a large discrepancy in subject ratio (Chapter 12, "Balancing the Subject Ratio") and the direction of the noses not facing directly at each other (Chapter 13, "The Nose X-Factor"). I've shown you here three variations of this pose, but keep in mind that there are far more.

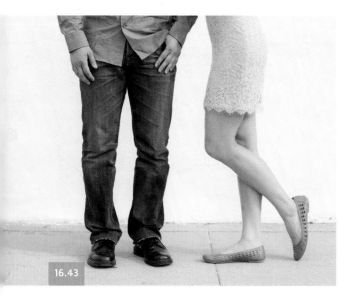

16.43

16.44

INTERPRETIVE

Pose Foundation

An interpretive photograph like the one in **Figure 16.43** leaves the interpretation or meaning open-ended. A photo of this sort asks more questions than it provides answers. Usually, an interpretive photo leaves the faces of the subjects out of the frame so that its message or story is delivered purely through body language.

P3S

Take a closer look at Figure 16.43. Notice the way she is standing and how her leg is bent. Then look at his body language with his hands and his stance. A lot of information is hidden in the pose. Learning how to tell a story with open interpretation could possibly be one of the best aspects of photography. That's why the most interesting photographs are the ones that leave so much to the imagination instead of being so literal.

Figure 16.44, edited by Jonathan Penny, has always been one of my favorite examples of an interpretive pose. I was exploring the concept of open-ended interpretation, so I forced myself to think outside the normal poses. Inspired by how chivalrous the groom was toward

16.45

his wife from the very beginning of the day, it was my desire to have his genuine chivalry expressed through their body language. Let's extract the hidden details from the pose.

First, you may have noticed the way he is looking at his bride. Even though you can't see her, you can imagine that she is looking elsewhere, and he is lovingly admiring her (Chapter 15, "Posing with Movement, Feeling, and Expression"). His left hand is holding her heavy bouquet while his right hand is gently holding hers (Chapter 6, "The Hand/Arm Context System," and Chapter 7, "Stylizing Hands and Fingers: Advanced Techniques"). Cropping her out of the frame certainly creates interesting subject placement (Chapter 10, "Interaction and Placement of Subjects"). There's no need to see her face to see how this couple loves and treats each other. But it is all subject to interpretation. How this photo speaks to me may not necessarily be someone else's interpretation.

Cropping off the heads of your subjects eliminates the possibility of viewers focusing on their faces, as shown in **Figure 16.45**. This means that the entire weight of the photograph rests on the couple's body language. I wanted to create a chic photo to complement the couple's modern and stylish vibe. An interpretive photo would be the perfect choice to isolate their style. I placed them against a light pink background I found on the grounds of the Hotel Bel-Air. The pink provided a good, clean contrast to the white of the dress

and the black of the tuxedo. I posed the bride with an exaggerated motion, while the groom stood motionless to create juxtaposition with the bride. Their outer arms were curved and posed, whereas the inner arms were hanging straight down.

During an impromptu photo shoot for a couple of friends in Beverly Hills, we were walking down the street, looking for a spot with good light to shoot. As we walked and talked, we noticed the small puddles of water on the sidewalk left over from the morning rain (see **Figure 16.46**). Drawing from my experience with interpretive poses, I knew that the way feet are posed could tell a lot about a person or, in this case, the couple. So as we walked, I thought the puddles could be used to say something about the couple in a more creative way than just pointing my camera at their faces and taking a photo.

To do this, I used the top of the frame to show their charming relationship using their feet, and the bottom of the frame, the puddle, to show their lovely interaction and the rest of their outfits. From the way the photo was cropped, it almost appears as if it were two different photos. There are now two visual stories that represent who they are as a couple. There was nothing special about the location where this photo was taken, so I used the top and bottom of the frame to keep the focus on the couple. If the location means something special to the couple, however, you can exercise your creativity and use the photographic frame to tell stories that matter in a creative and interpretive way.

16.46

16.47

For example, I took the photo in **Figure 16.47** spontaneously of my friends Mike Colon and his wife Julie during a casual walk in Rome. I used a similar technique as in Figure 16.46, but with a twist for the Rome location. With one of the most recognized landmarks in the world nearby, I posed their feet and placed them at the top of the frame and used the reflection in the puddle to give the viewer a glimpse of the Colosseum in the background. This is where an interpretive pose shines above all others. Without this pose, the photo would have been the typical photo of the couple standing in the middle of the street, probably kissing, with the Colosseum in the background. With so many creative and fun ways to tell a story, it's unfortunate that so few photographers push themselves to think beyond the obvious.

Tips

When posing a couple in an interpretive way, be sure to think of creative and unusual ways to use the entire photographic frame: the corners, the top, the bottom…every part.

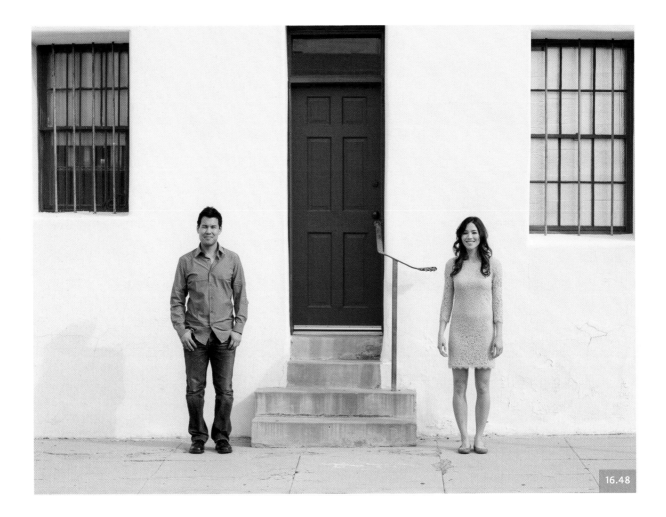

16.48

DISTANCE APART

Pose Foundation

Distance apart, the type of pose in **Figure 16.48**, is similar to "together side by side," except that there's usually more distance between the couple. At one extreme of this photo, you could place the bride and groom far from each other. But this option requires more attention to keep the focus on each person (Chapter 14, "Subject Emphasis"). The couple could be next to each other but farther apart than usual, or one could be in the foreground and the other in the background. Naturally, this type of pose is far from traditional, and some couples might not care for it. It depends on how you execute it. Honestly, I normally do not make this type of pose a priority when I'm working with couples unless I feel that it would be a good fit for the couple.

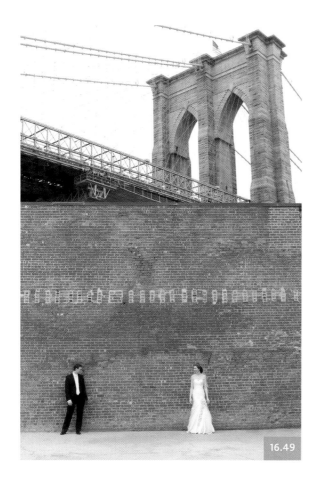

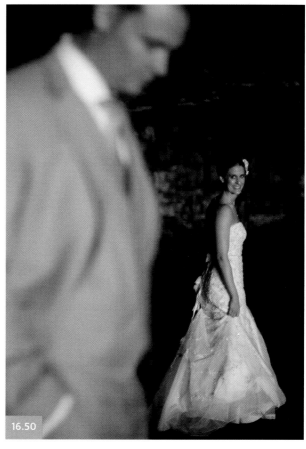

16.49

16.50

P3S

One of the most effective ways to execute a distance apart pose is to put the surrounding elements to good compositional use. Composition concepts such as contrast are a good complement to this pose. For instance, in **Figure 16.49** I used the oversized brick wall and the Brooklyn Bridge in the background to contrast with the relatively much smaller bride and groom. The small-versus-large contrast, combined with the couple standing some distance apart from each other, is not a traditional or normal wedding—which is precisely what makes this type of pose interesting.

For **Figure 16.50**, I took advantage of the high contrast between the dark cave and the lighter suit the groom Kent wore for his wedding. This time, however, I did not have my clients stand apart. Instead, I created that distance by placing the bride in the background and the groom in the foreground. Had the groom been wearing a black tuxedo, this particular arrangement probably would not have worked. There would not have been enough contrast to pull it off. Although this pose is named distance apart, it does not mean the couple must be out of reach. If the couple is holding hands but they are farther apart than the norm, it qualifies as a distance apart pose.

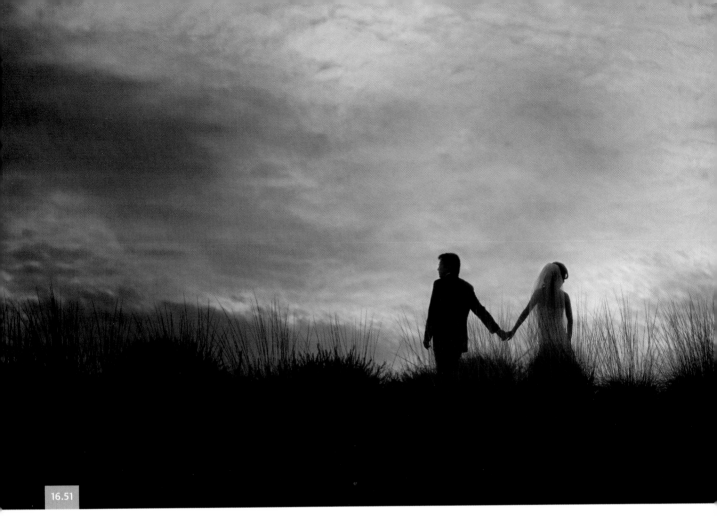

16.51

This is precisely what I did for **Figure 16.51**. I began by placing the couple at a higher vantage point from my position to ensure that their bodies would be silhouetted against the cloudy sky. While they kept their hands gently held, I asked them to move away from each other just enough to create some distance, enhancing the silhouetted quality. To finish the pose, I asked them to look in opposite directions (Chapter 15, "Posing with Movement, Feeling, and Expression"), and I asked the bride to bend her right elbow a tad to create another gap to better reveal her waistline (Chapter 5, "Creating Gaps with Lower Back and Elbows").

Tips

When using the distance apart pose, pay attention to how the compositional elements in the environment relate to the couple. Ask yourself if, compositionally speaking, the position where the couple is standing makes sense. Although the use of contrasts works well compositionally for this pose, there are many others, such as leading lines or framing (Chapter 14, "Subject Emphasis"). Lastly, reread Chapter 10, "Interaction and Placement of Subjects," because the interaction between the couple can get tricky with this type of pose. The last thing you want is to try this distance apart pose and end up with photos such as Figures 10.7, 10.8, and 10.11, shown in Chapter 10.

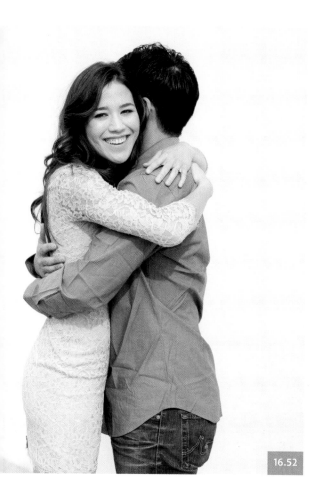

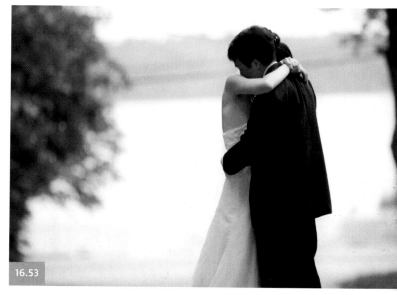

16.52

16.53

HUGGING

Pose Foundation

Hugging is a tender way to show a couple's affection without having to resort to kissing (see **Figure 16.52**). That makes hugging a great option, but the hugging pose can be deceiving. Pay close attention to the details of this pose, or it will look awkward.

P3S

Some aspects to keep in mind when posing a couple are to triple-check that one arm and hand is placed one higher than the other (Chapter 9, "Avoid Mirroring"). Also be sure that all the elbows point toward the ground (Chapter 11, "Point-of-Contact Check"). If one of their elbows is instead pointing toward the camera, which happens often when people hug, the elbow will be the closest object to the lens, making it the focal point instead of the faces (see **Figure 16.53**).

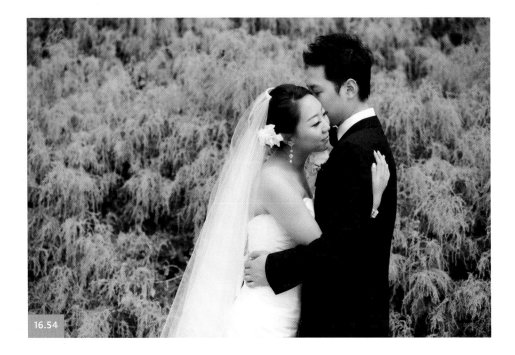

16.54

If you wish, you could go back a few chapters and review Figures 9.6 and 11.8. You must instruct the couple where to place their elbows before asking them to hug. Also make sure that you do not completely block one of their faces with the other person's head, as shown in Figure 16.53. A hug looks best when you remember to consider the visible head ratio (Chapter 12, "Balancing the Subject Ratio").

The height of the couple also plays a role in the execution of this pose. For example, if the couple is relatively close in height, as in **Figure 16.54**, then the woman should be closest to the camera, with the man's face visible enough to see his eyes. To aid in their interaction, his face should be turned toward her face, as if he were smelling her cheek with his eyes closed (Chapter 13, "The Nose X-Factor").

The couple shown in Figure 16.54 is in great shape, but if you are photographing a woman without sleeves, consider positioning the man's arms on the outside of her arms, and use his forearms to cover any unwanted arm fat visible to the camera. This will look completely natural without making it obvious that you are trying to cover up her arm. However, if the man is much taller than the woman, then the interaction must be changed to accommodate the difference in height, without hunching the man's back.

During my impromptu photo shoot of my amigo and great photographer Mike Colon and his wife Julie at Rome's Colosseum (see **Figure 16.55**), I dealt with the difference in height by placing her head with her chin down on the side of his chest closest to the camera. To keep the point-of-contact check equal on both of their faces, I then placed his chin completely over her head and asked him to look straight ahead. Despite their difference in height, I was able to keep their backs from hunching and their interaction romantic.

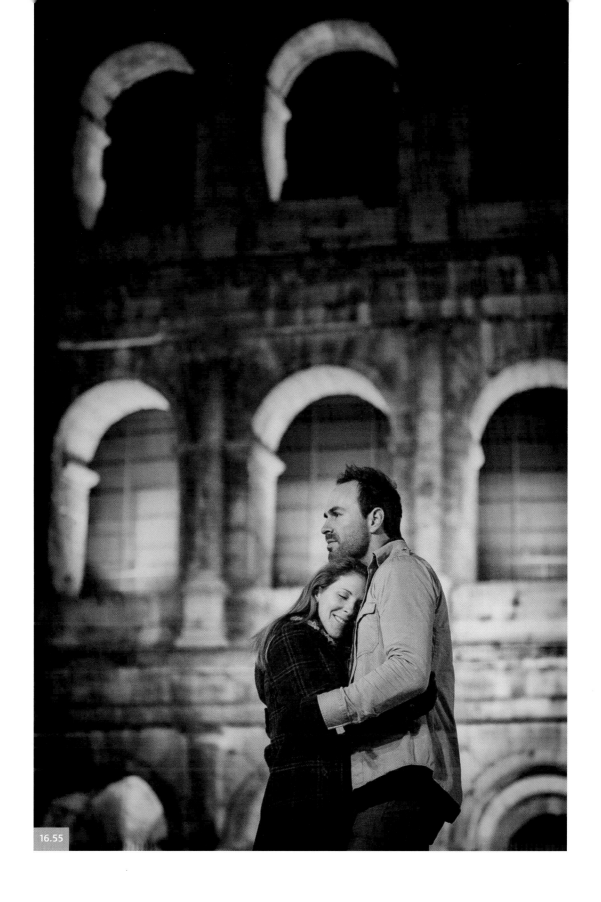

16.55

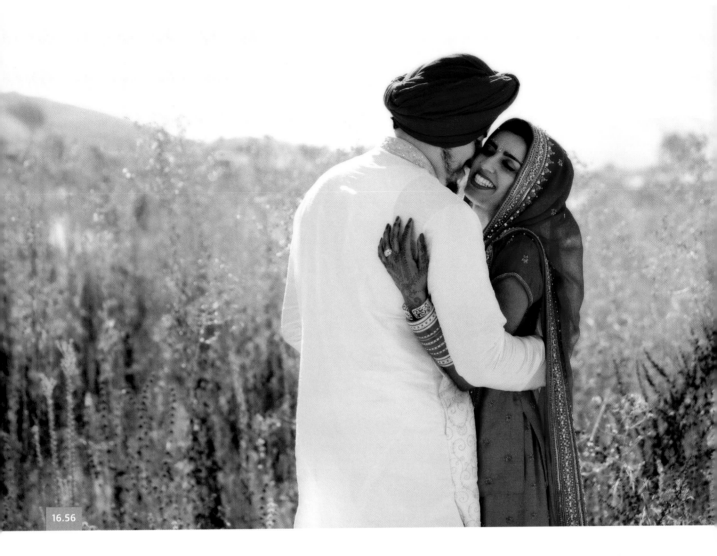

16.56

There are many other ways to execute a hugging pose well, but one of the best examples I found is **Figure 16.56**. Their interaction, the head ratio, and the hand and arm positions are all working together in perfect harmony.

Tips

Having read this section about how to pull off a posing photo, be specific with your directions to make all the pieces fall into place. It also helps to have your couple move into a hugging pose after they have understood your directions. Asking the man to smell her upper cheekbone as they are hugging not only will maintain their interaction toward each other, but it will make the couple laugh, giving you truly candid expressions.

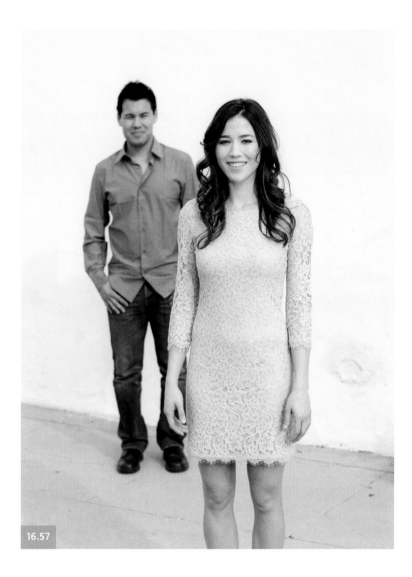

16.57

FOREGROUND/BACKGROUND

Pose Foundation

The option of experimenting with the foreground and background in a photograph can be one of the best ways to tell a story. Not only is it out of the ordinary, it's more visually interesting if done right (see **Figure 16.57**). For example, the person in the foreground could be in focus while the person in the background is out of focus. Just because the person in the background is out of focus does not mean that he or she does not contribute to the story; quite the contrary. Out of focus does not mean out of sight. The body language of the out-of-focus person is still recognizable, and that person's actions can be a meaningful part of the story. Choosing this option will give your photos a cinematic look. Think of the photo as a scene from a movie, in which the action in the foreground complements the action in the background. So put on your director's hat when choosing this option.

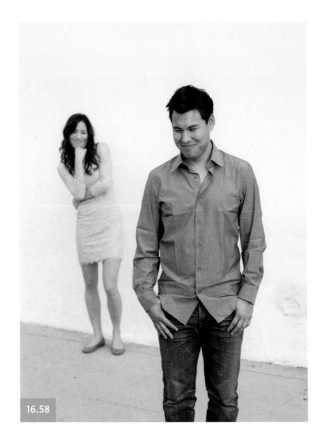

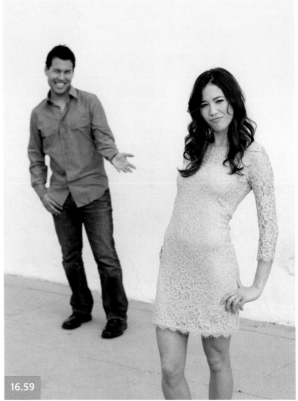

P3S

The photo used for the foundation of the pose in Figure 16.57 is just a starting point for you to use for subject placement. Clearly, there's no interaction or storytelling qualities in this image.

I approach the topic of clichés with respect, but I need to inform readers, photographers, and enthusiasts worldwide about turning away from using clichés—unless of course your clients request the cliché. The foreground/background pose has been subjected to almost as much abuse as kissing in front of a fountain or a landmark building. So let's go over some of the most common clichés. Hopefully, this will motivate you to avoid them.

Although it was hard for me to have to re-create these clichés for the book (see **Figures 16.58** and **16.59**), it was also a lot of fun, and we all had a good laugh doing it. This is the most common position I have seen photographers use. One person is in the background checking out the person in the foreground in a creepy manner. Usually, the person in the background has arms crossed or hands in pockets. The person in the foreground is usually smiling and looking at the camera.

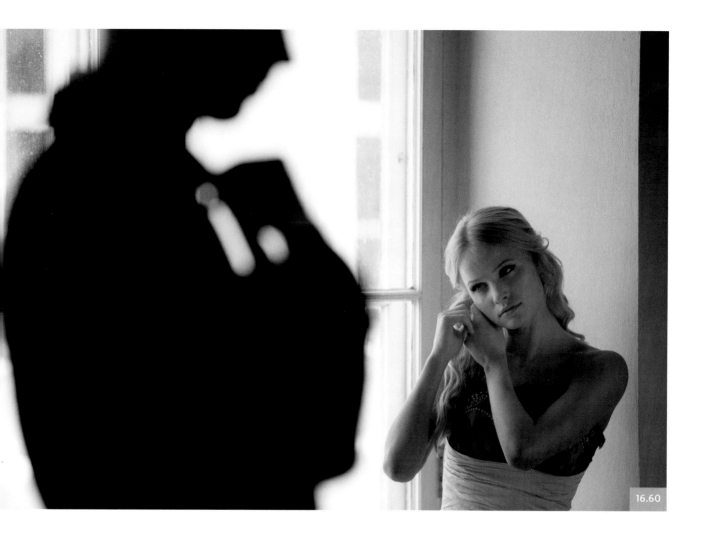

16.60

Now that we have that out of the way, let's look at some better possibilities for this pose. For **Figure 16.60**, I wanted to give a cinematic look to the bride and groom getting ready. I positioned the bride by the light and in the background with both of her hands occupied putting on her earrings (Chapter 6, "The Hand/Arm Context System"). The groom was positioned in the foreground, looking in the mirror and adjusting his tie in silhouette.

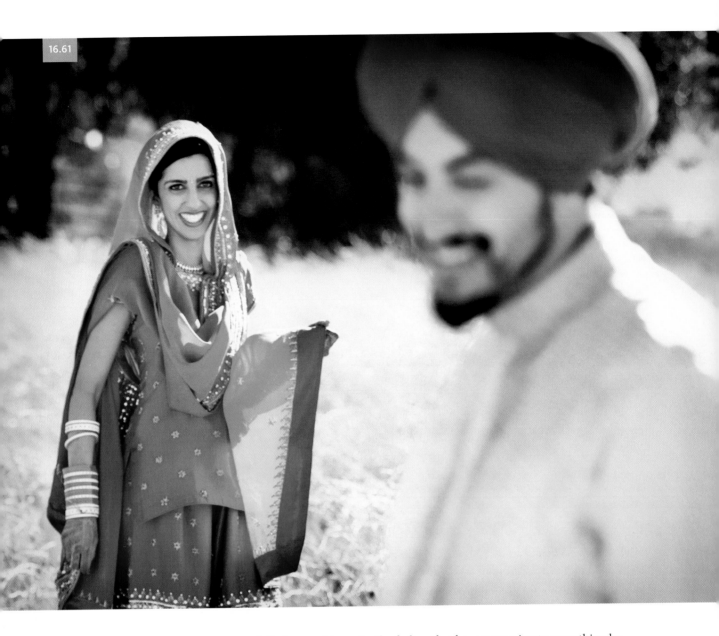

For **Figure 16.61**, I wanted to evoke the feeling that he was reacting to something he saw in a way the bride found charming, creating her genuine smile. You can tell something about the personalities of both couples. Most importantly, whatever is happening in the foreground is somehow linked with the person in the background (Chapter 10, "Interaction and Placement of Subjects").

Tips

Try coming up with something that is fun or realistic for each subject placement. Make sure that the story in the foreground connects with the story in the background, and vice versa. Remember that this type of pose has cinematic qualities to it, so borrow the elements of photojournalism to create this pose.

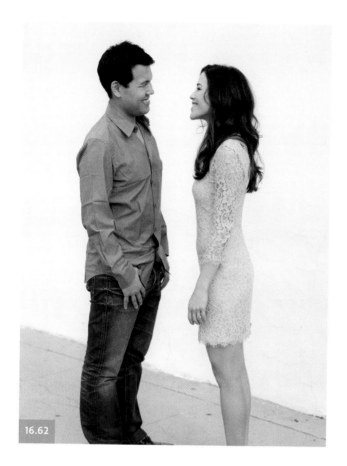

16.62

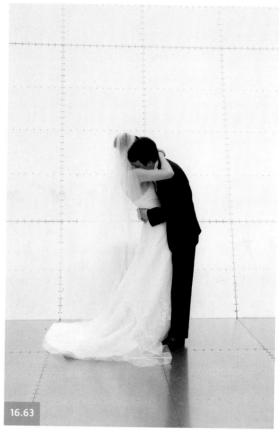

16.63

FACING EACH OTHER

Pose Foundation

In this pose (see **Figure 16.62**), the couple's bodies face each other, rather than necessarily their faces. In a way, this is another form of hugging. The same issues that crop up in a hugging and/or traditional pose occur when the couple faces each other. For example, try to spot all the issues happening with **Figure 16.63**. Although the couple is hugging, their bodies are still facing each other.

P3S

When the couple is close, with their bodies facing each other, they are invading each other's personal space. At that distance, simply looking at each other is not going to work. For their expressions to look genuine in this pose, there must also be a natural reaction occurring. For example, invading someone's personal space usually makes people laugh to deal with the awkwardness. Therefore, if they were going to be looking at each other that closely, a genuine smile or laughter would make sense (see **Figure 16.64** on the following page).

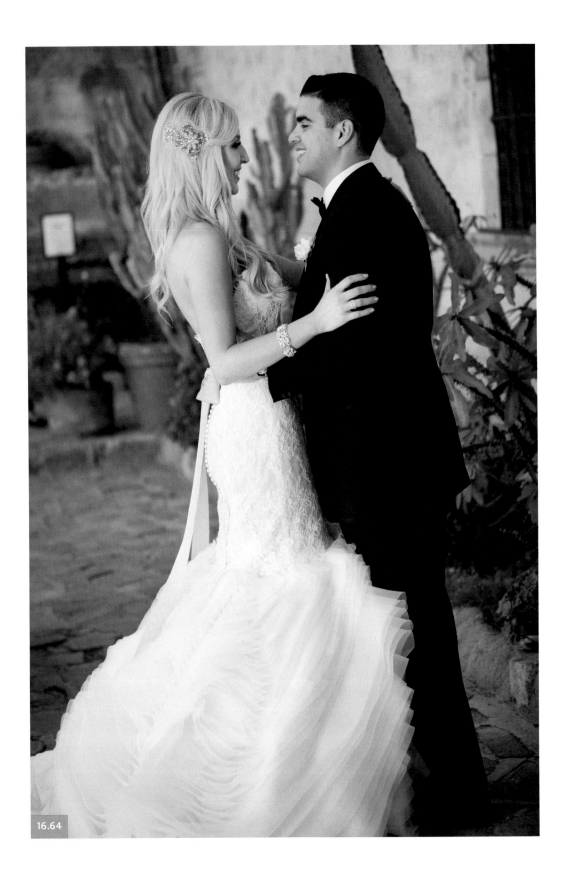

16.64

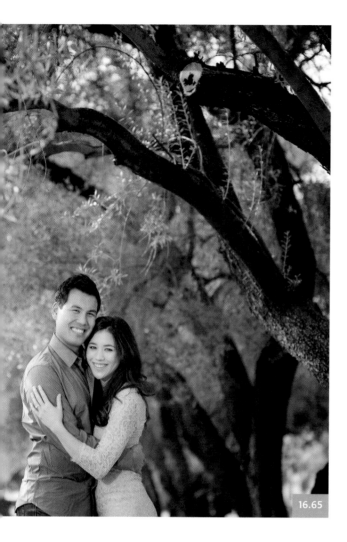

16.65

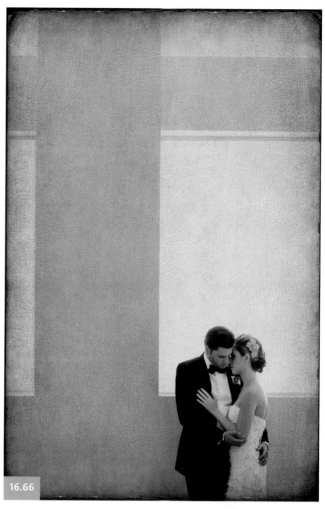

16.66

Creating an X-Factor on the noses by crossing them will be a great help in creating a photograph that appears natural (Chapter 13, "The Nose X-Factor"). For **Figure 16.65**, I created a quieter moment instead of a reactive expression. For a traditional look with the couple facing each other, see **Figure 16.66**. The photo looks very nicely done, because the pose incorporates the P3S concepts. Pay special attention to how straight their spines are, the hand positions, and how their interactions complement each other. To create a successful subject emphasis, I used the trees as a compositional element to frame them (Chapter 14, "Subject Emphasis").

Tips

When people are placed in this position, they almost automatically turn on their artificial smiles and look at the camera. They will also try to kiss, due to their closeness to each other. To avoid this, the couple must feel energy coming from your voice. That will turn their fake smile into a real smile. You need to push for it, or you won't get it. The other important pointer is to pose the eyes carefully (Chapter 15, "Posing with Movement, Feeling, and Expression"). Tell your couple exactly where to look to achieve the expression you want.

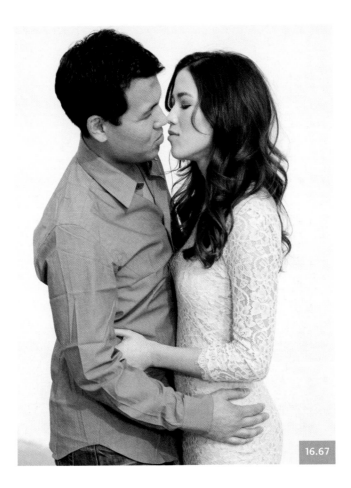

16.67

KISS ANTICIPATION

Pose Foundation

The anticipation of a kiss is much more tender than the kiss itself. As a teenager, I'm sure you remember that heart-pounding feeling in the moment you leaned forward to kiss the girl/boy of your dreams for the first time. It's nerve-wracking! But as soon as your lips lock, the intensity of that initial feeling fades away. There is an unexplainable energy that occurs just before you kiss someone. That feeling is what we are seeking when posing our couples just inches from kissing (**Figure 16.67**).

P3S

Look how charming the moment is between the couple in **Figure 16.68**. Because they are about to kiss, they both close their eyes to shut off some of their senses and enhance others, such as the sense of touch, to better feel the kiss. I asked the couple to lean in for a kiss but to stop inches from kissing. The key is to keep their eyes closed while they lean toward each other. Their senses must be in hypersensitive mode when they are

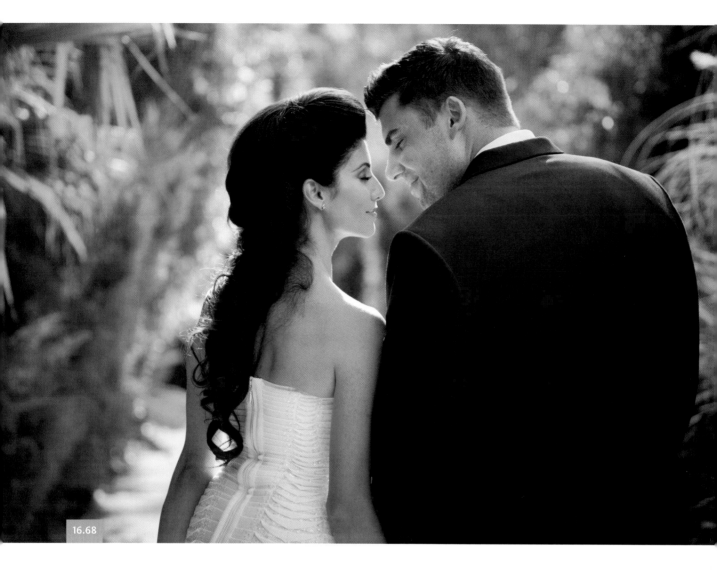

16.68

close enough, without colliding heads. The feeling of uncertainty will make people smile (Chapter 10, "Interaction and Placement of Subjects"). The eyes are very important for this pose, because it can throw the moment off if one person's eyes appear to be not "into it" (Chapter 15, "Posing with Movement, Feeling, and Expression").

Tips

When you feel like having your couples kiss, try photographing the anticipation of the kiss instead. Sometimes women use their hands to gauge where their partner's head is. That is totally acceptable. Just make sure that her fingers are not blocking his face (Chapter 7, "Stylizing Hands and Fingers: Advanced Techniques"). When the couple is in position with their lips inches from each other, try making them laugh. This will create an image they will love!

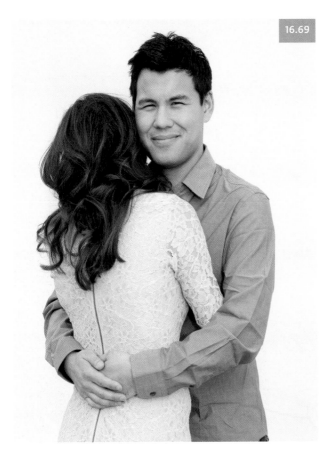

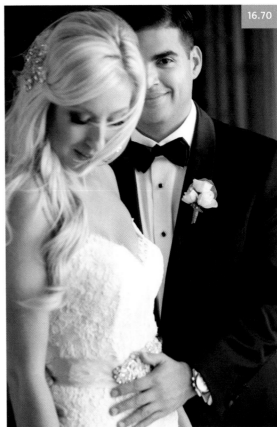

FEATURING HIM

Pose Foundation

This option and the next one will give your work variety. Having couples next to or in front of each other is nice, but variety is much more attractive! In **Figure 16.69**, the male subject is the center of attention, and the female subject is interacting with him but without calling too much attention to herself.

P3S

For **Figure 16.70**, I chose a large aperture to give me a shallow depth of field focused on the groom. Although the bride is closest to the camera, she is out of focus, keeping the attention on the groom. Since the bride's hair mostly covered her left eye, I thought it would be fun to show only one of the groom's eyes. I positioned my couple so that her head would block half his face, and then I showed her a spot on the floor that I wanted her to look at to pose her eyes. I asked the groom to pose his eyes in motion. So, first he had to look at the ground and then look up at me. He did this three times or so until the expression and smile were right.

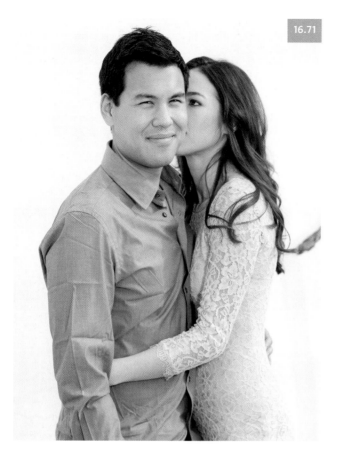

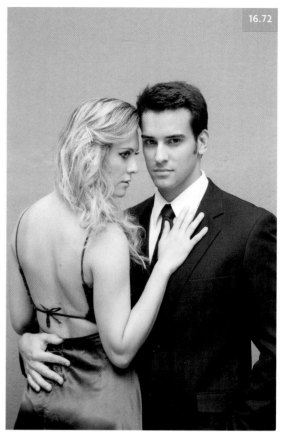

Pay close attention to the eyes of the female subject, especially the eyelids. If you fail to tell the female subject where to look, you could end up with a photo such as **Figure 16.71** or **Figure 16.72**. In Figure 16.71, Sarah's eyes should be closed considering how close she is to Neal's face. In Figure 16.72, the model's eyes and interaction look completely staged (Chapter 10, "Interaction and Placement of Subjects"). Almost closed or halfway closed eyelids usually give you the best results.

Tips

A tighter crop works best with this kind of pose. To finish this pose, you could piggyback on another pose. For example, start with the couple facing each other, then rotate yourself around the couple but have the male subject follow you with his eyes. Then make the necessary adjustments with the female subject for the pose to look right. Keep in mind what you learned in Chapter 12, "Balancing the Subject Ratio," when using this pose.

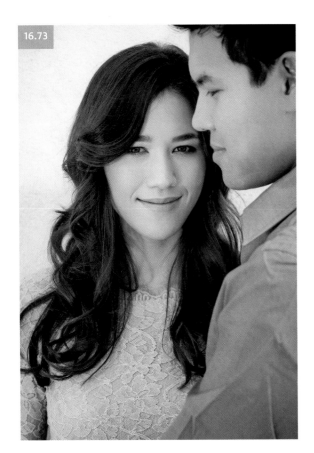

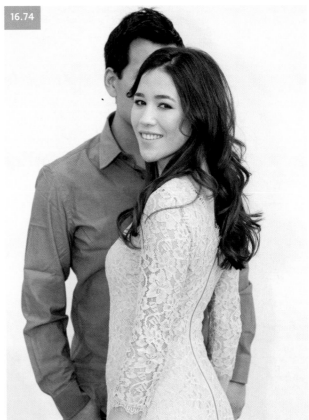

FEATURING HER

Pose Foundation

This pose is the reverse of the previous one: This time the female subject is in focus and the center of attention, whereas the male subject is on the sidelines but still interacting with his partner. Usually, but not necessarily, the person featured should be looking straight at the camera (**Figure 16.73**).

P3S

It is important to keep in mind the subject ratio when doing this pose (Chapter 12, "Balancing the Subject Ratio"). Although you are trying to make the male subject secondary in importance, that does not mean he should be completely blocked by her head, as shown in **Figure 16.74**. Just as in the hugging photos, you want to see more of the groom's face without bringing too much attention to him, as illustrated in **Figure 16.75**. Notice here that you can see a hint of the groom's eyes.

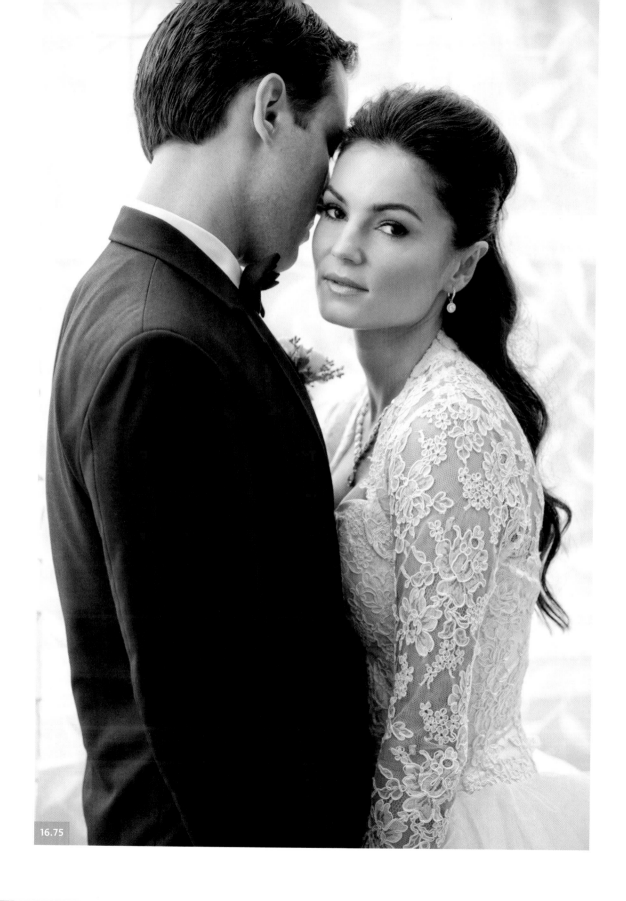

16.75

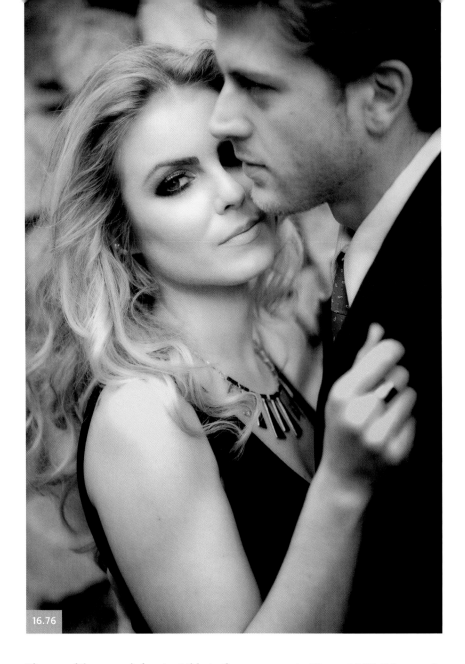

16.76

If more of the groom's face is visible to the camera, as in **Figure 16.76**, it is more important to throw the male subject's face out of focus using a large aperture and a long lens zoomed all the way in. Otherwise, the amount of his head showing in the photograph will detract from the female subject.

Tips

The use of selective focus is key to pulling off these last two poses correctly. Work particularly hard to make sure that the interaction between the couple looks natural and not staged. Use the techniques described in Chapter 15, "Posing with Movement, Feeling, and Expression," such as giving the brain something to count, or having the couple close their eyes, then open them. Such techniques will keep their eyes engaged properly.

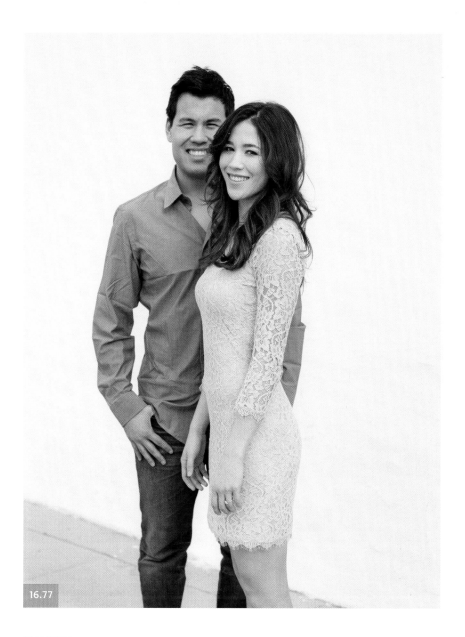

16.77

T-POSE

Pose Foundation

The "T" in T-pose refers to the couple's collarbones posed perpendicular to each other (**Figure 16.77**). This unique way of positioning couples can provide you with angles and perspectives that look fresh, tender, and playful.

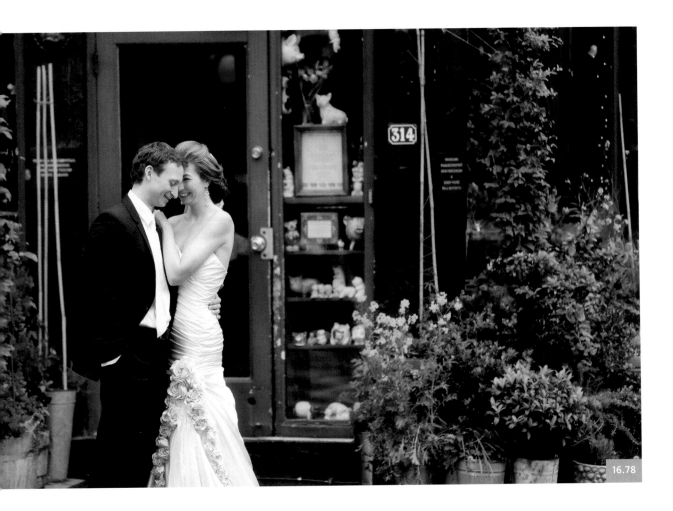

16.78

P3S

During a wedding assignment in Manhattan (see **Figure 16.78**), the couple shared a story with me about the neighborhood where this photo was taken. It brought back great memories of the beginning of their courtship. I wanted a pose that looked playful but still somewhat cozy. I chose the T-Pose, because it provides a perfect fit to convey these two different feelings.

Once in the T-Pose position, I asked the bride to engage with the groom directly. To be exact, I asked her to engage with his eyebrows but not to look at his eyes. The reason for this is to create an awkward request that she has never imagined doing before. This will cause them to react with laughter. I asked the groom to look at the ground and to keep looking at it, regardless of what happens. When the bride began to laugh from staring at his eyebrows for so long, he reacted with a similar response. Gotta love empathy!

During a shoot in Los Angeles with Brittany and Eric for their first anniversary photos, we traveled to the place where Eric proposed to Brittany. The pose is similar to that in Figure 16.78, but for this variation, I placed Brittany's collarbone facing straight at the camera and their hands engaged with their arms almost straight down (**Figure 16.79**). Their interaction had to be different, because the height difference would not allow the same interaction as in the previous photo. I needed to keep his back as straight as possible

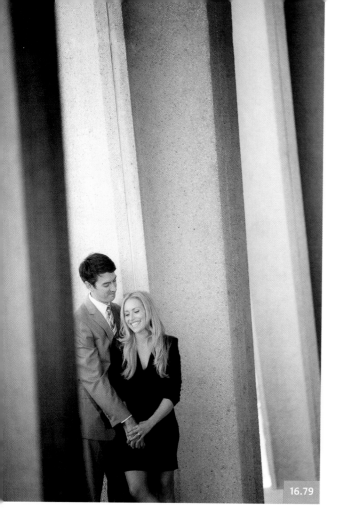

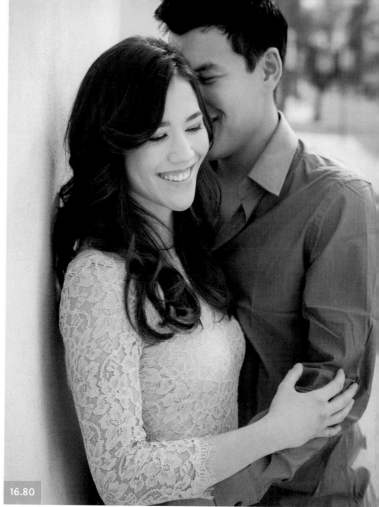

16.79

16.80

(Chapter 1, "Understanding and Posing the Spine"). So instead of looking at her eyebrow, I asked him to stare at her head. This made her self-conscious and caused her to react with a beautiful and contagious laughter. Even though the photograph is posed, the reactions and expressions on their faces are as real as it gets.

During my sister Sarah and soon-to-be brother Neal's engagement photo shoot, I wanted to create another fun image using the T-Pose option (see **Figure 16.80**). This time around, I posed Neal's eyes completely closed and asked him to smell her hair. I had to pose Sarah's eyes to make sure that they stayed fixed in the right position, just in case she laughed so hard that she would move her face and eyes out of whack. The visible arms were posed one hand higher than the other (Chapter 9, "Avoid Mirroring"). Everything was set. For the expression, I asked Neal to describe to me what her hair smelled like. Everyone started laughing!

Tips

The requests you ask of your clients must be made with confidence! Do not doubt yourself when asking. When posing with the T-Pose, experiment with the position of the hands. It will give your photos a very different look, as demonstrated in the examples shown here.

ONE LAST WORD

The best way to have fun during a shoot is to be skilled enough that you feel no anxiety or doubt about how effective you are. The poses presented in this chapter cover nearly every way you can pose a couple, with the exception of lying down. I left lying down out of the chart on purpose. The risk of asking your clients to lie on a dirty floor or on grass is too much for most situations. If their clothes get stained or dirty, it could derail the photo shoot, giving them a bad experience. Naturally, feel free to implement the lessons in this book and pose your couples lying down. But you must accept the risks, even if the couple gives you permission.

It's unrealistic to represent every combination of each of the poses in one book—in fact, it would be impossible. Use the examples in this chapter as a reference. Create your own variations of each of the poses. Let your style shine through your poses, and give your subjects a new appreciation of the art of posing!

CONCLUSION

I WISH I COULD TELL YOU that there's an easy and effortless way to learn a skill, but I don't want to lie. Posing is a skill. And a skill must be respected, practiced, and nurtured. Here's the reality: If you took the time to buy and read this book, I assume you have a deep desire to learn about posing people. If that's the case, read the book a second time. But read each chapter slowly and carefully. Make sure that you don't rush through any concepts. The skills you learn by reading this book will be extremely helpful, but at first your newly acquired skills will reside in your brain's short-term memory. The only way to ensure your brain will transfer your new skills to long-term memory is to explore each concept on your own, with a friend, or with someone who can help you by posing for you. Your brain needs constant reinforcement of a particular skill to deem it important. Reading the chapters is just the first step. Trying out the concepts is the second step. Analyzing your photographs based on the P3S posing system that you learn in this book is the third step.

When you engage in deeply focused and deliberate practice, your surroundings and distractions fade away, and you're able to concentrate solely on the task at hand. To achieve this level of focus, you simply have to set aside 15 minutes or so when you dedicate yourself to a task that has a clear starting point and a clear ending point. The clarity of the small goals is crucial to the process, and you must repeat the same tasks often and correctly. Keep this in mind, because this high-level practicing is something that anyone can do. So don't think for a second that you aren't capable of this, because you definitely are!

Before you begin to pose anyone, I recommend that you first define the purpose of the pose. For instance, is the objective of the pose to bring attention to the model's clothes or the model's face? The answers to these types of questions will dictate what choices you make at each of the P3S decision points. Not only should you know what the purpose of the pose is, but you should also try to visualize the pose in your head. Visualizing a pose is difficult if you have never tried it, because it requires your brain to form or imagine a photo that hasn't yet been seen. Practice previsualizing poses from now on, and you will witness the process becoming easier. Now that you have the purpose of the pose defined and the vision of the pose is in your head, you can begin making the necessary choices at each of the P3S decision points that will give you the results you're seeking.

Well, my friends, we have come to the end of the book. It is my sincere wish that you take posing into your own hands. Posing is nothing more than a skill that can be learned. No one is born with the posing gene. Great posing is not a natural talent but a skill that requires dedication, a desire to learn, and constant deliberate practice. If you wish to master the art of posing, then do it!

Happy posing.

—Roberto Valenzuela

INDEX

E

Edmonson, David, xii
elbows
 hugging poses and, 156, 158, 279–280
 point of first contact and, 156, 157–158
 positioning for couples, 127–128
emotions. *See* feelings/emotions
emphasizing the subject. *See* subject emphasis
energy of photos
 3-point combinations and, 45–48
 emotions/feelings related to, 43
expression, feeling, and movement, 230–233
eyelids, 222, 223
eyes
 3-point combinations and, 45–49
 brain tasks for posing, 224–227
 closing and reopening, 228–229
 emphasizing in photos, 44, 153
 guideline for controlling, 221
 importance of posing, 220–221
 point of first contact and, 153, 154
 techniques for posing, 224–229
 three parts of, 222–223

F

faces
 close interactions involving, 139, 146
 framing with arms/hands, 65–66, 67, 70–74
 Nose X-Factor and, 177–192
 See also heads
facing-each-other poses, 287–289
 P3S applied to, 287–289
 pose foundation for, 287
 tips related to, 289
fake smiles, 214, 289
family portraits. *See* group portraits
fashion photography, 45, 46
feelings/emotions
 associated with body language, 43, 85
 combining movement and expression with, 230–233
 matching in subject interactions, 141

feet
 crossed, 18–20
 direction of toes and, 21, 22, 23
 resting on props, 21–22
 uncrossed, 21–23
 See also legs
female subjects
 couple posing featuring, 294–296
 hand posing suggestions for, 95–99
 subject ratio related to, 166–167
fingers
 bent at 90-degree angles, 36–38
 couple posing suggestions for, 103–108
 Flash Card on posing, 38
 interlocking of, 104–105
 natural position of, 37
 origin of hands and, 113–122
 photographic importance of, 93
 placing for couples, 103–104
 pointing with hands and, 81–84
 pose analysis exercises on, 109–112
 See also hands
finishing touches, 213–236
 combining feeling, movement, and expression, 230–233
 photojournalistic posing, 213, 214–220
 pose analysis exercises, 234–236
 posing the eyes, 220–229
first point of contact. *See* point of first contact
fish lips, kissing with, 253
Flash Cards
 on 3-point combinations, 44, 45
 on angle of joints, 36
 on closing and reopening eyes, 228
 on controlling the eyes, 221
 on lifting the knee with a prop, 22
 on maximum time for holding poses, 220
 on Nose X-Factor concept, 184, 188
 on origin of hand issues, 117
 on parts of the spine and poses, 11
 on responses to posing instructions, 158
 on subject interaction/placement, 139, 141, 145
 on subject ratio, 172
 on wrist and finger poses, 38
fluidity of poses, 30–31

focus
 foreground/background, 283
 selective, 205, 206, 207, 296
focusing your attention, 13
foreground
 posing couples in background and, 283–286
 subject placement in, 140, 148
foreground/background couple poses, 283–286
 P3S applied to, 284–286
 pose foundation for, 283
 tips related to, 286
framing
 arms/hands used for, 65–66, 70–74
 holding objects combined with, 75, 76, 79
 pointing combined with, 81, 82, 84
 subject emphasis through, 206, 209
fun couple poses, 256–259
 P3S applied to, 256–259
 pose foundation for, 256
 tips related to, 259

G

gaps, 55–62
 creating natural looking, 56–57
 Flash Card on creating, 59
 lighting used to emphasize, 58
 pose analysis exercises on, 61–62
 reasons for creating, 55, 56, 59
 "S" curve for emphasizing, 60
 silhouetted subjects and, 80
 walls for emphasizing, 59
Gauguin, Paul, xii
Ghionis, Jerry, xiii, 44
gripping hands, 104, 105, 106–107
group portraits
 avoiding mirroring in, 131–133
 Nose X-Factor technique for, 186–188
 stances of people in, 23

H

Hand/Arm Context System (HCS), 63–92
 connecting option in, 85–88
 framing option in, 70–74

holding option in, 74–80, 261
 Key Execution Concepts of, 65–66
 overview and purpose of, 64–65, 88
 pointing option in, 81–84
 pose analysis exercises on, 89–92
 resting or resting on option in, 66–69
hands
 attention directed through, 38
 bent at 90-degree angles, 37–38
 common issues with posing, 95
 connecting through touch using, 85–88
 couple posing guidelines for, 103–108
 creating gaps using, 56–57
 creepy hands issue, 113
 female posing suggestions for, 95–99
 Flash Card on posing, 38
 framing subjects using, 70–74
 gripping problem with, 104, 105, 106–107
 HCS system for posing, 63–92
 hiding a double chin with, 107–108
 holding in couple shots, 104–107, 261–263
 importance of posing, 93
 inviting vs. defensive, 66
 male posing suggestions for, 100–101
 mirroring of arms and, 123–136
 natural curvature of, 37
 objects held in, 74–80
 origin of fingers and, 113–122
 pointing with fingers and, 81–84
 pose analysis exercises on, 109–112
 problems positioning, 64
 putting into pockets, 100–101
 resting or resting on position for, 66–69
 single posing of one, 65
 See also arms; fingers
harsh light, 202–203
HCS. *See* Hand/Arm Context System
heads
 3-point combinations and, 45–49
 close interactions involving, 139, 145, 146
 effects of tilting, 45, 47, 48, 180
 See also faces
her behind him pose, 246–249
 P3S applied to, 246–249
 pose foundation for, 246
 tips related to, 249

lumbar spine, 7–11
 curvature of, 7, 8, 10–11
 hips related to, 7
lying down poses, 300

M

male subjects
 featured in couple poses, 292–293
 hand posing suggestions for, 100–101
 subject ratio related to, 166–167
midday sun, 199
midpoint
 adjusting poses based on, 169–173
 shooting angle related to, 168
 subject ratio and, 168–169
mirror reflections, 209
mirroring, 123–136
 couple poses and, 126–130
 group portraits and, 131–133
 individual poses and, 124–126
 pose analysis exercises on, 134–136
models
 author's note to, xviii
 posing with movement, 215–216
movement
 combining feeling and expression with,
 230–233
 playful couple poses with, 258–259
 posing subjects with, 215–218

N

natural light. *See* sunlight
ninety-degree angles, 29
 arms bent at, 32–35
 couple poses and, 33–34
 Flash Cards about, 36, 38
 importance of, 29
 pose analysis exercises on, 39–42
 strength conveyed through, 34–35, 36
 wrists/fingers bent at, 36–38

Nose X-Factor, 177–192
 candid portraits and, 180, 182
 examples of implementing, 178–179
 explanation of, 177, 178–179
 Flash Cards on using, 184, 188
 group portraits and, 186–188
 parallel noses and, 183–185
 photographic style and, 188
 pose analysis exercises, 190–192
 spotting oversights related to, 188, 189
 variations on using, 180–182

O

obtuse vs. acute angles, 36
On Your Own exercises
 on 3-point combinations, 52–54
 on angle of joints, 39–42
 on finishing touches, 234–236
 on gap creation, 61–62
 on hand/finger posing, 109–112
 on HCS method, 89–92
 on mirroring, 134–136
 on Nose X-Factor, 190–192
 on origin of hands/fingers, 119–122
 on point of first contact, 162–164
 on spinal posing, 14–16
 on subject emphasis, 210–212
 on subject interaction/placement, 149–152
 on subject ratio, 174–176
 on weight distribution, 25–28
 See also pose analysis
open-ended interpretation, 272–273
origin of hands/fingers, 113–122
 Flash Card on working with, 117
 pose analysis exercises on, 119–122
 solutions to showing, 116–118
 visibility of, 114–115
outdoor portraits, 199
out-of-focus subjects, 283
overlap point
 adjusting poses based on, 169–173
 subject ratio and, 168–169

posing instructions
 client responses to, 158
 subject tasks as, 224–227
posing threshold, 3
posture
 proper, for photos, 6
 thoracic spine and, 5
pouting, 253
previsualizing poses, 302
props, lifting the knee using, 21–22
puddle reflections, 274, 275

Q

Quigg, Dylan, 203, 232

R

reflections
 mirror, 209
 water puddle, 274, 275
repeating elements, 209
resting or resting on the hands, 66
reviewing your own images, 23
robertovalenzuela.com website, xvii
romance, creating a sense of, 180, 181

S

"S" curve, 60
sclera, 222, 223
seated couple poses, 264–267
 P3S applied to, 265–266
 pose foundation for, 264
 tips related to, 266–267
seated subjects
 couple poses with, 264–267
 weight distribution of, 24
selective focus, 205, 206, 207, 296
senior portraits, 45
shifting the body weight, 18–23
 crossing the feet and, 18–20
 not crossing the feet and, 21–23

shooting angle
 midpoint as guide to, 168
 point of first contact and, 154, 155
shoulders
 dropping down and back, 6
 point of first contact and, 158, 160
side-by-side couple poses, 268–271
 P3S applied to, 268–271
 pose foundation for, 268
 tips related to, 271
silhouettes
 creating gaps for, 80
 distance apart poses for, 278
simple emphasis, 204, 205, 207
size, subject emphasis and, 205
slouching/hunching, 4–5
soft light, 202
spine, 3–16
 cervical, 4, 5, 11
 Flash Card on posing, 11
 importance of, 3
 lumbar, 7–11
 parts overview, 4–11
 photo review exercises on, 14–16
 pose analysis of, 12–13, 14–16
 stretching, 5–6
 thoracic, 4–7
stiffness
 bending joints to avoid, 30–31
 equal weight distribution and, 18
storytelling
 open-ended interpretation as, 272–273
 subject placement/interaction as, 148
strength
 conveyed through 90-degree angles, 34–35, 36
 posing men's hands for, 100
stretching, spinal, 5–6
style, photographic, 188
subject emphasis, 193–212
 brightness of subject and, 194–198
 compositional techniques and, 204–209
 compound emphasis, 204, 206–207, 209
 direction of light and, 199–203
 isolating main subjects for, 207–209
 pose analysis exercises, 210–212
 simple emphasis, 204, 205, 207